TREASURES
FROM THE
FITZWILLIAM

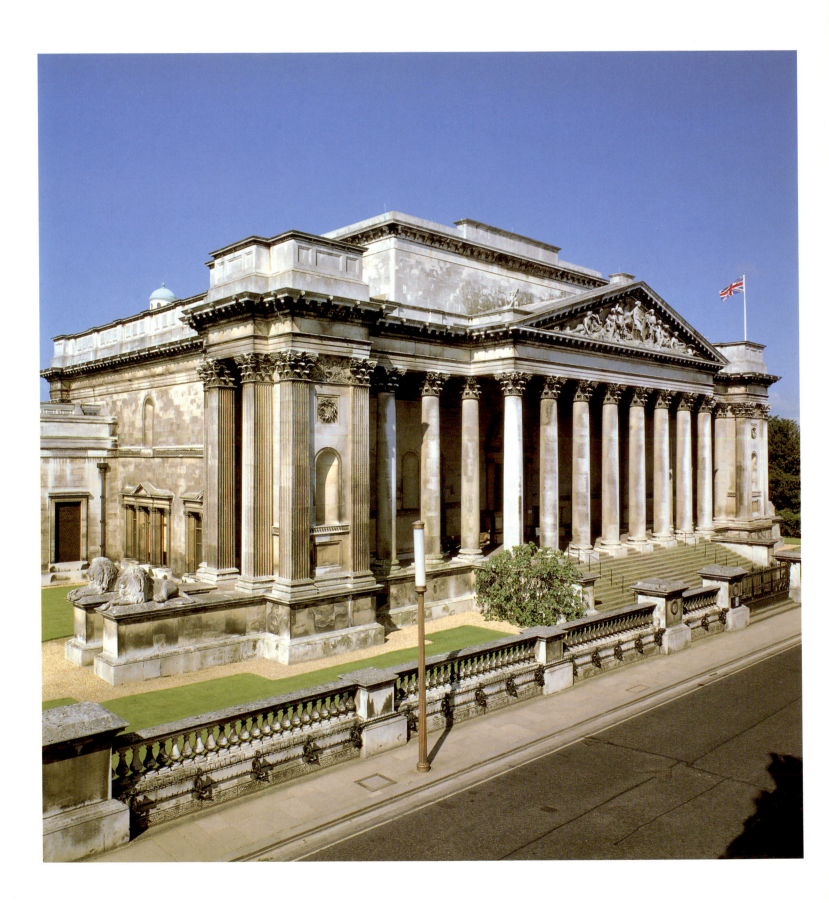

TREASURES
FROM THE
FITZWILLIAM

*"the Increase of Learning and other great Objects
of that Noble Foundation"*

The right of the
University of Cambridge
to print and sell
all manner of books
was granted by
Henry VIII in 1534.
The University has printed
and published continuously
since 1584.

CAMBRIDGE UNIVERSITY PRESS

CAMBRIDGE
NEW YORK NEW ROCHELLE
MELBOURNE SYDNEY

Published by the Press Syndicate of the University of Cambridge
The Pitt Building, Trumpington Street, Cambridge CB2 1RP
32 East 57th Street, New York, NY 10022, USA
10 Stamford Road, Oakleigh, Melbourne 3166, Australia

First published 1989

British Library cataloguing in publication data
Fitzwilliam, Museum
Treasures from the Fitzwilliam: ''the increase of
learning and other great objects of that noble
foundation''
1. Cambridgeshire. Cambridge. Museums.
Fitzwilliam Museum. Stock Catalogues, indexes
I. Title
069'.09426'59

Library of Congress cataloguing in publication data

Applied for

ISBN 0 521 37130 9 hard covers
ISBN 0 521 37979 2 paperback

Designed by Jim Reader
Design and production in association with
Book Production Consultants, 47 Norfolk Street, Cambridge CB1 2LE

Typeset by Omnia Typesetting · St Ives · Cambridgeshire
Printed in Singapore

CONTENTS

FOREWORD

The Fitzwilliam Museum was founded in 1816 by Richard, Viscount Fitzwilliam of Merrion, with a bequest to the University of Cambridge of pictures, books, manuscripts, and prints "for the purpose of promoting the Increase of Learning and other great Objects of that Noble Foundation". In the 173 years since then, the Museum has grown to fulfill Viscount Fitzwilliam's intention. Enlarged by other bequests and gifts and by discriminating purchases since its beginning, the Fitzwilliam now contains a collection that mirrors, in works of art and archaeology, the humane interests that are pursued in a great university.

Like the British Museum, the Fitzwilliam addresses the history of culture in terms of the visual forms it has assumed, but it does so from the highly selective point of view of the collector connoisseur. Works of art have been taken into the collection not only for the historical information they reveal but for their beauty, excellent quality, and rarity. The objects have most often been given or bequeathed by discerning collectors of an exceptional variety of interests, so that the holdings of the Fitzwilliam represent almost every medium and epoch of the history of art. In more recent years, diverse and remarkable purchases made by two great modern scholar-directors of the Fitzwilliam, S. C. Cockerell and Michael Jaffé, have further enriched the collections. It is a widely held opinion that the Fitzwilliam is the finest small museum in Europe.

The Syndics of the Fitzwilliam Museum have most generously agreed to lend the National Gallery of Art and four other American museums a representative selection of its best works, and we would like to thank Michael Jaffé, the Museum's present director, for organizing the exhibition. *Treasures from the Fitzwilliam Museum* includes paintings by Titian, Guercino, Rubens, Hals, Delacroix, Hogarth, Van Dyck, Renoir, and Degas, as well as drawings by artists such as Rembrandt, Annibale Carracci, Tiepolo, Puvis de Chavannes, and William Blake. Other objects among the loans are choice bronzes, ceramics, coins and medals, illuminated manuscripts, and decorative arts. We take pleasure in sharing this exhibition with the Kimbell Art Museum in Fort Worth, the National Academy of Design in New York, the High Museum in Atlanta, and the Los Angeles County Museum of Art.

At the National Gallery of Art, we acknowledge the contribution of D. Dodge Thompson, Ann Bigley Robertson, and Heather Reed of the exhibition office for their behind-the-scenes management of the myriad administrative details of the exhibition; Mary Suzor, registrar, for coordinating the packing and transport of the objects; and Elizabeth A. C. Weil and her able staff in the corporate relations office. We acknowledge Sydney J. Freedberg, chief curator, Beverly Louise Brown, coordinator of the exhibition, and Janice Collins, staff assistant, for their roles in seeing the exhibition to fruition. Thanks are also due to Gaillard F. Ravenel, Mark Leithauser, and Gordon Anson for their thoughtful design and installation of the splendid works of art.

We are most grateful to Philip Morris Companies Inc., whose generous financial support made this exhibition possible. Philip Morris's distinguished record of corporate support of the arts is well known to audiences across this country and abroad. The support of Hamish Maxwell, chairman and chief executive officer of Philip Morris and an alumnus of Cambridge University, was essential to the realization of this project from its inception. We appreciate the help of Stephanie French, director of cultural and contributions programs for Philip Morris. Thanks also go to the American Friends of Cambridge University, especially Gordon Williams and Stephen Price, for their enthusiasm and assistance with the project, and to British Telecom Inc. for the additional support it provided.

J. Carter Brown
Director
National Gallery of Art
Washington

INTRODUCTION

About the Fitzwilliam Museum

The bequest of Richard, 7th Viscount Fitzwilliam, to Cambridge in 1816 launched a novel idea, that a university should have its own museum of art (*frontispiece*), and, in this prime instance, that the museum should have its own library (*fig. 1*). His declared purpose for his university was to promote

"the Increase of Learning and other great Objects of that Noble Foundation"; and he bequeathed also money to house there fittingly his splendid collections. A benefactor of his standing in early-nineteenth-century England would have have been expected, especially in the year of high patriotic

fig. 1 The Founder's Library today

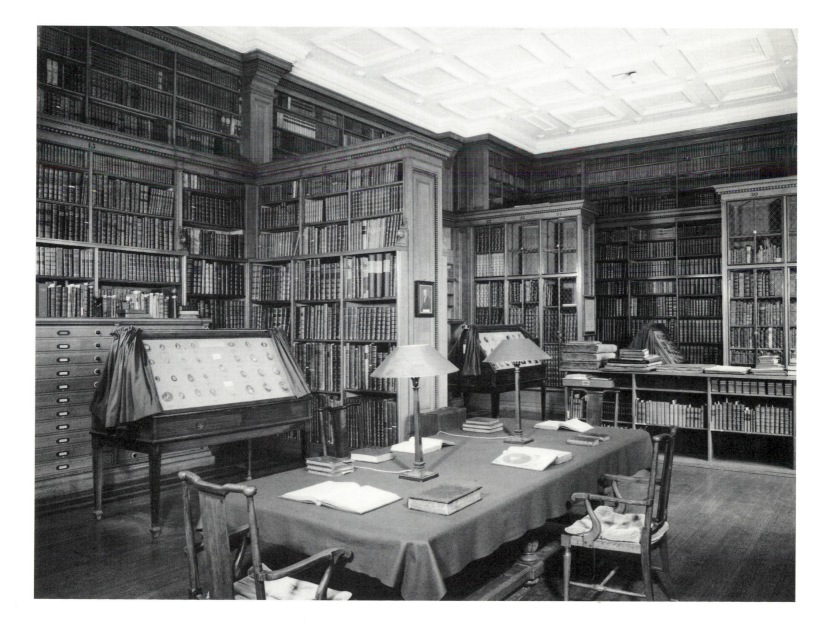

feeling that followed Wellington's victory at Waterloo, to have left the collections at least to what had been since 1753 the national repository in London, the British Museum. The Ashmolean Museum, by far the oldest public museum in Britain, and now more or less the Oxford equivalent of the Fitzwilliam (yet still without a library of books or manuscripts), was then no more than an overgrown cabinet of curiosities with attendant portraits, enlarging upon the *cimelia* of Elias Ashmole and John Tradescant; and Ashmole's offer in 1675 had not included a building.

Lord Fitzwilliam is said to have mistrusted the British Museum not only for the practice of its Trustees in selling "duplicate" books, but also for the inconsiderate handling that he observed acquisitions

to receive on arrival at Montagu House. Moreover he could outdo the Ashmolean not only by his art collections and his library, but also by the fitness of the museum which should house them. The Museum so munificently provided for, being founded upon a habit of collecting which reached from his primary and lifelong passion for music to manuscripts, books, Italian and Dutch paintings and prints, even to a few pieces of Rysbrack sculpture and to drawings of picturesque subjects, mainly connected with his visits to Italy, was an innovation which offered an example not only to Oxford, but also to Princeton, to Harvard, to Yale and thus to a host of university institutions which today thrive across the United States.

Our Founder's Bequest, although by the prudence of his Will no item that was his may be lent from the Museum of which the original building was to be erected at the cost of his legacy, is nonetheless of fundamental importance to an exhibition that has

fig. 2 The Founder's Building during construction, engraved by E. Challis 1838; showing sculpture envisaged by Basevi, but never installed in the niches

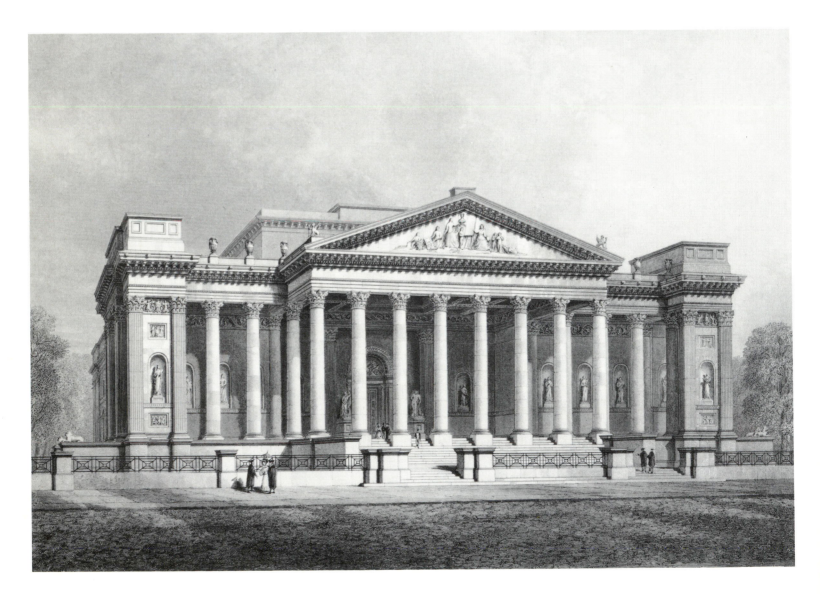

been especially chosen for the USA. Without his beneficent intent there might never have been such an art museum on Trumpington Street. Without his inherited wealth, his developing taste and his zest, the Museum bearing his name would not have attained, nor have been encouraged to sustain, such a high level of acquisition either in those areas which particularly interested him, European music and figurative arts, or in those which apparently did not: antiquities, numismatics, *orientalia,* together with the applied arts of the near East and of the West – and most recently North American art.

Thanks to its Founder, a rich amateur, and to a succession of benefactors following his lead in offering by gift or bequest a vast range of distinguished and desirable things, the Fitzwilliam has more than redoubled itself as a treasure house, a feast for the eyes of those who can come to Cambridge. Otherwise we should not have sought to share with a more extensive public across America the pleasure and interest to be had from exhibiting our finest available possessions in such variety. Our hope is to attract still more of you to Cambridge and to the Fitzwilliam, in order to enjoy repeatedly in their home setting the works which have been selected for this tour, besides a foison of things which could not be sent to you either because they are part of our Founder's Bequest or because they are too vulnerable for us to risk over 18 months on long journeys and through marked changes of climate.

Housing the Collections

The Founder's Building

Appropriately to the novelty of Lord Fitzwilliam's idea, the so-called Founder's Building (*fig. 2*) represents a novel departure. The University's response to his bequest enriched Cambridge with "a dominating and unforgettable monument" to vie, in terms of an early-nineteenth-century interpretation of the classical language of architecture, with the supreme triumph of the English Perpendicular style in the mid-fifteenth-century Chapel of King's College. Logically trivial, but in propaganda terms significant, are those pairs of mid-nineteenth-century spill vases which were manufactured in Staffordshire by Copeland: each is decorated by a transfer print, one showing the exterior of the world famous Chapel, the other the face of the Fitzwilliam toward Trumpington Street. Arthur James Balfour, as an elder statesman, wrote in *Chapters of Autobiography* (1930) of his

memory of coming in 1866 as a freshman aged 18 to his college: "The station fly which first conveyed me to Trinity took the road, as I remember, which passed the Fitzwilliam Museum. It is a fine building, though in a style by no means characteristic of University architecture. But for some odd reason I felt that it was the symbolic gateway into a new life: I was greatly moved and never pass it now without recalling something of that inexplicable thrill".

The 1834–5 competition to design the Museum had been more smoothly conducted than most in the nineteenth century. Victorious over the incipient gothic revivalists was George Basevi, a young kinsman of Benjamin Disraeli; and both the shell and the ornament of Basevi's building have been universally admired as his secular masterpiece. The only point of contention has been the Staircase Hall (*fig. 3*), which in its final form of the 1870s represented his ideas adapted first by Charles Robert Cockerell and secondly by Edward M. Barry. Basevi himself was aware that the problem was inherent in the decision to give prominence to the portico by setting it high above the picturesque confusion of seventeenth- and eighteenth-century house-tops on the opposite side of Trumpington Street. The entrance hall had to contain not only a grand staircase to the level of the five principal galleries, but also flights downward to the library rooms at the rear of the building (these are now galleries for Egyptian, Greek and Roman antiquities; *fig. 4*). On the not very large site which the University had succeeded in buying from Cambridge's oldest college, Peterhouse, it was hard to combine all these stairs within a hall which was also to display marble sculpture. Basevi first proposed a central staircase descending through an archway flanked by ascending flights, and then he reversed his scheme. Before the winter of 1845, when he fell to his death from scaffolding inside Ely Cathedral, he had changed again: but Cockerell, in executing the staircases, adopted a more opulent scheme of two ascending flights flanking a well, themselves flanked by two descending. These were never completed; and in 1870 it was decided to relieve the scalinated crowding of the Hall. An intermediate solution by the University's first Slade Professor of Fine Art, Matthew Digby Wyatt, to enlarge the Hall with an entrance apse was passed over. Instead Barry was commissioned to capture extra space by siting the downflights where Basevi had planned commodious offices for the Keeper and the Porter, the Fitzwilliam's two earliest officials. The Museum has felt ever since the lack of such useful spaces.

In the words of David Watkin, cataloguing our 1977

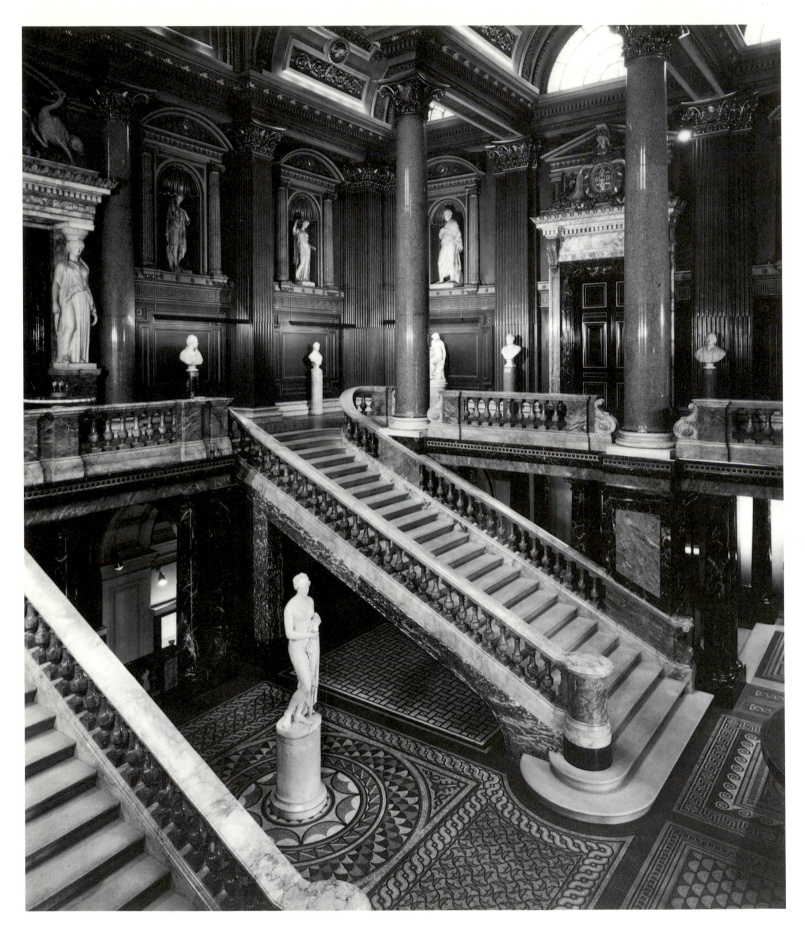

exhibition, *The Triumph of the Classical: Cambridge Architecture 1804–1834*, "The fine plasterwork of Basevi's ceilings, the bold sculptural details carved by W. G. Nicholl, the sumptuous metal gates and chevaux-de-frise along the balustraded entrance-wall are all rich in allusion to Greek and Roman sources and help make the building, like its contents, a liberal education in itself. The Neo-Classical vision of the public museum which gave us Klenze's Glyptothek in Munich of 1816, Schinkel's Altes Museum in Berlin and Smirke's British Museum both of 1823, Wilkins' National Gallery of 1832 and countless other proud porticos in Europe and North America, has found no finer or more eloquent expression than in the Fitzwilliam Museum, this great Temple of the Arts."

The Museum Expands

The Founder's Building, begun in 1837 and continued after Basevi's death under C. R. Cockerell's direction, opened in 1848 to members of the University and their visitors: members of the public were admitted on three days a week, providing that they were "respectably dressed". However exhaustion of funds left the entrance hall incomplete until 1871, when enough income had accumulated for E. M. Barry to finish the work in four years. The final cost, a little under £115,000, absorbed almost all of the capital sum provided by Fitzwilliam, which had been some £90,000 after payment of legacy duty, as well as the income therefrom. To provide for the growth of the collections there was no more building until 1921,

fig. 3 Staircase Hall, Founder's Building today

fig. 4 The Antiquities Galleries today

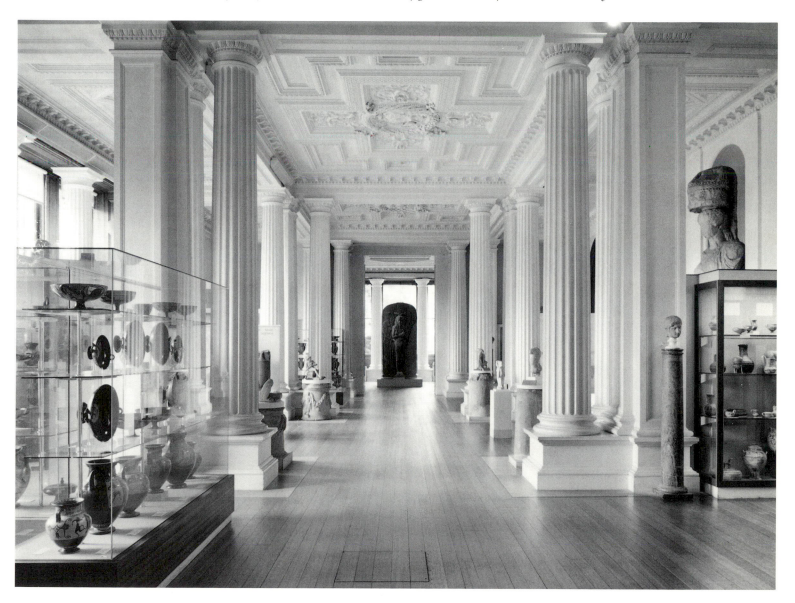

when the galleries named after Charles Brinsley Marlay were erected on two floors to the designs of A. Dunbar Smith and Cecil C. Brewer. While these Marlay Galleries were being built, the same firm of architects began the construction of a Coin Room and of a Manuscript Room, at the cost of William Newsam McClean, who, as his father and brother before him, was like Marlay amongst the Museum's chief benefactors in the first half of the twentieth century. It is a gratifying sequel that during the past dozen years we have been able to provide and equip two spaces for changing displays: of coins and medals in a gallery named for Humphrey Cripps (*fig. 5*); and of illuminated manuscripts and kindred materials in a gallery named for Anthony de Rothschild.

The upper Marlay Gallery is, like the principal gallery on the upper floor of the Founder's Building, clerestory lit. Its flanks are articulated by bays, in order to increase the wall space available for hanging early Tuscan masterpieces from the Museum's first great purchase of paintings in 1893; and the ends of the bays are resplendent with cases of appropriate *maiolica*. The palatial effect was enriched with carpets and furniture, domestic items which neither the Founder nor anyone else had thought appropriate for Museum display (carpets and rugs were acquired for the Fitzwilliam as furnishings for floors, and not registered as items in the collections as now the survivors of them have become through increasing rarity on the market). The pioneer combination of lighting and bay divisions, and the mingling of sculpture and applied arts with paintings, put the Fitzwilliam in the forefront of world museums. A further novelty introduced by the

fig. 5 The Cripps Gallery, opened 1985

fig. 6 *Courtauld Galleries: the Italian Gallery today*

Museum's greatest and longest reigning Director, Sir Sydney Cockerell (no relation to C. R. Cockerell, the architect), was the gold Japanese paper cladding the walls of the Marlay Gallery, today through successive rehangings light struck in patches and in places heavily worn, but still the most sympathetic background to "gold ground" and other *quattrocento* pictures.

The Marlay Gallery designs were ready soon after Marlay's death in 1912, but were delayed by the frustrating years of the First World War.

Sydney Cockerell's next innovation, working again with Smith and Brewer, was in the suite of galleries opened in 1931 through the gift of Sydney Renée Courtauld and her brothers, Sir W. J. Courtauld and Sir S. L. Courtauld. Those five Courtauld Galleries lead one from another on the upper floor. In them is

avoided any disturbing imbalance of cross-lighting, such as resulted from the clerestory of the Marlay Gallery, by the new roof being raised enough above ceiling height to allow lay-lights canted outward to deflect the fall of sunlight, and so to diffuse it along the flanks, while leaving a comparatively darker central spine of ceiling to moderate such exaggerated *chiaroscuro* as would have come from direct light striking bronzes or other reflecting surfaces below it (*fig. 6*). No art gallery in the past 58 years had made any sensible improvement upon this simple but subtle device; although we have seen in the recent Clore Gallery extension to the Tate Gallery in London a heavy-handed attempt at a similar resolution.

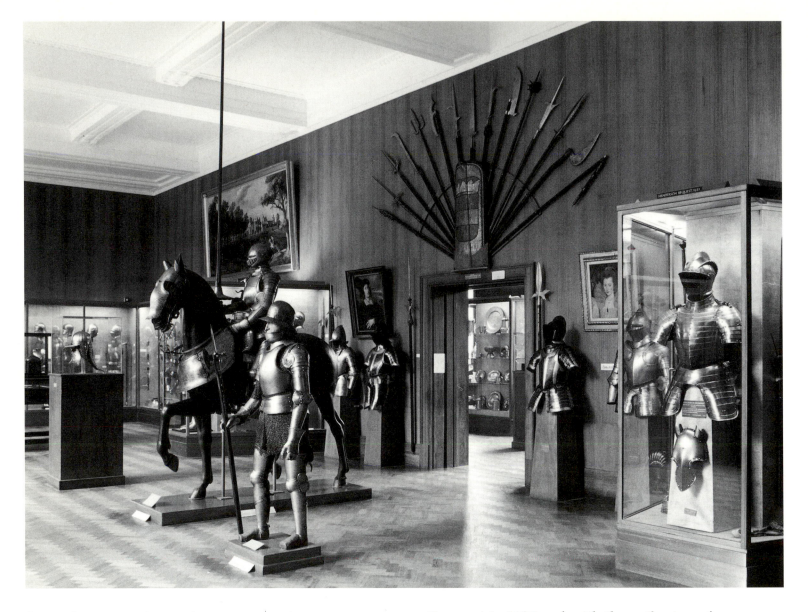

fig. 7 The Large Henderson Gallery (Armoury) today

The same Director with the same architects was responsible for the design of further additions to our buildings which were opened in 1936: upstairs the Charrington Print Room was provided by the gift of the Honorary Keeper, himself a notable giver, especially of portrait prints, to our collections; and downstairs the two James Steward Henderson Galleries were provided by a single bequest, the larger to display the only serious collection of armour in any British public collection between the latitudes of London and Edinburgh (*fig. 7*), the smaller for the applied arts (we show there medals, pewter vessels and stained glass, as well as an outstanding array of table glass). For all these extensions of the 1920s and 30s we have to thank Sydney Cockerell. With his

retirement in 1937 and with the gathering of war clouds, the Museum lost sight of his yet more ambitious proposals, all planned before the First World War, for completing by a grandiose court southward the range of buildings which had been instituted on two sides by the Courtauld, Charrington and Henderson Galleries, and which the Marlay Galleries connected on two floors to the Founder's Building. The Fitzwilliam kept its charm by not overextending itself or taxing the footwork of its visitors.

Yet while country houses may shed their wings, while abbeys and cathedrals, with more inhibitions, may dispense with chantreys and chapter houses, art museums, unless restricted by the testaments of their founders, may not sidestep the even keener issues of expansion calculated to keep pace with the growth of their collections and the liveliness of their pasts. To

house, and on appropriate occasions and themes to display, our growing collections of Dutch, French and Italian drawings, of British drawings and watercolours, and of Indian and Persian miniatures a special gallery with a students' room was added in the name of W. Graham Robertson adjacent to the Courtauld Gallery which today is hung with Flemish and Spanish paintings. Marvellous watercolours bequeathed from Graham Robertson's magnificent choice of work by William Blake eventually attracted from Sir Geoffrey Keynes his famous collection of work by Blake and Blake's circle in tempera, watercolour and pencil. The Museum had already, by acquisition in Cambridge from George Romney's son John, a Fellow of St John's College, a matchless wealth of his father's drawings. That had been in the 1830s, with Daniel Mesman's collection of Dutch and Flemish paintings, one of the first important additions to the collections since the Founder's Bequest.

By the extensions which opened in 1966 and 1975, both built to the plans of the late David Roberts and paid for almost entirely, as were the previous extensions, by appeals to private individuals, the Fitzwilliam has encased in its Anthony de Rothschild Gallery a *Schatzkammer* of illuminated manuscripts, ivories, fine metalwork, enamels and crystals, with sculptures in alabaster and stone, and portrait miniatures, all for the myopic pleasures of scrutiny. It has also, in a gallery purpose-built for temporary exhibitions, the space to run a programme, inaugurated in the summer of 1975, of a scope and variety exceeded only by the metropolitan centres of London and Edinburgh, and unsurpassed in quality by far larger and richer institutions. Most of these

fig. 8 The Adeane Gallery exhibiting "Morris & Company in Cambridge", 1980

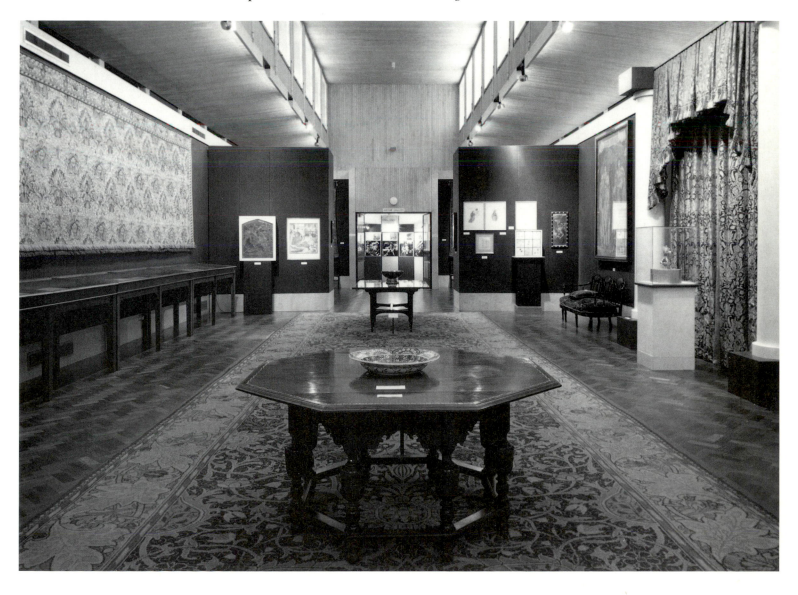

exhibitions are based on, or closely relevant to, our own collections; but through sponsorship we have been able to show thousands of our visitors three of especially American concern. In autumn 1976 we exhibited *100 American Drawings from the John David Hatch Collection,* ranging from the Colonial Period to the First World War; then, to celebrate our Queen's Silver Jubilee, we showed *Jubilation,* a choice of contemporary American paintings which had been acquired by British collectors during the 25 years of her reign; and last year we gave the only British showing to *An American Vision: Three Generations of Wyeth Art.* These various loans of American art have taken their place during the past dozen years among others of international consequence and attraction. The titles of some of them suggest the scope of our enterprise; *The Private Degas; Pharaohs and Mortals: Egyptian Art in the Middle Kingdom; "Beauty, Horror and Immensity": Picturesque Landscape in Britain 1750-1850; Morris & Company in Cambridge (fig. 8);* and *Korean and Chinese Ceramics.* We have sent to the United States two special exhibitions, each circulated by the International Exhibitions Foundation: *European Drawings from the Fitzwilliam* in 1976–7, and *Flowers of Three Centuries: 100 Drawings and Watercolours from the Broughton Collection* in 1983, ten years after we had inherited from Henry Broughton, 2nd Lord Fairhaven, the very large collection which he had assembled since the Second World War.

As important as any of these, not least in view of the resounding success of *Treasure Houses of Britain* at the National Gallery of Art in Washington, was last year's exhibition in the Fitzwilliam, with most of the works on loan and likewise unsuitable to travel beyond the inaugural venue: the catalogue of this, *The Hamilton Kerr Institute: The First Ten Years,* is also the first issue of what we intend as a biennial bulletin reporting on our Institute's undertakings and treatments, especially its work for research, for training of students and for supervision of interns (including those from America) in the conservation of easel paintings. Of the panel of three experts chosen to advise the organisers of the Washington exhibition two were from the Hamilton Kerr, one being the present Director, the other his immediate predecessor.

The Fitzwilliam's activity in exhibitions, four principal ones each year in addition to the specialist exhibitions proper to a university museum which regularly uses its collections for teaching, has demonstrated the need for further expansion in order to make the fullest use of such ground as remains to us for building. We need, in addition to galleries capable of taking large as well as smaller sculpture and related materials, good spaces to keep before our students and other visitors – over a quarter of a million annually in the most recent years – an eye-catching variety of the art of our time, not just painting and sculpture and the graphic arts, but also the applied arts in furniture, textiles and metalwork. Too often, in order to accommodate the larger temporary exhibitions which in their vigour have overflowed the purpose-built gallery (albeit the largest of its kind in East Anglia), we have been constrained to dismantle what we would otherwise wish to keep on display in the adjacent gallery in order to attract our visitors towards a shifting selection of Western art post–1950.

Life Inside the Buildings

Those with experience of art museums in America may be astonished that, while we offer tours by volunteer guides, we have no elaborate docent programme, and that we provide no 'Lektours'. They may be still more astonished that an art museum owned by a famous university should not have in its staffing an education department dedicated to children of school age. For this side of our operation the University of Cambridge, answerable for its expenditures to the Auditor-General, can spare no funds: but, by encouraging the offer of an attachment from the Cambridgeshire Education Authority, we have at last made progress and established a virtually full-time post. Our extra-curatorial responsibilities to the public, young or adult, do not end with the provision of well thought-out and well-labelled displays, either temporary or longer term, or with the trade of a museum shop and coffee bar.

The Friends of the Fitzwilliam Museum, instituted by Sydney Cockerell in 1909 in emulation of *Les Amis du Louvre,* is the oldest museum society in Britain; and it flourishes, with members far afield as well as local, as our supporters' club. It has no paid help. Every penny subscribed is available to the Director of the day to grasp for the Museum's collections some rapidly passing opportunity from the market without having first to refer his decision to the management committee, the Syndicate (cat. no. 35, 37a–b, 70, 95, 103, 121, 139). Our Friends have helped to raise substantial sums needed to pay for the long overdue effort to conserve our music manuscripts by organising series of benefit concerts, in addition to the occasional recitals which we enjoy holding in the Museum's galleries. The range and quality of these performances, both vocal and instrumental, would

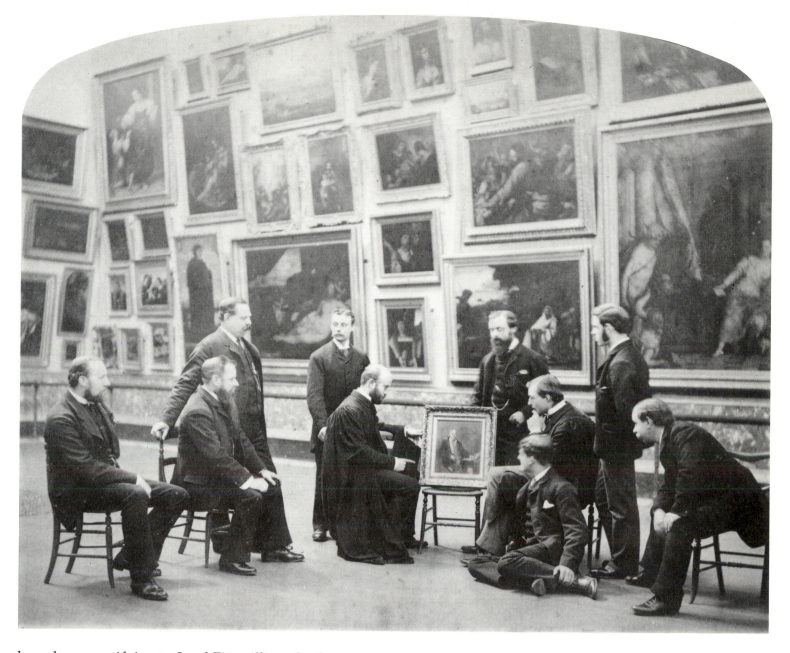

fig. 9 *The staff of the Museum in the Main Gallery of the Founder's Building (Gallery III) about 1880–90*

have been gratifying to Lord Fitzwilliam, both as a promoter of the ''Society for Antient Music'' and as a patron and collector of contemporary compositions. The outgoings of the Friends are covered partly by the jobbing production of their own printing press – the Fitzwilliam is the only museum in Britain to design and print in-house its posters, leaflets, programmes, invitations and the like, saving it considerable expense; partly by running subscription parties for the opening of our chief exhibitions; partly by organising special tours and expeditions.

The modern life of the Fitzwilliam is very different from that suggested by Victorian guidebooks, that of a disordered collection in which masterpieces of painting covered the walls indiscriminately tier upon tier from wainscoting to cornice (*fig. 9*), or were placed next to such miscellanea as a model of the Taj Mahal or boxes of Indian crabs. The Syndicate threatened to resign in a body when Vice-Chancellor Whewell, ex officio Chairman, prescribed without consultation the rehanging of the Venetian sixteenth-century masterpieces, in order to render less conspicuous the Titian *Venus and the lute player,* the Veronese *Mercury, Herse and Aglauros* and the Palma Vecchio *Venus returning to Cupid his arrow* (''the exhibition of nude figures in a public gallery is always a matter of some

embarrassment"). These three splendours of the Founder's picture-buying in London about 1800 are now shown together, with pride rather than embarrassment, in a place of special honour in our Courtauld Italian Gallery.

The addition since 1921 of new galleries and cabinets to the Founder's Building has in no way reduced its manifest suitability for University functions as well as for our own entertainments. The ball held in June 1864 in honour of the Prince and Princess of Wales (*fig. 10*) should not be the last of its kind. The royal and diplomatic visits with which we have subsequently been favoured have offered less obviously energetic, but no less animated occasions to remind those who govern the University of the rôle which the Fitzwilliam can play in the outward show of the "Noble Foundation".

The Growth of the Collections

The collections have grown largely by gifts and bequests, and in the most recent years also by occasional allocations (cat. 57, 93, 115) by Government of items accepted by Her Majesty's Treasury from private estates in lieu of cash settlement of liabilities to capital taxes. Not more than 10 per cent of all acquisitions have been made with the income of such funds as are available for the particular category of purchase in view; and major purchases have almost invariably needed the support, not only of the Regional Fund administered by the Victoria and Albert Museum for the Museums & Galleries Commission from their annual vote (maximum of 50 per cent support of approved purchases, to a present limit for any one institution in any one year of £60,000), but also of public-spirited outside bodies to which public museums competitively can present their cases, the National Art-Collections Fund and the National Heritage Memorial Fund pre-eminent amongst them. Last year Queen Elizabeth, The Queen Mother, opened our exhibition which celebrated the first 85 years of the NACF with a selection of works added over the past three quarters of a century with the help of that fund, a lifeline to a museum without the resources to pursue the ambitious purchasing policy of a national collection. The purchasing grant from the University of Cambridge stands at £2,600 *p.a.* to cover all five, very active curatorial departments.

The history of our benefactions from 1816 to 1958 has been set out in some detail by a former Director, Carl Winter, in his book *The Fitzwilliam Museum, an Illustrated Survey* (see Abbreviations, *Winter*): and this is no occasion to recite these afresh. Nevertheless it should not pass without comment here how certain acquisitions of the last 30 years have transformed sections of our collections, putting those in the first rank by international standards. The bequest in 1961 by D. H. Beves of his English and Irish table glass, probably the finest British private collection of his day, was a noble addition to what we had had in 1933 from the Rev. A. V. Valentine Richards, in 1950 from Mrs. W. D. Dickson, Honorary Keeper of Ceramics, and from others. The purchase in 1984 of the Chesterman collection of Greek terracotta figures called for a special exhibition, *Gods and Goddesses in Miniature:* it made such a remarkable addition to those which had been gradually amassed by the Museum since 1868. The small, but characteristically choice group of oriental fans and fan leaves which we had had from our first Honorary Keeper of the Oriental Collections, Oscar Raphael, was greatly augmented by the collection purchased in 1985 by the Friends, with most generous support from the National Heritage Memorial Fund, from the daughter of Leonard Messel; and the Great Britain-Sasakawa Foundation Fan Gallery (*fig. 11*), named for its principal donor, was especially created to display or to house all our fans both Eastern and Western or made in the East for Western markets, the first purpose-built fan gallery in Britain. Our display of Korean ware from our shares of the Raphael and Tapp collections attracted from G. St. G. M. Gompertz the much larger collection which he had formed after the Second World War (cat. 20), the showpieces being accompanied by sherds and an appropriate library which together make us a true centre in Western Europe for Korean studies; and the Hyundai Corporation has agreed to support the costs of a redesigned gallery. The gift, with the promise of an eventual bequest, of European bronzes from the collection formed by Lt. Col. the Hon. M. T. Boscawen, brings us in this field to a level with the Ashmolean (cat. 40); and in the field of Dutch drawings we have outranged the Ashmolean since we received the collection of Sir Bruce Ingram in 1963 (cat. 58, 60, 84).

Glass and fans, like paintings on panel, are not to be risked in travels abroad, with attendant packings, unpackings and a gamut of climatic changes. Otherwise we have, in selecting our best offering for this exhibition, kept in mind the sources of our benefactions. The brilliant eye and the benevolence of Charles Fairfax Murray brought us between 1893 and 1917, as then anonymous gifts, illuminated manuscripts, autograph letters, literary manuscripts and books; Egyptian, Greek, Roman and medieval

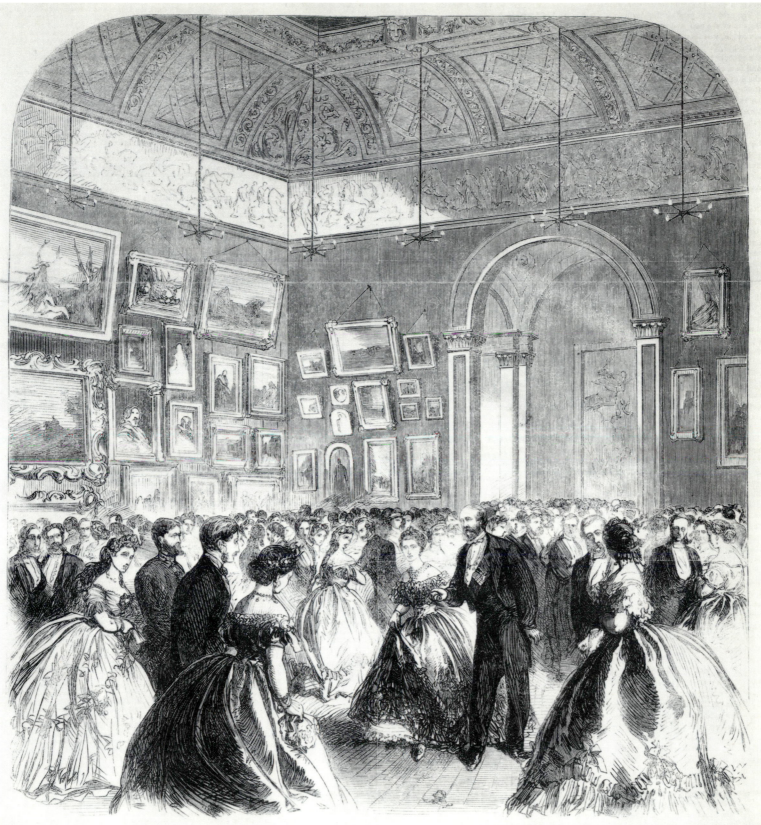

VISIT OF THE PRINCE AND PRINCESS OF WALES TO CAMBRIDGE.—THE BALL AT THE FITZWILLIAM MUSEUM.

fig. 10 Gallery III, from a wood-engraving published in The Illustrated Times, *London, Saturday 11 June, 1864*

''Visit of the Prince and Princess of Wales to Cambridge – The Ball at The Fitzwilliam Museum''

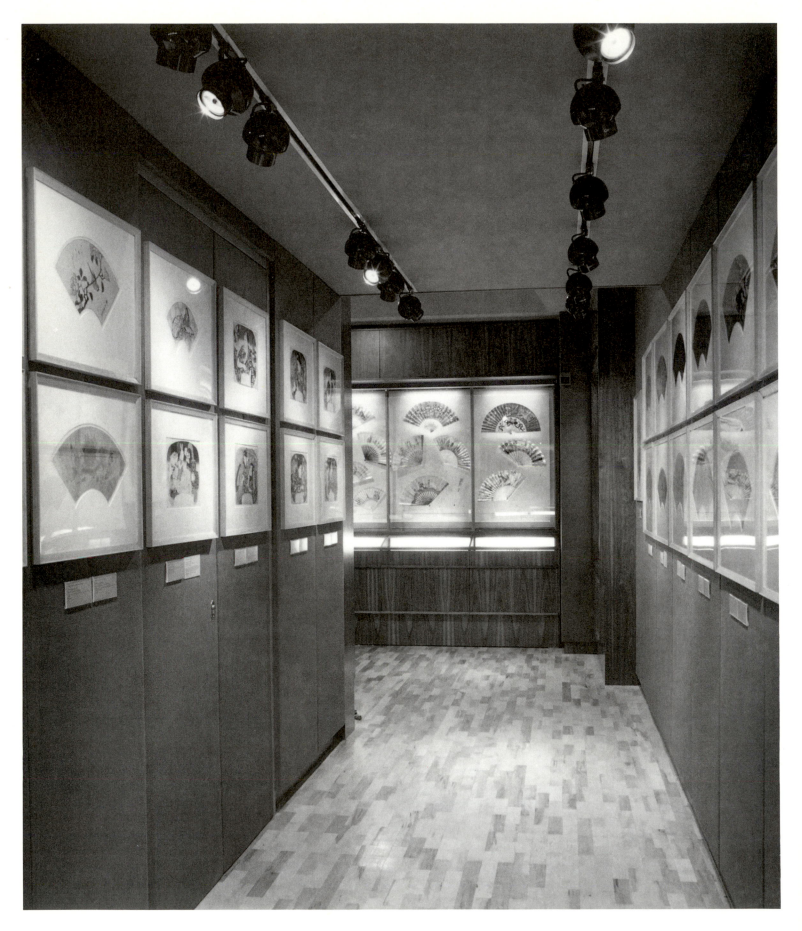

antiquities; furniture; music; pottery; prints, drawings and paintings, including many by Pre-Raphaelites (cat. 145). The most important painting which he gave was Titian's late masterpiece, painted for Philip II of Spain, his greatest patron, *The Rape of Lucretia;* and it is poignant that this, which was in the mid-nineteenth century offered to the USA by Joseph Bonaparte, should reappear (cat. 65) on the American side of the Atlantic as the biggest star in the constellation of our loan. Oscar Raphael divided his treasures between the Fitzwilliam and the British Museum. Our choice now reflects the quality of his taste: the marvellously preserved *Head of King Ammenemes III* (cat. 2); the Yue incense box (cat. 19); the zoomorphic ewers from Iran (cat. 22, 23); and the *Recumbent horse* in black jade (cat. 73). The Boscawen *Head of a Ram* by Riccio, from the base of a candlestick *all'antica* (cat. 40), and the Marlay *Bacchus* by Tetrode (cat. no. 42) evince the distinction of our bronzes to which their collections have contributed. Since I am officially Marlay Curator as well as Director, it adds a personal note of pleasure to have been able to include also Marlay's early painting by Jacopo Bassano (cat. 64). What we owe to Charles Ricketts and Charles Shannon (cat. 61, 87, 97 and 119), to Frank McClean (cat. 24, 25, 32), to Leverton Harris (cat. 45, 117), to Dr. J. W. L. Glaisher (cat. 74, 76, 77) and to a host of other discriminating people who have helped to advance our Founder's purpose is evident.

While it is layer upon layer of private taste which has given the Fitzwilliam its succulence, the collections are flavoured also by occasional purchases. We have included a pre-eminent few. The Breton Gospel Book with Anglo Saxon glosses (cat. 33), which had been in England for almost a thousand years, was accepted in 1980 by the National Heritage Memorial Fund with dazzling alacrity as beyond question a heritage item; and so it was purchased in the tradition of the decision taken in 1895, long before there was any heritage fund, to buy from William Morris the Grey-Fitzpayn Hours (cat. 38). The deep-cut alabaster relief of *The Adoration of the Magi,* signed A. H., was standing on the floor of a Brussels picture dealer, and bought in 1980 also (cat. 41). The Nepalese *Vishnu* (cat. 18) was brought to the Museum for opinion from a small house in Cambridge that same year. Not every year can we gather the means to buy such treasures. But after a full year of struggle and amazing generosity we raised the funds to buy from Samuel Courtauld's

granddaughter as recently as 1986 Renoir's triumph of Impressionism in a Paris street scene, *Place Clichy* (cat. 161). It is with this sophisticated ravishment of our senses that we match the indoor impression conveyed by Degas in *Au café,* a scene of modern life painted only a few years earlier (cat. 160).

Our exhibition has been made possible by the exceptionally generous support of Philip Morris Companies Inc. Our first thanks go to Hamish Maxwell, chairman and chief executive officer of that beneficent corporation, for the warmth of his personal interest and for his unfailing encouragement; and we are sensible of the debt we owe also to the friendly collaboration which we have enjoyed from Stephanie French and from Marilynn Donini and Karen Brosius in their cultural affairs department. We are also grateful for the additional support provided by Britsh Telecom Inc.

The organisation of the whole tour, as well as the inaugural showing in Washington, could not have been achieved without the genial persistence, and where necessary the patience, of our friends at the National Gallery of Art. We name particularly Sydney J. Freedberg and curatorial coordinator Beverly L. Brown; D. Dodge Thompson and Ann Bigley Robertson of the exhibitions department; Elizabeth Weil of the corporate relations department; and Gaillard F. Ravenel and Mark Leithauser of the department of design and installation. We acknowledge gratefully also the cooperation which we have had from the Director of the National Gallery of Art and from the directors of the four other participating institutions named by him in his introduction to this catalogue. The Members' Guild of the High Museum in Atlanta has provided the local backing needed for the showing there.

The catalogue has been prepared at the Fitzwilliam by those members of the curatorial staff whose initials follow each entry (the key to these initials is on p. xxviii). I thank them all: but I wish to mention particularly Robin Crighton who has, with invaluable assistance from Frances Hazlehurst, effectively our registrar, and from my own secretary, Fiona Brown, done so much to coordinate the effort at this end. Mary Archer, my fellow Trustee of the Fitzwilliam Museum Trust, was instrumental in introducing affordable insurance arrangements, without which the Syndics could not have allowed our treasures abroad.

Michael Jaffé

fig. 11 The Great Britain-Sasakawa Foundation Fan Gallery, opened 1987

ABBREVIATIONS

ABBREVIATION	REFERENCE
1 Non Bibliographical	
NACF	National Art-Collections Fund

2 Bibliographical General

Apollo	*Apollo,* vols. I– , London, 1925–
Bartsch	Adam Bartsch, *Le Peintre graveur,* 21 vols., Vienna, 1803–21
Benesch	Otto Benesch, *The Drawings of Rembrandt,* 6 vols., London, 1954
Burl. Mag.	*Burlington Magazine,* vols. I– , London, 1903–
Conn.	*Connoisseur,* vols. 1–214, New York and London, 1902–84
Lugt	Fritz Lugt, *Les Marques de Collections de Dessins et d'Estampes,* Amsterdam, 1921 and *Supplement,* The Hague, 1956

3 Fitzwilliam Publications

Acquisitions	Fitzwilliam Museum, *Principal Acquisitions 1979–83,* exh. handlist, Cambridge, 1983
Ann. Rep.	*The Annual Report of the Syndicate,* Cambridge 1949–66 *The Annual Reports of the Syndicate and of the Friends of the Fitzwilliam,* Cambridge, 1967–

ABBREVIATION	REFERENCE
Bayne-Powell	R. Bayne-Powell, *Catalogue of Portrait Miniatures in the Fitzwilliam Museum,* Cambridge, 1985
Bindman	D. Bindman, *William Blake. Catalogue of the Collection in the Fitzwilliam Museum,* Cambridge, 1970
Bourriau	J. D. Bourriau, *Pharaohs and Mortals: Egyptian Art in the Middle Kingdom,* exh. cat., Cambridge, 1988
Brunner-Traut	E. Brunner-Traut, *Egyptian Artists' Sketches: Figured Ostraka from the Gayer-Anderson Collection in the Fitzwilliam Museum, Cambridge,* Leiden, 1979
Cent Dessins français	Paris, Lille and Strasbourg, *Cent Dessins français du Fitzwilliam Museum,* introduction by Michael Jaffé, Cambridge, 1976
Chapman	H. A. Chapman, *A Handbook to the Collection of Antiquities and Other Objects Exhibited in the Fitzwilliam Museum,* Cambridge, 1898, 2nd edn. 1904.
Cormack I	M. Cormack, *J. M. W. Turner, R.A., 1775–1851. A Catalogue of Drawings and Watercolours in the Fitzwilliam Museum,* Cambridge, exh. cat., Cambridge, 1975
Cormack II	M. Cormack, *Rembrandt and his Circle,* exh. cat., Cambridge, 1966

ABBREVIATION	REFERENCE	ABBREVIATION	REFERENCE
Crighton	R. A. Crighton, *Cambridge Plate*, exh. cat., Cambridge, 1975	*James I*	M. R. James, *A Descriptive Catalogue of the Manuscripts in the Fitzwilliam Museum*, Cambridge, 1895
CVA	*Corpus Vasorum Antiquorum*, Great Britain, fascicule 6, Cambridge, Fitzwilliam Museum, fascicule 1, by W. Lamb	*James II*	M. R. James, *A Descriptive Catalogue of the McClean Collection of Manuscripts in the Fitzwilliam Museum*, Cambridge, 1895
Dalton	O. M. Dalton, *Fitzwilliam Museum, McClean Bequest, Catalogue of the Mediaeval Ivories, Enamels, Jewellery, Gems and Miscellaneous Objects Bequeathed to the Museum by Frank McClean, M.A., F.R.S.*, Cambridge, 1912	*Landscapes*	M. Cormack & D. D. Robinson, *Landscapes from the Fitzwilliam.* Loan exhibition in aid of the Friends of the Fitzwilliam Museum . . . , exh. cat., London, 1974
Darracott	J. Darracott (ed.), *All for Art: The Ricketts and Shannon Collection*, exh. cat., Cambridge, 1979	*Lely to Hockney*	*Cambridge Portraits from Lely to Hockney*, introduction by Michael Jaffé, Cambridge, 1978
European Drawings	International Exhibitions Foundation, *European Drawings from the Fitzwilliam*, introduction by Michael Jaffé, Washington, 1976–7	*MEC I*	P. Grierson & M. Blackburn, *Medieval European Coinage; with a Catalogue of the Coins in the Fitzwilliam Museum, Cambridge* I, Cambridge, 1986
FOF	*Friends of the Fitzwilliam Annual Report*, Cambridge, 1909–66	*Paintings I*	*Catalogue of Paintings Vol. I: Dutch, Flemish, French, German, Spanish*, M. Gerson & J. W. Goodison: Dutch & Flemish; J. W. Goodison & D. Sutton: French, German and Spanish, Cambridge, 1960
Gow	A. S. F. Gow, *Selected Works from the Andrew Gow Bequest*, exh. cat., London, 1978		
Grierson	P. Grierson, *Sylloge of Coins of the British Isles* [1]: *Fitzwilliam Museum, Cambridge*, I. *Ancient British and Anglo Saxon Coins* London, 1958	*Paintings II*	*Catalogue of Paintings Vol. II: Italian Schools*, J. W. Goodison & G. M. Robertson, Cambridge, 1967
Grose	S. W. Grose, *Fitzwilliam Museum. Catalogue of the McClean Collection of Greek Coins* I. *Western Europe, Magna Graecia, Sicily*, Cambridge, 1923	*Paintings III*	*Catalogue of Paintings Vol. III: British School*, J. W. Goodison, Cambridge, 1977
		Poole I	J. E. Poole, *English Delftware Dishes from the Glaisher Collection*, exh. handlist, Cambridge, 1981
Handbook	*Handbook to the Fitzwilliam Museum Cambridge*, Cambridge, 1971	*Poole II*	J. E. Poole, *Plagiarism Personified? European Pottery and Porcelain Figures*, exh. cat., Cambridge, 1986

ABBREVIATION	REFERENCE
Rackham	B. Rackham, *Catalogue of the Glaisher Collection of Pottery and Porcelain in the Fitzwilliam Museum Cambridge,* Cambridge, 1935
Robinson	D. D. Robinson, *Town, Country, Shore and Sea, British Drawings and Watercolours from Anthony Van Dyck to Paul Nash.* An exhibition from the Fitzwilliam Museum . . . [in Australia 1982–3], exh. cat., Cambridge, 1982
Robinson and Wildman	D. D. Robinson & S. Wildman, *Morris and Company in Cambridge,* exh. cat., Cambridge, 1980
Scrase	D. E. Scrase, *Drawings and Watercolours by Peter de Wint,* exh. cat., Cambridge, 1979
SNG IV, III	*Sylloge Nummorum Graecorum IV. Fitzwilliam Museum: Leake and General Collections* III. *Macedonia – Acarnania* (comp. F. M. Heichelheim), London, 1951.
SNG IV, V	*Sylloge Nummorum Graecorum IV. Fitzwilliam Museum: Leake and General Collections* V. *Sicyon – Thera* (comp. F. M. Heichelheim), London, 1958.
Treasures	*Treasures of the Fitzwilliam Museum,* Cambridge, 1982
Volk	*Anglo-Saxon Coins. An Exhibition Selected and Catalogued by Simon Keynes and Mark Blackburn,* ed. T. R. Volk, Cambridge, 1985
Winter	C. Winter, *The Fitzwilliam Museum: An Illustrated Survey,* London, 1958
Wormald and Giles	F. Wormald & P. M. Giles, *A Descriptive Catalogue of the Additional Illuminated Manuscripts in the Fitzwilliam Museum,* 2 vols., Cambridge, 1982

ACKNOWLEDGEMENTS

Thanks are due first to the individuals whose initials are appended to each entry, to Michael Jaffé and to David Scrase, Keeper of Paintings, Drawings and Prints for their suggestions and emendations. Other scholars and curators are acknowledged in the individual entries for their contributions: the remaining errors are mine. The authors are:

JDB	Janine Bourriau	Keeper, Antiquities
RAC	Robin Crighton	Keeper, Applied Arts
DWJG	David Gill	Assistant in Research, Antiquities
CH	Craig Hartley	Assistant Keeper, Paintings, Drawings, Prints
JAM	Jane Munro	Assistant Keeper, Paintings, Drawings, Prints
JEP	Julia Poole	Assistant Keeper, Applied Arts
JGP	Graham Pollard	Keeper, Coins and Medals
TRV	T. R. Volk	Assistant Keeper, Coins and Medals
PW	Paul Woudhuysen	Keeper, Manuscripts and Printed Books

The photography is by Andrew Morris, Chief Photographer, except for cat. 97, 113 and 158, which are by Bridget Taylor, Second Photographer, and for the black and white photographs in the introduction which are printed by Andrew Norman, Third Photographer; all at the Fitzwilliam Museum. Cat. 96 and 100 were photographed by Christopher Hurst, at the Hamilton Kerr Institute.

We also thank Julia Harding, Jim Reader and Tim McPhee of Book Production Consultants for their patience in copy-editing and design respectively.

Especial thanks go to Pery Burge for her assiduous work at the word processor in the many different recensions through which the catalogue has evolved.

RAC

THE CATALOGUE

Within the broad divisions the entries are arranged in chronological clusters, three-dimensional before two-dimensional, drawings before paintings. The precise category is noted at the top of each page. The individual entries, except for coins, are arranged as follows:

1 Cat. 00 (catalogue number) 1a Fitzwilliam inventory number
2 Artist's name (where relevant)
3 Artist's places and dates of birth and death
4 Title or description of object
5 Medium
6 Dimensions (in cm for everything except drawings and watercolours, miniatures, coins and medals, which are in mm)
7 How acquired by the Fitzwilliam
8 Coll: (collections history)
9 Ref: (abbreviated references to Fitzwilliam publications: see abbreviations, pp. xxv–xxvii)

10 Commentary
11 Author's initials (see acknowledgements, p. xxviii)

The coin and ancient medal entries are laid out as follows:

1 Cat. 00 (catalogue number) 1a Fitzwilliam inventory number
2 Place and date of issue
3 Description (obverse and reverse)
4 Metal and denomination
5 Weight 5a dimensions and die axis (where relevant)
6 Standard numismatic reference
7 How acquired by the Fitzwilliam
8 Coll: (collections history)
9 Ref: (abbreviated references to Fitzwilliam publications: see abbreviations, pp. xxv–xxvii)
10 Commentary
11 Author's initials (see acknowledgements, p. xxviii)

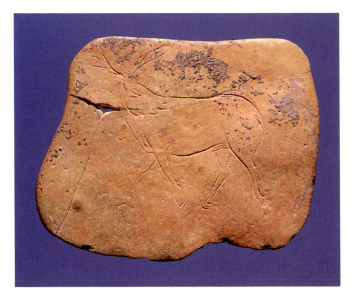

Cat. 1 GR. 5-1973

Reindeer, incised drawing. Paleolithic
(Magdalenian V) about 12000 BC

Limestone
H: 5.9cm W: 7.5cm D:4.5cm
Miles Burkitt bequest

Ref: *Treasures,* no. 1

The Magdalenian culture of France was
one of the greatest periods of paleolithic
artistic activity. Although some
Magdalenian objects have been found
elsewhere, the culture seems to have been a
French development. Cat. 1, from the
Laugerie Basse in the Dordogne, one of the
finest examples of naturalistic art to have
survived, was engraved, presumably with a
flint burin, at the height of the
Magdalenian V culture and before the
decline in skill visible in the subsequent
Magdalenian VI period. Reindeer, which
inhabited France during the paleolithic
period, are often depicted.

DWJG

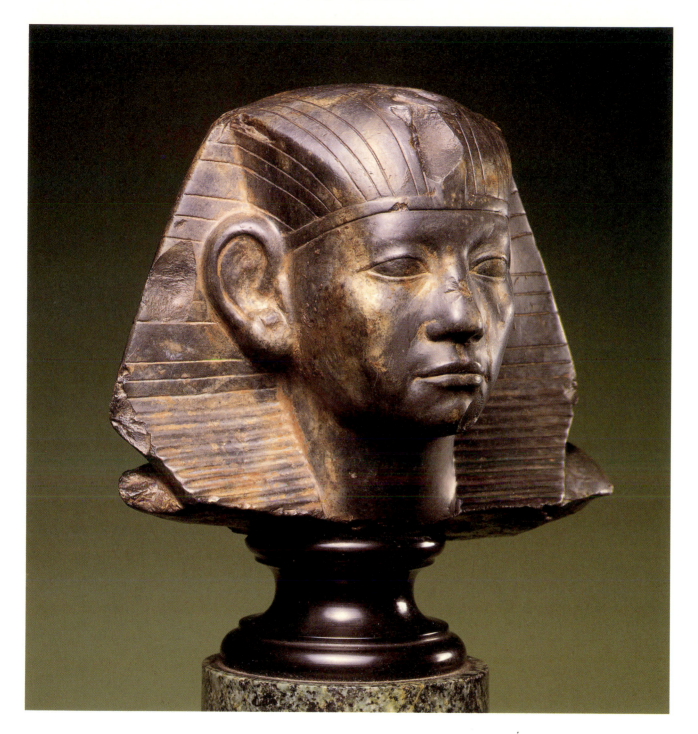

Cat. 2 E. 2-1946

Head of King Ammenemes III. 1843–
1798 BC

Shelly limestone
H: 11.6cm W:14.3cm D:15cm
Oscar Raphael bequest

Ref: *Bourriau*, pp. 44–5, no. 31; *Treasures*,
no. 4; *Winter*, no. 5

The head, part of a seated statuette, was found by Lord Grenfell during his excavations at Aswan in 1886. The dark, fossil-bearing limestone has no known source close to Aswan. This fact and the outstanding quality of the portrait suggest it was made elsewhere, almost certainly in a royal workshop. The modelling of the facial contours exploiting the softness of this rare stone is very sensitive. The bone structure shows a strong, square face but the painstaking modelling of the surface suggests the vulnerability of flesh about to fall into the creases of middle age. In this way the sculptor conveys both the humanity and the divine authority of the Pharaohs.

JDB

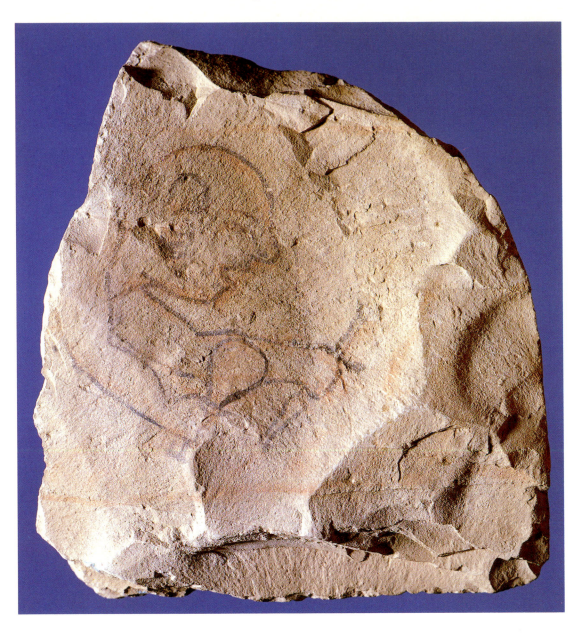

Cat. 3 EGA. 432a-1943

Unshaven stonemason, painter's
sketch. About 12th century BC

Painted limestone flake
H: 15.6cm W: 18cm D: 2.2cm
Given by R. G. Gayer-Anderson

Ref: *Brunner-Traut,* p. 40, pl. xii, no. 14, and
p. 6, pl. xxxviii, no. 46; *Treasures,* no. 6

This sketch is the rarest survival from
Ancient Egypt, an artist's caricature. It
comes from Deir el Medineh, a village in
southern Thebes, where lived workmen
engaged in excavating and decorating the
tombs in the Valley of the Kings. The
surrounding hills provided flakes of
limestone, which were used like leaves of
sketch books, for amusement, and for
learning or teaching. The medium ensured
that these ephemera survive to illuminate
the distant past in a special way.

The subject matter may be outside the
canon of official art but the artist still
abides by its rigid conventions in the
depiction of the human body. The man's
eye is not shown in profile, and he has two
right hands. He is a stonemason, perhaps
levelling the ground in preparation for
building. A great pile of rocks is in front of
him and he wields a hammer and chisel.
He appears plaintive, open mouthed, his
chin bristling with indignation. His
expression recalls other records of the Deir
el Medineh workmen which tell us that
they went into the desert in work gangs for
periods of two weeks at a time, and there
were frequent complaints of delays in the
supply of food and water. On the reverse is
a dedication to the snake-goddess
Meretseger, ''She who loves Silence'', who
was believed to inhabit the mountain peak
above the workmen's village.

JDB

Cat. 4 GR. 9-1917

'The Pig Painter'

Attic red-figured pelike. About 470–460 BC

Clay
H: 34.7cm W: 25cm
Given by the NACF

Coll: *Thomas Hope (1770–1831); his son H. T. Hope (d. 1862); his daughter, m. the 6th Duke of Newcastle; Lord Henry Francis Hope; Hope vases sale, Christie's 23 July 1917, lot 45*

Ref: *CVA* Fitzwilliam 1, pl. 33 (271) 2 and pl. 34 (272) 4

The scene on this container for wine and oil provides the name for the Athenian pot-painter dubbed by Sir John Beazley 'The Pig Painter'. This man, active towards the middle of the fifth century BC, is thought to have belonged to a group called the 'Mannerists' because of their stylised adaptation of earlier motifs.

On the obverse are two men, a pig and a piglet. The man on the left, carrying a sack over his shoulder, is probably a traveller. The man on the right is carrying two baskets on a pole. That a similar scene is found on a jug in Tübingen suggests that the scene on cat. 4 may be interpreted as Odysseus and the swineherd Eumaios. This encounter occurred when Odysseus after ten years of adventures returned to his island home of Ithaca from the Trojan War. In his absence the suitors of his wife Penelope had taken control of the palace. Odysseus drove them out with the help of the faithful Eumaios. However, the scene may not be mythological and could easily be a depiction of everyday life in rural Greece.

On the reverse is a more formal scene showing a bearded man and a youth. The incised ligature on the underside may be a mark added by the merchants; it finds parallels on other Athenian red-figured pots from Campania and Etruria in Italy. The find-spot of the Fitzwilliam *pelike* is unknown but other pots attributed to the same painter have been found as far afield as Agrigento (Sicily), Naucratis (Egypt) and Kertch (Crimea). This reflects the movement of Athenian decorated pots over long distances, taking advantage of trade in other commodities. Athenian pottery has been found in the cargoes of shipwrecks alongside metal ingots and transport-containers of wine and oil. One of the very few ancient references to the export of Athenian pottery records the activity of Phoenicians as far away as the Atlantic coast of Africa.

DWJG

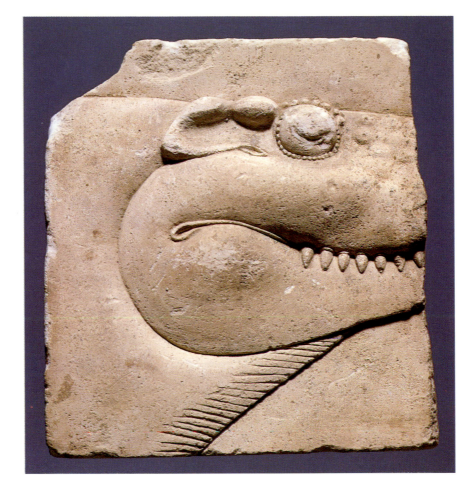

Cat. 5 EGA. 4545-1943

Sobek, sculptor's study of crocodile god. 3rd–1st century BC

Limestone
H: 11.3cm W: 10.5cm D: 2.3cm
Given by R. G. Gayer-Anderson

This Sobek is an Egyptian sculptor's study in relief. Such objects were carved to a fixed canon of proportions on rectangular plaques. Some with suspension holes through the upper corners may have been used as studio models. The work illustrates the artist's intimacy with the movement and shapes of animals. The crocodile had been worshipped since prehistoric times, but animal cults, including that of Sobek, were practised most fervently and elaborately at this time. Catacombs of mummified crocodiles dedicated to the god were laid down in several places. This fine, strong sculpture may have been dedicated to Sobek, after use as a model, in one of his many shrines in the Faiyum. The Faiyum was famous, even as late as the middle of the twentieth century, for its marshes, its great lake, and the richness of its wildlife.

JDB

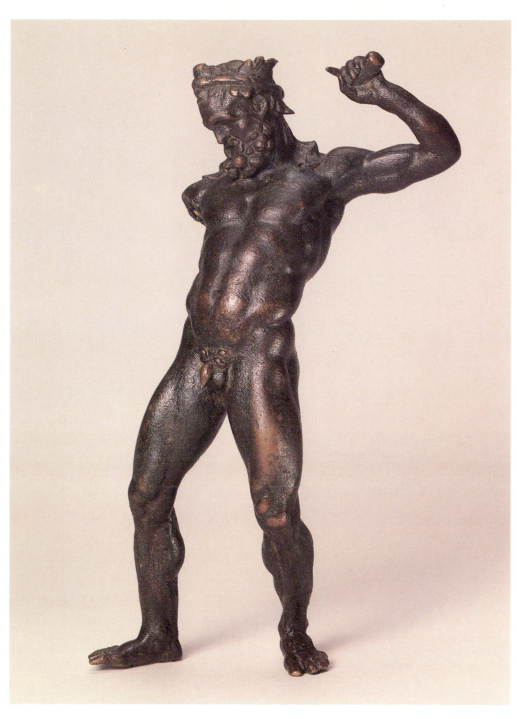

Cat. 6 GR. 1-1864

Statuette of drunken Herakles. About 2nd century BC

Bronze
H: 27cm W: 13cm D: 11cm
Purchased by the University

Coll: *Col. W. M. Leake*

This Hellenistic bronze statue from Agrinion in Aitolia shows Herakles. In his left hand he would have held a club, fitted separately. The pose, once thought to show the Greek hero in a drunken rage, may derive from the position of the figure on the shoulder of a metal vessel. The mounting of a similar bronze Herakles in the Fitzwilliam suggests this (R. Nicholls, 'The drunken Herakles: a new angle on an unstable subject', *Hesperia* 51 (1982), pp. 321–8). Traces of a support between the shoulder blades suggest that the back would have been mounted on the vessel's steeply sloping sides. Bronze vessels decorated with figures are not uncommon. One of the best known is the wine-mixing vessel, just under 1 metre high, from Grave Beta at Derveni in northern Greece. The size of the Herakles suggests that he was mounted on an even larger vessel. In antiquity the surface of the bronze would have been kept polished so giving the appearance of gold.

Other figurines of this type are known. Some are in the reverse of the pose found here, which may indicate that pairs of these figures were mounted either side of a handle. The treatment of the Herakles may have been influenced by the work of Lysippos, active in the second half of the fourth century BC, but the vessel to which the Herakles belongs was probably made in the third century BC. Other versions of this type continued to be made well into the Roman period. The type was copied in the late Italian Renaissance although the source of the pose was by then forgotten.

DWJG

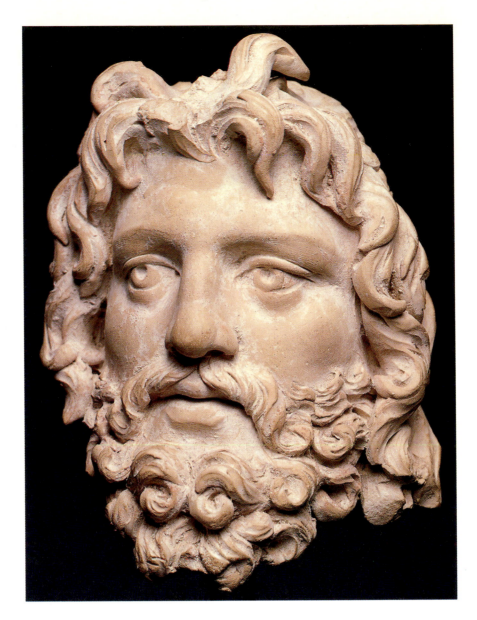

Cat. 7 GR. 16-1891

Head of Jupiter. 1st–2nd century AD

Terracotta
H: 14.8cm
Bought

Coll: *Lord John Savile Lumley; Mrs Pullen*

Ref: *Treasures,* no. 20

This head was excavated by Lord John Savile Lumley in 1884 at Civita Lavinia, the ancient Lanuvium, situated in the Alban Hills just outside Rome. The identification relies in part on the testimony of the excavators, who named it apparently after finding parts of the body; in part because the head seems to be derived from the same original – perhaps of the fourth century BC – as other late Hellenistic and Roman marble copies that represent Zeus or Jupiter. The hair may have originally been painted red.

The head was found in a complex of Imperial date mistakenly known as the 'Villa of Caligula'. The date suggested for it depends on the fact that it was found with sculpture of the middle and late second century AD; however it may be a much earlier work. It is a further instance of Roman taste for the Greek – a taste inspired, in part, by plunder taken in war. The desire for 'Greek Art' with which to decorate the homes of eminent Romans may have resulted in the formation of workshops producing marble and terracotta copies of Greek originals for this market.

DWJG

ANCIENT COINS
Cat. 8–15

The earliest coins in the Western world are of the end of the seventh century BC or shortly thereafter. They were made in Lydia, a kingdom on the Aegean seaboard of Asia Minor, and in neighbouring Greek communities. They comprised small pieces of electrum, an alloy of gold and silver naturally occurring in the region, which were produced to prescribed weights. One side (reverse) was pierced with a punch as proof that the piece was throughout of electrum, while the same blow caused a badge to be impressed on the other side (obverse) from an engraved die fixed in an anvil or set in the ground. This badge or type identified the issuer of the coinage and was thus the guarantee of its face-value, a reassurance made necessary by possible variations in the proportion of gold to silver from one batch of metal to another. While some of the cities in Asia Minor, notably Cyzicus, continued to produce electrum coins into the fourth century BC, the principal coining metal of the late archaic and classical periods was silver. In one Greek tradition, reported by Herodotus (*Histories* I.94), the first people to make coins of silver were the Lydians, although the identification of this coinage with the *stater* shown here (cat. 8) is now questioned.

Within Greece proper, where the idea of coinage appears to have taken hold soon after its development in Asia Minor, the choice of silver reflects this metal's availability in Macedonia and Thrace, on the island of Siphnos in the Cyclades, and at Laurium near Athens. By the end of the sixth century silver coins were being produced throughout the Greek world, as far as Southern Italy and Sicily, while in the course of the next century, minting extended to Southern Gaul and North Eastern Hispania. The appearance of coinage began to change. By the time of the Persian Wars (490–479 BC), mints such as those at Corinth and Athens were producing coins on which the name of the community was given in an inscription or legend and on which the reverse punch-mark had been replaced by a second pictorial type. But it was in the mints of the Sicilian cities that Greek coinage of the classical period reached its artistic peak (cat. 9). Here artist-engravers, such as Cimon, Euainetos and Exacestidas, were sufficiently well-regarded to be able to place their signatures on the dies which the various minting authorities commissioned from them.

The history of Greece during the following century was dominated by two powerful kings of Macedon, Philip II and his son Alexander III, the Great. By 338 BC, Philip was master of Greece proper. One of the sources of his strength was his kingdom's mineral wealth. He produced a prolific gold coinage, the first in the Greek series to achieve the international currency of the Persian *daric*, which 150 years earlier had replaced the gold version of the lion/bull *stater* shown here (cat. 8). Such was the diffusion and popularity of the *philippeios* that its types of the head of Apollo and of Philip's victorious Olympic chariot were copied for their own coinages by later generations of Celts in the Rhineland, Gaul, and Britain (cat. 11). In the course of a bare dozen years Alexander (336–23 BC) extended Macedonian rule eastwards to the banks of the river Indus, implanting in each of the conquered territories a common culture based on the Greek language and on Greek or Hellenic practices, of which his coinage provided perhaps the most immediate expression. Though an hereditary monarch, Alexander did not place his own head on the coins of his empire (the standard type of his silver issues was the bust of Heracles). It was left to his successors, beginning in 305 BC with Ptolemy I, king of the former Macedonian possessions in Egypt, to follow the example of Persian satraps or governors and of minor native princes of Lycia in portraying themselves on their coinage. Henceforth portraiture was to be the rule for precious-metal coins issued by Hellenistic monarchs. An exception, however, is provided by the so-called 'pedigree' issues of two Greek rulers in India, Antimachus and Agathocles (cat. 10). Here it is not the reigning king but earlier monarchs who are commemorated, their 'portraits' an element in developing an elaborate ruler-cult.

Rome did not produce its own coinage until the last quarter of the fourth century BC. For most of the following century an indigenous system of heavy bronze pieces, the face-value of which was derived from their metal content, ran in parallel with a silver and light bronze currency which, though struck in the name of the Romans, was almost wholly Greek in character. It was not until about 214 BC, during the second Punic War, that the city instituted as her standard precious-metal unit a distinctively Roman piece, the silver *denarius*. Over the next two centuries, during which the republic was governed by a fiercely competitive oligarchy, this coinage became increasingly a vehicle for self-advertisement by the annual magistrates charged with its production. A

simple statement of the moneyer's name coupled with 'national' devices gave way to pictorial types associated either with the moneyer himself or with members of his family. Finally in 44 BC the Senate conferred on Julius Caesar the right to place his head on the republic's coinage in a manner of a Hellenistic ruler. The issue that commemorates the murder of the *dictator perpetuus* (cat. 12), while vindicating republican liberty with its reverse type, repeats the Caesarian challenge to tradition by portraying the very Marcus Junius Brutus who a year before had led the conspiracy to remove the tyrant. The coin types of the ensuing empire regularly combine the Hellenistic East's tradition of dynastic portraiture with the propaganda style of the later republican moneyers.

Although the central government of the empire held a virtual monopoly of the production of precious-metal coins (in the East there were some provincial issues in silver and rather more in silver-alloy or billon), local communities throughout the Balkans, Greece and the Asian and Syrian provinces were responsible for an abundant, if sometimes irregular, production of copper and copper-alloy pieces. In places this coinage continued until the second half of the third century AD. The reasons for making an issue were various. In some cases, the motive appears to have been primarily economic, with the coinage meeting the community's need for small change. In others as much importance may have been attached to a coin's commemorative possibilities as to any commercial benefit to be had from its striking, whether the celebration was of the local magistrate responsible for the issue, of an honour bestowed on the city, or of an imperial visit. The coinage of the Eleans for Hadrian falls into the 'celebratory' category (cat. 13).

The remnants of local or provincial coinage were swept away by Diocletian at the end of the century (AD 294). From that point a uniform coinage in all three metals was struck at up to 20 imperial mints located throughout the empire. Each centre's product can normally be identified by a mint signature placed on the coin, usually in the form of the first two or three letters of the town's name (cat. 14).

During the first three centuries of the empire, Rome's only real rival was whichever power occupied the area roughly corresponding to modern Iraq and Iran. First this was the Parthian Arsacid dynasty, whose followers, originally nomads from Central Asia, had established themselves in territories previously ruled by the Hellenistic rulers of Syria; and then

from AD 224 the empire of the Sasanians, a native Iranian dynasty (cat. 15). The thin flan that characterises Sasanian silver coinage was subsequently adopted by the Umayyad caliphs under whose rule Persia passed in AD 651 on the flight and murder of the last Sasanian king, Yazdgard III. By AD 718 Islamic *dirhems* of the reformed coinage were being struck as far West as Spain. The numismatic wheel had turned its first full circle.

TRV

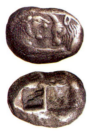

Cat. 8 CM. 33–1967

Lydia under Persian (Achaemenid) rule: Sardis mint. About 547 – about 510 BC

Obverse: Lion forepart leaping right, bull forepart rushing left: facing each other.
Reverse: Two incuse squares of equal size.

Metal and denomination: silver (AR) *stater* or 2-*siglos* (Persic standard)

Weight: 10.70gm Diameter: (max.) 21mm (min.) 15mm

Standard literature
E. Babelon, *Traité des monnaies grecques et romaines*, II: *Description historique*. I, Paris, 1907, no. 407, pl. x. 7.

Bought from the S. G. Perceval Fund

Coll: *P. Spiro collection (private treaty sale); A. M. Woodward collection (Glendining, London, 27 September 1962, lot 136, pl. iv)*

Ref: *Treasures*, no. 15a

One of the earliest pure silver issues in the 'Greek' series – the metal was extracted from naturally found electrum – this coinage has traditionally been attributed to Croesus, King of Lydia, whose legendary wealth remains a measure of comparison to our own day. Its attribution to the period after the absorption of the kingdom by the Achaemenid state in 547 BC is suggested by its 'Persic' weight-standard and by the iconography of the obverse: the bull, the royal beast of Persia, faces the lion of Lydia. (For the date and attribution of this issue, see M. Price, 'Croesus or pseudo-Croesus? Hoard or hoax? Problems concerning the sigloi and double-sigloi of the Croesid type', *Festschrift für Leo Mildenberg*, eds. A. Houghton, S. Hurter, P. E. Mottahedeh, J. A. Scott, Wetteren, 1984 pp. 211–21.)

Cat. 9 McClean 2466

Sicily, Naxos: Naxos(?) mint. About 460 BC

Obverse: Head of Dionysus right, wearing ivy-wreath.
Reverse: Greek legend: N=AXI=ON. Naked Silenus squatting right, holding *kantharos*.

Metal and denomination: silver (AR) *tetradrachm* (Attic standard)

Weight: 17.34gm Diameter: 29mm Axis: 120°

Standard literature
H. A. Cahn, *Die Münzen der Sizilischen Stadt Naxos*, Basel, 1944 = *Basler Studien zur Kunstgeschichte 2*, no. 54: 9 (this coin).

Given by J. R. McClean, 1906–12.

Coll: *R. Carfrae collection (Sotheby, Wilkinson, & Hodge, London, 23 May 1894, lot 56, pl. iii. 4)*

Ref: *Grose*, no. 2466, pl. 83. 8; *Handbook*, 1971, pl. iv. b; *Treasures*, no. 15c; *Winter*, pl. 11. 5a–b.

Naxos, on the East coast of Sicily, was the island's oldest Greek settlement and, towards the end of the sixth century BC, probably the first Sicilian community to mint coins. Dispossessed of their city by Hieron, tyrant of Syracuse, the Naxians regained their home in about 461 BC. This issue, considered one of the masterpieces of Greek numismatic art, celebrated the city's regained independence. Its special character is suggested by the fact that all 56 specimens listed by Cahn were struck from the same pair of dies, a survival rate unparalleled in ancient coinage and perhaps an indication that most derive from a single, unidentified, find. The reverse legend identifies the issue as 'of the Naxians'; the types advertise the territory's wine industry. (For the site, see P. Rizzo, *Naxos Siceliota. Storia, topografia, avanzi, monete*, Catania, 1894.)

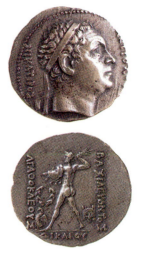

Cat. 10 CM. 22–1971

Bactria (N. W. India): Agathocles: Balkh(?) mint. about 200 – about 170 BC

Obverse: Greek legend: ΑΝΤΙΟΧ[ΟΥ] ΝΙΚΑΤΟΡΟΣ. Head of 'Antiochus Nicator' right, wearing diadem.
Reverse: Greek legend: ΒΑΣΙΛΕΥΟΝΤΟΣ ΑΓΑΘΟΚΛΕΟΥΣ ΔΙΚΑΙΟΥ. Zeus left, holding *aegis* and thunderbolt; at his feet, eagle left; symbol: wreath; monogram: Greek letters.

Metal and denomination: silver (AR) *tetradrachm* (reduced Attic standard)

Weight: 16.75gm Diameter: 32mm Axis: 360°

Standard literature
P. Gardner, *The Coins of the Greek and Scythic Kings of Bactria and India in the British Museum*, ed. R. S. Poole, London, 1886, p. 164, no. 1 (same dies).

Bought from the University Purchase Fund and the Coin Duplicates Fund, with a contribution from the Regional Fund administered by the Victoria and Albert Museum.

Coll: *with A. H. Baldwin & Son Ltd., London*

Ref: *Ann. Rep.* 1971, p. 15, pl. VII; *Treasures,* no. 15d

The Agathocles whose name as ruling king appears on the reverse of this coin ('of Agathocles the Just, during his reign') is, like the Antimachus who was responsible for a similar run of so-called 'pedigree' coins, known only from his coinage. The purpose of these issues, in which the ruler is associated with a series of royal predecessors, is controversial; but they were presumably intended to underscore the king's legitimacy. The King Antiochus portrayed on the obverse may be one of the Seleucid rulers of Syria (?Antiochus I), although none is known to have held the epithet *Nicator* ('the Conqueror'). The reverse type copies that of an issue by Diodotus, the Seleucid satrap (governor) responsible in about 250 BC for Bactria's establishment as a separate kingdom. (See, in general, F. Holt, 'The so-called "pedigree coins" of the Bactrian Greeks', *Ancient Coins of the Graeco-Roman World. The Nickle Numismatic Papers*, eds. W. Heckel, R. Sullivan, Waterloo (Ont.), 1984, pp. 69–85.)

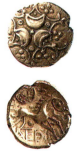

Cat. 11 CM. 249–1960

Britain, Iceni: Antedios: indeterminate mint. About AD 25 – about 47

Obverse: Three crescents in ornamental compartment.
Reverse: **ANTEDI** (partly in ligature). Horse right; above, ring-ornament or sun.

Metal and denomination: red-gold (AV) *stater*

Weight: 5.37gm Diameter: 18mm

Standard literature
R. P. Mack, *The Coinage of Ancient Britain,* 3rd edn, London, 1975, no. 418.

Found at Lakenheath, Suffolk, in 1959, with 66 (*sic*) Roman silver *denarii*, 2 gold *staters* of the Catuvellauni, and 412 silver coins of the Iceni (see G. Briscoe, R. A. G. Carson, R. H. M. Dolley, 'An Icenian coin hoard from Lakenheath, Suffolk', *British Numismatic Journal* XXIX, 1958–9 [1960], pp. 215–19). The entire hoard was acquired by the Fitzwilliam Museum

Bought from the S. G. Perceval Fund

Ref: *Ann. Rep.* 1960, p. 4, pl. I; *Treasures,* no. 15b.

The Iceni were a Celtic tribe established in what is East Anglia today. This rare *stater* (two specimens only recorded) struck in the name of Antedios, together with a more plentiful silver issue of broadly similar type, is probably contemporary with the invasion of Britain by the Roman emperor Claudius in AD 43. The types are not immediately derived from the *philippeios* tradition, although the crescent symbol present here, as on many British issues, probably echoes the laurel-wreath worn by Apollo on the Greek prototype. The ruddiness of the gold is due to the admixture of copper. (For the coinage of the Iceni, see D. F. Allen, 'The coins of the Iceni', *Britannia* I 1970, pp. 1–33, no. 116, pl. iv (this coin).)

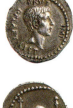

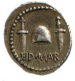

Cat. 12 CM. 1474–1963

Roman Republic: L. Plaetorius Cestianus for M. Junius Brutus, indeterminate mint (Greece or Asia). 43–42 BC

Obverse: **BRVT = IMP, L·PLAET·CEST.** Head of Brutus right, bearded.
Reverse: **EID · MAR.** Cap of Liberty (*pileus*), two daggers.

Metal and denomination: silver (AR) *denarius*

Weight: 3.84gm Diameter: 20mm Axis: 10°

Standard literature
M. H. Crawford, *Roman Republican Coinage,* I, Cambridge, 1974 [1975], no. 508/3.

Given by Rev. H. St. J. Hart

Ref: *Ann. Rep.* 1963, p. 4, pl. III. e; *Treasures,* no. 15f

Perhaps the most celebrated of all Roman coins, noticed even in the ancient literary tradition (Dio Cassius 47. 25. 3), the reverse type commemorates the assassination of Julius Caesar on the Ides (i.e. 15) of March 44 BC. But the powerful image of the cap of Liberty between two daggers with which Brutus appeals to recipients of the coin is belied by his placing his own likeness on the obverse. Leader of the conspirators against Caesar, Brutus shared in the Senate's amnesty of 18 March. After receiving a dispensation from his duties as *praetor urbanus,* he was assigned the supervision of the corn supply in Asia and appointed governor of Crete. He left Italy in late August, proceeding first to Athens and then to Macedonia. Having won over that province for the 'Liberators', his command was legitimated by the Senate. In the spring of 43 BC he moved eastward. Following victories against the Bessi, a Thracian tribe, he was saluted as 'Imperator' (victorious general), the title by which he is styled on this coin. Jointly with his fellow conspirator Cassius, he received a second salutation in Sardis (Asia Minor) early the following year. With men, money, and supplies collected in the East, he and Cassius moved to Macedonia to confront the forces of Antony and Octavian. On 23 October 42 BC, defeated in the second battle of Philippi, Brutus committed suicide. His coinage, however, continued to circulate; a specimen was included in a recently found East Anglian hoard (Beck Row, 1979), deposited towards the end of the first century AD. The issue is countersigned by L. Plaetorius Cestianus, Brutus's financial officer. The orthography of the reverse legend attests to contemporary Roman usage; the normalised form familiar from modern printed texts is 'ID(ibus)'.

11

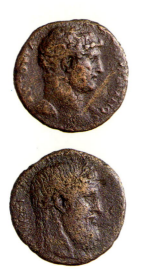

Cat. 13 Leake 1875

Peloponnese, Elis: for Hadrian (AD 117
–138): Elis(?) mint. AD 133 or AD 134/5

Obverse: Greek legend: AYTOKPA=[TΩP]
AΔPIANOC; bust of Hadrian front right,
armoured: head right, bearded.
Reverse: Greek legend HΛEI[ΩN]; head of
Zeus right, wearing olive-wreath.

Metal and denomination: bronze (AE)
2(?)-unit

Weight: 24.06gm Diameter: 31mm
Axis: 30°

Standard literature
SNG IV, V, no. 3722 (this coin).

Bought from the Fitzwilliam Fund, 1864
(on beneficial terms specified in
Lt. Col. Leake's will)

Coll: *W. M. Leake collection*

Ref: *SNG IV,* V, no. 3722; *Treasures,* no. 15e

During the 430s(?) BC, Pheidias
executed a colossal ivory and gold
statue of Zeus for the god's sanctuary at
Olympia. According to the Roman
rhetorician Quintilian "its beauty could be
said to have added something to traditional
religion, so adequate to the divine nature
was the majesty of his work" (*Inst. Orat.*
xii. 10. 9; trans. Richter, p. 14). Our best
idea of this masterpiece, of which no three-
dimensional copy survives, comes from the
coin issue shown here, to date recorded in
only five specimens. That it is a faithful
representation of the statue's head, rather
than a reworking according to
contemporary canons, is due to the self-
conscious classicising of art under Hadrian,

the ruler portrayed on the obverse
(Αὐτοκράτωρ translates the Latin
Imperator). The occasion for the coin's
striking is uncertain, whether as one of a
regular sequence of issues for successive
celebrations of the Olympic Games (Liegle)
or to mark the visit to the sanctuary in
134/5 of the emperor himself (*SNG IV,* V).
(For the Pheidian Zeus, see G. M. A.
Richter, *Three Critical Periods in Greek
Sculpture,* Oxford, 1951, this coin at fig. 7;
and J. Liegle, *Der Zeus des Phidias,* Berlin,
1952, this coinage at pp. 38–90; for Elean
strikings for Hadrian, including a fifth
recently identified example of this issue,
see P. R. Franke, 'ΗΛΙΑΚΑ–ΟΛΥΜΠΙΑΚΑ',
*Mitteilungen des Deutschen Archäologischen
Instituts – Athenische Abteilung* 99, 1984, pp.
319–33. pl. 51–52; for the suggestion that
the engraver of this issue was an 'imperial
medallist', see J. M. C. Toynbee, 'Greek
imperial medallions', *Journal of Roman
Studies* XXXIV, 1944, pp. 65–73 at p.67.)

Cat. 14 1330: 10

Roman Empire: Magnus Maximus (AD
383–8); London mint. AD 383(?)

Obverse: **D N MAG MA=XIMVS P F
AVG**; bust of Magnus Maximus front right,
armoured and draped: head right, wearing
diadem of pearls and rosettes.
Reverse: **VICTOR=IA AVGG;** mint-mark:
AVG OB; two emperors seated to front,
robed: heads wearing diadems: they hold a
single globe; above, bust of Victory to
front; below, palm-branch.

Metal and denomination: gold (AV) *solidus*

Weight: 4.38gm Diameter: 21mm
Axis: 180°

Standard literature
J. W. E. Pearce, *Valentinian I to Theodosius I*

= *Roman Imperial Coinage,* eds. C. H. V.
Sutherland, R. A. G. Carson, IX, London,
1951, p. 2, no. 2(b).

Bought from the ?Fitzwilliam Fund, 1887

Ref: *Treasures,* no. 15g

In AD 383, Maximus, the Roman
commander in Britain, revolted against
Gratian, the emperor in the West. To
finance his rebellion, the mint at London
was briefly reopened. The otherwise
unattested mint signature **AVG,** for the
more usual **LON,** stands for *Augusta,* the
name by which *Londinium* had come to be
known. The formula **OB** (for *obryzum*)
certifies the purity of the gold. This rare
coinage in the names of both Maximus and
Theodosius, emperor in the Eastern
provinces, constituted the last imperial
issue to have been struck in Britain. The
reverse type of two emperors is a standard
one for the period, though it enabled the
rebellious commander to associate himself
with Theodosius (so, too, **AVGG,** for two
Augusti or emperors). After initial success
in Gaul and Italy, Maximus was defeated
by the emperor he claimed as a colleague
and was put to death. The emperor's titles
are conventional and may be loosely
translated 'Our Lord, Magnus Maximus,
the Pious, the Fortunate, *Augustus'.*

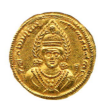

Cat. 15 CM. 1–1954

Sasanian Empire: Xusrō II (AD 590–
628): indeterminate mint. AD 611
(year 21)

Obverse: Pahlavi legend, with king's name
and title: **hwslwb MLK'-'n MLK'** (Xusrō
šāhān šāh = 'Xusrō, King of Kings'); and
celebratory formula: **GDH 'pzwt'** (xwarna
afzūt = 'his splendour has increased'); bust

of Xusrō to front, robed: head right, wearing elaborate crown.
Reverse: Pahlavi legend, with celebratory formula: ꜣylꜣn ꜣpzwtꜣnyt' (?) (Ērān afzūtanēt (?) = 'Iran has increased' (?)); and regnal year: yꜣcwyst' (yāzvīst = 21); bust of female deity (Anahita(?)) to front, robed: head surrounded by flaming nimbus.

Metal and denomination: gold (AV) *solidus* or *dīnār*

Weight: 4.55gm Diameter: 23mm Axis: 100°

Standard literature
J. de Morgan, *Monnaies orientales* I. *Numismatique de la Perse antique* iii. *Dynastie sassanide*, Paris, 1933 = *Traité des monnaies grecques et romaines* (ed. E. Babelon) III, coll. 723–4, no. 211 (1½ *dīnār*).

Found in 'Syria'; from a hoard

Given by the Friends of the Fitzwilliam

Ref: *FOF* 1954, p. 5 (ill.); *Treasures*, no. 15h

Grandson of Xusrō or Chosroes I (AD 531–79), the ruler under whom the Sasanian empire reached its greatest splendour, Xusrō II gained the throne with aid of troops despatched by the Byzantine emperor Maurice. The murder of his Western patron by Phocas in 602 provoked Xusrō II to an invasion of Byzantine territory that was initially very successful; Antioch (Syria), Jerusalem, and finally, in 619, Alexandria (Egypt) fell to the Sasanians. This success was, however, short-lived. Phocas had himself been deposed in 610. His successor Heraclius (610–41), one of the greatest rulers in Byzantine history, undertook a recovery of Byzantine fortunes that eventually secured the empire from external threat. In 627 the Sasanian army was defeated at Nineveh and in the following year Xusrō II was murdered by his own generals. Within a generation of Xusrō's death, the Sasanian empire had collapsed in the face of the Arab invasion that was to gain Persia for Islam.

Gold was rarely struck by the Sasanians: prestige pieces rather than regular coins for domestic currency. The adoption of Roman weight-standards for gold issues (here that of the contemporary *solidus*) does, however, imply a measure of convertibility. The issue of year 21 of Xusrō's reign presumably celebrates Sasanian victories over the Byzantines. Its fabric is quite unlike either the thin, broad flans of contemporary silver coins or even of the gold issues of years 33 and 34 and may indicate a mint in one of the newly occupied Byzantine cities (Antioch(?)).

Note, too, the alleged find-provenance of this example. As in the case of the much commoner silver issues, the royal portrait is distinguished by an extremely elaborate crown. The reverse probably shows Anahita, the principal female deity in the Aryan pantheon, who was later absorbed by the syncretic teachings of Zoroastrianism, the state religion of Sasanian Iran. A goddess associated with water, she was identified by the Greeks with either Aphrodite or Artemis. The legends are written in cursive Pahlavi, the transliteration and transcription of which are notoriously difficult. In addition to Persian vocabulary, there are foreign words which stand, rather like ideograms, for the vernacular expression that was actually voiced. These forms in Hozvāreš are conventionally transliterated with capital letters. Thus, the Semitic word **MLK**ꜣ (malkā) stands for the Persian *šāh* (= king). Here the transcribed Middle Persian text, together with an English translation, is shown in parenthesis. (For the transliteration of the Pahlavi legends, see R. Göbl, *Sasanian Numismatics*, Braunschweig, 1971, table xv; for the Sasanian coinage in general, see D. Sellwood, P. D. Whitting, R. Williams, *An Introduction to Sasanian Coins*, London, 1985.)

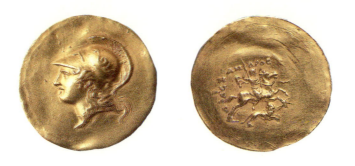

ANCIENT MEDAL

Cat. 16 Leake 4210

Macedonia: time of Gordian III(?) (AD 238–44); Beroea mint(?). AD 242(?)

Obverse: Head of Athena left, wearing Corinthian helmet decorated with snake.
Reverse: Greek legend:
Α=ΛΕΞ=ΑΝ=ΔΡΟC. Alexander riding right on Bucephalus, hunts lion with spear.

Metal: gold (AV)

Weight: 21.42gm Diameter: 37mm Axis: 5°

Standard literature
H. Gaebler, *Die antiken Münzen von Makedonia und Paionia* I., Berlin, 1906 = *Die antiken Münzen Nord-Griechenlands* (ed. F. Imhoof-Blumer) III., no. 875, pl. iv. 1 (this piece).

Acquired by Lt. Col. Leake at Serrai (*Serrhae*), Thrace, in 1806(?); found locally(?)

Bought from the Fitzwillam Fund, 1864 (on beneficial terms specified in Lt. Col. Leake's will)

Coll: *W. M. Leake collection*

Ref: *Handbook*, 1971, pl. iv. e; *SNG IV*, III, no. 2351

Leake acquired this remarkable piece during the Napoleonic Wars, having been commissioned in 1804 by the British Government to advise the then Turkish administration on the defence of Greece against a possible French invasion. It thus predates the discovery of the Tarsus (Southern Turkey) hoard of 1863 and the controversial Aboukir (Egypt) hoard of 1902. Both hoards contained, in addition to Roman imperial coins, a number of gold medals. These have a number of features in common with the Serrai specimen shown here. Their principal subject matter is the Macedonian royal House: Philip II, his wife Olympias, and, above all, their son Alexander III, the Great. They display, too, a common fabric: broad flans, produced by hammering the outlying field. The dating of these pieces to imperial times is established not only by their association in the hoards with third-century AD coins, but by the derivation of some of the reverse types from issues of the Roman empire and by the suggested assimilation of some Macedonian 'portraits' to the features of such Roman rulers as Caracalla (AD 198–217). Their precise date and purpose are, however, uncertain, if indeed they are the same for each specimen. The presence of a Roman gold multiple equivalent to eight *denarii aurei* of the emperor Severus Alexander (AD 222–35) in the Tarsus hoard, together with 23 regular gold coins, of which the most recent is an issue of Gordian III datable to AD 243, may indicate an imperial cult of Alexander the Great promoted by his Roman namesake and admirer. But the probable finding of the Leake medal in North Greece and the issue, also during the third century AD, of a series of bronze coins in the names both of the provincial council of Macedonia and of its capital Beroea, which similarly celebrate the memory of Alexander, together provide a possible connection between the gold series and the god-king's cult in his 'home' province. In AD 242, so-called 'Olympic' Games in honour of Alexander were celebrated at Beroea, probably on the occasion of a visit by the emperor Gordian III, then en route to Syria. The possibility cannot be excluded that the Serrai medal was a *nikoterion* or prize-piece struck for that celebration.

The workmanship of the Serrai medal is not as fine as that of the three Tarsus pieces acquired for the Bibliothèque Nationale, Paris, by Napoleon III in 1868. Two of these have as their reverse type the same theme as the medal shown here: Alexander lion-hunting with his horse Bucephalus. Their obverses, from different designs, clearly portray Alexander. The head of Athena which appears on the obverse of the Leake medal is appropriate to Alexander – she appears on the King's own coin issues wearing a helmet similarly decorated with a snake; by the third century AD, the head may have been read as a 'portrait' of the king (J. R. M. Jones, *A Dictionary of Ancient Greek Coins*, London, 1986, p. 1, this piece illustrated). (For 'Greek' medals of the imperial period see J. M. C. Toynbee, *op. cit.* cat. 14, especially pp. 70–3, pl. iii. 5 (this piece); for the Tarsus medals, see R. Mowat, 'Les Médaillons grecs du Trésor de Tarse et les monnaies de bronze de la communauté macédonienne, *Revue Numismatique*, 4th series, VII, 1903, pp. 1–30, pl. I–IV.)

TRV

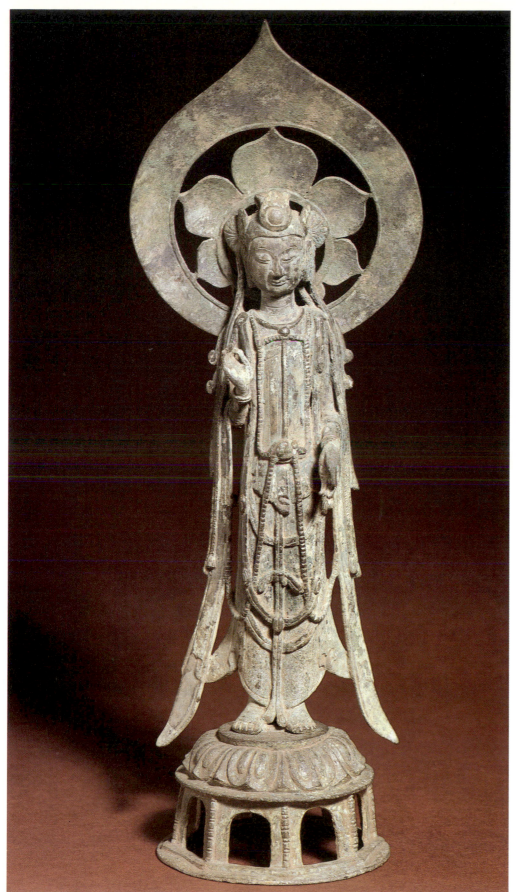

Cat. 17 O. 3-1968

Figure of Guanyin. About 570–90

Bronze, probably formerly gilt
H: 42cm W: 15cm D: 11.4cm
Mrs. W. Sedgwick bequest, through the
NACF

Coll: *bought C. T. Loo, 1934*

Guanyin (Sanskrit *Avalokitesvara*) is one of the enduring figures in the popular Buddhist pantheon. He/she is invoked whenever mercy is called for, and acts particularly on behalf of mothers and children.

This example, with arcaded lotus pedestal and 'jewel' shaped-oriole, cast separately, has a heavily mineralised patina. Presumably once gilt overall, no gilding is now visible. The usual attributes, a flask for holy water and a willow switch, are missing, although a trace of what may have been the stem of the latter is visible in the left hand.

In the absence of any inscription the dating must be speculative. In a manuscript description of about 1968 W. Watson records the 1934 opinion of Oswald Siren, dating it to 530, at the very end of the Northern Wei Dynasty (424–532). His own, and more likely, dating was end of Northern Chi/beginning of Sui (about 570 – about 590).

The finest items in the Sedgwick collection of Chinese art were bequeathed to various British collections, the Fitzwilliam being enriched by 18 wonderful bronzes and ceramics.

RAC

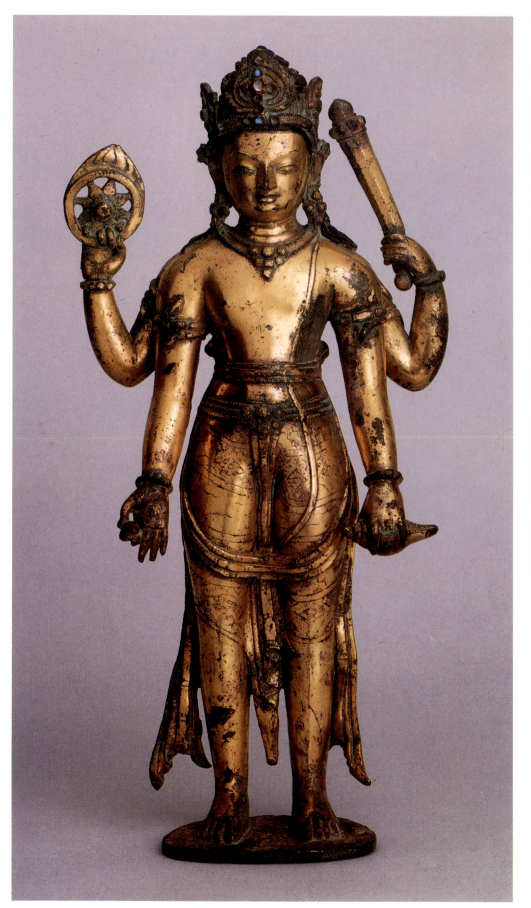

Cat. 18 O. 1-1980

Vishnu. 12th–14th century, or earlier

High-copper bronze, incised, gilt, set
with gems and painted
H: 34cm to base (38.5cm including lugs) W:
16cm D: 7cm
Bought from the Cunliffe Fund, with
contributions from the Regional Fund
administered through the Victoria and
Albert Museum, the NACF, and the
Ancient India and Iran Trust

Coll: *Miss Sibley Miller, by gift 1939 to her
god-daughter Mrs. L. Renzulli, from whom
bought*

Ref: *Ann. Rep.* 1980, pl. VI; *Treasures*, no. 23

This exceptionally fine and rare Nepalese
statuette was probably the central figure
of a triad, depicting Vishnu, his consort Sri
Lakshmi and an anthropomorphised form
of his bird-mount Garuda. It is fitted with a
tang on each foot for insertion into the
original base. It also originally had an
auriole, and retains an attachment lug for
this between the shoulder blades.

It is solid cast, and when acquired was
encrusted with ancient corrosion products
and decayed varnish: root marks on the left
leg indicated long burial. Cleaning revealed
the gilding to be largely intact. No attempt
has been made to straighten the mace,
probably bent when the piece was dug up.

Shown with four arms, he holds the
wheel of life and death; the mace which
destroys illusions; the lotus seed of creation
and the conch-shell on which is blown the
primordial sound.

RAC

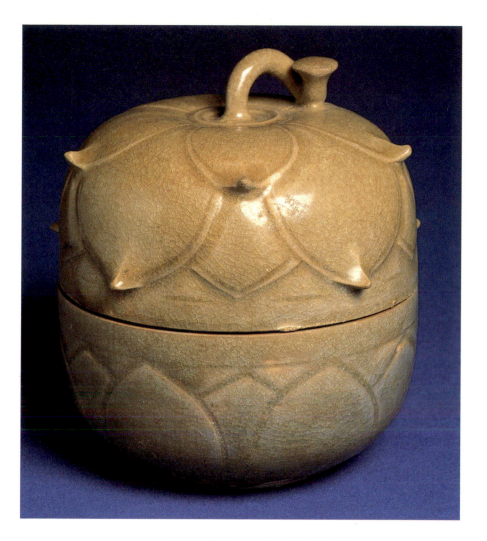

Cat. 19 O.C 24-1946

Yue ware circular box and cover. 9th–
10th century

Stoneware, thrown, modelled and incised,
celadon glaze
H: 11.6cm Diameter: 10.1cm

Coll: *Messrs. Sparks, 1936*

Ref: *Treasures*, no. 25

This box, most likely for incense in a
temple, is imaginatively modelled as a
double lotus. It can with confidence be
assigned to the Yuyao province of Wuyue,
an ardently Buddhist kingdom (present-
day Zhejiang province), and has been
ascribed to the famous kilns of Shanglinhu,
whence tribute was despatched to the
metropolitan capital at Changan. The shape
is probably derived from an original in
precious metal, although the handling is
purely ceramic.

The subtle green of the celadon glaze,
resembling old jade, is produced when
minute quantities of iron in the glaze are
fired to high temperature in an oxygen-
starved, or reducing, atmosphere.

RAC

Cat. 20 C. 73-1984

Inlaid bowl. 2nd half 12th century

Stoneware, thrown, inlaid and celadon glazed
H: 6.3cm Diameter: 16.3–16.8cm
Given by Mr. and Mrs. G. St. G. M. Gompertz

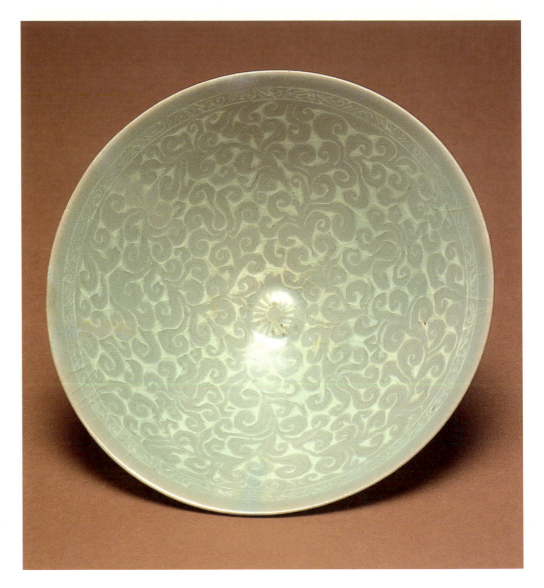

One of over 150 objects, given, with an accompanying library of Koreana, to celebrate the centenary of Anglo-Korean diplomatic relations. The gift, combined with the eighty or so pieces already here, brought the Fitzwilliam collection of Korean ceramics to world-class. This is a fitting tribute to Gompertz, whose monographs, *Korean Celadon*, London, 1963, and *Korean Pottery and Porcelain of the Yi Period*, London, 1968, remain the best introduction to the subject in English, and whose achievements in this field led to the award of a C.B.E. in 1984.

The quality of the collection has attracted commercial support: Lazards, Barclays Bank International and the Korean Merchant Bankers Corporation have given funds for a catalogue by Professor Yun Yong-i of Wonkwang University, to be published by the Cambridge University Press, and Hyundai has given money for new cases for the display.

This bowl shows the uniquely Korean ceramic technique of inlay (*sanggam*) to perfection. Inlay was also popular on bronzes, using silver, and on lacquer, using irridescent shell. The interior of the bowl is carved and inlaid in white slip, producing a positive white design for the central chrysanthemum and scroll around the rim, and a white background to an allover leaf-scroll pattern (*posang tangch'o*) in between. The outside has four evenly spaced chrysanthemum sprays inlaid in white and black slip. The glaze is crazed, particularly near the edges of the inlay, and exhibits the kind of refraction effect known to Japanese connoisseurs as *hoseki zogan* (jewellery inlay).

Professor Yun dates this piece by comparison with the similar bowl excavated from the tomb of Mun Kong-yu (d. 1159) (Gompertz, 1963, pl. 60) and assigns it to the Yuch'on-ni kiln, Puan, N. Cholla province.

RAC

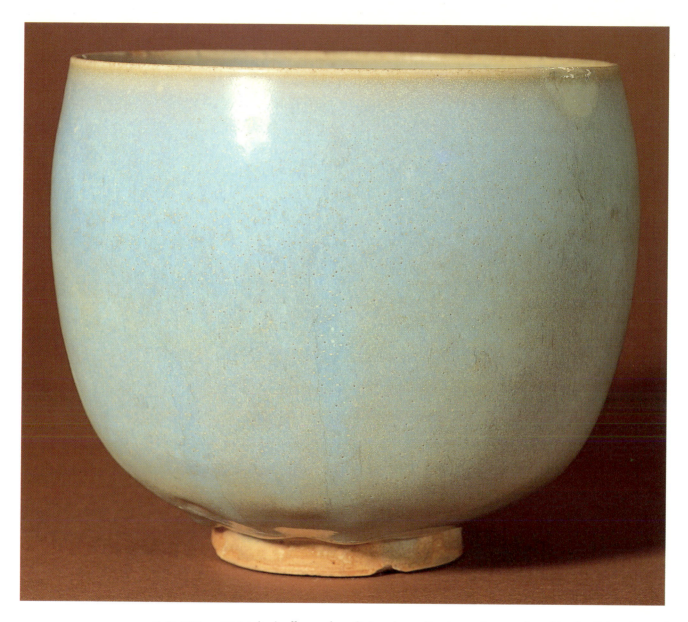

Cat. 21 C. 64-1934

Jun ware ovoid bowl. 12th century

Stoneware, with opaque blue glaze
H: 16.8cm Diameter: 19.5cm
Bought from the Glaisher Fund

Coll: *Sir Frank Brangwyn, from whom bought*

This ware, named from Junzhou near the Northern Sung capital Kaifeng, was principally produced at various sites in Henan, production continuing until the fourteenth and even fifteenth century. Fine early pieces such as this are famous for the subtle duck-egg blue monochrome glaze, which derives its opacity from thousands of tiny bubbles, evolved during firing and trapped within on cooling. They are due to potash in the raw-glaze mixture, added probably as a mixture of plant-ash and crushed quartz-feldspar rock. The blue colouring depends on minute quantities of iron, reduced in the firing (cat. 19). This contrasts with the buff body, oxidised where exposed, in a subsequent oxygen-rich phase of firing.

Later examples of Northern Jun are further enhanced with splashes of red and purple copper. Variants of the glaze were also produced in Wuzhou in Zhejiang province, in Guangdong, Yixing, and in Japan.

RAC

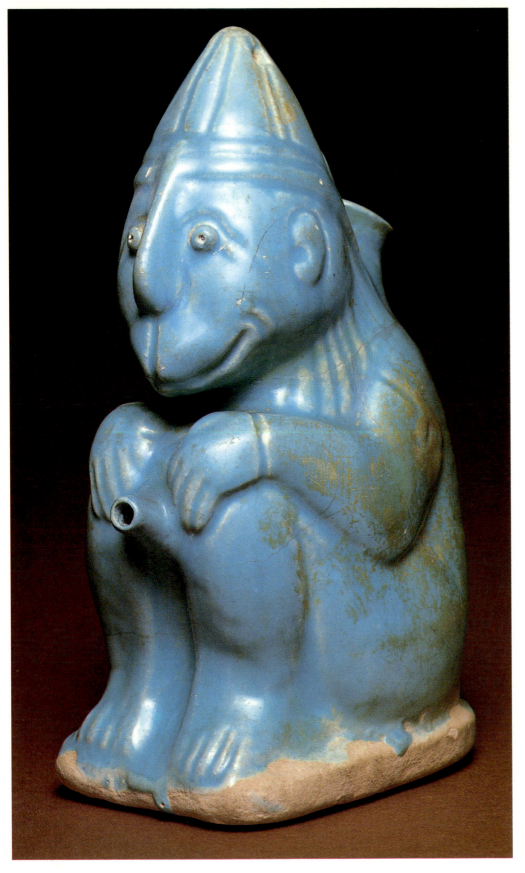

Cat. 22 O.C. 163-1946

Ewer in the form of a monkey.
12th century

Moulded frit, with monochrome turquoise
copper glaze
H: 20.6cm W: 7.5cm D: 11.8cm
Oscar Raphael bequest, 1940

Cat. 23 O.C. 164-1946

Ewer in the form of a recumbent cat.
Late 12th – early 13th century

Moulded frit, with clear and cobalt-blue
glazes and overglaze copper-lustre
H: 10.6cm W: 10.1cm D: 18.4cm
Oscar Raphael bequest, 1940

The monkey and the cat are fine
examples of a class of figurative
ceramics produced in Iran between the
middle of the twelfth century and the
Mongol invasions of the early thirteenth.
Popular models are hawks, bulls, lions,
camels and mounted warriors. Many are
without obvious function, and doubt has
been expressed as to whether ewers such as

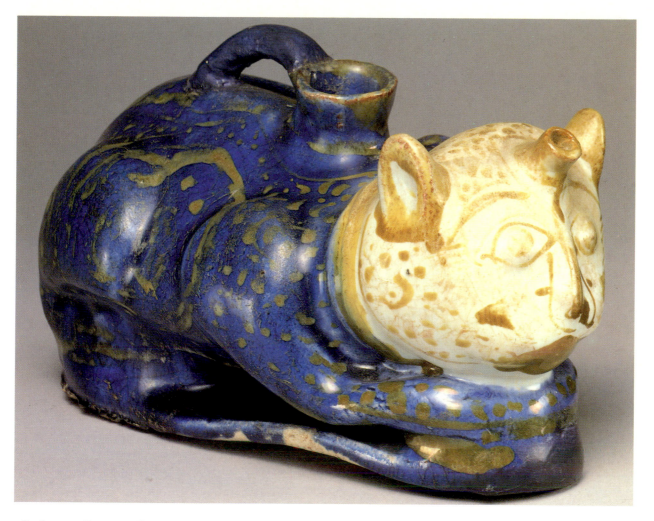

these were really for use. Some small models have deliberately roughened bases and served as rubbing stones for the bath. The ewers may have been for perfume in the same context.

The monkey, presumably a pet, wears a conical cap, with two tiny holes in the crown, perhaps for the attachment of a tassel, and a long-sleeved jacket.

The cat's features are picked out in copper lustre, requiring a second firing in smokey, oxygen-poor, reducing atmosphere, a technique first prominent in Abbasid Iraq in the ninth–tenth centuries, then in Fatimid Egypt, then Iran. Subsequent transmission through Moorish Spain to Italy brought lustre to the repertoire of the Western European potter

(cat. 44). The attribution to Kashan rather than Rayy depends on the reasoning in O. Watson, *Persian Lustre Ware*, London, 1985, pp. 41–2 and pl. 101.

The zoomorphic class of ewers seems to have been an important influence on the latten acquamaniles of medieval Europe.

RAC

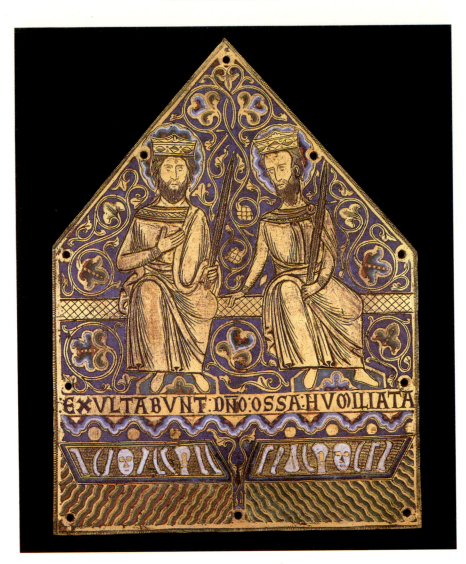

Cat. 24 M. 31-1904

Gable-shaped end plaque from a reliquary. About 1200-10

Champlevé enamel on copper, engraved and gilt
H: 24cm W: 17.7cm
Frank McClean bequest

Coll: *Debruge-Dumenil; Lord Hastings; Frank McClean*

Ref: *Dalton*, pp. 101–2, no. 52.

Relics played a significant role in medieval religious life, and religious institutions which owned them attracted pilgrims and benefactions. Great exertions were made to acquire even tiny fragments of a Saint or Martyr, and splendid reliquaries were made to house them. During the twelfth and thirteenth centuries the most common type of housing, often

described as a *chasse*, was shaped like a small church with gables, and a pointed roof.

This plaque probably formed the gable-end of such a reliquary. The opposite end was almost certainly occupied by a plaque of similar shape and design which is now in the Keir collection. Alternatively they may have come from the transept façades of a larger reliquary. Both pieces, together with a rectangular plaque decorated with the *Dormition of the Virgin*, which has been associated with them on stylistic grounds, were brought together for exhibition at the British Museum in 1981. (Marie-Madeleine Gauthier and Geneviève François, *Medieval Enamels, Masterpieces from the Keir Collection*, London, 1981, p. 17, no 10.)

The crowned figures holding palms of martyrdom represent two of the *Four Crowned Martyrs* or *Quattuor Coronati*, seated above their open sarcophagi and the words *EXULTABUNT DŇO OMNIA OSSA HUMILIATA* ("the humiliated bones shall

rejoice in the Lord"), from the Vulgate, Psalm L: 10. The matching plaque has an inscription imitating Psalm XXXIII: 21, *CUSTODIT DŇS OMNIA OSSA SCŌR* ("the Lord preserves all the bones of the Saints"). Neither the names of the *Crowned Martyrs* are known, nor the place and date of their deaths. They are said to have been martyred at Rome or in Pannonia during the reign of Diocletian (AD 284-305). According to one version of their legend (L. Réau, *Iconographie de l'Art Chrétien*, III, Paris, 1958, pp. 348-50), they were stonemasons or sculptors who refused to make a statue of Aesculapius, and, on Diocletian's orders, were enclosed alive in lead coffins and drowned in the Tiber. Although the martyrs became the patrons of masons, their cult was not widespread. A basilica dedicated to them is on the Caelian Hill in Rome, and the abbey of Saint-Sernin at Toulouse in France possessed relics.

JEP

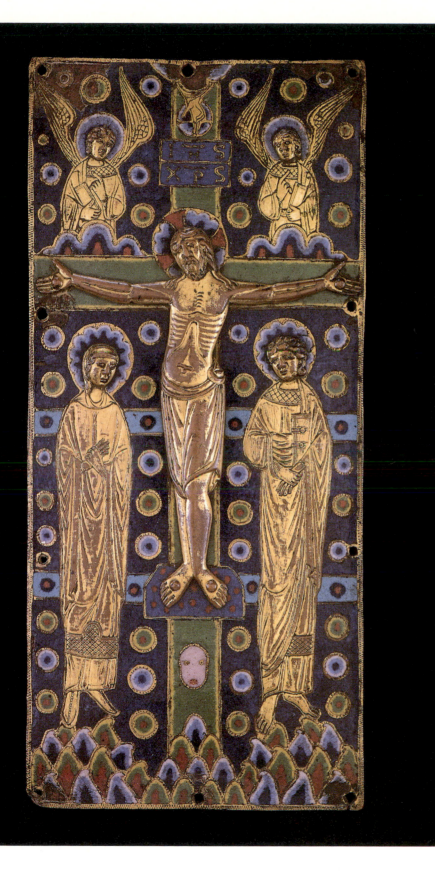

Cat. 25 M. 34-1904

Crucifixion with the Virgin, St. John, and two angels. About 1200

Champlevé enamel on copper, engraved, chased and gilt
H: 23cm W: 10.2cm
Frank McClean bequest

Ref: *Dalton,* p. 103, no. 52, pl. XV

This plaque belongs to a stylistic group made at Limoges over a period of some twenty years about 1200. It once formed the central panel of a book cover, probably an evangelistary. The figure of Christ and the heads of the Virgin Mary, St. John and the two witnessing angels overhead are chased in low relief and attached to the slightly convex surface of the plaque by studs. At top centre, the nimbed hand of God descends from a cloud over the *titulus*, IHS/XPS, an abbreviation for Jesus Christ in Greek, and the skull of Adam is shown on the Cross below Christ's feet.

Comparable plaques are illustrated and discussed in Marie-Madeleine Gauthier and Geneviève François, *op. cit.* cat. 24, p. 15, no. 6 & pl. 6, and Mme Gauthier's *Emaux du moyen age occidental*, Fribourg, 1972, p. 112 & pl. 64-5. Both have retained their frames and differ iconographically from the Fitzwilliam panel in lacking the skull and in showing Adam rising from the tomb below the Cross. On some Limoges panels both features occur together. They refer to the legend that the Cross was erected on the burial place of Adam, also to the belief that through the sacrifice and resurrection of Christ, mankind might be redeemed and gain eternal life. Through this iconography the book cover proclaimed the message of the text within and provided a focus for meditation on the transitory nature of earthly life.

JEP

MEDIEVAL AND EARLY MODERN EUROPEAN COINS
Cat. 26–31

During the fifth century AD waves of Germanic tribesmen from Northern and Central Europe took control of most of the territories ruled in the name of the Western emperor in Rome. When the last holder of that title was deposed in 476, the imperial regalia were sent by Odovacer, king of the Germanic mercenaries in Italy, to Constantinople in recognition of the Eastern or Byzantine emperor's formal sovereignty over all the lands that had once constituted the Roman empire. Not surprisingly, the earliest coins of the migration period are copies of Roman or Byzantine prototypes. Outside Italy, it is overwhelmingly a coinage in gold. Originally based on the *solidus* (compare cat. 14), issues increasingly corresponded to the third-*solidus* or *tremissis*. The development of 'national' coinages in the West is marked in three ways: by the adoption of the Germanic weight-standard of 20 barleycorns (a weight of gold referred to as a 'shilling' or cut-piece), some 12½ per cent lighter than its Roman equivalent; by types whose appearance is more and more remote from that of their imperial prototypes; and by a debasement of the metal itself, as Byzantine subsidies to the Western kingdoms declined during the seventh century. By the beginning of the eighth century gold coins were no longer regularly struck in the Christian West. They were not to re-emerge as a significant element in European coinage for over 500 years.

The second period of medieval European coinage (from about 650 to 1200) is dominated by the silver penny; to this piece the Latin term *denarius* was attached, giving us the French *denier*, Italian *denaro*, and Spanish *dinero*. Its classic form is derived from reforms of the currency undertaken on the Continent by the Frankish king Pepin the Short (751–68), and by his son Charlemagne (768–814), first as king and then as 'Roman' emperor. In Britain, parallel reforms were undertaken in the Anglo-Saxon kingdoms established in South-East England, notably by Offa of Mercia (759–96). The result was a piece of good silver, struck on a flan which is broader and thinner than that of its predecessors (cat. 26). The coinage is no longer struck on the pretended authority of the Eastern emperor, but proclaims the king as sovereign issuer. Although later British Isles issues of silver pennies generally retain their weight and metal quality, many Continental series decline in weight and/or fineness. In parts of Germany the solution was to conserve the quality of the silver, but to spread it so thinly that the resulting penny, known by numismatists as a 'bracteate', was able to take an impression on only one face (cat. 27). The series achieved a rich iconography, particularly on the issues that employed the thinnest and broadest flans.

The last period of medieval European coinage (from 1200 to about 1450) is marked by two major developments: the reintroduction of good silver coins; and a return to the use of gold as a regular part of the currency. Both developments had their origin in Italy, the former at Venice, where the first '*grossi*' (*denari*) were struck in 1202. Over the next century and a half, these 'large' pennies were to become the *gros* in France, *croat* in Catalonia, *groat* in England, and *Groschen* in Germany. Gold coinage was reintroduced in the Hohenstaufen kingdom of Naples/Sicily in 1231. By the middle of the century, it had already spread to Florence (the *fiorino d'oro* or florin) and to Genoa. No one pattern of gold piece held universal sway. In France and England the preference was for broad flans. As in the case of the silver 'bracteate', this led to some of the most splendid examples of numismatic art (cat. 28).

Two innovations inaugurate the early modern coinage of Europe. New finds of silver made possible ever heavier coinages to a point where even gold issues could be matched by silver pieces of equivalent value. Although a generation later than the first such issue (that of Archduke Sigismund of the Tyrol (1486)) and although of little artistic value, the huge *Guldengroschen* coinage of the Counts of Schlick left its mark on world currency by bequeathing to us the term 'dollar' (cat. 30). The larger coins also radically transformed the appearance of European currency by the restoration of numismatic portraiture. Ironically, it was at Venice that the revolution began, since the presumption of Doge Nicolò Tron in placing his own head on the new silver *lira* (1472) was never repeated during the Serenissima's remaining 300 years. But at Milan the idea of placing the duke's head on suitably sized coins caught on (cat. 29) and from there the practice spread through most of Europe. Such pieces were generally referred to as 'testoons' (or its equivalent), from the Italian word *testa*, meaning head. Although the introduction of portrait types did much to enliven the appearance of the coins, reverse types were still generally dependent on heraldic forms, such as armorial shields and *imprese* (personal devices). An exception to the rule was the often very imaginative coinage struck by Scotland during the second half of the sixteenth century (cat. 31).

TRV

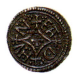

Cat. 26 Young 115

British Isles: Anglo-Saxon, Mercia: Offa (757–96): Canterbury or London mint, Eadhun (moneyer). Before about 792.

Obverse: **OFFA, REX** (various pellets). Bust of Offa front facing, robed: head, with elaborate coiffure, right.
Reverse: **EA=D=HV=N=** (various pellets). Geometric ('lozenge') design, with 4 crosses at centre, Greek cross, with 4 pellets.

Metal and denomination: silver (AR) penny

Weight: 1.18gm Diameter: 18mm Axis: 90°

Standard literature
J. J. North, *English Hammered Coinage* I, 2nd edn, London, 1980, no. 303.

Found at Deddington Castle, Oxfordshire, before 1866 (D. M. Metcalf, 'A coin of Offa from Deddington Castle, Oxon', *British Numismatic Journal* XL, 1971, pp. 171–2)

A. W. Young bequest, 1936

Coll: *P. W. P. Carylon-Britton collection (Sotheby, Wilkinson, & Hodge, London, 17 November 1913, lot 271, pl. vii)*

Ref: *Grierson*, no. 389; *MEC* I, no. 1126; *Volk*, no. 25; *Treasures*, no. 37a

The introduction of broad flans in about 770 provided die-engravers with the opportunity for more elaborate designs than are generally to be found on the preceding 'sceat' coinage. Royal authority for the coinage is usually spelt out, though the place of minting is in most cases omitted. Offa's coinage prior to his adoption of a heavy penny on the pattern

of Charlemagne's *novus denarius* of about 793/4 is remarkable both for the variety of its types and for its artistic independence from contemporary Continental issues. Indeed, this flowering numismatic design is seen by some as comparable with the brilliance of insular manuscript illumination of the eighth century (Blunt, pp. 42–3). The most remarkable issues of this series are those on which the king is portrayed. Such coins were presumably intended to impress the user, whether by projecting the image of Offa in the guise of a Roman emperor or, as here, with an extraordinary hairstyle more redolent, perhaps, of his Germanic past (S. D. Keynes in *Volk*, p. 8). (See, in general, C. E. Blunt, 'The coinage of Offa', *Anglo-Saxon Coins: Studies presented to F. M. Stenton*, ed. R. H. M. Dolley, London, 1961, pp. 39–62, pl. iv–vii, this coin illustrated at no. 39.)

Cat. 27 1691: 01

Germany: Swabia, Sigmaringen-Helfenstein (County): Gottfried III (1247–63); Sigmaringen mint

Obverse: Stag prancing left; plain raised border and circle of pellets.

Metal and denomination: silver (AR) 'bracteate' *Pfennig* (penny)

Weight: 0.41gm Diameter: 20mm

Standard literature
J. Cahn, *Münz– und Geldgeschichte der im Großherzogtum Baden vereinigten Gebiete* I. *Konstanz und das Bodenseegebiet im Mittelalter bis zum Reichsmünzgesetz von 1559*, Heidelberg, 1911, pp. 131 and 448, no. 215, pl. x.

Probably found at Wolfegg, Württemberg, in 1895 as part of a hoard of about 8,000 'bracteates', all issues from the immediate region of Lake Constance, buried during the second half of the thirteenth century (R. von Höfken, 'Zur Brakteatenkunde Süddeutschlands: 13. Der Wolfegger Brakteatenfund'. *Archiv für Brakteatenkunde* III, 1894–97, pp. 185–222, pl. 37. 64a, this issue). This Sigmaringen issue was unknown before the hoard's discovery.

Acquired through the interest of the Rev. W. G. Searle, before 1908, probably as his gift.

Coll: *?With A. E. Cahn, Frankfurt am Main*

The typical Swabian 'bracteates' are of small diameter and struck on relatively thick flans of regular shape. They display a particular elegance of workmanship. The cusped circle, as well as protecting the type, made them easier to stack, and so to count. Animal types, both mythic and real, occur on the issues of a number of Swabian states of their region; so, Reichenau (lion, gryphon), Überlingen (lion), St. Gallen (Paschal lamb), Schaffhausen (ram), and Bishopric of Chur (ibex(?)). An ornamental border normally takes the place of a legend. The attribution of this type to Sigmaringen was made on the basis of its sharing the device of the later Town seal.

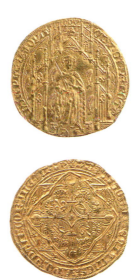

Cat. 28 CM. 49–1956

France: Anglo-Gallic, Guyenne: Edward, the Black Prince (1362–72): Poitiers mint. Before 1366(?)

Obverse: Gothic letters (some reversed):
ED: PO·GNs: REG: A=NGLI: PNPS: AQVIT (stops: voided quatrefoils). An elaborate Gothic canopy, under which Edward, Prince of Wales, the Black Prince, stands facing, robed and caped: head facing, wearing wreath of roses; with left hand, he points at sword held in right hand. At feet of prince, 2 leopards; to either side, 2 ostrich feathers.
Reverse: Gothic letters (some reversed): (cross) **DNs: AITO: et: PTECTO: ME: et: I**

IPO: sPAIT: COR: MEVM: (stops: rosettes), **P** (mint-mark). An ornamental quatrefoil set over square; within, a cross tipped with acorns; in angles (1, 3), fleur-de-lis between 2 ostrich feathers; (2, 4) leopard between 2 ostrich feathers; at centre, rosette.

Metal and denomination: gold (AV) *noble aux plumages* ('pavillon d'or')

Weight: 5.32gm Diameter: 33mm Axis: 105°

Standard literature
L. M. Hewlett, *Anglo-Gallic Coins*, London, 1920, pp. 111–12, var. a (this coin).

Given by the Friends of the Fitzwilliam

Coll: *R. C. Lockett collection (Glendining, London, 29 February 1956, lot 22, pl. i); B. Roth collection (Sotheby, Wilkinson, & Hodge, London, 14 October 1918, lot 298); F. McClean collection (Sotheby, Wilkinson, & Hodge, London 11 June 1906, lot 68, pl. i); A. B. Richardson collection (Sotheby, Wilkinson, & Hodge, London, 22 May 1895, lot 77).*

Ref: *FOF* 1956, p. 4, fig. b; *Treasures*, no. 37b.

In July 1362, King Edward III of England (1327–77) erected the English possessions in South-West France into a principality vested in his son Edward, Prince of Wales, the Black Prince. The gold coinage of Aquitaine (Guyenne) for the Black Prince includes some of the most magnificent issues of medieval France. The most splendid of the series, and the apogee of Gothic numismatic art, is the *pavillon d'or* probably struck from gold paid as ransom to the English Crown for French prisoners, including the French king himself, John II. On the obverse, the prince is styled 'Edward, First-born of the King of England, Prince of Aquitaine'; in evident parody of contemporary French regal issues where the king points to his sceptre as the symbol of his authority, Edward is shown gesturing towards his drawn sword. The reverse type is new to both the French and English series; it presents a complex pattern of emblems and devices: the ostrich feathers of the Prince of Wales (repeated from the obverse), leopards from the royal arms of England and fleurs-de-lis from those of France. The accompanying legend is taken from Psalm 28:7: 'The Lord is my helper and my protector and my heart has placed its hopes in Him'. The *pavillon* was struck in both heavy-weight (as this specimen) and light-weight issues. Weighing about 4.5gm, the latter (presumably later) issue was probably made in 1366 to finance the prince's military campaign of the following year to

assist Peter I, King of Castille, against an attempted usurpation by the illegitimate Trastámara prince supported by the French king. Failure to recover the costs of this successful expedition led to a financial and political crisis in Guyenne which culminated in renewed hostilities with France. In 1371, the prince, now a sick man, surrendered to his father the government of his principality.

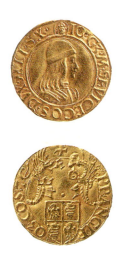

Cat. 29 CM. 9–1956

Italy: Lombardy, Milan (Duchy): Giovanni Galeazzo Maria Sforza (1476–94): Milan mint. 1481(?)

Obverse: (oval with miniature bust of St. Ambrose) **IO′ Gz′ M′ SF′ VICECOS′ DVX′ MLI′ SX.** Bust of Giovanni (Gian) Galeazzo Maria Sforza-Visconti front right, armoured: head right, wearing cap.
Reverse: (cross) **= ′ PP′ ANGLE = Que ′COS′ etC′=.** Shield with ducal arms: (1, 3) eagle, (2, 4) *biscia*; 2 helmets: that to the left surmounted by dragon devouring a 'Saracen', that to right surmounted by monster with wings and human face and holding ring.

Metal and denomination : gold (AV) 2-ducat

Weight: 6.89g Diameter: 27mm
Axis: 335°

Standard literature
Corpus Nummorum Italicorum V. *Lombardia (Milano)*, Rome, 1914, p. 186, as no. 12.

Given by P. Grierson

Coll: *R. C. Lockett collection (Glendining, London, 29 February 1956, lot 215, pl. ix);*

anonymous collection (Münzen und Medaillen, Basel, 6 December 1946, lot 312, pl. xi)

Ref: *Ann. Rep.* 1956, p. 3, pl. II.d; *Treasures*, no. 37d

Referred to in contemporary documents as a *testone ducale da due ducati*, this coin has as its obverse type a portrait bust of the young duke. Unlike his predecessors, who appear on their coins bare-headed, Gian Galeazzo is shown wearing a fashionable 'sugar-loaf' cap. The elaborate heraldry of the reverse weaves together various devices or symbols of the Visconti-Sforza family. The left-hand helmet echoes the famous Visconti *biscia* device of a serpent swallowing a youth ('Saracen'), while the right-hand helmet incorporates a device adopted by Francesco I Sforza (1450–66) to commemorate the gold and jewelled ring which his father, the famous condottiere Muzio Atendolo Sforza, had received from Nicolò III of Ferrara to mark his loyalty and courage. The 'pellet' above the shield is the impression made by the compass-point inserted by the engraver in order to describe the base-line for the circular legend.

Gian Galeazzo, who succeeded his father at the age of seven, is here styled 'Sixth Duke of Milan, Count of Pavia and Anghera, etc.' The legend omits any reference to the regency, either of his mother, Bona of Savoy (1476–80), or of his uncle, Ludovico il Moro (1480– or 1481–94). Such issues have traditionally been dated to the period between the resignation of Bona on 2 November 1480 and the treaty with Genoa signed by the Regent Ludovico in March 1481. There is, however, documentary evidence of il Moro's acting as the duke's guardian as early as November 1480. Besides, the issue of double ducats appears to have been too substantial to be the product of a brief six-month period. Precise dating of the issue is, therefore, an open question. (For the 'sole' coinage of Gian Galeazzo, see C. Crippa, *Le Monete di Milano dai Visconti agli Sforza dal 1329 al 1535*, Milan 1986, pp. 223–31, especially no. 1).

Cat. 30 Dewick 241

Bohemia, Schlick (Lordship): Stephen (1505–26) and brothers; with Louis I (II of Hungary), King of Bohemia (1516–26), St. Joachimsthal (Jáchymov) mint: Hans Weizelmann (mint-master). 1520–5.

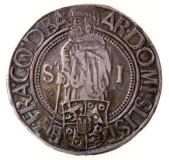

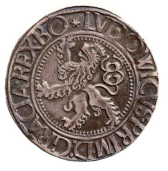

Obverse: **AR · DOMI: SLI: ST=E = et: FRA · Com: D: BA** (stops: rosettes); **S = I.** Half-figure of St. Joachim front left, holding pilgrim's staff; shield with arms of (1, 3) Weissenkirchen, (2, 4) Schlick, and (inescutcheon) Bassano.
Reverse: **LVDOWICVS · PRIM · D: GRACIA · REX · BO** (stops: rosettes), mint-mark: star. Twin-tailed lion of Bohemia left.

Metal and denomination: silver (AR) *Guldengroschen* (2nd type)

Weight: 28.66g Diameter: 41mm Axis: 85°

Standard literature
J. S. Davenport, *European Crowns 1484– 1600*, Frankfurt am Main, 1977, no. 8141.

Rev. E. C. Dewick bequest, 1918

In 1512 substantial silver deposits were discovered in a valley on the south side of the Erzgebirge range, in what is today North-West Czechoslovakia. Systematic extraction began three years later and by the end of the following year some 400 dwellings had been established in what had previously been a deserted area. The land had been mortgaged to the Counts of Schlick, who now named it St. Joachimsthal (literally, vale or dale of St. Joachim). They proceeded to organise the territory under a charter issued by King Louis of Bohemia– Hungary. A mint had already been established by 1519, its product clearly identified by the figure of St. Joachim shown on the obverse (the accompanying legend describes the heraldic shield as 'the

arms of Stephen and his brothers, Lords of Schlick, Counts of Bassano', the second being a town in the Veneto). Regular production began in 1520. Between then and 1528, when the new Hapsburg king, Ferdinand I (1526–64), claimed the mint for the Crown, over two million silver pieces had been struck. The unit (a half-piece was also struck) was officially a *Guldengroschen*, that is a coin whose silver value was the equivalent of the gold *Gulden*; but almost from the start such coins were known as *daler* (1526), *Joachimer* (1527), or *Jochim daler* (1529). Such was the wide acceptance of the St. Joachimsthal issue, that its familiar name became a generic term for large silver coins, e.g. *Taler* (German), *tallero* (Italian), *daalder* (Low Countries), *dollar* (English). (For the history of the St. Joachimsthal mint, see L. Nemeškal, *Jáchymovská mincovna v 1. polovině 16. století* (1519/20–1561). *Význam ražby to'aru*, Prague, 1964; for the history of the 'dollar', see *Vom Taler zum Dollar 1486–1986*, eds. W. Hess, D. Klose, Munich, 1986 (exhibition: Staatliche Münzsammlung, Munich).)

Cat. 31 Smart 729

Scotland: James VI (I of England) (1567–1625): Edinburgh mint. 1591

Obverse: (cinquefoil) ·**IACOBVS** · **6** · **D** · **G** · **R** · **SCOTORVM**·. Bust of James VI front right, wearing tunic: head right, wearing hat with cockade; thistle (symbol).

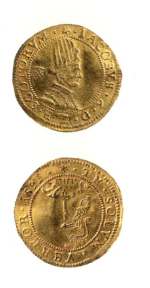

Reverse: (cinquefoil) ·**TE** · **SOLVM** · **VEREOR** · **1591**·. Crowned lion seated left, points, with sceptre, at cloud inscribed with the Hebrew four-lettered name of God: **yhvh**.

Metal and denomination: gold (AV) 4-pounds Scots ('hat-piece')

Weight: 4.48g Diameter: 29mm Axis: 360°

Standard literature
E. Burns, *The Coinage of Scotland* II. *James I AD 1406 to Anne AD 1707*, Edinburgh, 1887, p. 394, no. 1.

Given by T. J. G. Duncanson, 1930

Coll: *F. B. Smart collection*

Ref: *Treasures*, no. 37f

In 1591 the Scottish Parliament passed an Act the professed intention of which was to simplify the kingdom's currency – then a profusion of some 20 denominations – and to bring it in line, so far as possible, with that of England. All but one of the existing gold denominations was to be called in and be replaced by a new issue of 22-carat gold (the English 'Crown' standard of .916 fineness) struck in four-pound and two-pound pieces, though the latter appears never to have been issued. The advantage to the Crown of such a change was the profit to be derived from re-coining; in this case, the mint-master was authorised to retain as royalty a twelfth part of the new issue. The types of the new coin uphold the claim made on James' behalf by modern scholars that before his accession to the English throne his Scottish coinage, particularly in gold, 'presents an almost bewildering succession of well-conceived and executed designs' (R. A. G. Carson, *Coins, Ancient, Medieval & Modern*, London, 1962, p. 260). The king is shown on the obverse wearing a strange tall hat, whence the coin's nickname of 'hat-piece'; while the reverse offers a politico-religious allegory: the Scottish lion rules without fear of any but God himself ('Thee alone do I fear'; like so many of James' coin legends, the Latin text constitutes a metrical phrase). The statement applies perhaps as much to the Church of Rome, as to Scotland's powerful neighbour.

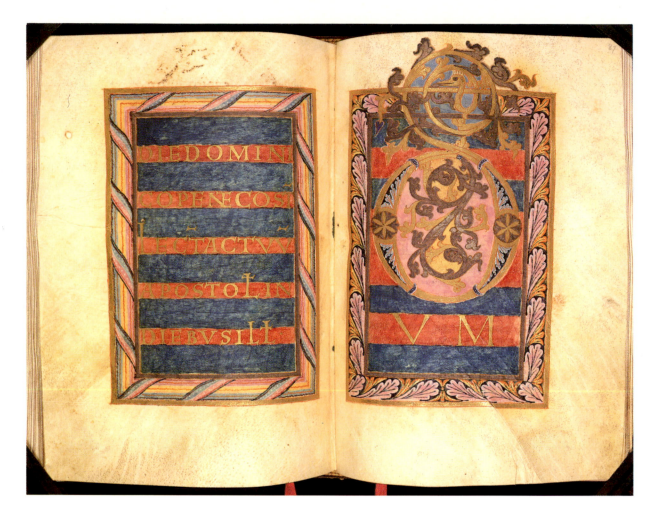

Cat. 32 MS. McClean 30

Lectionary for the Epistle at the Mass.
About 960–90

Illuminated manuscript on vellum
H: 26.7cm W: 19cm
Frank McClean bequest, 1904

Coll: *Barrois collection (Ashburnham),
testator*

Ref: *James II*, no. 30

The manuscript was written and
illuminated in Germany, probably at
Reichenau. Closely related to a Gospel Book

now at Leipzig (Stadtbibliothek, no. CXC),
this book is one of the most important
documents for the history of Western
liturgy, being evidence of a continuing
epistle-tradition deriving from the sixth
and seventh centuries. There are ten fully
decorated pages, with initials formed of
gold and silver interlacing on coloured
grounds, with frames of ornament in the
Reichenau style. Ten smaller initials show
similar decoration. An ivory panel of the
late tenth century was formerly attached
to the cover of the modern binding
(Fitzwilliam Museum M.16-1904).

PW

Cat. 33 MS. 45-1980

Gospel Book, with Capitulaire, in
Latin, with some Anglo-Saxon glosses,
in an insular hand. 9th–10th century

Illuminated manuscript on vellum
H: 27cm W: 19cm
Bought with contributions from the
Regional Fund administered by the Victoria
and Albert Museum, the NHMF, and
Dr. G. D. S. Henderson in memory of
Francis Wormald

Coll: *J. Witham, chapter-clerk of Ripon
Cathedral; Harry Lawrence Bradfer-
Lawrence; by descent to Col. P. L. Bradfer-
Lawrence and his sister Mrs. B. E. Gray, from
whom bought*

Ref: *Ann. Rep.* 1980, pl. IV

The manuscript was written in Brittany
in a Carolingian miniscule, and altered
and glossed in England in the tenth
century.

There are seven miniatures – outline
drawings with tinted areas – depicting
Eusebius, the Four Evangelists, the Betrayal
of Christ and the Crucifixion, decorated
Canon Tables and initials. In the decoration
there are two main streams of influence,
one coming from the Carolingian of Tours,
and the other ultimately insular. One of the
very few Breton Gospels to survive, this is
the only one known to have been in
England as early as the tenth century.

A full discussion is in F. Wormald, *An
early Breton Gospel Book . . .* ed. Jonathan
Alexander, Cambridge, Roxburghe Club,
1977.

PW

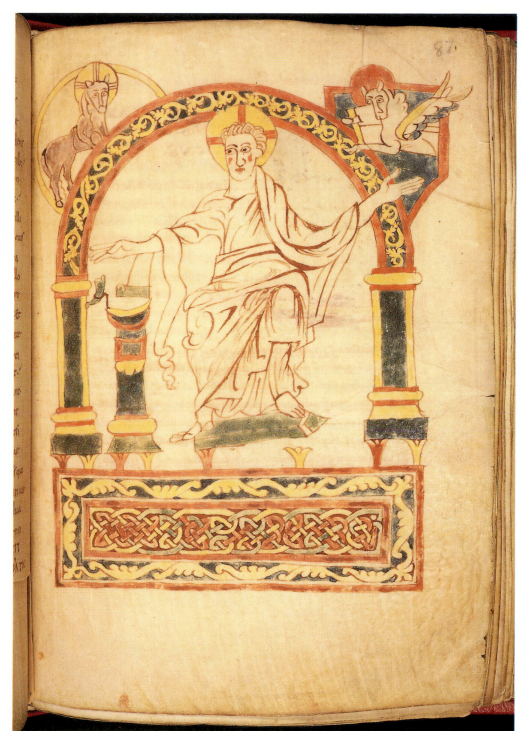

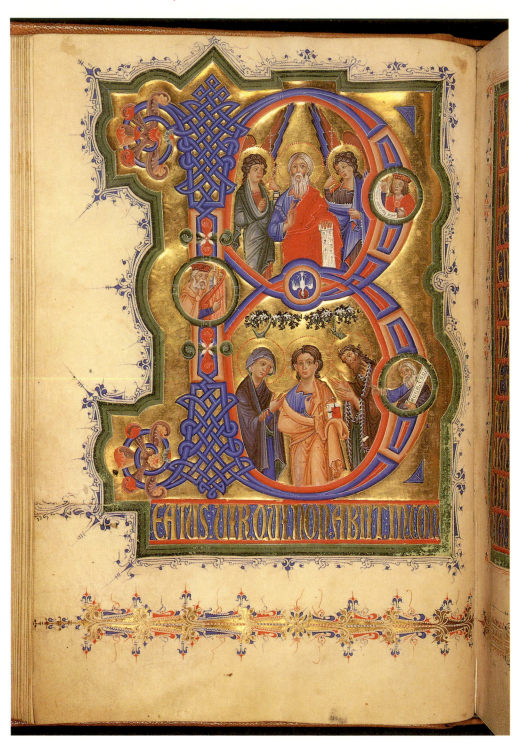

Cat. 34 MS. 36-1950

Psalter, in Latin, with Calendar and Litany. Between 1259 and 1266

Illuminated manuscript on vellum
H: 32.6cm W: 20.3cm
T. H. Riches bequest, 1935

Coll: *Bertram, 4th Earl of Ashburnham;*
H. Yates Thompson

Ref: *Ann. Rep.* 1950, pl. IV; *Winter,* no. 29;
Wormald and Giles, pp. 414–29

Written and illuminated in Germany, probably for Helen, daughter of Albert of Saxony, on the occasion of her marriage, soon after 1257, to Henry III, Duke of Breslau, d. 1266. The Calendar decoration shows the Occupations of the Months, the Signs of the Zodiac, and the Twelve Apostles. Each page of the Calendar has an architectural framework, surmounted by roofs and turrets, with a variety of grotesque beasts at the bases of the columns. There are 28 full-page miniatures forming a series of scenes for the Life of Christ, ten large historiated initials for the Psalms, and many marginal miniatures. At least three hands may be distinguished, all German artists, the two chief ones working in an Italianate style associated wth Giovanni da Gaibana of Padua.

PW

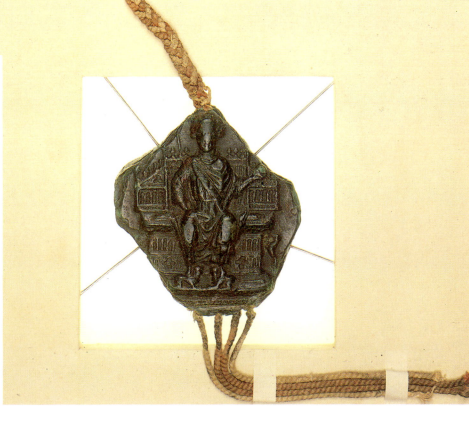

Cat. 35 MS. 46-1980

Free Warren Charter. 1291

Illuminated leaf on vellum; wax seal
H: 19cm W: 28cm
Given by the Friends of the Fitzwilliam

Coll: *Sir Thomas Pilkington; from whom bought directly by Harry Lawrence Bradfer-Lawrence; by descent to Colonel P. L. Bradfer Lawrence and his sister Mrs. B. E. Gray, from whom acquired*

Ref: *Ann. Rep.* 1980, pl. V

A grant of game rights by Edward I to Roger de Pilkington; with the Great Seal of England, given by the King at Norham, 10 June 1291. Initial E in gold and colours, with a full border of birds, animals, trees and a huntsman.
 Discussed in Charles Clay, 'An illuminated charter of Free Warren', *Antiquaries Journal,* 11, 1931, pp. 129–32.

PW

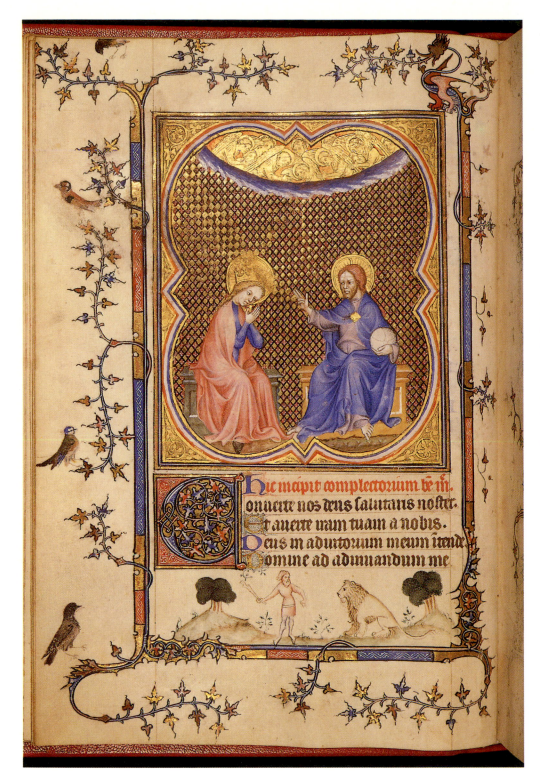

Cat. 36 MS. 3-1954

Book of Hours (Use of Paris), with
Masses and Prayers, in Latin and
French. 14th century (after 1370)

Illuminated manuscript on vellum
H: 25.3cm W: 17.7cm
Bequeathed by Viscount Lee of Fareham,
1947

Coll: *Duke Philip the Good of Burgundy;
Mrs. W. F. Harvey*

Ref: *Ann. Rep.* 1954, pl. II; *Winter*, no. 32;
Wormald and Giles, pp. 479–99

Written and illuminated in France,
probably at Paris, for Philippe
le Hardi, Duke of Burgundy (1342-1404).
Portions of a manuscript in Brussels
(Bibliothèque Royale MS. 11035-37) once
formed part of the same book. Cat. 36 was
later owned by Philip the Good, Duke of
Burgundy, and additions were made
during the fifteenth century by at least
seven miniaturists. The fourteenth century
decoration comprises calendar miniatures
of the Occupations of the Months and
Signs of the Zodiac, eleven large miniatures
with full ivy-leaf borders, and 104 small
square miniatures. Two hands may be
distinguished, both working in a style
associated with the so-called *Maître aux
Boquetaux.*

PW

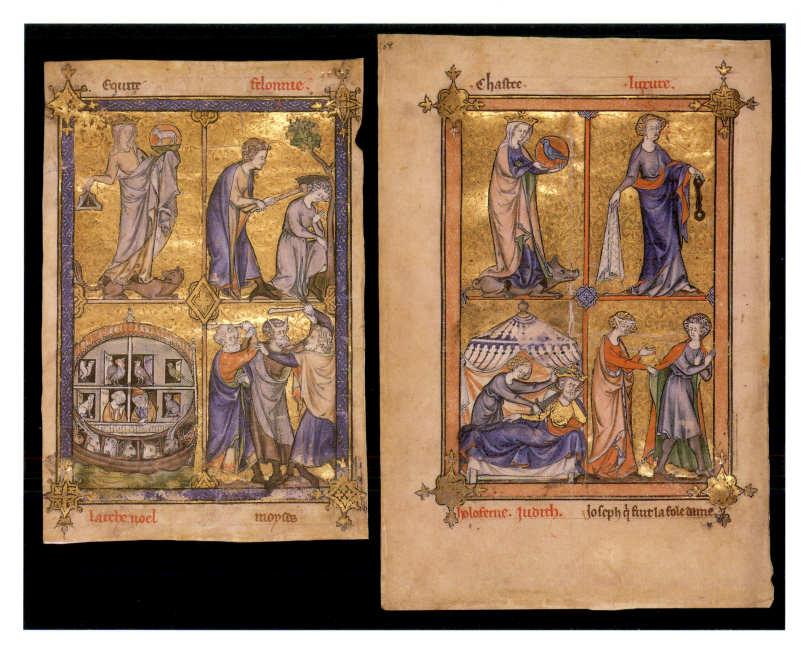

Cat. 37a MS. 192 Cat. 37b MS. 368

MAÎTRE HONORÉ

Leaf from La Somme le Roi, by Frère Laurent. About 1300

Illuminated leaf on vellum
H: 12.7cm W: 10.2cm
Given by S. Sandars, 1892

Ref: *FOF* 1934, p. 4, no. 9; *James I,*
p. 399, no. 192

MAÎTRE HONORÉ

Leaf from La Somme le Roi, by Frère Laurent. About 1300

Illuminated leaf on vellum
H: 17cm W: 12cm
Given by the Friends of the Fitzwilliam, 1934

Ref: *Wormald and Giles,* pp. 369–70

Illuminated by Maître Honoré, who was working in Paris in 1296 for Philippe le Bel, King of France. The leaves have full-page miniatures in four compartments, representing the allegorical figures of a Virtue and the contrasting Vice: Chastity and Lust, exemplified by Judith and Holofernes, Joseph and Potiphar's wife (MS. 192), and Equity and Felony, exemplified by Cain and Abel, Noah's Ark, and Moses slaying an Egyptian (MS. 368). The rest of the manuscript is in the British Library, London, Add. MS. 54180.

PW

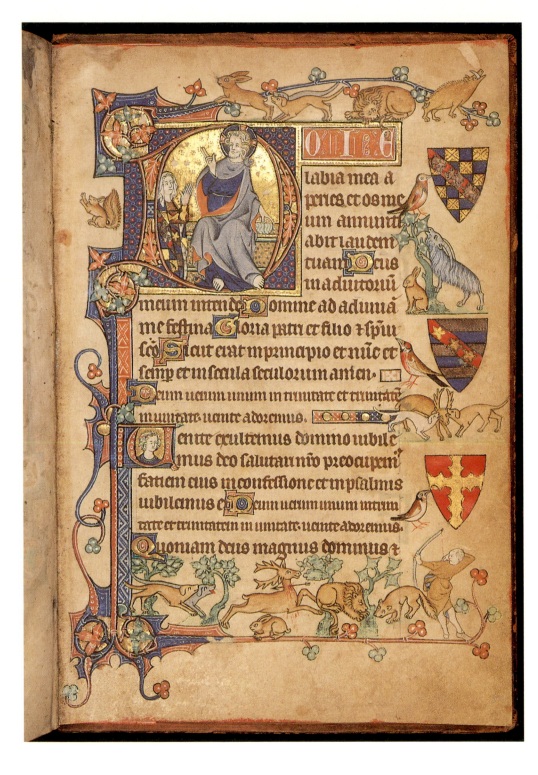

Cat. 38 MS. 242

Grey-Fitzpayn Hours (Use of Sarum).
About 1300

Illuminated manuscript on vellum
H: 24.7cm W: 16.7cm
Bought 1895

Coll: *Sir Andrew Fountaine (1676–1753);*
William Morris (1834–96)

Ref: *James I,* pp. 398–9; *Winter,* no. 30;
Wormald and Giles, pp. 157–60

The manuscript was written and
illuminated in England, probably for
the marriage of Sir Richard de Grey of
Codnor Castle, Derbyshire, to Joan,
daughter of Sir Robert Fitzpayn. There are
two full-page miniatures remaining, the
Annunciation and the Trinity. Historiated
initials and full borders are on ff. 3, 29, 55b.
There is an abundance of decorative
initials, many with portrait busts, and a
great variety of animals and grotesques.
The style is related to the Tickhill Psalter
from Worksop (New York Public Library,
Spencer Collection, MS. 26). Two leaves,
ff. 37 and 55, which had probably been
excerpted in the 1770s, were given to the
museum by Samuel Sandars in 1892.
Morris, who purchased the volume in 1894,
was made aware of the missing folios by
his friend and collaborator Emery Walker,
who recognised them whilst preparing the
plates for M. R. James' catalogue. In an
unusual, but satisfying deal, Morris agreed
to sell the manuscript to the Fitzwilliam,
provided that the missing parts could be
united with it, and that he could retain it
until his death. The enlarged manuscript
duly entered the collection in October 1896.
 PW

Cat. 39 MS. 304

**Miniature, of Pentecost, from a Book
of Hours.** About 1485

Illuminated leaf on vellum
H: 12cm W: 8cm
Given by A. A. de Pass, 1920

Coll: *M. Guillon of Roermond, Holland*

Ref: *Wormald and Giles*, p. 294

In the centre the Virgin, wearing a
white wimple with gauffered edge and
blue robes. Around her, the Apostles look
up to the Dove. This miniature, which is
closely related to a similar one in the
British Libary (Add. MS. 38126), has been
ascribed to Simon Marmion and is an early
example of a scene treated in half-length
format. It is northern French or Flemish.

PW

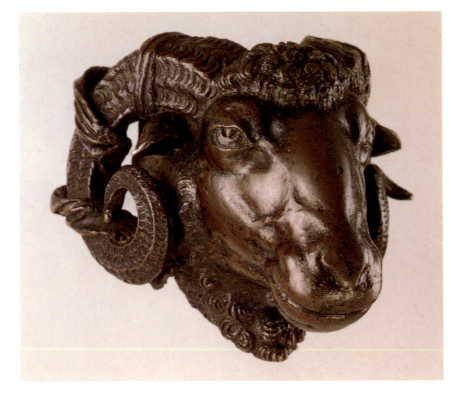

Cat. 40 M. 22-1979

BRIOSCO, Andrea, called RICCIO
Trent 1470 – 1532 Padua

Head of a Ram. About 1507

Bronze, cast and chased, dark brown patina
H: 8.3cm W: 10cm D: 11.3cm
Given anonymously from the collection of
the late Lt. Col. the Hon. M. T. Boscawen,
D.S.O., M.C., in his memory

Ref: *Ann. Rep.* 1979, pl. XII; *Treasures,* no. 36

The son of the Milanese goldsmith Ambrogio di Cristoforo Briosco, Riccio ('Curly', because of his hair), was trained in his father's Paduan workshop, where he learned that attention to surface-finish characteristic of his finest autograph bronzes. He learned the sculptor's trade from Donatello's pupil Bartolomeo Bellano, whose forte was the small bronze. The best known of his documented works, the Paschal candlestick in the Santo at Padua, is in effect an assemblage of small sculptures and reliefs. It includes many of the themes which preoccupied the humanists of sixteenth-century Padua: satyrs, sphinxes, centaurs, the whole apparatus of classical ornament. The iconographic scheme for the candlestick, devised by the scholar and humanist Giambattista de Leone, strikes a balance between profane and religious imagery. Of particular relevance to cat. 40 are four filleted sacrificial ram's heads.

Riccio's *bronzetti* were much copied, and few convincingly autograph examples survive; but the particular working of this one justifies an attribution to Riccio's own hand (see *Natur und Antike in der Renaissance,* exh. cat. Frankfurt am Main, 1986, cat. 232).

RAC

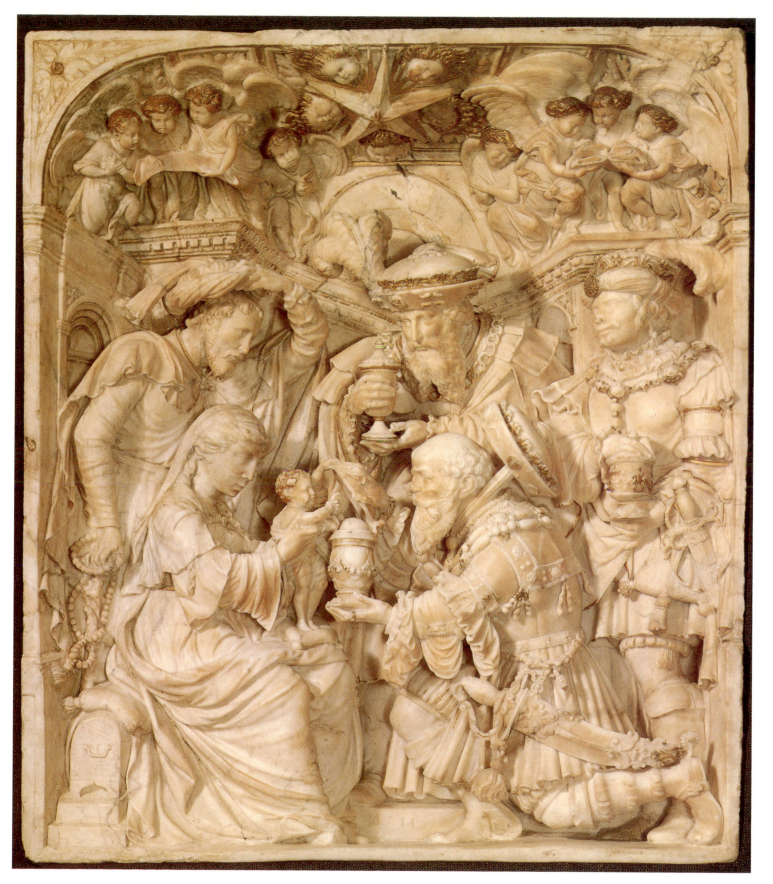

Cat. 41 **Adoration of the Magi**

Cat. 41 M. 3-1980

ANONYMOUS ?A. H. Mid-16th
century

Adoration of the Magi. About 1540

Alabaster, carved, with painted and gilt
details
Signed: A. H.
H: 78.5cm W: 68.5cm D: 20cm
Bought from the Cunliffe, Leverton Harris
and Marlay Funds, with contributions from
the Regional Fund administered through
the Victoria and Albert Museum, and the
Eranda Foundation

Coll: *?Wittelsbach collection: Queen Elizabeth
of the Belgians; with R. Van der Broek,
Brussels, from whom bought*

Ref: *Ann. Rep.* 1980, pl. VII; *Treasures,*
no. 43

This extraordinary *tour-de-force* of
alabaster carving in high relief remains
something of a mystery. The medium, and
the combination of Italianate and Northern
styles strongly suggest Flanders as a source,
and the richly detailed costumes and
weapons a date of about 1540. The chief
Flemish centre for alabaster carving was
Mechelen (Malines), but the list of sculptors
working there in the sixteenth century has
no name to correspond to the A. H. carved
to the right of the Virgin's foot.

This relief is exceptional both in size and
composition. An analogy for the former, in
Middelheim Castle, Antwerp, until its
demolition in 1912 is an *Adoration of the
Shepherds* now in the Museum Vleeshuis,
Antwerp (*Lapidarium Catalogue* 1979, no.
44), with similarly Italianate *putti,* but
certainly by a lesser hand. The closest
comparison for the latter, although much
more simply carved, is a Spanish,
sixteenth-century poplar-wood relief,
illustrated in Beatrice Gilman, *Catalogue of
Sculpture (Sixteenth to Eighteenth Century) in
the Collection of the Hispanic Society of
America*, New York, 1930, p. 89, ill.

The only other clues to origin are
iconographic, as Michael Jaffé pointed out
on acquisition: the prominent five-pointed
star, rather than the more usual six-pointed
one, and the rosary, superfluous to the
iconography of the *Adoration of the Magi,*
yet twined round Joseph's staff, point to a
Dominican commission.

Cleaning and conservation in 1980
showed the head of the Virgin to be neither
original, nor a specially carved replcement.
Perhaps our group had lost its Virgin's
head in the wave of Protestant iconoclasm
which swept the Low Countries in the
1560s, and was later married to a fragment
from a similarly victimised piece.

RAC

Cat. 42 MAR.M. 204-1912

TETRODE, Willem Danielsz van
(ascribed to) Delft?; active Florence
1549, active Cologne 1574; died?

Bacchus. ?1570s

Bronze, cast and chased
H: 50.5cm W: 15.2cm D: 14cm
C. B. Marlay bequest

Ref: *Winter*, no. 51

This heavily cast and extensively
chased bronze, the surface pale and
without artificial patination in
Netherlandish taste, is a free variant after
an Antique marble of a Satyr teasing a
panther with a bunch of grapes. Many
examples of this composition survive, e.g.
see P. P. Bober and R. Rubenstein,
Renaissance Artists and Antique Sculpture,
London 1986, Cat. 73.

The outstretched hand, which in the
marbles grips a vine, here probably held a
cup.

First recorded, already with Marlay, in
the *National Exhibition of Works of Art*,
Leeds, 1868, as "Florentine Cinquecento",
this bronze has been ascribed to a
bewildering variety of hands, ranging from
Giambologna to Johann Gregor van der
Schardt. The only other example now

known, in the Museum für Kunst und
Gewerbe, Hamburg (inv. nr. ST. 183/
1963,38), is still given to Schardt.

In his paper *'Schardt, Tetrode and some
possible sculptural sources for Golzius'*, (in
Netherlandish Mannerism, ed. G. Cavalli-
Bjorkman, Stockholm, 1985, pp. 97-107), A.
F. Radcliffe advances the present
attribution on the basis of technical factors
linking this and the Hamburg bronze to the
Hercules and Antaeus group in the Victoria
and Albert Museum, and thence to a group
of bronzes now divided between the
Bargello and the Uffizi. These are
documented as by Tetrode (known in Italy
as Guglielmo di Daniele Fiammingo), for a
studiolo signorile to the commission of
Gianfrancesco Orsini in the late 1550s.

Tetrode is recorded as working with
Cellini in 1549, and later with Guglielmo
della Porta. After some time spent in
Florence in the 1560s he returned to his
native Delft in 1568, leaving to become
sculptor to the Archbishop-Elector of
Cologne in 1574.

He seems to have left models and moulds
behind: in the 1624 inventory of the Delft
goldsmith Thomas Cruse there are a
number of items by him. Of greatest
interest in the present context is an entry
for "1 Bacchus form, mit 1 form van der
Tiger van Tettero", raising the intriguing
possibility that our Bacchus was originally
complemented by a separately cast panther.

RAC

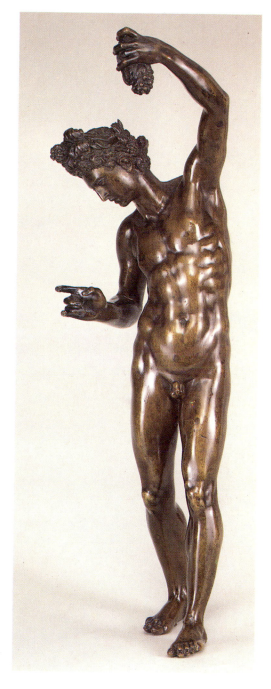

Cat. 43 M. 19-1938

Workshop of NEGROLI, Filippo
Active 1532–45, died after 1551

Parade burgonet in pseudo-Roman style. Mid-16th century

Embossed steel with gilt details
H: 31cm W: 20cm D: 30cm
Gift of the Friends of the Fitzwilliam, with a contribution from the NACF

Coll: *?1st Lord Amherst of Hackney (1835–1909); 'Theatrical junk', sale, 1935; Mr. Jones; Foster's Sale Room, Pall Mall, 1936, to Capt. R. P. Johns; to Mr. J. Hunt, 1937, from whom acquired*

Ref: *FOF* 1938, p. 3, no. 3; *Treasures*, no. 35; *Winter*, no. 49

This proud, if battered, masterpiece in embossed and chased steel is in the form of a burgonet, with pseudo-Roman details, particularly the fall-piece (not a visor, since there are no holes for seeing through!), which imitates the general form of a gladiator's visor, the face modelled as a lion mask. The existing cheek-pieces are old replacements, lacking the extensions to the chin. Also missing is an adjustable brow-plate which, by analogy with similar pieces, may have borne a signature. The skull is adorned on the right with a winged, nude half-figure of Fame, and on the left a similar Victory, each with a skirt of acanthus leaves, from which, triton-like, emerge bifurcated foliage scrolls. The comb, topped with acanthus, is decorated with a band of trophies: musical instruments, guns, armour, shields, ewers, basins and the like. These include, on the right, an open book, false-damascened in gold with the much worn Greek inscription *ΤΑΥ[ΤΑ]ΙΣ Π[Ρ]ΟΣ ΑΣΤ[Ε]ΡΑΣ*, By these things to the stars; the sense being that immortality is born of the fruits of Fame and Victory.

The attribution to the Negroli was first made by C. R. Beard (*'A new found casque by the Negroli'*, Conn. vol. CI, p. 293–9) and supported by C. R. Cripps-Day (*'The greatest armour collector of all time'*, Conn. vol. CXV, pp. 86–93, and vol. CXVI, pp. 22–9).

Despite garbling the reconstruction of the Greek (*op. cit.*, pl. III), Beard correctly associated cat. 43 with a group of helmets adorned with Fame and Victory, and either signed by or attributable to the Negroli, and in particular with a closely similar helm, formerly in the armoury of Ferdinand, Archduke of Austria (1529-95) at Schloss Ambras, now in the Waffensammlung, Kunsthistorisches Museum, Vienna (inv. A 693). It has since the sixteenth century been associated with a round shield, which amongst other inscriptions carries the Greek motto *ΠΡΟΣ ΤΑ ΑΣΤΡΑ ΔΙΑ ΤΑΥΤΑ* (To the stars through these). This also has an abbreviated Latin text, which has been much chewed over; until Beard's time it was thought to indicate the maker Lucio Piccinino. The interpretation given in *Sonderaustellung Karl V* (exh. Vienna, cat., 1958, cat. 90, 91) is that both helm and targe were presented to Karl V by his brother Ferdinand, King of Austria, to commemorate the former's second campaign agaist the Turks in Algeria of 1541. It entered the Schloss Ambras collection around 1565, and the Archduke was twice portrayed with the helm (Cripps-Day, *op. cit.*, pls. V & XVII).

The Negroli link is further reinforced by another Fame/Victory helm which bears the same Greek inscription as cat. 43 (G. F. Laking, *A Record of European Armour and Arms*, vol. IV, p. 42, pl. 143), which in turn closely resembles a signed example in the Real Armería, Madrid (Beard, *op. cit.*, pl. VIII).

The history of the helm in Britain is obscure: Beard asserted that it had "been in England for the better part of a century, if not more" (*op. cit.*, p. 299); and Cripps-Day (*op. cit.*, footnote p. 24) reports the reputed Amherst provenance, although it was not in the Amherst sale at Christie's, 11 December 1908. It then resurfaced in a sale of 'theatrical junk' in about 1935, and was acquired shortly thereafter for the then newly opened Armoury at the Fitzwilliam.

RAC

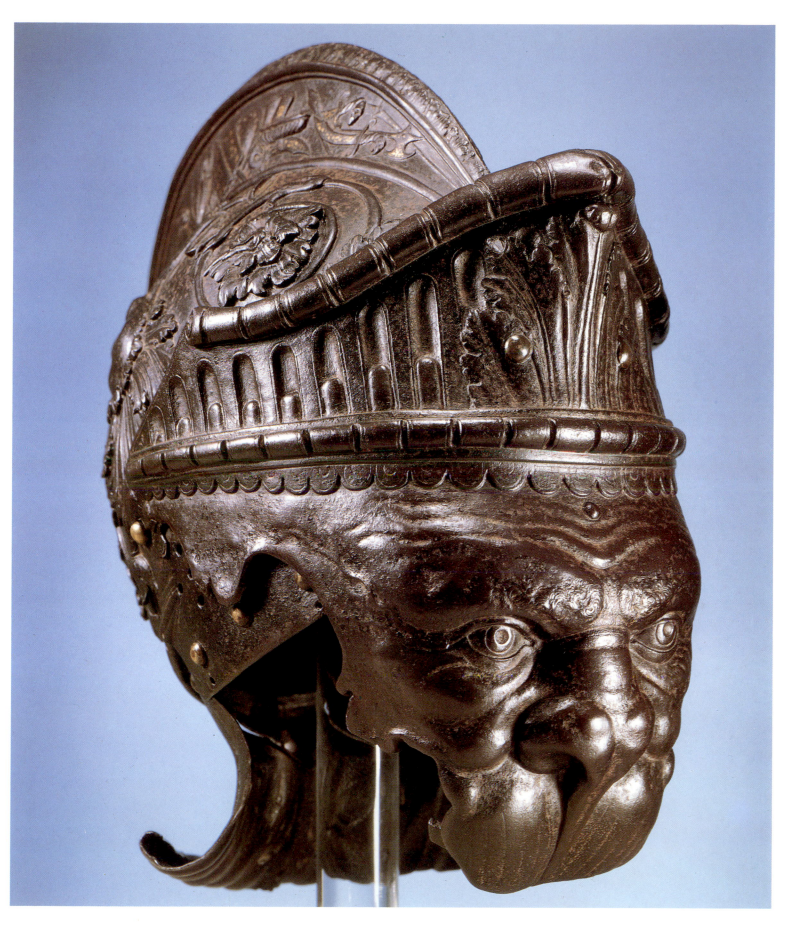

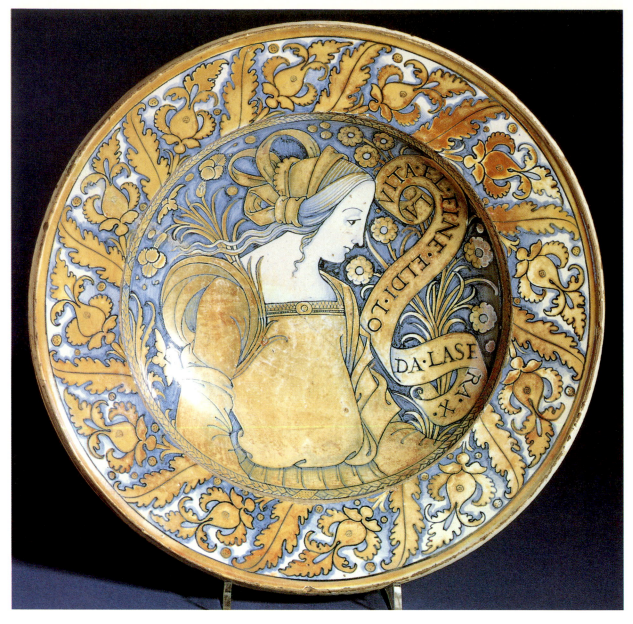

Cat. 44 C. 24-1932

Dish. About 1500-30

Tin-glazed earthenware painted in blue
and silver-yellow lustre
H: 7.5cm Diameter: 39.5cm
Bought from the Glaisher Fund

Coll: *Max Goldschmidt-Rothschild; Kurt
Glogowski; his sale, Sotheby's 8 June 1932, lot
30*

Ref: *Rackham,* vol. I, p. 285, no. 2191, vol. II,
pl. 167

Large decorative *piatti di pompa* were a
speciality of Deruta between about
1500 and 1560. Some were painted in the
restricted palette of high-temperature

colours used by all maiolica potters, others
in cobalt-blue and a distinctive silver-
yellow lustre, which was peculiar to Deruta
ware. This dish is a particularly beautiful
example of the latter, the lustre carefully
applied and giving pale silvery highlights
to the deft and flowing outlines of the
design.

Busts and half-figures of young women,
usually accompanied by a scroll bearing
their name or a quotation, were among the
most popular subjects for the decoration of
these dishes. The representations were
drawn from a group of stock types, and
seem rarely to have been actual portraits.
Deruta potters favoured the chaste, slender
type of feminine beauty depicted by
Pintoricchio and Perugino, and retained
this predilection after the plumper

Raphaelesque type had become
fashionable. The girl on this dish, for
example, is strongly reminiscent of the
Eritrean Sibyl in Perugino's fresco *God the
Father announcing the Salvation* in the
Collegio del Cambio at Perugia, which is
only a short distance from Deruta. The scroll
in front of her is inscribed *LA/VITA.
EL.FINE.ELDI.LO/DA.LASE/RA.X*
("La vita el fin e 'l di loda la sera") "Day by
the evening, life by its end is crowned", a
quotation from Petrarch's *Le Rime,* XXIII,
31. Variants of this occur on other Deruta
dishes: in the Metropolitan Museum of Art
(94.4.320); in the Museo Nazional, Ravenna
(1855.(V.C.168)); and at the Musée
National de la Renaissance at Écouen (Inv.
E.C1.2430).

JEP

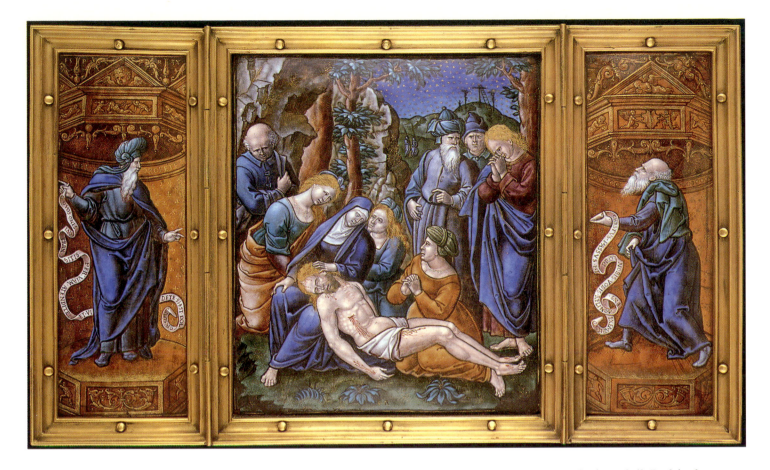

Cat. 45 M. 1-1926

REYMOND, Pierre
Limoges 1513 – about 1584 Limoges

Triptych: The Lamentation, Daniel and St. Peter. 1538

Painted enamel on copper
Initialled: PR
Centre panel: H: 20.3cm W: 17.4cm
Side panels: H: 20.3cm W: 7.8cm
Frame: H: 22.9cm W: 38.7cm
F. Leverton Harris bequest

Coll: *William Beckford; 10th–12th Dukes of Hamilton; J. E. Taylor; F. Leverton Harris*

During the second half of the fifteenth century Limoges enamellers adopted the technique of painting in enamels on copper. This gave them greater freedom to emulate the style of contemporary easel and fresco painting, and to use a more varied palette than had been possible earlier (cat. 24, 25). The increasing availability of illustrated books and prints from the late fifteenth century onwards provided sources of design for classical, biblical and secular subjects.

The central panel of this triptych was based on either the engraving of *The Lamentation* by Marcantonio Raimondo or by Agostino Veneziano after Raphael (*Bartsch,* xiv, 37 & 39). The prophet Daniel on the left wing holds a scroll inscribed *O VOS OMNES QUI TRANSITIS PER VIAM ATENDITE ET VIDETE SI EST DOLOR SIM* (Lamentations 1:12: "O all ye who travel by the road, wait and see if there is such sorrow"). The Apostle on the right wing (probably St. Peter) has one inscribed *CHRISTUS PASSUS EST PRO NOBIS VOBIS RELINQUENS EXEMPLUM* (1 Peter 2:21: "Christ suffered for us, leaving for you an example"). All three panels bear the initials PR for Pierre Reymond; and the left wing is dated *38* for 1538. In his *Walters Art Gallery Catalogue of the Painted Enamels of the Renaissance* (Baltimore, 1967, p. xxiii), Philippe Verdier noted two other triptychs known to have been executed by Reymond in 1538, both for members of the Bourbon family. However, as his *atelier* was extremely prolific, many of the enamels bearing his initials must have been produced by his assistants.

In the late eighteenth or early nineteenth century the triptych came into the possession of one of England's greatest and most eccentric collectors, William Beckford

(1759–1844) of Fonthill. Beckford was passionately interested in Renaissance art, and particularly admired the works of Raphael. When the contents of Fonthill Abbey were offered for sale by Mr. Christie in 1822, the catalogue included as lot 87 on day 1, "An extremely curious enamel on copper, in three divisions, the centre representing the Descent from the Cross, and Daniel and St. Paul in the side compartments, in an ebony frame". Although the description does not coincide precisely with the Fitzwilliam's triptych, it was almost certainly the same. The sale planned for 1822 did not take place; and a year later, when the collection was sold by Phillips, the triptych was not in the catalogue. On Beckford's death, it passed to his son-in-law, Alexander, 10th Duke of Hamilton (1767–1852). In 1862 the 11th Duke lent it to the *Special Exhibition of Works of Art*, no. 1750, at the South Kensington Museum (now the Victoria and Albert Museum). It was eventually sold by the 12th Duke in 1882 (Christie's, Hamilton Palace Sale, lot 971). After further owners, it was bequeathed by F. Leverton Harris, whose medieval and Renaissance *objets d'art* and sculpture greatly enhance the Fitzwilliam's collections.

JEP

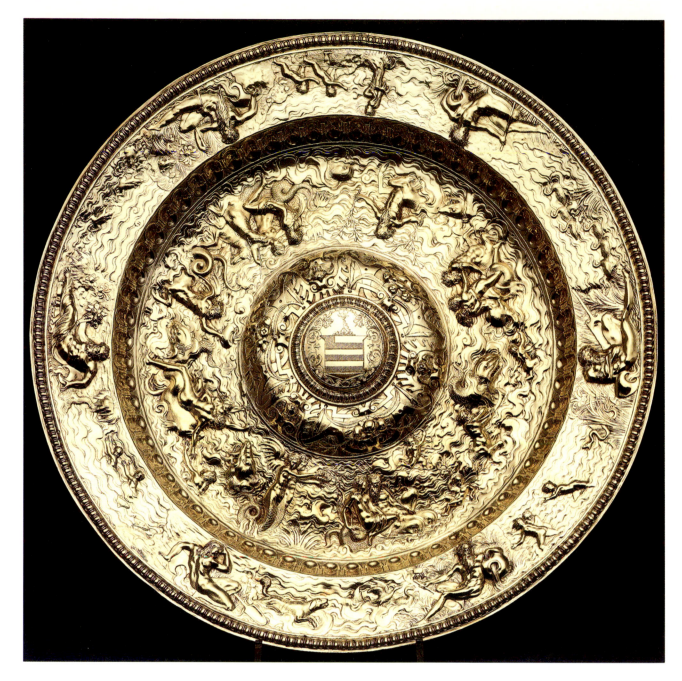

Cat. 46 M/P. 9-1938

Basin. 1560 or 1583

Silver-gilt with embossed, chased and
engraved ornament
Parisian maker's mark with erased letters,
date letter partly erased, probably H
crowned
H: 4.4cm Diameter: 45.5cm
L. D. Cunliffe bequest, 1937

Coll: *Sir Samuel Montagu; Swaythling
collection, sold Christie's 6–7 May 1924, lot 13*

Ref: *Crighton,* p. 32, no. EB2; *Treasures,* no.
42

French goldsmith's work in the
Mannerist style is known almost
entirely from representations in paintings,
drawings and prints, and in the form of
enamelled gold mounts for hardstone
vessels, notably those displayed in the
Gallerie d'Apollon in the Musée du Louvre.
This basin is one of very few extant pieces
wrought entirely in silver. A selection of
the others, including ewers, basins and
tazze are illustrated in the late John
Hayward's *The Virtuoso Goldsmiths and the
Triumph of Mannerism 1540–1620,* 1976, pls.
377–97.

Of all the three-dimensional *objets d'art*
exhibited here, this basin will most repay
close observation. Its central boss is
decorated with strapwork terminating in
scrolls, a common feature of Mannerist
silver deriving from the cartouches which
form part of the decoration of the *Galerie
François I* at Fontainebleau executed during
the 1530s to the designs of Rosso Fiorentino
and Primaticcio. Their immediate
prototype, however, was a design for a
tazza by Jacques Androuet du Cerceau
(1510/15 – about 1584). Another of his *tazza*
designs (John Hayward, *op. cit.,* pl. 104)
provided most of the figures of nereids and
tritons disporting themselves amorously in
the waves of the main field. The remaining
two groups were taken from his *Combat de*

centaures marines. Between the figures the goldsmith has added some extraordinary sea monsters with enormous jaws. On the rim, six river gods reclining on islands are linked by subsidiary subjects: a snake frightening three boys; four frogs; a flotilla of swans; and a hound chasing ducks. The waves undulating over the rest of the surface create an effect of continual metamorphoses, as from a distance the figures seem to emerge from and subside into the shimmering surface.

This watery subject matter, the elongation of the figures and the absence of undecorated areas, are all characteristic of Mannerist taste; but by the standards of the time, the design of the Fitzwilliam basin exhibits remarkable restraint on the part of the goldsmith.

Intricacy and virtuosity of execution appealed greatly to the highly educated and art-conscious patrons of the time, who enjoyed handling their treasures in private, and displayed them ostentatiously to demonstrate in public their power and taste. Ewers and basins, dishes, *tazze* and ornate cups of exotic materials were arranged on tiered buffets at meals, and may never have been intended for use.

The engraved crest and coat-of-arms in the centre of this basin are those of the Fuller family of Hyde House, Great Missenden, and Germans, Buckinghamshire. They were probably added in the early nineteenth century. They also occur on an English silver-gilt ewer of 1583, now in the Victoria and Albert Museum (M.250-1924), with which the Fitzwilliam basin was paired when it belonged to Sir Samuel Montagu during the late nineteenth and early twentieth centuries.

JEP

MUGHAL COIN

Cat. 47 T. 1114–1918

Mughal Empire: Akbar (AD 1556–1605); Āgra (Town) mint. AH 981 (= 1573/4)

Obverse: Arabic/Persian legend, with Kalima (Profession of Faith): **Lā ilāh illā allāh**; **Muḥammad rasūl allāh**; names of the four orthodox caliphs: **Abī Bakr, ʿUmar, ʿUthmān, ʿAlī**; and year **981**.
Reverse: Arabic/Persian legend, with king's name and title: **Jalāl al-Dīn Muḥammad Akbar Pādishāh-i Ghāzī**; benediction ('may his rule be eternal'): **khullida mulkuhu**; and place of minting: **ḍarb-i baladah-i Āgrah**.

Metal and denomination: gold (AV) *miḥrābī*-shaped *muhr* (mohar)

Weight: 10.79gm Diameter: (max.) 34mm (min.) 21mm Axis: 190°

Standard literature
H. N. Wright, *Catalogue of Coins in the Indian Museum Calcutta* III. *Mughal Emperors of India*, Oxford, 1908, no. 70 (same dies).

Judge J. D. Tremlett bequest

Ref: *Treasures*, no. 22

Akbar modelled his coinage on that of Sher Shah, the Sūrī chieftain who displaced his father Humāyūn on the Mughal throne between AH 947 and AH 962 (AD 1540–59). Throughout the first 30 years of Akbar's life the currency shows few changes. In common with most issues in the Muslim tradition, it is at this time non-pictorial. The obverse declares the Muslim Profession of Faith, 'There is no god but God; Muḥammad is the Prophet of God', and lists the names of the four orthodox caliphs; the reverse gives the name of Akbar and his title 'the victorious king', coupled with a benediction (compare the Sasanian issue at cat. 15). Within the types are also included the year of issue reckoned from the Hijra (the flight from Mecca of the prophet Muḥammad in June AD 622) and the place of minting, here Āgra, the town where in AD 1566 Akbar established the capital of his empire. The artist's skill lies in arranging these elements in such a way that the calligraphy achieves an harmonious whole. In the case of the coin shown here, the effect is enhanced by the use of a flan formed in the shape of a prayer-niche (*miḥrāb*). This rare form is known for only three issues in the Mughal series.

TRV

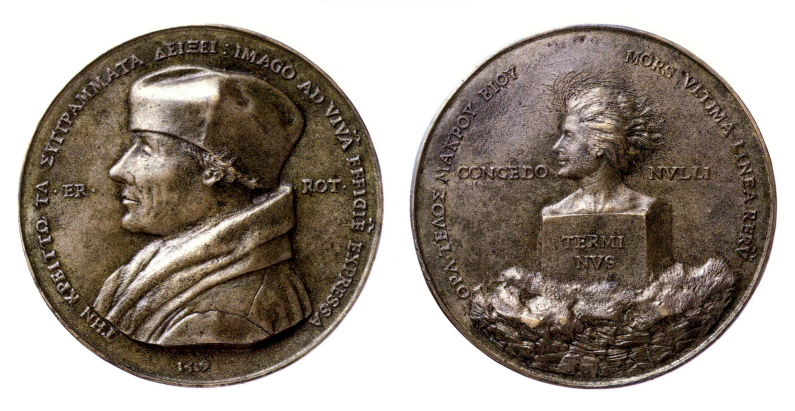

Cat. 48 CM. 28-1979

METSYS, Quentin
Louvain 1464/5–1530 Antwerp

Desiderius Erasmus (1465/6 – 1530).
1519

Bronze
Diameter: 106.6mm
Bought, University Purchase Fund with a
contribution from the Regional Fund
administered by the Victoria and Albert
Museum

Coll: *from Spink's auction no. 2, Zürich, 28
November 1979, lot 280*

Ref: *Ann. Rep.* 1979, pl. XIII; *Treasures*, no.
40

Obverse: *THN KPEITTΩ TA
ΣΥΓΓΡΑΜΜΑΤΑ ΔΕΙΞΕΙ*: (The better
[Image] will my writings show).

IMAGO AD VIVĀ EFFIGIĒ EXPRESSA 1519
(A portrait made from life) across the field,
·ER· ROT·
Bust to the left, wearing a flat cap with a
crown of four points and a coat with fur
collar.
Reverse: *OPA TEΛOΣ MAKPOY BIOY*
(Contemplate the end of a long life)
MORS VLTIMA LINEA RERV (Death is the
ultimate boundary of things): across the
field, *CONCEDO NVLLI* (I yield to none)
A head of Terminus on a stone cube
inscribed *TERMINVS*, rocky foreground.

Quentin Metsys (Matsys, Massys)
became a Master in the Guild at
Antwerp in 1491. He painted a celebrated
double-portrait of Erasmus and Pierre
Gilles which was presented to Sir Thomas
More in October 1517. The medal is
ascribed to Metsys by references to it in the
correspondence of Erasmus with Willibald
Pirkheimer in Nuremberg in 1524. The
symbol of Terminus on the reverse was
adopted by Erasmus to express his desire
to avoid the contemporary political and
theological factions of Europe.

Erasmus, born at Rotterdam and
educated at the University of Paris, became
a famous classical scholar, theologian and
satirist. He produced in 1516 an edition of
the New Testament in Greek, with a Latin
translation. He became even more famous
for his collections of ancient aphorisms, his
imaginary conversations, and his satire.
His life in England between 1510 and 1515
covered a period in Cambridge as Lady
Margaret Professor of Theology, 1511–15.
He was so engaging a personality for
probity, humour and scholarship, that he
enjoyed the intimate friendship of Sir
Thomas More, in whose home he wrote a
contemporary satire, *In Praise of Folly*.

JGP

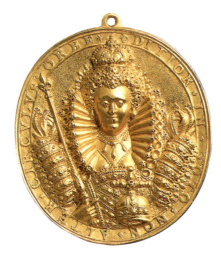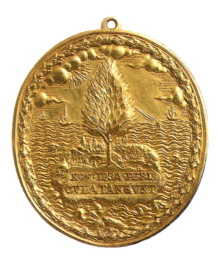

Cat. 49 Given by A. W. Young, 1936

HILLIARD, Nicholas
Exeter 1547 – 1619 London

Dangers averted. About 1589

Gold, cast and chased
H: 60.08mm W: 52.2mm
Given by A. W. Young

Coll: *Charles Butler, his sale, Sotheby's, 3 July 1911, lot 815, bought by donor*

Obverse: DITIOR·IN·TOTO·NON·ALTER· CIRCVLVS·ORBE ("No other circle in the whole world more rich"). A facing bust of the crowned queen, wearing ruff and gown with puffed sleeves, holding a sceptre and an orb. The field is tooled with roses.
Reverse:
NON·IPSA·PERICVLA·TANGVNT· ("Not even dangers affect it"). An island with a bay tree growing on it, set in a stormy sea with ships; a wreath surround.

The medal, attributed to Hilliard (Auerbach, *Nicholas Hilliard*, London, 1961, p. 138; p. 325, cat. 213), represents the new security of the realm after the defeat of the Spanish Armada in 1588. The powerful, hieratic image on the obverse reflects the current notion of the divinity of Queen Elizabeth's rule and is similar to the second Great Seal of the Realm, 1584, and a design for a Great Seal of Ireland, about 1595, both of which were designed by Hilliard. The inscription speaks of its own honour in encircling the effigy of such a queen. The reverse alludes to the belief that the bay tree protected places from lightning and wearers of its leaves from sickness.

JGP

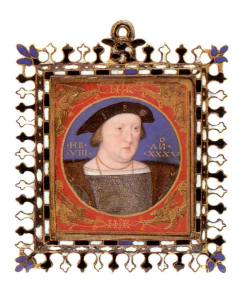

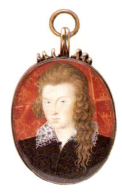

Cat. 50 PD. 19-1949

HORNEBOLTE or HORENBOUT, Lucas
about 1490/5–1544 London

Henry VIII. About 1525-7

Bodycolour on vellum on card
H: 53mm W: 48mm
Inscribed in gold: centre, *HR/VIII*; and
centre right, *A.N/XXXV*; and upper centre
and lower centre, with the initials *HK*
Bought from the Spencer George Perceval
Fund

Coll: *Hollingsworth Magniac (Colworth
collection) ; his sale, Christie's, 4 July 1893, lot
192 [as by Holbein and from the Horace
Walpole collection at Strawberry Hill], where
bought by Colnaghi; the 8th Duke of
Buccleuch, from whom bought*

Ref: *Ann. Rep. 1949, pl. II; Bayne-Powell,
pp. 128-30; Winter, no. 61-1*

This, one of the earliest surviving
portrait miniatures, is of prime
importance in showing the emergence of
the independent portrait miniature from
the illuminated manuscript.

Cat. 50 emerges from the techniques of
the Ghent-Bruges school with which
Hornebolte was associated before he came
to England about 1524. Examination
confirms technical similarities, particularly
in the use of gold for painting the jewels in
small touches over ochre ground; the only
difference is in the quality of parchment,
which is thinner than that used for books.
The censing angels in the four corners are
common in the corners of Flemish books.
They are often, but not exclusively, shown

against a vermilion background (V. J.
Murrell, 'The art of limning, in *Artists of the
Tudor Court*, exh. cat., Victoria and Albert
Museum, 1983, p. 15). Also similar is the
decorative intertwining of the initials of
Henry and Katherine of Aragon in the
borders; close comparison may be made
with the illuminations in a Book of Hours
(fol.8v) in the British Library (Add.
MS.35314) which is attributed to
Hornebolte's studio.

Henry VIII, here shown aged between 35
and 36, was patron of the arts with a keen
awareness of the value as propaganda of
self-imagery. His idea to have his portrait
in miniature is likely to have been derived
from the example of the French court,
following the arrival in England in
December 1526 of a gift to him from
Marguerite, later Queen of Navarre, of two
jewelled lockets containing portraits of
François I and his two sons. The following
summer Henry reciprocated with
miniatures of himself, Katherine of Aragon
and their daughter Princess Mary. Robert
Bayne-Powell (*op. cit.*, p. 130) has argued
from an interpretation of the inscription
Anno XXXV, according to the Tudor
meaning that the sitter has attained the
given age, that the present miniature could
have been painted in the first half of 1527,
after he had seen the French miniatures,
and that it may therefore be the prototype
of the one of the King which was sent to
France.

Two repetitions with variant costume are
in the Royal collection; a third is in the
Buccleuch collection.

The frame is a nineteenth-century
reproduction, enamelled dark blue and
white.

JAM

Cat. 51–3

HILLIARD, Nicholas
Exeter 1547 – 1619 London

Cat. 51 No. 3856

Henry Wriothesley, 3rd Earl of Southampton. 1594

Bodycolour on vellum on playing card,
three hearts on the reverse
Oval; H: 41mm W: 34mm
Inscribed in gold on left of the head: *Anō
Dm 1594*; and, on right: *Etatis suae 20*
L. D. Cunliffe bequest, 1937

Coll: *? C. Sackville Bale; ? J. Whitehead 1889;
L. D. Cunliffe*

Ref: *Bayne-Powell, p. 114, col. pl. III*

A man of refined literary taste, the 3rd
Earl of Southampton (1573–1624) was
the patron of several Elizabethan poets, and
a close acquaintance of Shakespeare.
During the 1590s he was associated with
Robert Devereux, 2nd Earl of Essex.
Imprisoned for his part in the Essex
Rebellion of 1601, he was released and
restored to favour under James I.

This, the earliest known portrait of
Southampton, shows the sitter aged 21, his
hair worn in a 'lovelock' to the side of his
head. The Earl is thought to have initiated
this fashion about 1594, but it was never
followed.

The use of a red curtain to provide a
warm background occurs for the first time
in a portrait miniature. Before then artists
had almost invariably used a plain, cool
blue. In the early 1570s Hilliard had
experimented with the use of light green to
complement the rose tint of flesh in a
miniature of an *Unknown man* (formerly
called a self-portrait) also in the Fitzwilliam
Museum (PD.20-1949, *Bayne-Powell*, p. 110,
col. pl. I). However, the major development
in his style came in the 1590s with his
introduction of the 'wet-in-wet' method of
painting background draperies (V. J.
Murrell, *op. cit.*, cat. 50, p. 16). The
technique involved floating thicker
pigment over a first layer of colour in order
to render areas of shadow. In later
miniatures Hilliard invented a quicker
method of lifting out areas of wet pigment
with a dry brush to create highlights. Apart
from being faster to execute, the technique,
as exemplified in this miniature, allowed a
more subtle distinction of textures and a
more convincing rendering of volume.

Another miniature of Southampton,
painted by Peter Oliver about 1620, is also
in the Fitzwilliam's collection (no. 3873;
Bayne-Powell, p. 170). A full-length by an
unknown English artist of his wife,
Elizabeth Vernon, was acquired by the
Fitzwilliam in 1984 (PD.6-1984).

JAM

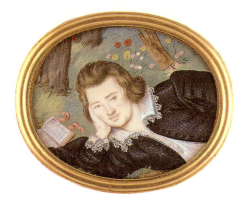

Cat. 52 PD. 3-1953

Henry Percy, 9th Earl of Northumberland. About 1595

Bodycolour on vellum stuck to a playing card with three hearts showing on the reverse
Oval; H: 50mm W: 60mm
Bought from the E. E. Barron Fund with contributions from the Friends of the Fitzwilliam Museum

Coll: *Probably in the possession of Lady Dorothy Percy, who married Robert Sidney, 1st Earl of Leicester, and by descent to the Lords de L'Isle and Dudley; Captain Bertram Currie; his sale, Christie's, 27 March 1953, lot 23, from which bought*

Ref: *Bayne-Powell, pp. 117–18, col. pl. II; FOF 1953, p. 5; Winter, no. 61-4*

Henry Percy, 9th Earl of Northumberland (1564–1632), was a collector of books and patron of men of letters. Known from his interest in science and alchemy as the 'Wizard Earl', he was one of those noblemen around Raleigh, who in the 1590s devoted their time to deep philosophical and mathematical study under the influence of Renaissance humanism. He served under Leicester in the Low Countries in 1585–6, and fought against the Spanish Armada, but was imprisoned for 15 years in the wake of the Gunpowder Plot. Following his release in 1617 he lived in retirement at Petworth in Sussex.

According to Strong, this is one of a series of portraits from the 1590s depicting men in the fashionable attire of the melancholic ('The Elizabethan malady', *Apollo*, vol. LXXIX, April 1964, p. 267). He relates it and the larger version in the Rijksmuseum, Amsterdam, to a passage in George Peale's 'Honour of the Garter', written in celebration of Northumberland's investiture with the Order of the Garter in 1593 (*Artists of the Tudor Court*, exh. cat., Victoria and Albert Museum, 1983, pp. 158–9).

Formerly ascribed to Isaac Oliver, the attribution to Hilliard has in recent years been doubted only by Strong, who considers it to be a half-length copy by Hilliard's pupil Rowland Lockey of the version in the Rijksmuseum (*The English Renaissance Miniature*, exh. cat., Victoria and Albert Museum, 1983, p. 140). However, as Bayne-Powell has pointed out, the superior handling of the sitter's features and clothes, particularly the white shirt, argues for the attribution to Hilliard himself of the Fitzwilliam miniature, as the *ad vivum* likeness on which the Rijksmuseum portrait was based.

JAM

Cat. 53 No. 3898

Unknown woman. About 1595

Bodycolour on vellum, mounted on the back of a playing card (''hearts''), overpainted with brown watercolour
Oval; H: 68mm W: 51mm
Bought with money bequeathed by Mrs. Coppinger Pritchard in memory of her father, Thomas Waraker, LL.D, and with a grant from the NACF, 1942

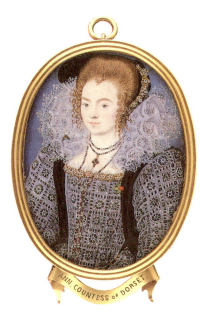

Coll: *J. Whitehead; the 8th Duke of Buccleuch, from whom bought*

Ref: *Bayne-Powell, p. 113, col. pl. I; Winter, no. 61-3.*

The sitter in this, one of Hilliard's most enchanting miniatures, remains unidentified; and the meaning of the device of the berry and leaves, pinned to her dress, is lost. Both former identifications, as the Countess of Dorset and the Countess of Pembroke, are discounted. Anne Clifford, Countess of Dorset, would have been a young girl at the time this portrait was painted. There is no resemblance to known portraits of the earlier Countess of Dorset (about 1580, Knole, Kent), or with the Countess of Pembroke. Bayne-Powell has suggested that she may be a courtier, perhaps one of Queen Elizabeth's maids of honour.

JAM

Cat. 54-6

OLIVER, Isaac
Rouen 1557/67 – 1617 London

Cat. 54 No. 2753

Unknown lady. About 1605

Pen and brown ink over traces of black
chalk on paper
Rectangular; H: 143mm W: 117mm
Verso: black chalk scribbles and sketches of
part of an arm and a hand
Inscribed, perhaps in a 19th-century hand,
Mary Queene of Scotland
Bought from the Marlay Fund, 1946

Coll: *H. E. Backer*

Ref: *Bayne-Powell,* pp. 163–4, repr.

The status of this drawing is uncertain.
Nobody has endorsed Van Regteren-
Altena's suggestion that it is a copy of the
original by the Dutch artist Mathijs van
den Bergh (about 1617–87). Bayne-Powell
(*op. cit.,* p. 163) has pointed to the small,
but significant, differences in the head-
dress and the angle of the head as evidence
of the drawing's preparatory status. He
endorses Strong's view that a copyist
would have been more likely to reproduce
the circular form of the original. More
recently Graham Reynolds has argued that
the rejuvenation of the sitter's features and
the precise copying of the outline of the
costume show all the characteristics of a
later rendering of an existing painting
(*Apollo,* November 1985, p. 402).

 The drawing may have been intended as
a study for pose and costume, not *ad vivum*
(John Woodward, *Tudor and Stuart
Drawings,* London, 1949, p. 19).

 JAM

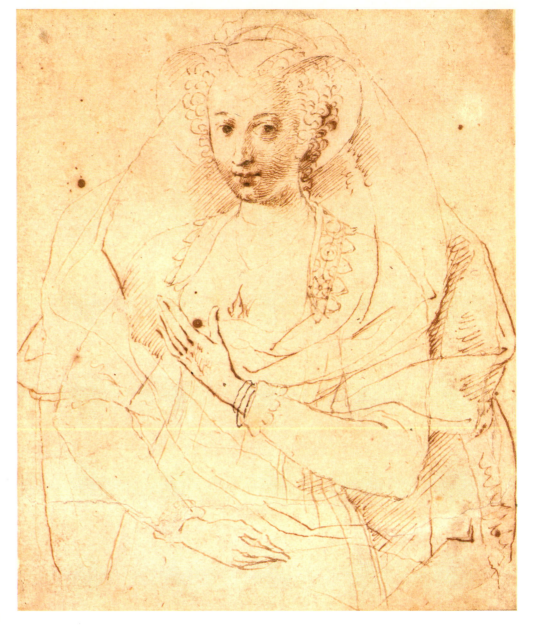

Cat. 55 No. 3902

Unknown lady. About 1605

Bodycolour and watercolour on card
Signed: with initials in gold, lower left: *I.O.*
Circular; diameter 120mm
Bought with money bequeathed by Mrs.
Coppinger Prichard in memory of her
father, Thomas Waraker, LL.D, and with a
grant from the NACF, 1942

Coll: *8th Duke of Buccleuch, from whom
bought*

Ref: *Bayne-Powell,* pp. 164–5, col. pl. II;
Winter, no. 61-6

This is one of Oliver's most impressive
portraits. The sitter is boldly presented,
full face and three-quarter length, her
penetrating glance framed by the heart-
shaped curves of her bonnet and by her
tightly curled hair. The handling of detail,
in particular the lace, the embroidery and
the jewellery, is exquisite, although sadly
much of the original scintillating effect of
the last has been lost due to the oxidisation
of the silver.

 The strongly Mannerist composition
reflects the impact of Oliver's visit to Italy
in 1596. The position of the hand on the
bosom, and the use of the billowing gauze
veil to augment the sitter's personality,

may be compared with a miniature of
about 1595–1600, also of an unknown lady,
in the Victoria and Albert Museum (P.12-
1971) which Strong (*op. cit.* cat. 52, p. 166)
has related to Veronese's portrait of an
Unknown lady of 1560 in the Musée du
Louvre. As he observes, the circular format
was inspired by the Renaissance tondo.

 The sitter's identity remains unresolved.
Strong (*op. cit.* cat. 52, pp. 183, 185) follows
the traditional identification as Lucy
Harrington, Countess of Bedford and
suggests a date of about 1615 on grounds of
costume. Bayne-Powell, arguing that her
coiffure would have been outdated by
1614–15 (hardly acceptable in the case of

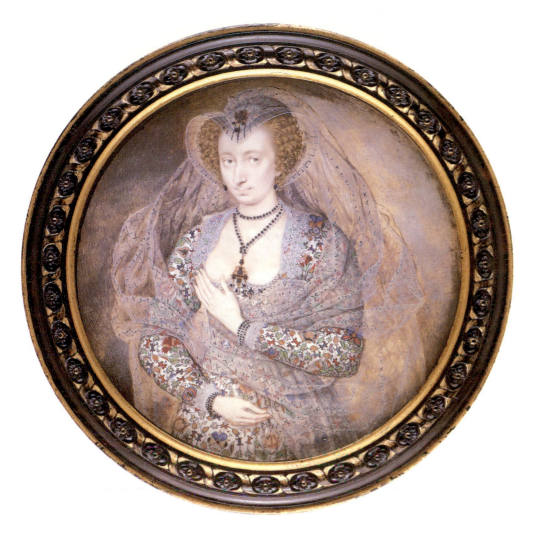

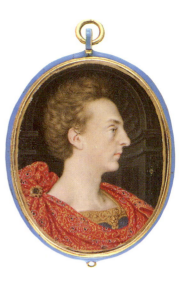

one of England's most avant-garde court ladies), suggests a date about 1605. He points to the lack of physical resemblance to *Lady Bedford in masquing dress,* a portrait of 1606 at Woburn Abbey.

Oliver's preparatory drawing for this miniature is also included in this exhibition (cat. 54).

JAM

Cat. 56 No. 3903

Henry Frederick, Prince of Wales 1594-1612. About 1610-11

Watercolour on vellum on card

Signed, with initials in monogram in gold, centre right: *I.O*
Oval; H: 48mm W: 37mm
Bought from money bequeathed by Mrs. Coppinger Prichard in memory of her father Thomas Waraker, LL.D, and with a grant from the NACF, 1942

Coll: *King Charles I; the 8th Duke of Buccleuch, from whom bought*

Ref: *Bayne-Powell,* pp. 166–7, col. pl. III; *Winter,* no. 61-7

Prince Henry is shown in profile, *à l'antique,* against a classical shell niche. This was a very popular representation of the Prince, and its allusion to the Roman

imperator or classical warrior-hero type reflects the cosmopolitan sophistication of the Stuart court under the Prince and his mother Anne of Denmark.

Oliver entered these charmed circles as "painter for the Art of Limning" to the Queen in June 1605. From 1610 he became limner, subsequently painter, to Prince Henry. This is his earliest known portrait of the Prince, painted about 1610–11. Strong (*op. cit.* cat. 52, p. 173) has argued convincingly that the classical references represent the direct expression of Inigo Jones's presentation of the Prince in Ben Jonson's masques *The Barrier* (1610) and *The Masque of Oberon* (1611). He compares Jones's design for a head-dress for the Prince garlanded with laurels (*op. cit.* cat. 52, fig. 225), and he cites Jonson's description of the Prince in the Barriers, his first public exercise of arms, as, "like Mars . . . in his armour clad".

Bayne-Powell considers this the prime version. Replicas are in the Victoria and Albert Museum (Salting bequest P.149 – 1910), the National Portrait Gallery (no. 1572) and the Mauritshuis (Rijksmuseum no. A.4351).

Henry Frederick died of typhoid fever in 1612, aged 18. He was succeeded as Prince of Wales by his younger brother, later King Charles I of England, who is thought to have been the first owner of this miniature.

JAM

Cat. 57 PD. 3-1979

CARPACCIO, Vittore
Venice 1455/65 – 1525/6 ? Capo d'Istria

Two groups of ecclesiastics, facing one another. About 1500

Pen and brown ink over red chalk on paper
Irregular; H: 214mm W: 278mm
Inscribed, lower right: *9.29; 10*

Accepted by Her Majesty's Treasury in lieu of estate duty and allocated, at the request of Mrs. Colville, to the Fitzwilliam Museum

Coll: *Padre Sebastiano Resta; Giovanni Matteo Marchetti, Bishop of Arezzo; Cavaliere Marchetti da Pistoia, sold through John Talman in 1716 to John, Lord Somers (L. 2981); Thomas Hudson (L. 2432); Sir Joshua Reynolds (L. 2364); Thomas Banks (L. 2423);*

?Mrs Lavinia Forster; ?Ambrose Poynter; Sir Edward John Poynter (L. 894), his sale, Sotheby's, 24–8 April 1918, lot 23; Viscount Lascelles; by descent to his son; his sale, as Earl of Harewood, Christie's 6 July 1965, lot 118; Captain Norman Colville; his widow

Ref: *Ann. Rep.* 1979, pl. X

Borenius published this sheet of drawings in 1916 as two separate studies by Carpaccio, altered later, for the *Obsequies of St. Jerome* of 1502 in the Scuola di San Giorgio degli Schiavoni, Venice ('Two unpublished North Italian drawings', *Burl. Mag.* XXIX, 1916, p. 271); and he so recommended it to Lord Lascelles. Subsequent authorities doubted the connection with the painting (A. E. Popham, 'Vittorio Carpaccio, The Death of St. Jerome', *Old Master Drawings,* 1935,

p. 11; R. van Marle, *The Italian Schools of Painting*, The Hague, 1936, vol. XVIII, p. 344). As Popham observed, the different levels on which the figures are standing and the fact that the acolytes holding the censer and the aspergillum appear on different sides of the officiant would appear to confirm that this is not a single integrated composition. The Tietzes even removed the work from Carpaccio's corpus, attributing the sheet unconvincingly to Lazzaro Bastiani (H. Tietze and E. Tietze-Conrat, *The Drawings of the Venetian Painters of the 15th and 16th Centuries*, New York, 1944, p. 61, no. 254 and p. 153, no. 167A(ii)).

While the drawing is characteristic of Carpaccio's angular style around 1500, the connection with the painting in the Scuola di San Giorgio remains hypothetical.

JAM

Cat. 58 PD. 404-1963

HEEMSKERCK, Maerten van
Heemskerck 1498 – 1574 Haarlem

**"Neither shalt thou covet thy
neighbour's house".** 1566

Pen and brown ink on paper, incised for
transfer
Signed and dated, lower left: *Martijn van
Heemskerck inventor/1566*
H: 196mm W: 250mm
Bequeathed by Sir Bruce Ingram

Coll: *Sir Anthony Westcombe; Dr. Bayley;
Kaye Dowland, 1869; Ingram (L. 1405a); with*

Messrs. Colnaghi, 1949, from whom bought

Heemskerck worked as a painter and
as a designer of stained glass, but his
most impressive work was as a print-
maker. He produced drawings for series of
prints illustrating biblical scenes, the lives
of saints and theological and moral
allegories. He began by doing himself the
work of engraving, but handed over to a
team of assistants as the volume of his
practice increased.

This drawing, incised for transfer, is a
model for the last in the series of
engravings by Herman Jansz. Muller (about
1540–1617) illustrating *The Ten*

Commandments (Hollstein XIV, 17 – 26). The
print bears the legend, in Latin, from
Deuteronomy V: 21: "Neither shalt thou
covet thy neighbour's house, his field, or
his manservant, or his maidservant, his ox,
or his ass or any *thing* that *is* thy
neighbour's."

To ease the translation from drawing to
print Heemskerck worked the composition
to a highly finished state, using fine,
regular pen hatchings which closely
approximate the technique of the engraver.
A self-portrait, dated 1553, showing the
artist in Rome in front of the Colosseum, is
also in the Fitzwilliam Museum (No. 103).

JAM

Cat. 59 No. 3128

CESARE, Giuseppe, called IL
CAVALIERE D'ARPINO
Arpino ?1568 – 1640 Rome

**A group of standing and seated
figures.** About 1588

Red chalk
H: 280mm W: 210mm
Bequeathed by Rev. E. Kerrich, 1872

Coll: *? J. Richardson Snr.; A. C. de Poggi, his
sale, Christie's 20 April 1791; Rev. Thomas
Kerrich; testator*

Giuseppe Cesare, dubbed cavaliere di
Cristo by Pope Clement VIII, enjoyed
a meteoric rise to fame. He arrived in Rome
in 1582, where he began to work in the
logge of the Vatican under the direction of
Nicolò Circignani (1519 – after 1591). In the
following year he was occupied with the
decoration of the Sala Vecchia degli
Svizzeri and the Sala dei Palafrenieri. He
received his first major public commission
aged 20 from Cardinal Alessandro Farnese
for two frescoes illustrating the life of St.
Lawrence in the nave of San Lorenzo in
Damaso in Rome.

This drawing, attributed in the Kerrich
collection to Rosso, and subsequently to
Bellange, was correctly attributed by Philip
Pouncey. H. Röttgen (*Il Cavaliere d'Arpino*,
Rome, Palazzo Venezia, 1973, no. 72) has
suggested that it is a study for the group of
officials of state on the left of the fresco of
St. Lawrence among the poor and the sick,
which, together with the other fresco
painted for San Lorenzo, *Saint Lawrence
accompanying Saint Sixtus to martyrdom,* was
destroyed in the nineteenth century. A
bozzetto of the composition is with E. V.
Thaw and Co. Inc., New York; a later copy
is in the collection of Prince Boncompagni
Ludovisi, Rome.

The Rev. Thomas Kerrich (1748–1828),
Librarian of the University of Cambridge,
wrote an important early catalogue of the
prints of Maerten van Heemskerck (*q.v.* cat.
58), published posthumously in 1829. On
his death his magnificent collection of
prints and drawings by the old masters
passed to his son the Rev. R. E. Kerrich,
who in 1872 bequeathed them, together
with six Dutch paintings and eight oil
sketches by Rubens, to the Fitzwilliam.

JAM

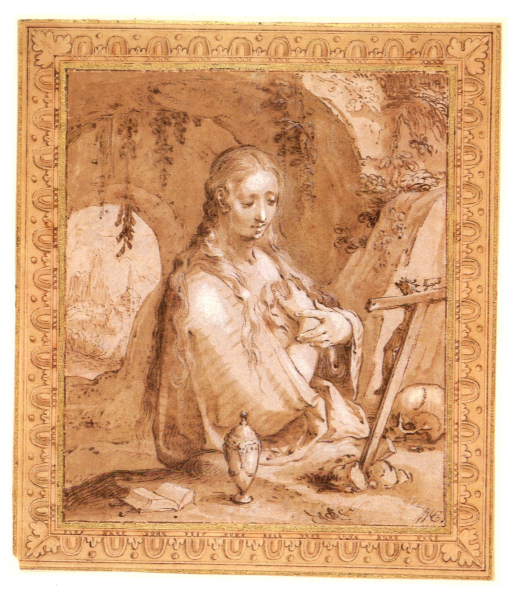

Cat. 60 PD. 164-1963

GOLTZIUS, Hendrik
Muhlbrecht (Limbourg) 1558 – 1617
Haarlem

The Penitent Magdalen. About 1590–1

Pen, brown ink, brown wash, heightened
with white on buff-tinted paper, framed
with four lines in pen and brown ink.
Incised for transfer and mounted on an
?18th-century board
H: 195mm W: 170mm
Bequeathed by Sir Bruce Ingram

Coll: *Sir Gregory Osborne Page Turner, his
sale, ?Christie's 18 November, 1824 lot 150;
William Esdaile (L. 2617), his sale, Christie's
June 1840 (with two others) lot 591, bought
Tiffin; Binden Blood (L. 3011); Miss Geaves
1937; with P. & D. Colnaghi; bought testator
(L. 1405a), 2 December 1936*

Bequeathed with 969 other Dutch
Flemish and English drawings from the
Ingram collection, this drawing was then
attributed to the Flemish Mannerist painter
Abraham Bloemaert. The attribution to
Goltzius was made by David Scrase, who
compared it with a drawing in the
Staatsgalerie, Stuttgart (Inv. no. 1697),
clearly annotated as being after the
engraving by Jacob Matham, after Goltzius
(*Bartsch* 114). ('A drawing by Hendrick
Goltzius', *Master Drawings,* vol. 16, no. 4,
1978, pp. 397–8.)

Goltzius was one of the most renowned
draughtsmen and engravers of his day.
More than any of his contemporaries he
was responsible for the familiarisation of
the Italian sense of *disegno* in the
Netherlands. His first exposure to Italianate
art was probably gained while still an
apprentice to his father in Duisburg, where
he became familiar with the work of Frans

Floris (1516/20–1570) and Maerten van
Heemskerck (cat. 58). From about 1588,
while he was in close contact with Carel
van Mander and Cornelis Cornelisz. van
Haarlem, he developed a particular affinity
with Bartolomeus Spranger, whose
drawings he frequently engraved (E. E. J.
Reznicek, *Hendrick Goltzius Zeichnungen,*
Utrecht, 1961, K. 82).

The precise dating of this sheet is
uncertain, but both the composition and
the assured handling of human anatomy
place it after his journey to Italy in 1590–1.
David Scrase (*op. cit.,* p. 397) has drawn
attention to stylistic similarities with a
drawing of *Fides* in Copenhagen, dated
1592, and with a drawing of the *Holy
Family* (Reznicek K. 50), both of which were
engraved by Matham.

JAM

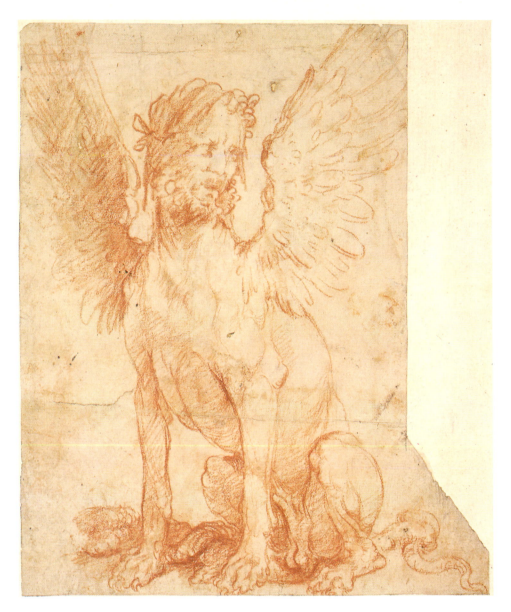

Cat. 61–2

CARRACCI, Annibale
Bologna 1560 – 1609 Rome

Cat. 61 No. 2083A

A Male Sphinx. About 1595-6

Verso: Study for *Hercules bearing the globe*,
brush, grey wash, and scribbled line in red
chalk
Red chalk on paper, cut at top and along
right-hand side
Irregular; H: 221mm W: 181mm
C. H. Shannon bequest, 1937

Coll: *Ricketts and Shannon*

This sheet was attributed in the
Ricketts and Shannon collection to

Domenichino. A. E. Popham in 1955
associated the recto with Correggio's
design for the cupola of Parma Cathedral.
The correct attribution to Annibale Carracci
was made in 1984 by Michael Jaffé, who
identified both sides of the sheet as studies
for the ceiling decoration in the Camerino
Farnese, Annibale's first major Roman
commission, about 1595–6 ('A drawing by
Annibale', *Burl. Mag.*, vol. CXXVII,
November 1985, p. 776). The recto shows a
preliminary idea for the sphinx in the
fresco of *Hercules resting* (John Rupert
Martin, *The Farnese Gallery*, Princeton,
1965, fig. 11), although in the painting the
sphinx is shown in profile, and not full-
front, as the drawing implies. Comparison
with the study of a dog for the fresco of
Mercury and Paris, now in the Musée des
Beaux-Arts, Besançon (Martin, *op. cit.*, no.

101, verso, pl. 187), shows a similar
muscular treatment in the chest and
forepaws, while the bearded face is close to
a black-chalk study, also at Besançon, for
one of the two atlas herms on the right of
the fresco of *Polyphemus and Acis* in the
Galleria Farnese (Martin, *op. cit.*, no. 119,
fig. 234). As Jaffé has pointed out, the
tempered classicism evident in the drawing
of the animal evinces Annibale's attempt to
accord his style with the taste of Rome.

The grey-wash study for *Hercules bearing
the globe* on the verso is one of many
drawings which survive for this fresco.
Martin (*op. cit.*, pp. 180–3) has discussed in
some detail Annibale's difficulties in
establishing a pose which conveyed the
straining of the body under the weight of
the globe.

JAM

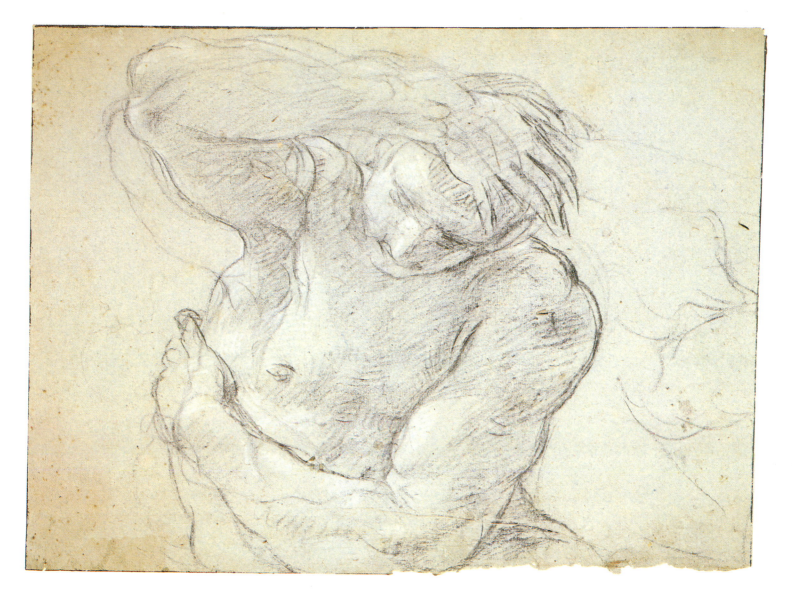

Cat. 62 No. 3131

Study of the head and torso of a man, his right hand on his head, his left clasped round his body. About 1595–6

Verso: study of a seated, draped, male nude, turned to left
Black chalk on blue paper, heightened with white, old tear lower right, laid down
Irregular: H: 276mm W: 367mm
Given by A. A. Van Sittart, 1876

The old attribution of this sheet to Andrea Sabatini (about 1484–1530) was rejected in 1939 by Otto Benesch, the first to associate the sheet with the Carracci. A tentative attribution to Agostino by Jacob Bean and to Guido Reni by Philip Pouncey have proved less convincing than Michael Jaffé's suggestion that the drawing was executed by Annibale during his Bolognese period.

No precise correlation can be made with extant figures in Annibale's work, but the recumbent posture bears comparison with that of one of Medusa's two sisters in *Perseus slaying Medusa* in the Camerino Farnese, Rome (repr. D. Posner, *Annibale Carracci*, 1971, vol. II, pl. 92h). The treatment of the hands and shifting outline is also paralleled in the drawing of Polyphemus for the fresco of *Polyphemus and Galatea* on the end vault of the Galleria in the Musée du Louvre (Inv. 7196; repr. J. R. Martin, *op. cit.* cat. 61, fig. 197). Posner has observed at length (*op. cit.,* vol. I, pp. 79 ff.) that the style which Annibale formed in Bologna did not change until the completion of his first Roman commission; if this sheet is indeed a preliminary idea for the fresco, this would suggest a date of late 1595 or early 1596, shortly after Annibale had moved to Rome.

JAM

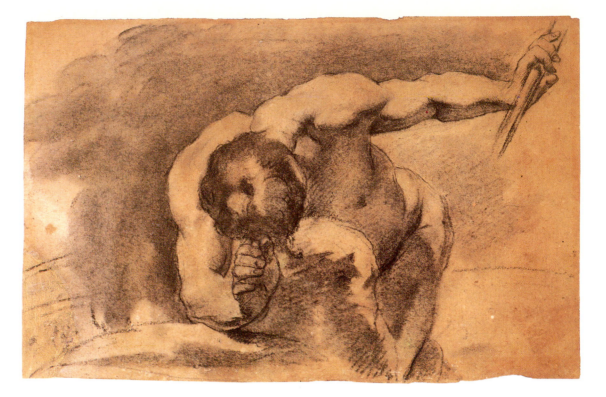

Cat. 63 PD. 118-1985

FACCINI, Pietro
Bologna about 1562 – 1602 Bologna

**Study of a male nude, leaning
forward, holding a staff.** After 1595

Black chalk on paper
Numbered, verso, in pencil, *B154A*
H: 279mm W: 421mm
Bought from the Biffen Fund

Coll: *Kate Ganz, from whom bought*

Ref: *Ann. Rep.* 1985, pl. III

Faccini's interest in drawing from the
nude has been noted by many authors.

Malvasia records his debt as a draftsman to
Annibale Carracci (*q.v.* cat. 61, 62), and
observes that "e quindi è che persuaso dal
suddetto, tanto disegno dal nudo, che
infiniti si vedano di que' suoi modelli in
tutte le piu famose raccolte" ('he made so
many drawings from the nude, that large
numbers of these were to be found in all
the most famous collections'), (*Felsina
pittrice*, Bologna, 1841 edn., vol. I, p. 398).

The deliberate anatomical distortions and
dramatic effects of light and shadow in this
sheet are characteristic of Faccini's life
studies. Similar sheets are in the Berlin
Kupferstichkabinett, in the Uffizi, and in
the Teyler Museum, Haarlem. The last
shows the torso treated in the same staccato
manner. B. W. Meijer and C. van Tuyll
(*Disegni Italiani del Teylers Museum Haarlem*,
Florence and Rome, 1983-4, cat. 50,
pp. 122–3), argue a date subsequent to a
possible journey made to Venice in 1595
(proposed by F. Arcangeli, *Maestri della
pittura del Seicento Emiliano*, exh. cat.,
Bologna, 1959, p. 60).

Mario di Giampaolo, whose monograph
on Faccini is forthcoming, has doubted the
attribution of both the Fitzwilliam and the
Teylers sheets. If not by Faccini the
drawing is certainly by an artist influenced
by him. The morphology is close to that in
paintings by Francesco Naselli (d. about
1630) (see E. Riccomini, *Il Seicento Ferrarese*,
Bologna, 1969, pl. 7a).

JAM

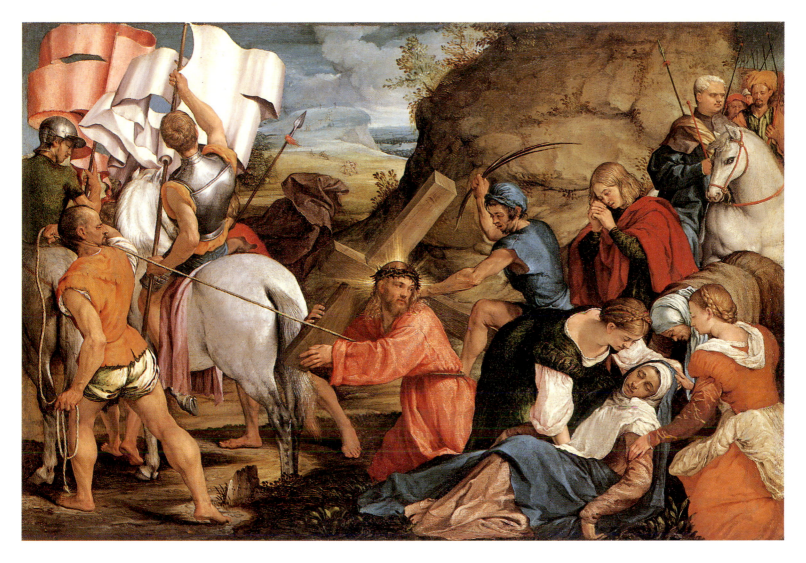

Cat. 64 M.6

DA PONTE, Jacopo, called BASSANO
Bassano about 1510 – 1592 Venice

The Journey to Calvary. About 1540

Oil on canvas
H: 80.7cm W: 118.3cm
C. B. Marlay bequest, 1912

Coll: *Peter Norton (1857); testator (by 1906)*

Ref: *Paintings II*, pp. 11–12

Native to Bassano in the Veneto, Jacopo based his earliest style on the works of Titian and of Bonifazio de' Pitati which he saw in Venice. This painting, showing his development away from that style, may be contemporary with the *Adoration of the Magi* (National Gallery of Scotland, Edinburgh, no. 100), or slightly later, when he was incorporating elements of Central Italian *maniera* into his work through his knowledge of prints. In this case both the scheme of the composition and specific figures derive from Raphael's ''Lo Spasimo di Sicilia'' (Prado, Madrid, no. 298), which Jacopo probably knew through Agostino Veneziano's engraving of 1517. The figure on the left pulling the rope is particularly close to Raphael, and is characteristic of the artificial proportions and torsion which started to pervade Jacopo's work. The group of mourning women may have come from another source, perhaps a Crucifixion or Deposition. There has been disagreement about the extent to which Parmigianino's influence is evident in the Fitzwilliam picture. The influence is certainly more apparent in later paintings of the 1540s, such as the *Rest on the flight to Egypt* (Ambrosiana, Milan, no. 40) or the *Christ on the way to Calvary* (National Gallery, London, no. 6490), which shows a further reworking of Raphael's ''Lo Spasimo'' on still more Mannerist terms.

Notwithstanding these influences, Jacopo's paintings always show the sheer pleasure in paint, colour, and the depiction of nature, so typical of Venetian art.

CH

Cat. 65 No. 914

TIZIANO VECELLIO, called Titian
Pieve di Cadore, about 1480/85 – 1576
Venice

Tarquin and Lucretia. About 1568–1571

Oil on canvas
Signed: *TITIANVS – F*
H: 182cm W: 140cm; reduced on all sides
Given by C. Fairfax Murray, 1918

Coll: *Philip II of Spain (1571); Spanish Royal
collections; taken by Joseph Bonaparte on his
flight from the Spanish throne (1813);
"distinguished Foreign Nobleman" (J.
Bonaparte), sale Christie's 24 May 1845, lot 71
bought in; C. J. Nieuwenhuys; William
Coningham sale, Christie's 9 June 1849, lot 57
bought in; John, 2nd Lord Northwick; his sale,
Phillips, Thirlestane House, Cheltenham, 29
July 1859, lot 1001, acquired Nieuwenhuys;
Charles Scarisbrick; anonymous sale (C. J.
Nieuwenhuys), Christie's 17 July 1886, lot 53,
acquired Charles Fairfax Murray; Charles
Butler (decd.) sale, Christie's 25 May 1911, lot
91, acquired Agnew & Sons Ltd; resold to
donor*

Ref: *Paintings II*, pp. 171–5; *Winter*, no. 53

Painted entirely by Titian for his
greatest patron and delivered in 1571.
The subject (Livy, *History of Rome*, I) shows
Sextus Tarquinius compelling Lucretia,
wife of Tarquinius Collatinus, to submit to
his desires by threatening to kill her and
then to cut the throat of a slave to make it
appear that they had been caught in
adultery. In 1520 Titian had depicted
Lucretia's consequent suicide (Royal
Collections, London). His choice, for Philip,

of the rape scene was probably influenced
by transalpine prints which would have
been readily available to him in Venice.
Two engravings by Aldegrever show the
rape scene in a claustrophobic bed-
chamber: in the 1539 version, after George
Pencz, Tarquinius seizes Lucretia by her
upstretched arm; in the 1553 version,
bedroom slippers litter the foreground. A
print by the Fontainebleau etcher, Master
L. D. (his last dated prints are of 1547),
anticipates Titian's composition in several
ways: Tarquinius, fully clothed, thrusts one
knee upon the sheet and brandishes a
dagger above Lucretia's head; a servant,
dressed and hatted, lifts the folds of the
parted bed-curtains. Moreover, the etching
shows the platform of the bed which is to
be seen in Cornelis Cort's 1571 engraving
after the Titian, and which was presumably
trimmed from the lower edge of the
painting.

X-radiographs reveal how Titian
originally conceived the stabbing as an
upward action, as in another version of
Tarquin and Lucretia, effectively a workshop
production (Musée des Beaux Arts,
Bordeaux). The more effective downward
stab is also seen in Titian's variant in 'dead
colour' (Vienna, Akademie der Bildenden
Künste). Titian described the painting as
'an invention involving greater labour and
artifice than anything, perhaps, that I have
produced for many years'. The stormy
energy of the draughtmanship (particularly
evident in x-rays), the vigorous handling of
paint and the expressive use of colour, are
all hallmarks of Titian's remarkable late
style. (For a full discussion, see Michael
Jaffé and Karen Groen, 'Titian's "Tarquin
and Lucretia" in the Fitzwilliam', *Burl.
Mag.*, CXXIX March 1987, pp. 162–72.)

CH

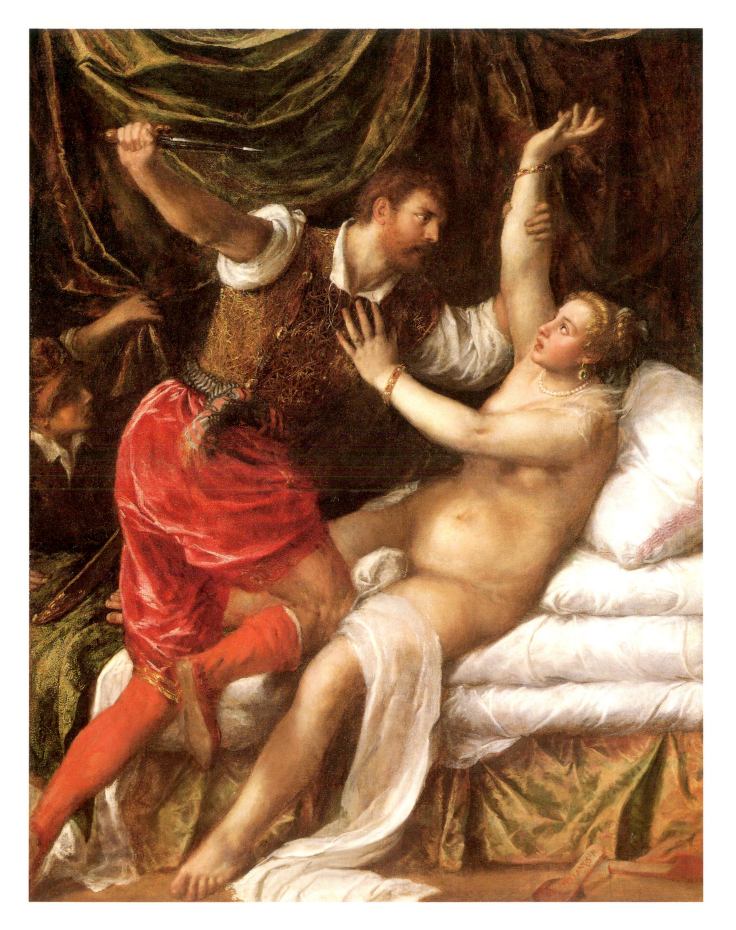

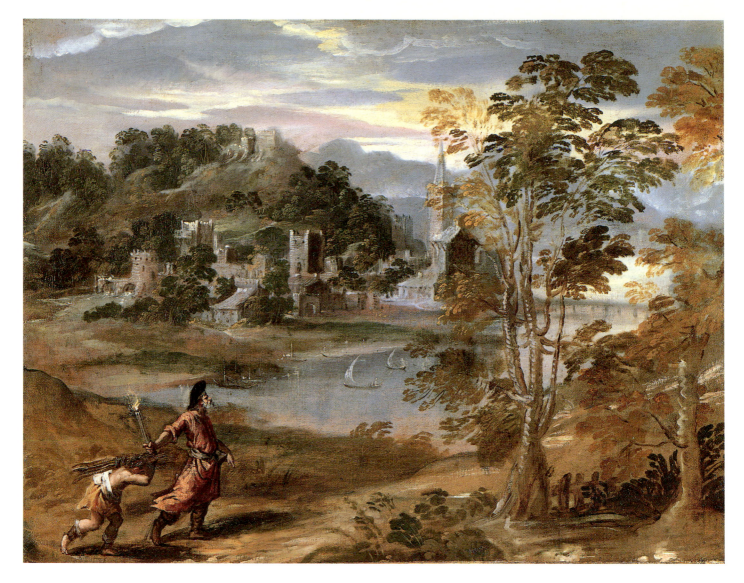

Cat. 66 No. 113

SCARSELLA, Ippolito, called SCARSELLINO
Ferrara 1550 – 1620 Ferrara

Landscape with Abraham and Isaac.
About 1590–5

Oil on canvas
H: 58.4cm W: 74.8cm
Edward FitzGerald bequest, 1883

Coll: *Mr. Stodart; Edward FitzGerald (by 1847)*

Ref: *Paintings II*, pp. 171–75

Considered by FitzGerald as a work by Titian, and subsequently catalogued as 'School of Jacopo Bassano' until it was ascribed to Scarsellino by Bernard Berenson in 1909. Scarsellino was son of the painter Sigismondo Scarsella and went to Venice around 1570, where he probably worked in the studio of Veronese before returning to his native Ferrara. The influence of Venetian art is here apparent: the figures, the composite, but recognisably North Italian landscape, the colouring, and the brushwork, reflect the examples of Titian, Tintoretto and Bassano. Scarsellino may also have been aware of the work of the Carracci in Bologna, particularly the landscape frescoes in the Palazzo Magnani of 1587 which have affinities with cat. 66 and with the two landscapes with biblical scenes by Scarsellino in the Pinacoteca Nazionale, Naples (nos. 1499 and 1500; see M. A. Novelli, *Lo Scarsellino*, Bologna, 1955, pp. 25–8).

Scarsellino can be seen as a transitional figure between Renaissance and Baroque, but his art is most remarkable for its strongly individual sensibility. Although he painted large altarpieces, his fame rests on intimate pictures such as this, highly lyrical in colouring and sensuous in handling. They were painted for the cabinets of private patrons in Ferrara whose taste for poetic landscapes had been served earlier by Dosso Dossi (1479–1542). The element of fantasy in Scarsellino's landscapes probably derives from this tradition. After about 1590, when the Counter-Reformation took hold in Ferrara, such landscapes tended to be peopled by biblical rather than mythological figures, but the subject remained essentially landscape. Even Scarsellino's major church commission, the fresco in the apse of San Paolo in Ferrara (1595–6), has the air of one of his cabinet landscapes writ large. The extreme looseness of handling of the tree on the right suggests that this may have been a *modello* for a larger painting in fresco.

CH

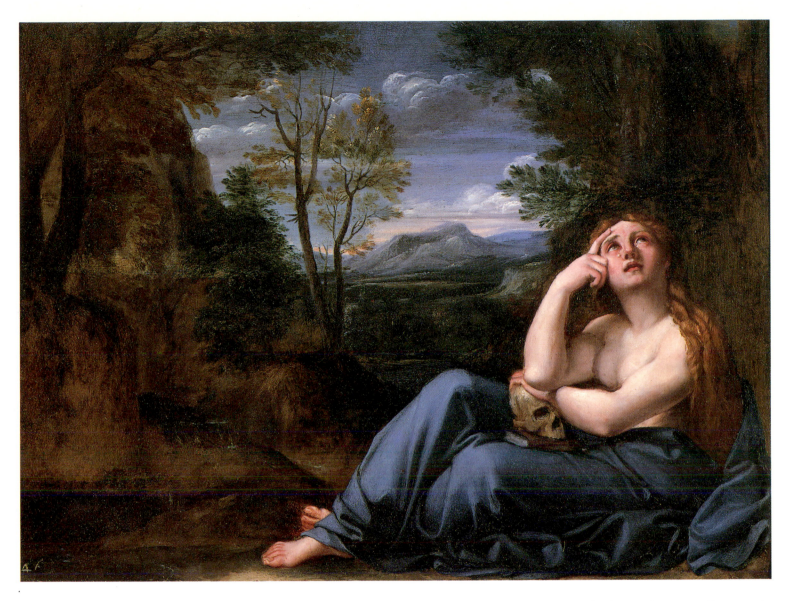

Cat. 67

PD. 12-1976

CARRACCI, Annibale
Bologna 1560 – 1609 Rome

**The penitent Magdalene in a
landscape.** About 1598

Oil on copper
Inscribed lower left in white oil paint *46[]*
and scratched on verso *Card Borghese*
H: 31.8cm W: 42.7cm
Given by the Friends of the Fitzwilliam
with a contribution from the NACF

Coll: *Cardinal Scipione Borghese; thence by
descent; sold to Durand (1790s), who sold it to
William Young Ottley (1799–1800); sold by
Ottley, Christie's 16 May 1801, lot 18; with
Hazlitt, Gooden and Fox (1975), from whom
acquired*

Ref: *Ann. Rep.* 1976, pl. V

This picture, no. 460 in the 1693 inventory of the Borghese collection, was probably acquired by Cardinal Scipione within five years of Annibale's death in 1609. Stylistically it seems to be from the period of Annibale's last phase of work on the celebrated ceiling of the Camerino in the Farnese Palace (cat. 61 and 62). This period established Annibale as the leading exponent of a new style based on the close observation of nature and the influence of Raphael.

The loose, north Italianate landscape is unfinished, conspicuously at the sides, perhaps because Annibale abandoned the picture in order to give more Roman emphasis to the subject in a second, larger version on canvas which is now in the Galleria Doria-Pamphilij in Rome. The Doria-Pamphilij version can also be dated about 1598. It shows a more open landscape in which the figure plays a smaller part; the landscape is more elaborately handled than the Borghese–Fitzwilliam version whilst the figure is more perfunctory.

Two coarse copies of the Borghese–Fitzwilliam composition are known (private collection, Lancashire; and Dulwich College Picture Gallery). There was also a vogue for copying the right half of both the Borghese–Fitzwilliam composition (private collection, Sussex) and the Doria-Pamphilij (private collection, Surrey). The eighteenth-century print by Carlo Faucci also shows the right half only of the Fitzwilliam version.

For a full discussion of the painting and its documentation see Michael Jaffé, 'The penitent Magdalene in a landscape by Annibale Carracci', *Burl. Mag.*, vol. CXXIII, February 1981, pp. 88–91.

CH

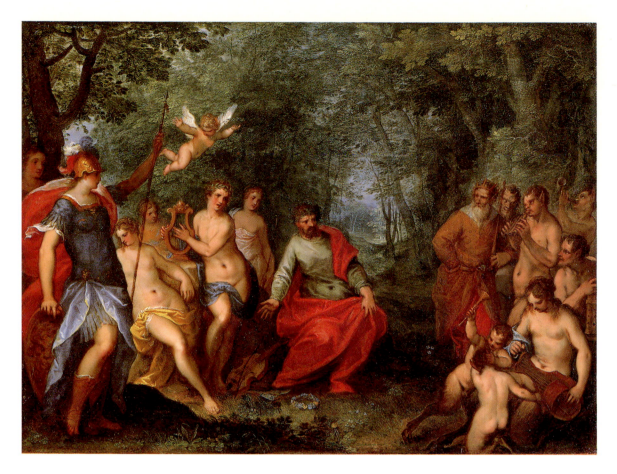

Cat. 68 PD. 23-1981

ROTTENHAMMER, Hans.
Munich 1564 – 1625 Augsburg
BREUGHEL, Jan I.
Brussels 1568 – 1625 Antwerp

The contest between Apollo and Pan.
1599

Oil on copper
Signed: *Gio. Rottenhammer / Venetia / 1599*
H: 25.2cm W: 33.9cm
Bought from the Gow Fund with
contributions from the Regional Fund
administered by the Victoria and Albert
Museum, and the NACF

Coll: *E. Permann, Stockholm, sold Bukowski,
1980, bought jointly by David Carritt Ltd
London and Livie of Munich, from whom
bought*

Ref: *Acquisitions*, p. 125, no. 3; *Ann. Rep.*
1981, pl. XVI

Formerly called *The contest between
Apollo and Marsyas,* the proper
identification was made by Ingrid Jost
('Drei unerkannte Rottenhammer

Zeichnungen in der Uffizien', *Album
discipulorum Prof. Dr. J. G. van Gelder*,
Utrecht, 1963, pp. 76–8). The two
contestants were often confused and
conflated in the sixteenth century. This
painting includes elements from both
stories (Ovid, *Metamorphoses* VI:382–400
and XI:146–193). Pan on the right plays his
pipes (syrinx) in contest with Apollo, who
stands by the Muses to the left, holding his
lyre. Apollo was judged the winner by the
mountain god Tmolus, who sits in the
centre. King Midas, who stands in the
picture by Pan and wears a gold crown,
disagreed with the verdict and was
rewarded with ass's ears by Apollo. The
satyr to the extreme right holds a double-
flute (visible on the very edge of the
painting) and may represent Marsyas. The
double-flute was invented by Minerva,
who stands on the left, wearing a helmet
and supporting a shield. She laid a curse on
the flute and cast it aside when the other
gods laughed at the sight of her cheeks
bulging as she played. Marsyas found it
and was challenged to a musical contest by
Apollo, the victor to choose the fate of the
loser. The Muses judged in Apollo's favour
and Marsyas was flayed alive.

Rottenhammer and Breughel established
friendly ties in Rome in 1593–4. In 1596

Breughel wrote from Antwerp
recommending Rottenhammer to Cardinal
Federigo Borromeo in Milan. Among their
collaborations are several small copper
plates, begun by Rottenhammer in Milan or
Venice and then sent by Cardinal Borromeo
to Antwerp for Brueghel to complete; they
were then returned to Milan. An example is
the *Engelreigen* of 1605–6 in the
Ambrosiana, Milan (no. 75).

The extraordinarily fine quality of the
woodland landscape in the Fitzwilliam
picture leaves no reasonable doubt that its
execution was by Jan I Breughel himself,
the figures having been painted by
Rottenhammer. It is comparable with the
three small landscapes with *The rest on the
flight into Egypt* in Vienna (Akademie, no.
909), the Hague (Mauritshuis, no. 283) and
Schleissheim (Gemäldegalerie, no. 996).
Variants of this composition include a
version formerly in the collection of M.
Rogers, and another formerly at Sanssouci
(now lost). The latter, undated and
unsigned, probably dates from
Rottenhammer's later Augsburg period,
1602–5. It is very close to the Fitzwilliam
picture although there are several small
variations and, judging from a photograph,
the landscape is not so fine.

CH

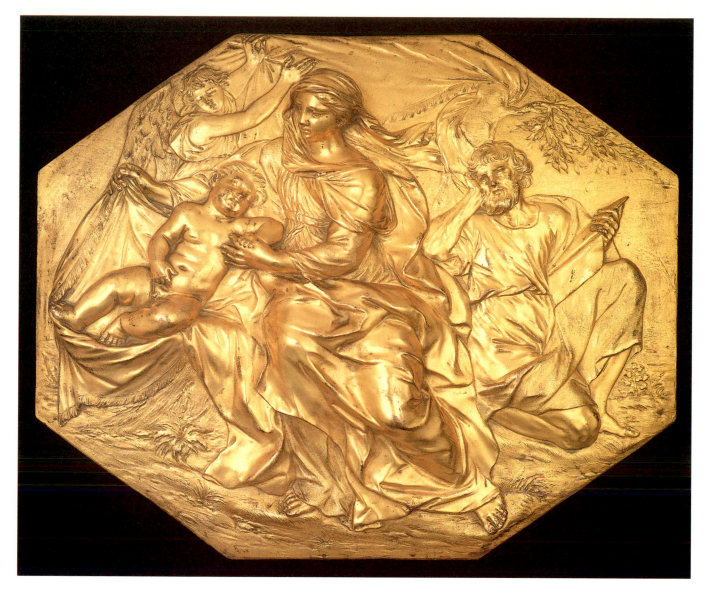

Cat. 69 M. 1-1939

ALGARDI, Alessandro (after a model by)
Bologna 1598 – 1654 Rome

The rest on the flight into Egypt.
?1635–40

Bronze, cast, chased and gilt
H: 29.3cm W:35.5cm
Given by Mrs. Alys Kingsley

Born the son of a silk-merchant, Algardi was allowed to pursue an artistic career. By 1617 he was studying in the Accademia degli Incaminati (the Academy of the Pathfinders) founded by Annibale and Agostino Carracci and their cousin Lodovico. There he learned drawing from casts and modelling in clay; his prowess in the latter was such that the painter Lodovico, by then sole survivor of the founders, tried his own hand at sculpture.

After Lodovico's death in 1619, Algardi travelled to Mantua, where he provided models for casting for Ferdinando Gonzaga. He may also have learned marble-carving whilst restoring Gonzaga antiquities. By 1625 he was in Rome, having visited Venice, and the rest of his career was spent there. Eventually he took on assistants of whom the best known were Domenico Guido, Ercole Ferrata and Michel Anguier (cat. 71).

As well as restoration of antiquities, and monumental projects such as the tomb of Pope Innocent X, Algardi's *oeuvre* continued to include models for casting in bronze and precious metals such as cat. 69.

There is no evidence that Algardi was directly involved in the casting of any of his small models, indeed many may have been posthumous: Ferrata is known to have inherited a number. Variations in detail are common, elements being added or omitted to suit format or ease of production.

This octagonal version is described by Jennifer Montagu (*Alessandro Algardi*, 2 vols., New Haven and London, 1985, cat. 4.C.2) as "despite the fact that the wing of the angel has been slightly clipped to fit under the frame, . . . superior to any other known cast". The cast itself is wonderfully crisp, and meticulous afterwork on the background enlivens the whole composition.

Called ?Italian or ?Netherlandish when acquired, the present attribution was first advanced by J. Pope-Hennessy in 1963, and confirmed by the inscription on a mid-seventeenth-century engraving by Edward le Davis (Montagu, *op. cit.*, cat. 4.E.1).

RAC

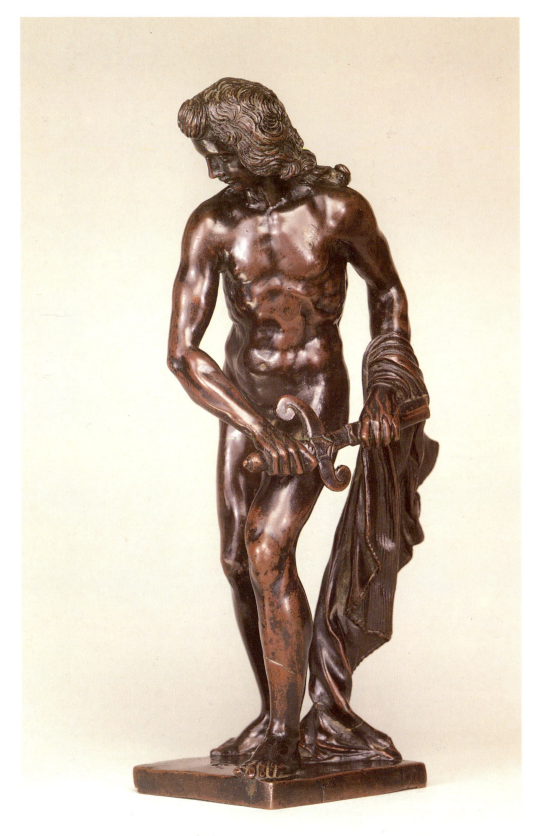

Cat. 70 M.20-1980

ANONYMOUS: Florentine Granducal workshop

David. Mid-17th century

Bronze, cast, chased and formerly gilt, now brown lacquered
H: 23.1cm W: 7cm D:12.9cm
Given by the Friends of the Fitzwilliam, with a contribution from the Regional Fund administered by the Victoria and Albert Museum

Coll: *Sotheby's 13 December 1979, lot 248; Alex Wengraf Ltd, from whom acquired*

Ref: *Ann. Rep.* 1980, pl. VIII

This intriguing sculpture illuminates several problems surrounding the models, manufacture, dating and attribution of baroque *bronzetti*.

Called "David, perhaps Roman, mid 17th century" by Sotheby's, the bronze was retitled "Gladiator" by Wengraf and ascribed to the circle of Pietro Tacca, on the grounds of the afterwork in the cloak.

This attribution was accepted by A. F. Radcliffe in a draft entry for his forthcoming catalogue of the Fitzwilliam bronzes, and extended by association with six gilt bronze allegorical figures on a *stipo*, or Florentine cabinet, formerly in the collection of King George IV of England, and another, bearing the arms of Grand Duke Ferdinando II of Tuscany, in the tribuna of the Uffizi.

However, Dr. Anthea Brook, in her unpublished doctoral thesis, 'Sculptors in Florence during the Reign of Grand Duke Ferdinando II of Tuscany (1621 – 1670): Ferdinando Tacca and his circle' (pp. 362–4 and note 39, p. 428), links the figure of *Onore* on this *stipo* with documentation in the *guardaroba* for payment to Francesco d'Orazio Mochi for the wax, 2/5 bracchia in height, in August 1646, and to the goldsmith Carlo Balatri for the casting, finishing and gilding in March 1647. Without close comparison between cat. 70 and this rare documented example, it would be imprudent to advance too definite an attribution, either of the model or the cast.

Cat. 70, at one time gilt, has been repatinated, probably in the nineteenth century. The model is known in no other cast.

RAC

Cat. 71 M. 1-1970

ANGUIER, Michel (after)
Eu 1613 – 1686 Paris

Ceres. About 1700, after a model of
1652

Bronze, cast and chased with dark lacquer
H: 54.2cm W: 34.5cm D: 22cm
Bought from the Cunliffe and Leverton
Harris Funds

Coll: *Prince Wiasemski; Spitzer collection; his
sale, Paris, 17 April 1893, lot 1465; J. E. Taylor
collection, his sale, Christie's 1 July 1912, lot
41; Sir Ernest Cassel collection, Brook House
sale, Puttick & Simpson 25–7 May 1932, lot
739; ?Duke of Westminster; Gerald Kerin Ltd,
from whom bought*

Ref: *Ann. Rep.* 1970, pl. III

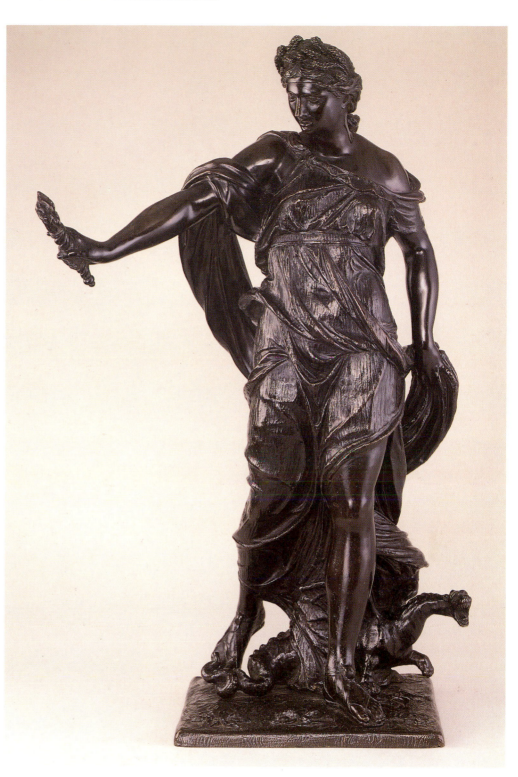

Michel Anguier was a pupil in Paris
of the sculptor, painter, engraver and
architect Simon Guillain, whose varied
oeuvre includes many bronzes, and who in
1648 was one of the founders of
l'Académie. In emulation of his teacher,
Michel travelled to Rome with his brother
François in 1641 and worked in the studio
of Alessandro Algardi (cat. 69), Michel
staying until 1651.

On his return, he assisted François in the
completion of the Montmorency tomb.

He is recorded in 1690 as still having
been busy in 1652 with the models for six
figures of Olympian Gods (seven are
listed!), 18 pouces (45cm) high,
subsequently cast in bronze and in the
possession of Tessier de Montarsis, jeweller
to the King (cited in M. Charageat, *La
Statue d'Amphitrite et la Suite des Dieux et
Déesses de Michel Anguier*, in *Archives de
l'Art Français, Nouvelle Période*, To. XXIII,
1968, p. 113). Cat. 71 is the "Cérès éplorée"
(desolated) perhaps intended as a pair to
another in the sequence the "Pluton
mélancolique".

She holds a torch to peer into the depths
of Hades, represented by the dragonet
squirming between her feet and by the
asphodel flowers represented on the
integrally cast base. A similar example is
engraved in P. Charpentier, *Suite au cabinet
du Sieur Girardon, Sculpteur Ordinaire du
Roi*, Paris 1710 (Victoria and Albert
Museum copy, pl. g, no. 11), and
catalogued as by Anguier.

An example in the Victoria and Albert
Museum (No. 85'65) of the same size as cat.
71, but with bare breasts, is of the type

which served loosely as the basis for a
biscuit de Sèvres figure in 1778, attesting to a
continuing taste for the subject.

The bronzes, seemingly produced in a

variety of sizes, are impossible to date
precisely, but the colour and finish of
cat. 71 point to manufacture about 1700.

RAC

Cat. 72 M. 60-1984

SOLDANI-BENZI, Massimiliano
Montevarchi 1656 – 1740 Galatrona

Leda and the swan. Early 18th century

Bronze, cast, chased and lacquered in red-gold
H: 34.5cm W: 31.5cm D: 14.4cm
Given by John Winter Esq., in memory of his father Carl Winter, Director of the Fitzwilliam (1946–66)

Coll: *Prince Ludovico Trivulzio; Luccardi collection, Milan; Zürich art market, where bought by donor*

Ref: *Ann. Rep.* 1984, pl. V

Soldani was employed by Grand Duke Cosimo III of Tuscany, and sent by him to study in Rome with Ciro Ferri and Ercole Ferrata. There he executed a medal of Queen Christina of Sweden. His experience in mintwork progressed by a period in Paris; and in 1688 Cosimo appointed him "Master of Coins and Custodian of the Mint". Besides numerous medals and reliefs, he executed figures and groups in the round, many on religious themes in accord with the morbid pietism of his patron.

Nothing is known of the origin and date of the model for cat. 72, and its pair, *Ganymede and the eagle,* also in the Fitzwilliam (M. 59-1984). Both were attributed to Falconet when purchased by the donor.

Marchese Carlo Ginori, proprietor of the Doccia porcelain factory, purchased numerous molds from Soldani's heirs. Many waxes or biscuit porcelains from them, including the *Leda,* are preserved at Doccia to the present day (K. Lankheit, *Die Modellsammlung der Porzellanmanufaktur Doccia,* Munich, 1982, pl. 115). A glazed porcelain of the *Leda* is reproduced in G. Morrazzoni, *Le Porcellane Italiane, vol. II,* Milan, 1960, pl. 253b, and the only other bronze recorded to date is in the Nelson-Atkins Museum, Kansas City. The *Ganymede,* for which no model survives or is recorded at Doccia, exists in porcelain at the Palazzo Venezia in Rome (private communication from Jennifer Montagu); no other bronze is at present known.

The dating depends on a related, but more elaborate *Leda* group, paired with an *Andromeda,* which do not occur in a list of available models sent by Soldani to the Fürst von Liechtenstein in 1702, and are therefore presumed to be later (Jennifer Montagu, *The Twilight of the Medici,* exh. cat. Detroit and Florence, 1974, cat. 70 and 71).

It is likely that, like the above, the Fitzwilliam bronzes were originally supplied with marble bases with bronze mounts, and were exhibited in SS. Annunziata in 1767 by Marchese Carlo Gerini (Montagu, *op. cit.,* cat. 71).

RAC

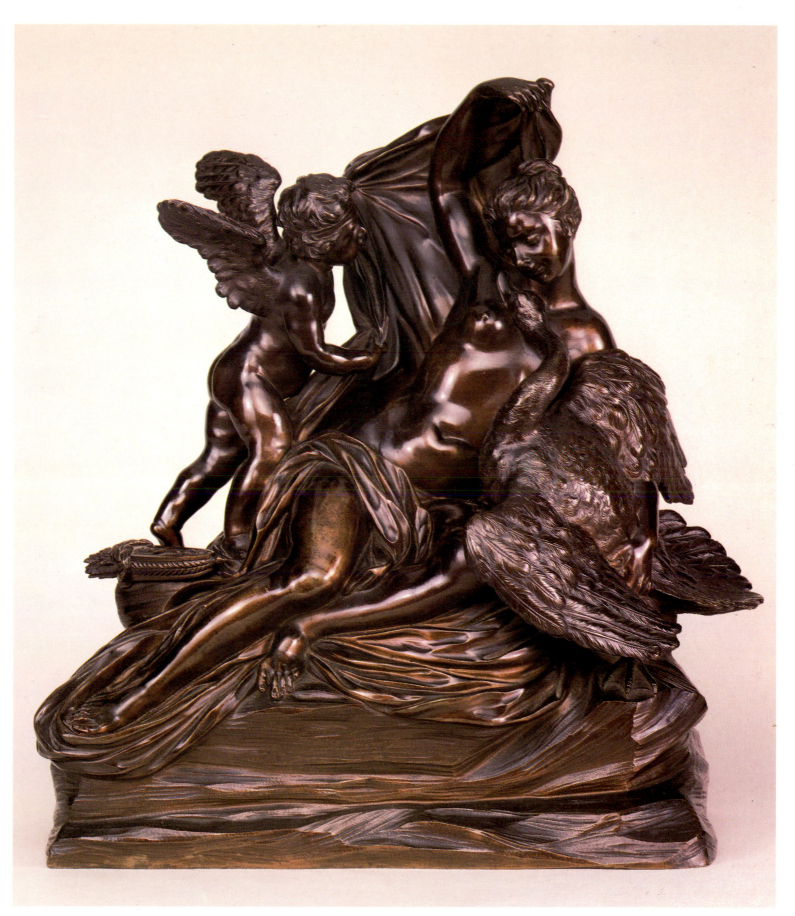

Cat. 73 O. 34-1946

Recumbent horse. 17th century

Black and grey jade
H: 14.9cm W: 25.1cm D: 10.9cm
Oscar Raphael bequest

Coll: *Qing Imperial collection, ?Winter Palace, Beijing to 1900; sold British Legation, Beijing; anon. Chinese collection 1900; bartered by Mr. Williamson, from whom bought by testator*

Ref: *Winter*, no. 18

Acquired by Raphael before 1915, when it was shown with a 56lb green buffalo and a white dragon–horse (all now in the Fitzwilliam) in the Burlington Fine Arts Club Exhibition of Chinese Art (*Illustrated Catalogue . . .* , London 1915, no. 7 case C, cat. p. 35 and no. 6 case C), this exceptional black horse has been associated with legend and has been involuntarily rejuvenated. Catalogued (*op. cit.*, p. 29) as "not likely to be older than the Sung" a version of its history is also given. The fuller, but still undocumented, recension given in the notes to the list of Raphael's collections, made before the division of the bequest between the Fitzwilliam and the British Museum, reads:

"Story of 1, 2 & 3. Dr. Bushell told me that he knew these three animals, as they stood before 1900 in the corridor of the Winter Palace at Peking. He said that a catalogue existed of the Palace, which stated that the buffalo and the horse date from the Han Dynasty, (this may be true of the buffalo but the horse is probably T'ang). It is known that they were already regarded as sacred objects and were used annually in a festival, when they were brought to Peking at the time of its being made capital by the Emperor Yung–lo (1405–25) about 1420 AD. K'ang–hsi, inspecting the contents of the palace in the early years of his reign, was shown them and asked how it was that the Lung–Ma which brought the books of knowledge from over the waves of the Yellow River, was not represented. This one was accordingly made. In the Boxer troubles, on the relief of the Legations, these three animals were removed with many other objects to the Garden of the British Legation; and at a sale, two days later, were bought by a Chinese official who afterwards exchanged them for some jewels: the new owner, Mr. Williamson, later brought them to England."

In the same notes is found eloquent optimism about the source of the rare black jade:

"The Chinese evidently attach great importance to the rarity of this boulder as they have not removed the scaly outer surface on the horse's rear quarter; and on its off quarter they have filled up a small flaw with some hard composition. On the karakash r. there existed until destroyed by the advancing sand a village named Borasana (Sven Hadyn), (Boulder of Black Jade). As this is the only historic black jade boulder of any size, it was probably *its* discovery which gave the name to the village. This horse is also said to resemble one of five various–coloured jade horses made for the Emperor Huan–tsung (713–755 AD), and illustrated in *Ku yu t'u*, published 1341 by Chu Teh–jun." (Applied Arts Departmental Archives; Raphael Collection, Jades, pp.1–2.)

The Royal Academy Catalogue of the International Exhibition of Chinese Art (1935/6 no. 1017) placed the horse in the 9th century AD and repeated the Yongle story. The joint Arts Council / Oriental Ceramic Society Loan Exhibition, *The Animal in Chinese Art* (1968, cat. 222), baldly calls cat. 73 "Yuan / Ming Dynasty", and the similarly organised *Chinese Jade throughout the Ages* (1978, cat.394) dates the horse "late Ming or early Ch'ing, 17th–18th century". The commentary (*op. cit.*, p. 118) refers to the story in connection with the buffalo: "Among the buffaloes pride of place must be given to the massive and noble beast in the Fitzwilliam (no. 395). Associated with this is the story of its having been brought to Peking and installed in the time of the emperor Yung–lo (1403–24) as a precious relic of the Han dynasty.

"This is no longer accepted, and while not long ago the buffalo was exhibited tentatively as a work of the Sung dynasty, a Ming date is probably the earliest that most authorities would today be willing to accept for it".

RAC

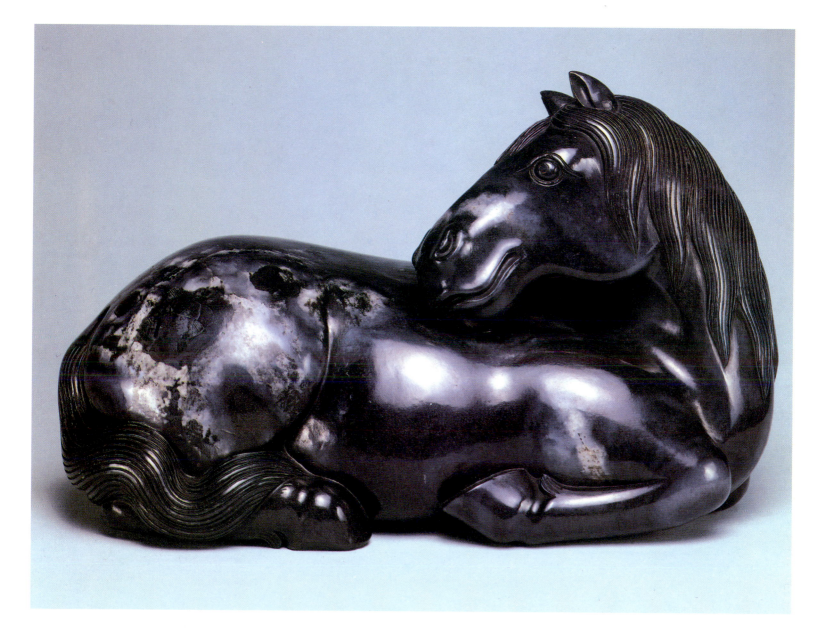

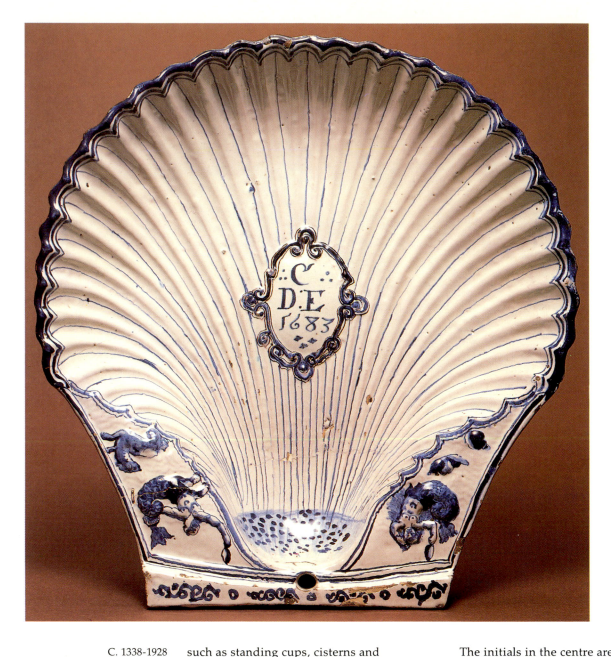

Cat. 74 C. 1338-1928

Basin in the form of a shell.1683

Tin-glazed earthenware painted in blue
H: 7.6cm W: 42.4cm L: 44.2cm
Bequeathed by Dr. J. W. L. Glaisher

Ref: *Poole I*, p.4, no. 10; *Rackham*, vol. I,
p. 173, no. 1338

During the seventeenth century, London delftware potters often imitated the forms of metalwork vessels, such as standing cups, cisterns and embossed dishes. This unusual basin, moulded in the shape of a shell, appears to have been copied from an early seventeenth century silver prototype, such as a shell basin in the Victoria and Albert Museum, which was made by the London goldsmith "T.B." in 1610–11, and is accompanied by a mermaid–shaped ewer (Victoria and Albert Museum M.10 & A 1974. Philippa Glanville, *Silver in England*, London, 1987, fig. 89). Another set of this type is in the Toledo Museum of Art.

The initials in the centre are those of the owners: a man and wife, who if the standard practice for writing initials was followed, had a surname beginning with C. The date might be the year of their marriage or simply that in which they purchased the basin, which they could have commissioned from one of several delftware factories in the London area, probably in Southwark, or Lambeth.

JEP

Cat. 75 C. 3-1961

Figure of a lady. About 1680 – 1700

Hard-paste porcelain, decorated overglaze
with polychrome enamels.
H: 38.7cm
Given by the Friends of the Fitzwilliam

Ref: *FOF* 1961, p. 4

Despite a distinguished ceramic
tradition reaching to the Neolithic
mists, Japan produced no translucent white
porcelain before the seventeenth century.
Following Hideyoshi's campaigns in Korea
of 1592–8, Korean potters were brought
back to settle in Kyushu with an initial
supply of raw materials, later
supplemented by local alternatives. Early
seventeenth century wares were tentative
and for Japanese consumption, but by the
late 1640s overglaze enamelled wares were
sufficiently advanced to be offered for sale
to the Dutch, who, following the exclusion
order of 1630, were the only Westerners
allowed to trade directly with Japan.

The uncertainties of trade with China in
the chaos following the collapse of the
Ming dynasty encouraged the Dutch to
build up porcelain trade with Japan, and
the period between about 1680 and the first
decades of the eighteenth century saw a
burgeoning of this traffic.

The enamelled style originated by the
Kakiemon family was thus the first to be
seen in Europe, and formed an important
component of aristocratic decorative
schemes, such as Burghley House, Ham
House, and the Royal Porcelain Rooms in
Dresden. In turn they were much imitated
by the early European porcelain factories.

Whilst the idea of porcelain figures is
likely to have been copied from Chinese
originals, principally the monochrome
blanc de chine from Fujian province, the
Japanese examples are distinctly *sui generis*.
This *geisha* figure is in the tradition of one
probably documentable at Burleigh in 1688
(Soame Jenyns, *Japanese Porcelain*, London,
1965, p. 125, pl. 55B), but on grounds of
costume and hair–style is certainly
somewhat later (cf. *op. cit.*, pl. 63B (ii)).

RAC

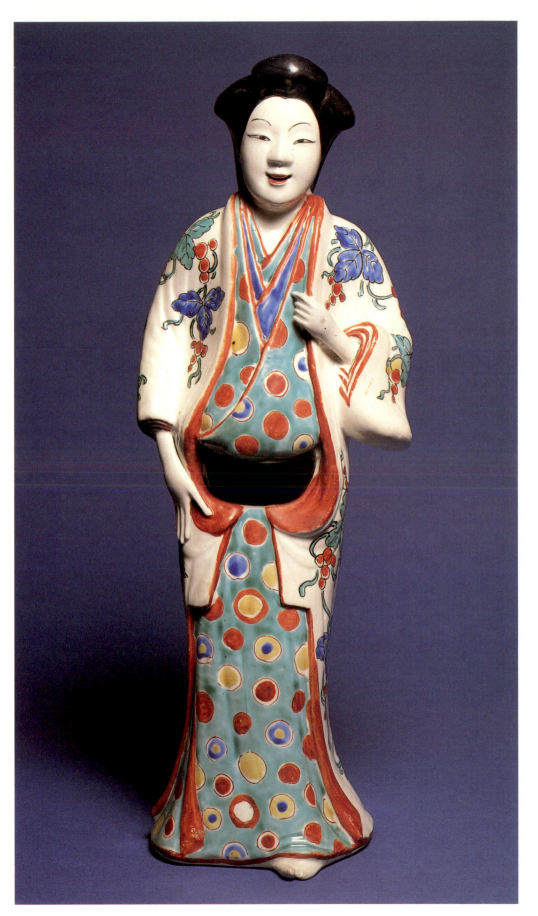

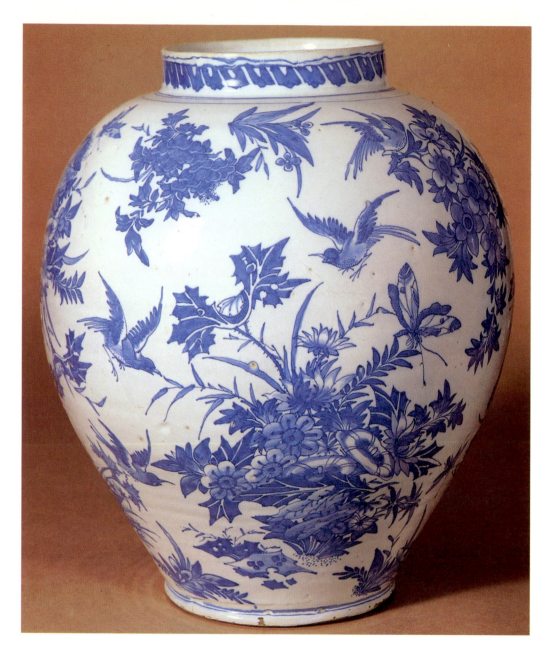

Cat. 76 C. 2857-1928

Vase. About 1680

Tin-glazed earthenware painted in blue
H: 39.5cm Diameter: 32.5cm
Bequeathed by Dr. J. W. L. Glaisher

Coll: *bought by testator, Haslingfield, Cambridge, 1898*

Ref: *Rackham,* vol. I, p. 356, no. 2857

The Frankfurt faience factory was founded in 1666 when the City Council granted a concession to Johann Simonet backed by Bernhard Schumacher and Johann Cristoph Fehr. From 1667 to 1693 it was under the proprietorship of Fehr, then of his widow, and from 1714 to 1721 their sons. The factory survived until 1772, but its finest pottery had been manufactured during the late seventeenth and early eighteenth centuries.

Like factories at Delft, Frankfurt imitated Oriental blue and white porcelain in late-Ming or Transitional style, particularly dishes, potiches and double gourd-shaped vases. Initially Delftware was also influential, but Frankfurt painters developed a distinctive interpretation of Oriental themes. Some of the most outstanding pieces dating from about 1670–80 were decorated by a painter known today as 'the Master of the Large Vases'. The factory also produced typically German forms, such as lobed and fluted dishes, and bulbous long-necked jugs with metal mounts and covers, which have Oriental or European decoration, including heraldic and floral designs, classical, biblical or genre scenes.

The vase shown here may originally have had a domed cover. Its large size and bold, simple form is enhanced by an extremely white tin-glaze. The whole surface is covered with a freely painted design in the style of the 'Master of the Large Vases', with birds and butterflies among Oriental flowers. The almost lavender blue used for the decoration is characteristic of Frankfurt faience.

JEP

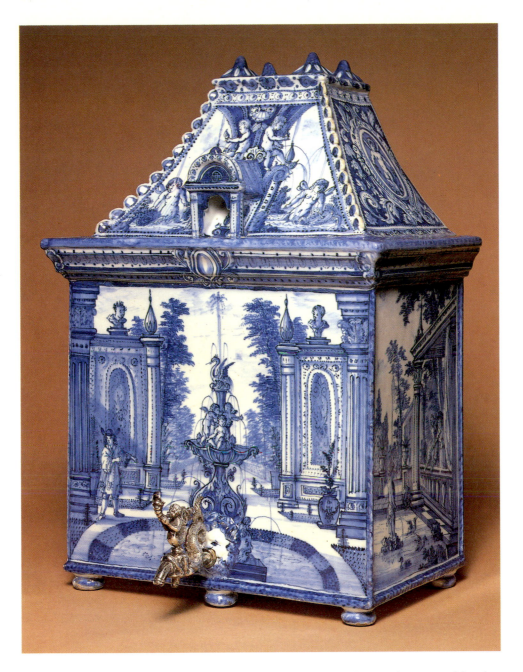

Cat. 77 C. 2416-1928

House-shaped cistern. About 1700

Tin-glazed earthenware painted in blue
Mark: *AK* in monogram on base and lid
H: 42.3cm W:30cm D:24cm (including tap)
Bequeathed by Dr. J. W. L. Glaisher

Ref: *Rackham,* vol. I, p. 314, no. 2416; vol. II,
pl. 193

Adriaen Kocks, whose monogram
appears on this cistern, purchased
The Greek A pottery in 1686. Under his
directorship, which lasted until his death
in 1701, it became one of the most
important factories in Delft. Among its
patrons were the Stadtholder, William of
Orange and his wife Mary Stuart, who
commissioned pottery for Hampton Court
after their accession to the English throne
in 1689. A high proportion of The Greek
A's output imitated the Oriental porcelains
imported by the Dutch East India
Company, or combined European and
Oriental forms and decoration. In contrast,
this extremely unusual cistern is wholly
European in design.

The cistern is shaped like a large Dutch
house, the roof of which lifts off to enable it
to be filled. However, instead of decorating
it to resemble a house, the painter has
shown three entrancing views of the formal
Baroque garden which might have been
seen from its windows. The spigot, in the
shape of a dolphin and a merman blowing
a conch shell, is set into a mask on the front
where it appears to be part of the fountain
which is the central feature of the design.
The slope of the roof is decorated with
youthful tritons and *putti* holding garlands,
and, on the top, there are two jellyfish,
shells and a starfish. These motifs are not
so incongruous to the design as they at first
appear, for maritime trade was the major
source of Dutch power and wealth in the
seventeeth and early eighteenth centuries.

JEP

75

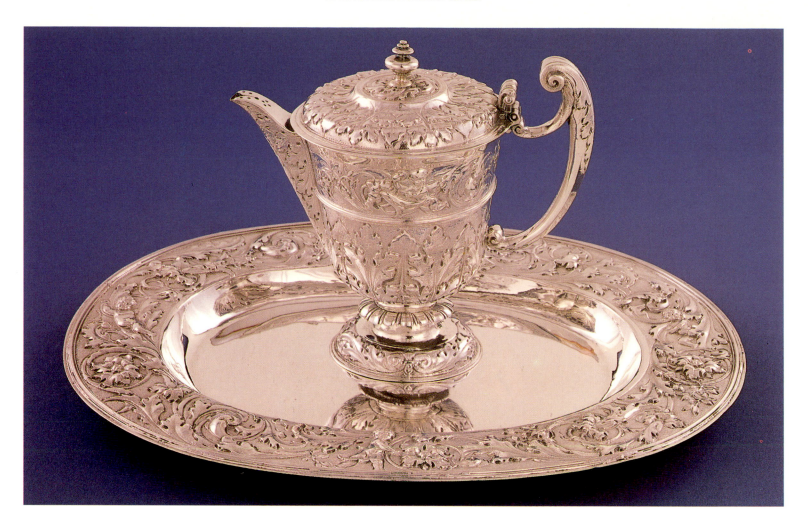

Cat. 78 M.468 & A – 1985

Ewer and basin. About 1658

Silver, embossed, chased and matted
Ewer H: 19.8cm
Basin L: 41.5cm W: 30.2cm
Bought from the Gollan, Rylands and
Marlay Funds, grants from the Beatrice
Nellie Stuart Bequest Fund of the NACF
and the Regional Fund administered by the
Victoria and Albert Museum

Coll: *the descendants of Sir William Lockhart
of Lee, from whom bought*

Ref: *Ann. Rep.* 1985, pl. XVI

According to family tradition, this
ewer and basin were given to Sir
William Lockhart of Lee (1621–75) by Louis
XIV about 1658. Lockhart in his youth had
pursued a military career in the French
army before returning to Scotland in 1645
to fight in the Civil War. Initially a Royalist,
he espoused Republican views in 1648 and
soon won the esteem of Cromwell, whose
niece he married in 1654. His knowledge of

French probably influenced his
appointment as Cromwell's ambassador to
the Court of France. Sir William arrived in
Paris in April 1656 and by March 1657 had
successfully concluded an anti-Spanish
treaty with the French. In 1658 he took
command of the English forces besieging
Dunkirk, and on its surrender, became
Governor. After Cromwell's death later in
the year, Lockhart delivered the greetings
of his successor, Richard Cromwell, to
Louis XIV, and remained in France until
the Restoration in 1660. By 1670 he was
back in favour at Court and in 1674 was
again appointed ambassador to France, but
his stay in Paris was cut short by his
sudden death in 1675.

Although their forms are typically
French, the ewer and basin are unmarked,
which has given rise to doubts as to
whether they are indeed French. The *Listes
des présents du roi* do not cover Lockhart's
first embassy, nor do Alphonse Maze-
Sencier's extracts in *Le Livre des
Collectioneurs* (Paris, 1885) mention a gift to
the British ambassador in 1674, although
they record one on 7 August to "Mme

Lokard, femme de l'ambassadeur
d'Angleterre" of "un table de bracelet de
perles et diamants" valued at 10,960 livres.
The customary gift for an ambassador at
that date was a *boîte à portrait*, one of which
was given to Lockhart's predecessor,
Sunderland, in 1673.

Establishing a firm attribution is made
more diffiult by the paucity of seventeenth-
century French silver as a result of the
melts ordered by Louis XIV in 1687, 1689
and 1709. Much of what is extant is in the
form of a few extremely opulent silver or
silver-gilt toilet services, some of which
include ewers and basins. These have
survived because they were purchased by
members of the Swedish, Dutch and
English royal houses. Many more are
known from documentary evidence. Louis
XIV had at least five and often presented
toilet services to relatives and visiting
royalty. It is not inconceivable therefore, if
we accept the Lockhart family tradition,
that a ewer and basin could have been
given to an ambassador. Lockhart lived in
considerable state in Paris: but if he had
purchased these pieces for himself during

either period of his residence, it is most unlikely that they would have been unmarked.

The closest comparable French ewer and basin are those of 1670–1 accompanying a silver-gilt toilet service mainly by Pierre Prévost of Paris, which was acquired by William of Orange and his wife, Mary Stuart, probably at the time of their marriage in 1677 (Chatsworth; Faith Dennis, *Three Centuries of French Domestic Silver*, New York, 1960, I, pp. 190–5). Another pair, ungilt, and decorated entirely differently, belong to the toilet service of the Swedish princess Hedvig Sophia, who married Frederic IV, Duke of Holstein-Gottorp, in 1698. (Rosenborg Castle, Copenhagen, see G. Boesen, 'Le service de toilette français de Hedvig Sofia', *Opuscula in Honorem C. Hernmarck*, Stockholm, 1966, pp. 22–38.) This probably belonged to her grandmother, and was assembled from pieces dating from 1658 to 1676, of which the basin is the earliest and the ewer, like this example, is unmarked. The Lockhart basin can also be compared with a silver-gilt example of about 1660 in the Musée du Louvre (OA 10214).

JEP

 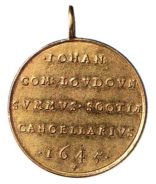

Cat. 79 CM. 248-1964

SIMON, Abraham
London 1617 – 1692 London

John Campbell (1589–1663), Earl of Loudoun. 1645

Gold
Signed: *A. S.* on the truncation (incised)
H: 45.55mm W: 37mm Weight: 19.32g
Given by Mr. Herbert Schneider through the Friends of the Fitzwilliam

Coll: *R. W. Cochran-Patrick (acquired in 1876), his sale, Sotheby's 9 December 1957, lot 162, bought H. K.Hepburn-Wright, with Spinks, from whom bought by donor*

Ref: *FOF 1964, p. 3*

Obverse: bust to the left, wearing a cap, a buttoned doublet and a garment with a broad turned-down collar: incised on the truncation *A.S.*

Reverse: *IOHAN:COM:LOVDOVN: SVMMVS.SCOTIAE CANCELLARIVS 1645* (John, Earl of Loudoun, Lord Chancellor of Scotland).

Abraham Simon (1617–92) and his brother Thomas (1618–65) were in their time the principal medallists of England. During the Civil Wars, Abraham, as a Royalist, lived abroad; Thomas continued to serve the government. The medals by Abraham were only cast from wax models.

James Campbell was created Earl of Loudoun in 1633 and appointed Lord Chancellor of Scotland in 1641. He vigorously opposed both the episcopy and the crown in Scotland, but changed to the Royalist side in 1648. At the Restoration of the monarchy in 1660 he was heavily fined by Charles II.

JGP

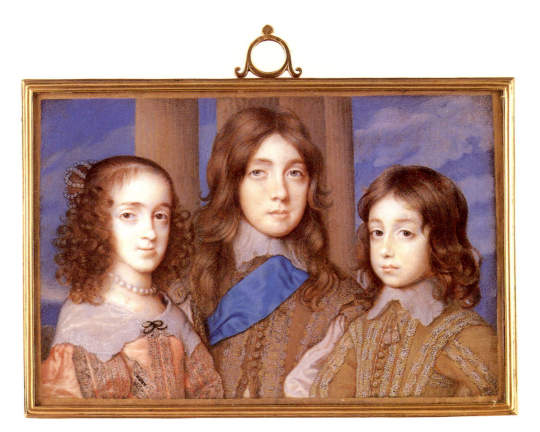

Cat. 80 No. 3877

HOSKINS, John
About 1595 – 1665

Three children of Charles I (James, Duke of York, 1633–1701; Princess Elizabeth, 1635–50; Henry, Duke of Gloucester, 1639–60). 1646-8

Watercolour on vellum on card
Rectangular; H: 79mm W: 119mm
L. D. Cunliffe bequest, 1937

Coll: *9th Earl of Northumberland; with Philips; testator*

Ref: *Bayne-Powell*, pp. 131-2, repr., col. pl. III

Hoskins was appointed miniature painter to Charles I in 1640 and awarded an enormous annual pension of two hundred pounds, which in the event was never paid. In the late 1620s and throughout the 1630s he painted numerous portraits of the King and of his Queen Henrietta Maria, both from life and from portraits by Van Dyck, but appears to have ceased to work by the mid-1640s, perhaps because of a debilitating illness or a stroke (John Murdoch, *The English Miniature*, London, 1981, p. 96).

This triple portrait must have been painted between early autumn in 1646, when the children were placed in the custody of the Earl of Northumberland after the King's defeat in the Civil War in 1645, and April 1648, when James escaped to France. Of the three children only James survived to maturity. Elizabeth, named 'Temperance' because of her sweet nature, died a prisoner in Carisbrooke Castle at the age of 15; Henry, the third son, died of smallpox in 1660, having distinguished himself as a volunteer with the Spanish army in Flanders from 1657 to 1658.

Typically for Hoskins at this period, the composition manifests the general influence of Van Dyck, although his sensitive characterisation of the children exceeds mere pastiche.

A full-length of the same children by Sir Peter Lely, dated 1647, likewise commissioned by the Earl of Northumberland, is at Petworth House, Sussex (National Trust).

JAM

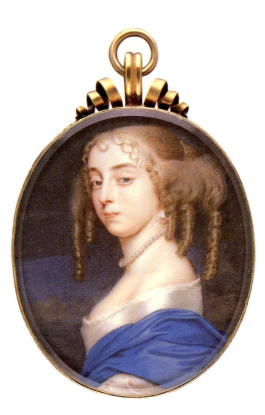

Cat. 81 No. 3826

COOPER, Samuel
London ?1608 – 1672 London

Unknown lady. About 1660

Bodycolour on vellum on card
Oval; H: 68mm W: 58mm
Signed with monogram in black, lower
centre right: *SC*
L. D. Cunliffe bequest, 1937

Coll: *William Ashley; his sale, Christie's 15
May 1884, lot 15; testator*

Ref: *Bayne-Powell*, p. 38, col. pl. IV; *Winter*,
no. 70-3

Cooper was the leading miniaturist of the seventeenth century in England. With his elder brother Alexander he was brought up "under the Care and Discipline" of his maternal uncle John Hoskins (*q.v.* cat. 80), to whom he was apprenticed as a miniaturist from about 1625. By 1642, the year of his earliest dated miniature, he had established his own practice in London, and in 1663 he was appointed King's Limner to Charles II. Remarkably, his reputation survived the political upheavals of mid-century, and he enjoyed the successive patronage of the Caroline Court, the Commonwealth leaders and Charles II.

Few of Cooper's female portraits rival the present miniature for quality and strength of characterisation. Painted about 1660, it shows the sitter in fashionable *décolletage*. The sharp twist of the neck and powerful modelling of the flesh convey a directness and sense of mass unparalleled in earlier miniatures. Like many of his generation, Cooper was deeply influenced by Van Dyck's court portraiture, particularly in his loose brushwork and more naturalistic palette.

The identity of the sitter remains a mystery; however, her youthful appearance excludes a former identification as Lady Lucy Percy, who would have been in her early sixties at the time this portrait was painted.

JAM

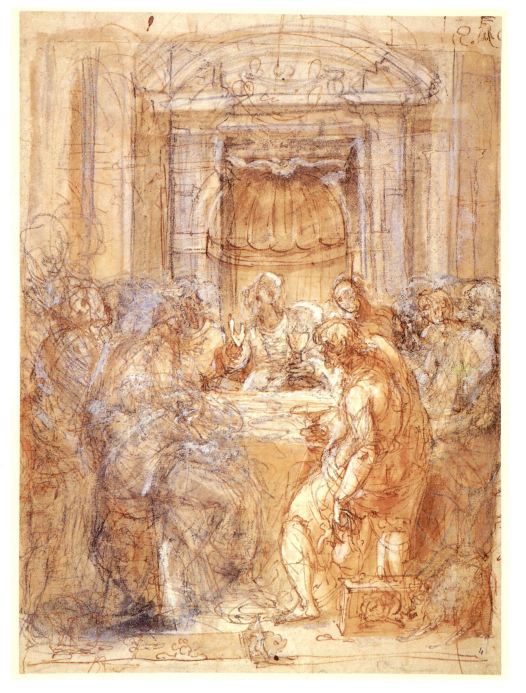

Cat. 82 PD. 13-1977

CARDI, Ludovico, called IL CIGOLI
Castelvecchio di Cigoli 1559–1613
Rome

The Last Supper. About 1590–1

Black chalk, pen and brown ink, brown
wash, heightened with white on paper

Verso: *Studies for disciples at the Last Supper;
architectural studies*
Black and red chalks, brown ink

Watermark: a star above a cartouche with
crossed swords below a fleur-de-lis
H: 325mm W: 238mm
Bought from the Rylands Fund

Coll: *Christie's 30 March 1976, lot 38; with
Adolphe Stein, Paris, from whom bought*

Ref: *Ann. Rep.* 1977, pl. V

A study for the altarpiece commissioned
in 1591 by the Confraternità del
Sacramento for San Andrea Apostolo,
Empoli (destroyed 1944). The painting was
unusual in depicting a nocturnal scene. No
indication of this is given in the present
drawing, in which Cigoli's main concern is
to establish a meaningful relationship
between the participants in the drama; the
verso shows alternative positions for the
two disciples at the front of the table. In the
finished painting Cigoli maintained the
tauter solution already realised on the
recto, which uses the poses and gestures of
the two disciples to enclose the
compositional circle around Christ, thus
drawing attention to his gesture of
benediction. The close fitting of so many
figures in a confined space shows Cigoli
still working in a late Mannerist formula;
however, the fact that the grouping
becomes even tighter in the finished
painting and that the height of the ceiling
is reduced, suggests that the composition
may also have been determined by spacial
constraints in the chapel.

The composition served as the basis for a
1603 version, more open and classicising in
its disposition of the figures, which was
executed in *pietre dure* for the New Sacristy
for the Medici in San Lorenzo, Florence,
and now in the Pitti Palace. (Miles Chapell,
'Some works by Cigoli for the Capella de'
Principi', *Burl. Mag.*, CXIII, October 1971,
pp. 580–2.)

JAM

Cat. 83 No. 2621

PROCACCINI, Camillo
Bologna about 1555–1625 Milan

Two men's heads. About 1600

Black and red chalks, touched with white,
on light-brown prepared paper
H: 224mm W: 161mm
Given by Sir Frank Brangwyn, 1943

Coll: *Lansdowne, sold Sotheby's 25 March
1920, lot 92*

Procaccini made chalk studies of
grotesque heads and figures in
fantastic head-dress which bear no
relationship to his finished paintings. Their
function is unknown, but, as Nancy Ward
Neilson has observed (*Camillo Procaccini,
Paintings and Drawings,* New York, 1979,
p. 361, fig. xiii), it seems likely, given
Procaccini's popularity with private
collectors, that they were intended for a
connoisseur's market, and may reflect the
early-seventeenth-century fashion for
burlesque.

Ascribed to Federigo Zuccaro (1543–1609)
when in the Lansdowne collection, it
entered the Fitzwilliam as 'School of
Barocci', an attribution independently
rejected by John Gere, Anthony Blunt and
Philip Pouncey. Although the colouristic
effects of light and shade show a Venetian
influence, the handling of red chalk and
white highlights is closer to the sixteenth-
century school of Parma, particularly to
Parmigianino and Girolamo Bedoli (Ward
Neilson, *loc. cit.*). The composition and
decorative flourish in the treatment of the
plumed hat recall a larger drawing of *Two
heads* at Chatsworth (no. 398; Ward
Neilson, fig. 351) although the latter lacks
the delicacy and soft *sfumato* effects of the
present sheet. This is among the most
outstanding of a collection of 233 drawings
given in 1943 by Sir Frank Brangwyn (1867–
1956) to the Fitzwilliam, which had earlier
purchased this artist's collection of Near
and Far Eastern Ceramics (cat. 21).

JAM

Cat. 84 PD. 696-1963

SAVERY, Roelandt
Kortrijk (Courtrai) 1576–1639 Utrecht

A romantic landscape. About 1606–7

Black chalk with watercolour washes on
four sheets of paper, stuck together
Inscribed in ink, verso: *Savery (Roeland),
peintre né a courtray, 1576, mort à Utrecht
en 1639*
H: 371mm W: 549mm
Bequeathed by Sir Bruce Ingram

Coll: *P. & D. Colnaghi, from whom bought by
Ingram, 1956 (L. 1405a)*

The years which Savery spent at
Prague, from about 1603 to 1613/14, were
his most productive. Both the landscape
and its inhabitants fascinated him, and
drawings which survive from this period
show how sensitively he responded to the
wild Bohemian landscape.

According to Sandrart, it was Savery's
extraordinary ability to depict rocks,
mountains and waterfalls which prompted
the Emperor Rudolph II to send him to the
Tyrol in order to explore its "rare marvels
of nature" (*Joachim von Sandrarts Academie
der Bau- Bild- und Mahlerey-Künste von
1675*, ed. A. R. Peltzer, Munich, 1925, p.
175). J. A. Spicer-Durham has dated this
drawing about 1607, towards the end of
Savery's two-year tour ('The Drawings of
Roelandt Savery', Ph.D. dissertation, Yale
University, New Haven, 1979). It is a
remarkable evocation of atmosphere and
mountain drama.

JAM

Cat. 85 No. 2048

VAN DYCK, Sir Anthony
Antwerp 1599–1641 London

**Study of a kneeling figure, bending
towards the right.** About 1620

Black chalk on buff paper, heightened with
white on paper; some old water stains
H: 353mm W: 286mm
C. H. Shannon bequest, 1937

Coll: *Ricketts and Shannon*

Possibly a study for an apostle at an
Assumption. No precise correlation
exists with any known painting by Van
Dyck on this theme, although the pose is
similar, in reverse, to that of the soldier in
the foreground of the *Martyrdom of St.
Sebastian* in the Alte Pinakothek, Munich
(Kl.d.K. 134). Michael Jaffé considers the
drawing a drapery study from life, rather
than for a particular painting, and dates it
in Van Dyck's first Flemish period, about
1620.

JAM

Cat. 86 PD. 57–1973

LISS, Johann
Oldenberg about 1597-1631 Verona

Nude woman standing. About 1625

Black and red-brown with yellow, green
and white chalks on buff paper.
Watermark: oval enclosing monogram of
Christ above a cross
Inscribed, verso, lower left, in pencil with
monogram *AP* or *AEP/J.A. Watteau;* and,
lower right: *10*
H: 391mm W:250mm
Bought from the Cunliffe Fund

Coll: *with Leo Franklyn, London; with Kurt
Meisner, Zürich*

Previously ascribed to Watteau and to
Rubens, this drawing was attributed
in 1973 to Liss by Michael Jaffé, who
proposed it as one of the life drawings
made by Liss at the artists' academy in
Venice. Sandrart records that it was to these
drawings that Liss referred in order to give
to his paintings of female figures "at once a
special grace and extraordinary
lifelikeness" (A. R. Peltzer (*op. cit.* cat. 84)).
 Here the plump fist of the model can
clearly be visualised as holding onto a
support such as a pole, or shaft, as in the
Decision of the Magdalene, Gemäldegalerie,
Dresden (Inv. no. 1840). The powerful
stance and weighty handling of the
draperies also bears comparison with two
pen and ink drawings of similarly larger-
than-life female figures given to Liss by
Otto Fröhlich, and likewise associated with
his academy studies (Edmund Schilling,
'Betrachtungen und Zeichnungen von
Johann Liss', *Festschrift für Karl Lohmeyer*,
Saarbrücken, 1953 p. 5, figs. 2 and 3.)
 Use by Liss of pale-green chalk for half-
shadows on the legs, and his observation of
light and reflected light as modelling agents
conform to his handling of oil paint, where
similar realism is often observed.
 L. S. Richards (Augsburg and Cleveland
Museum of Art, *Johann Liss*, 1975–6, no.
B.54, p. 146, fig. 61), dates the drawing
"early in the second Venetian period",
about 1625.

JAM

Cat. 87–91

REMBRANDT, Harmensz van Rijn
Leiden 1606–1669 Amsterdam

Cat. 87 AD. 12.39-159

Jupiter and Antiope: the larger plate.
1659

Etching, burin and drypoint printed with
plate-tone in black ink on Japanese paper
H: 138mm W: 205mm
Signed in the plate: *Rembrandt f 1659*
Transferred from Cambridge University
Library (1878)

Coll: *Cambridge University Library (L. 2475)*

This is the first state of the print (C.
White and K. G. Boon, *Hollstein's Dutch*
and Flemish Etchings, Engravings and
Woodcuts, Volumes XVIII, XIX,
Amsterdam, 1969, no. 203).

The nymph Antiope was the daughter
of the river god Asopus (or, according
to Pausanias, Nycteus). She was loved by
Jupiter (Zeus), who deceived her by
assuming the guise of a satyr to surprise
her asleep. The subject of this print was
identified as ''Venus and Satyr'' in the
inventory of the printseller Clement de
Jonghe shortly after Rembrandt's death (C.
White, *Rembrandt as an Etcher*, London,
1969, pp. 185–6), but an inscription (not by
Rembrandt) in the second state of the plate
describes it as Jupiter and Antiope. The
composition seems to have been inspired
by Annibale Carracci's etching of *Jupiter
and Antiope* (*Bartsch* 17). White (*loc. cit.*)
suggests that Carracci's print supports the
identification of Rembrandt's subject but

Carracci's print may well show Venus and a
satyr (Diane DeGrazia Bohlin, *Prints and
Related Drawings by the Carracci Family*,
National Gallery of Art, Washington, 1979,
no. 17).

Rembrandt had etched a similar subject
about 1631 (White and Boon *op. cit.* cat. 87,
no. 204) which is usually called *Jupiter and
Antiope: the small plate* although the early
inventories again raise doubt about the
subject (White, *op. cit.*, p. 175). A drawing
in the Musée du Louvre (*Benesch* 1040)
probably shows Jupiter and Antiope and
may have been made in preparation for the
1659 etching although the composition
differs. The female nude was the subject of
a number of other late drawings and
etchings by Rembrandt.

CH

Cat. 88 No. 2139

The supper at Emmaus. About 1648–9

Pen, brown ink, brown wash, heightened
with white on paper
Inscribed in ink verso: *Rembrant* (sic), and
numbered *2328*
Inscribed on the old mount in a similar
hand: *de Emausgangers*
H: 199mm W: 182mm
C. H. Shannon bequest, 1937

Coll: *Frans van de Velde, sold Amsterdam, 16
January 1775, lot 146, bought Grebe; J. Goll
van Frankenstein, sold July 1833, bought de
Vries; J. L. C. van den Berch de Heemstede,
Amsterdam, sold Amsterdam, F. Muller, 19
January 1904, lot 291; bought Artaria, Vienna;
possibly Edward Cichorius; ?Eisler, sold
Christie's, date unknown, bought by Ricketts
and Shannon.*

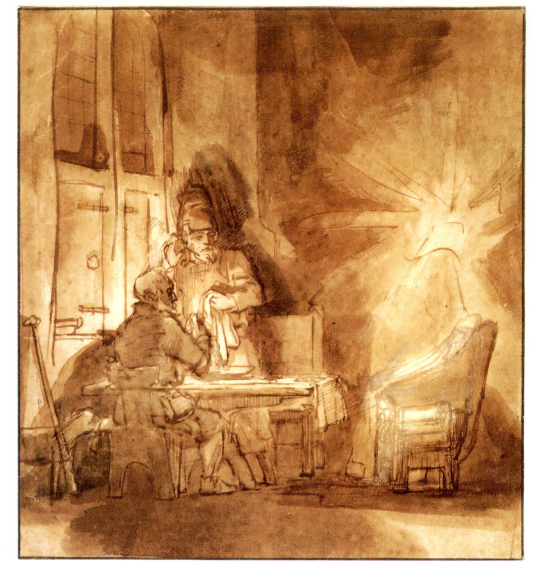

The Emmaus scene is one which
occupied Rembrandt throughout his
career in paintings, drawings and
engravings. The subject (Luke 24: 30–1),
depicts Christ's miraculous appearance
before his disciples after his resurrection
from the tomb: ''And it came to pass, as he
sat at meat with them, he took bread and
blessed it, and brake, and gave it to them.
And their eyes were opened, and they
knew him, and he vanished out of their
sight.''.

This drawing is related to a print,
possibly after a lost painting, dated 1634
(White and Boon, *op. cit.* cat. 87,
Amsterdam, 1969, no. 43, I), but differs in
its more dramatic presentation of the event.
By their relatively subdued gestures and
expression, Rembrandt brilliantly conveys
the disciples' overwhelming sense of awe.
Bold contrasts of shadow and light enhance
the psychological intensity of the drama:
the disciples in the darkness of disbelief,
Christ triumphant in the light of spiritual
salvation. As Benesch observes (*Benesch*,
vol. I, no. 11, p. 5), this conception
completely reverses an earlier idea for the
subject in a drawing of about 1629,
formerly in the W. Bode collection, in
which the figures of the Apostles almost
fade in the spiritual penumbra emanating
from Christ.

The attribution to Rembrandt has not
always been accepted. Benesch hesitated,
considering certain weaknesses in
execution to indicate the work of a faithful
copyist, but later he revised his opinion,
and returned it to Rembrandt's corpus
(Chicago Art Institute, exh. cat., *Rembrandt
after 300 years*, 1969, no. 122, repr.).

Rosenberg observed that the convincing
expression and technique are evidence of
the master's hand; certainly the *pentimenti*
on Christ's chair, and the conception of the
seated disciple, represented as a solid
silhouette, combined with the
psychological effect of light, argue in favour
of its authenticity. This is also argued by J.
G. van Gelder in his account of a visit by
Falconet to Goll van Frankenstein's
collection. There Falconet describes the
Fitzwilliam drawing, pointing out the
figure of Christ, disappearing upwards (in
De Kroniek van het Rembrandthuis,
Amsterdam, 1979, 1, pp. 2–8). Van Gelder
follows Valentiner in dating it 1648–9. Two
prints after the drawing (by J. Buys in 1765
and Ploos van Amstel in 1821) as well as at
least two copies (National Gallery of
Scotland, Edinburgh, no. 2762, and
Dresden (reproduced van Gelder fig. 5))
testify to the drawing's renown.

JAM

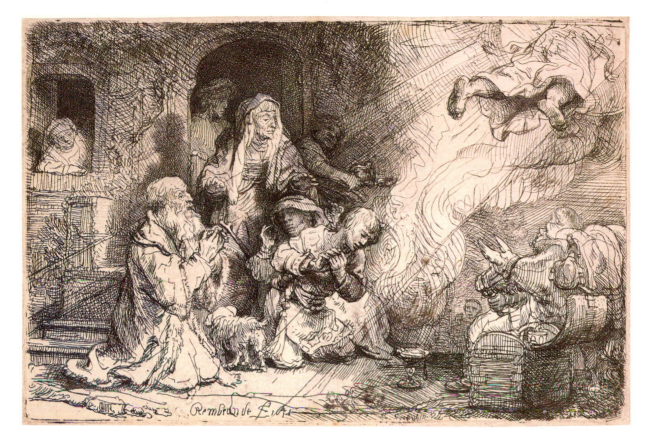

Cat. 89 Charrington 1933

The angel departing from the family of Tobias. 1641

Etching and drypoint printed in black ink on paper. First state
Signed and dated in the plate: *Rembrandt f 1641*
H: 103mm W: 154mm
Given by John Charrington

Rembrandt depicted episodes from the Book of Tobit on several occasions, including an etching of 1651 of *The blindness of Tobit*. Tobit, exiled in Babylon, sent his son Tobias to Media to collect debts. Tobias was accompanied by the angel Raphael in disguise, who advised him to catch a fish and save its entrails. The entrails proved to have miraculous healing powers and, after returning home, Tobias used them to cure his father's blindness. Raphael then revealed himself as an archangel and departed. Tobias praised God for his mercy. This etching shows the last part of the story (Tobit 12:16–22). In the foreground are the valuables which the family offered to Raphael; Rembrandt may have taken the idea for this detail from a painting by his master, Pieter Lastman (Statens Museum, Copenhagen, Inv. No. 3922), the drawing for which Rembrandt retouched in about 1635–7 (*Benesch* 474; Rembrandt House, Amsterdam, no. X).

The composition is remarkable for the novel and dramatic departure of the angel. A painting of this subject by Rembrandt of 1637 (Musée du Louvre, no. 1736) has a similar arrangement of figures except for the angel. A similarly chopped figure was employed in a drawing by Rembrandt of about 1650 (*Benesch* 638a; Ashmolean Museum, no. 184*), and the figure of the angel completely disappears to leave behind a shaft of light in Rembrandt's alteration to a drawing by his pupil C. D. Van Renesse (*Benesch* 1373; Albertina, Inv. 8782).

This is the rare first state (White and Boon, *op. cit.* cat. 87), which exists in only two other known impressions (American private collection; and Bibliothèque Nationale, Paris). It differs from later states in details of shading, but may be treasured chiefly for the freshness of the impression and the rich drypoint which shows wear in later states.

CH

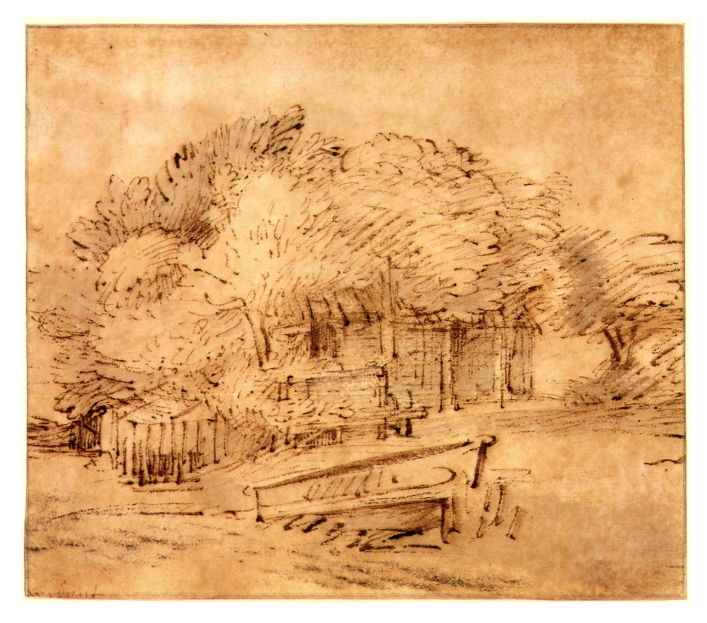

Cat. 90 No. 3106

**Farmhouse beneath trees, with a
footbridge.** About 1652

Reed pen and brown ink, traces of black
chalk and white heightening, grey wash,
on paper
Inscribed bottom left: *Rembrandt*
H: 15.9mm W: 18.2mm; cut down on all
sides
Source unknown, probably acquired at turn
of present century

Ref: *Cormack II*, no. 6

Used in reverse for the etching of
1652 (cat. 91). It is closer to the etching
than the drawings of the same motif in
Rotterdam (*Benesch*, vol. VI, 1272) and in
Berlin (probably Rembrandt school,
Benesch, op. cit., 1273, recto). Rembrandt
made a number of landscape drawings
with a reed pen between 1650 and 1652,
mostly representing clumps of trees and
copses (*Benesch, op. cit.*, 1245–54, 1272–4,
1284–5). The reed pen work in cat. 90 is by
Rembrandt, but the white heightening
and grey washes were almost certainly added
by another seventeenth-century hand. This
was first suggested by Dr. Göpel (Leipzig)
in 1931, and E. Haverkamp-Begeman has
pointed out that in this respect it is similar
to two landscape drawings in the Frick
collection, New York (*Benesch, op. cit.*, 1313,
1325).

CH

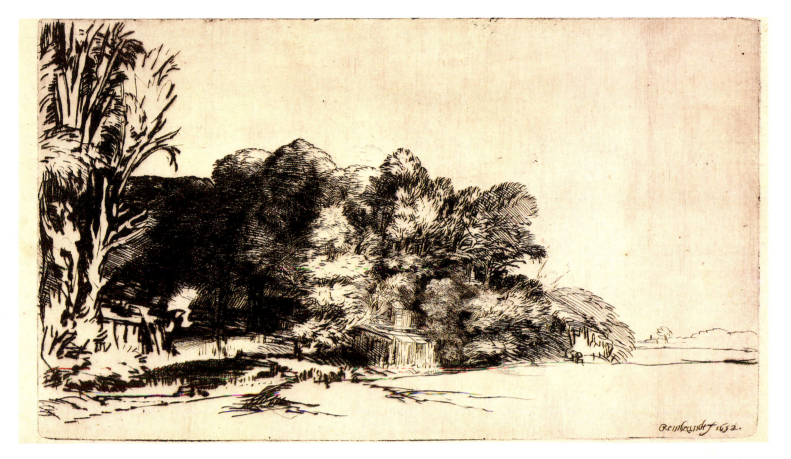

Cat. 91 AD. 12.39-388

Clump of trees with a vista. 1652

Drypoint printed with plate-tone in black ink on paper
H: 124mm W: 211mm
Signed in the plate: *Rembrandt f. 1652*
Transferred from Cambridge University Library 1878

Coll: *Cambridge University Library (L. 2475)*

The view on the left of the print of the hut behind trees is studied in a drawing in the Fitzwilliam Museum, cat. 90. The same motif is seen from a different viewpoint in a drawing in Rotterdam (*Benesch, op. cit.* cat. 90, 1272). The central clump of trees and barn are the subject of a drawing in Berlin (*Benesch, op. cit.*, 1273, recto), which is probably by a follower of Rembrandt.

This is the second state of the print (White and Boon, *op. cit.*, cat. 87, no. 222). The sketchy first state may have been engraved in drypoint direct from nature, whilst the additional work of the second state was probably added in the studio with the aid of the drawings. It seems unlikely that the composition could have been wholly compiled in the studio from the existing drawings.

A painting by a follower of Rembrandt dated 1654 repeats the composition of the print in reverse with a few variations (Montreal Museum of Fine Arts, no. 910). A Rembrandt school drawing, perhaps connected with the painting, is in the Lugt collection (no. 220).

The spontaneous feeling of the print derives mainly from Rembrandt's control of the light effects. He left films of ink on the plate and wiped away highlights so as to evoke the play of sunlight and shade. In early impressions such as this, the burr thrown up by the drypoint needle has not yet worn and has trapped and printed rich deposits of ink.

CH

Cat. 92 PD. 717-1963

SIBERECHTS, Jan
Antwerp 1627 – about 1703 London

Undergrowth by the bank of a stream.
About 1670–80

Black chalk, watercolour and bodycolour on
paper
Inscribed, verso in ink: *From the Devonshire
Collection*
Verso: some rapid sketches in black chalk
H: 391mm W: 327mm
Bequeathed by Sir Bruce Ingram

Coll: *The Dukes of Devonshire; H. S.
Reitlinger; his sale [he was long dead by the
time of the sale], Sotheby's 26 May 1954, lot
480 (as by Patrick Nasmyth), bought
Colnaghi, from whom acquired by testator,
May 1954*

Ref: *Ann. Rep.* 1963, pl. XVI

Siberechts spent the first part of his
career in Antwerp, but by 1674 had
moved to England, where he was
extensively employed as a painter of
decorative landscapes and country house
views.
 The attribution of this more informal
landscape study to Siberechts was first
proposed by James Byam Shaw on the
basis of similarities with the handling of
foliage in his oil paintings, particularly
with a signed painting *The brook*, (T. H.
Fokker *Jan Siberechts,* Brussels, 1931, pl. 30),
although close comparison may also be
made with the pollarded tree in the
background of a painting of 1672, *The ford*,
in the Museum of Fine Arts, Budapest (Inv.
no. 1226).
 Several drawings of a similar type,
tentatively attributed to Siberechts, are in
the British Museum (no. 1909-4-6-8), the
Fondation Custodia, Paris (Inv. no. 4542)
and in the Oppé Collection, London (*The
Paul Oppé Collection,* exh. cat., London,
Royal Academy, 1958, no. 409).

 JAM

Cat. 93 PD. 8-1979

RUBENS, Sir Peter Paul
Siegen 1577–1640 Antwerp

The death of Hippolytus. About 1611

Oil on copper
H: 49.5cm W: 70.2cm
Accepted by Her Majesty's Treasury in lieu
of estate duty and allocated to the
Fitzwilliam Museum

Coll: *The dealer Bryan who brought it to
England; Duke of Bedford (by 1796); Duke of
Bedford sale, Christie's 19 January 1951, lot
55, acquired by Lord Plunket*

Ref: *Acquisitions*, p. 126, no. 5; *Ann. Rep.
1979, pl. XIV*

Hippolytus, accused by his stepmother,
fled from his father Theseus, along
the shore of the Corinthian Sea. His horses
shied as a horned bull blowing water from
its nostrils emerged from a huge wave. A
wheel broke off the chariot and Hippolytus
was dragged to his death by his horses
(Ovid, *Metamorphoses* XV: 497–529).

Painted within a few years of Rubens's
return to Antwerp from Italy, the picture
derives several elements from Italian
sources. The figure of Hippolytus is closely
modelled on Michelangelo's drawing of
Tityus (Windsor, Royal Collection, no. 429).
Rubens adapted the pose in a drawing
from life (Musée du Louvre, no. 1029)
which he also used for his painting of
Prometheus (Philadelphia, W'50-3-1). The
horses derive from Leonardo's cartoon for
The Battle of Anghiari, of which Rubens
made two copies: a drawing in Paris
(Musée du Louvre) and a painting in
Vienna (Akademie, no. 246). The figures
fleeing in the background are reminiscent
of those in Annibale Carracci's *Polyphemus*,
which Rubens studied in Palazzo Farnese,
Rome. The features of the bull derive from
a drawing by Rubens after Jost Amman's
woodcut illustrations to a 1580 edition of
Flavius Josephus (Musée du Louvre, no.
22.608)

A sketchier version (panel, 51cm ×
64.5cm) was in the collection of Count
Antoine Seilern (now Courtauld Institute,
London, no. 19). It omits the shells in the
foreground and the figures fleeing in the
background (Ovid, line 514) and
Hippolytus is less closely modelled on
Michelangelo's *Tityus*. A different version
of the subject, probably earlier, is
preserved in a drawing (Bayonne, Musée
Bonnat) preparatory to a lost painting.

The late Ludwig Burchard sought to
attribute the painting of the litter of shells
and foreground detail to Jan I Breughel, but
the traditional attribution of the entire
painting to Rubens appears correct. The
shells may have been included to flatter the
interests of a particular patron and the
contents of his cabinet.

CH

Cat. 94 No. 1131

BARBIERI, Giovanni Francesco, called
IL GUERCINO
Cento 1591–1666 Bologna

The betrayal of Christ. About 1621

Oil on canvas
H: 113.5cm W: 140.2cm
Given by Capt. R. Langton Douglas, 1921

Coll:*Bartolommeo Fabri, by 1621; Ginetti,
Rome, by 1678; Aldobrandini; Thomas Hope,
by 1818; sale of Hope Heirlooms, Christie's 20
July 1917, lot 96, bought by donor*

Ref: *Paintings II*, p. 76; *Winter, no. 56*

This and a companion picture, *The
Incredulity of Thomas,* now in the
National Gallery, London (no. 3216), were
probably painted for Bartolommeo Fabri in
Cento early in 1621 immediately before
Guercino's departure for Rome. Fabri was
one of Guercino's early patrons and in 1616
had provided two rooms for Guercino's use
as an Academy of the nude. In 1621 both
paintings were engraved by Giovanni
Battista Pasqualini with a dedication to
Fabri.

The maturity of Guercino's early style
shows in its characteristic use of dramatic
lighting and a tightly organised
composition of half-figures, tense with
implied motion. The lighting and the use of
the noose to suggest a nimbus seem to
derive from *The Kiss of Judas* by Ludovico
Carracci in the Art Museum, Princeton
University, No. 87–67. Many other versions
are known: none is generally accepted as
autograph. Two at least of these (Rome,
private collection, and Civica Pinacoteca,
Ascoli Piceno) appear to be seventeenth-
century derivations from the painting
rather than the print. Two studies for the
heads of Christ and one of the soldiers
were recorded in 1694 and 1699 but their
present location is not recorded. A drawing
of Christ being arrested by two soldiers
(Christie's 9 December 1986, lot 47) can
only vaguely be connected with the
painting. For a fuller discussion of it, its
documentation, and the numerous copies,
see Denis Mahon, *Il Guercino, Catalogo
Critico dei Dipinti,* exhibition catalogue of
the Palazzo dell'Archiginnasio, Bologna,
1968, pp. 103–6. To the copies which Mahon
cites can be added: Christie's 13 April 1984,
lot 57; Sotheby's 11 July 1979, lot 326;
Galerie Morgan, Stockholm, 1976;
Pinacoteca Comunale di Fermo; and a
drawing by Franc Caucig, of about 1781–7,
Akademie der Bildenden Künste, no. 997.

CH

Cat. 95 PD. 3-1965

BERRETINI, Pietro, called PIETRO DA CORTONA
Cortona 1596–1669 Rome

The calling of St. Peter and St. Andrew. About 1626–30

Oil on canvas
H: 28cm W: 57cm
Given by the Friends of the Fitzwilliam, with contributions from E. M. Forster, the I.M.E. Hitchcock bequest, and the Regional Fund administered by the Victoria and Albert Museum

Coll: *Marcello Sacchetti, Villa Sacchetti, Castel Fusano, Ostia; Chigi family, Castel Fusano (from 1755); marchese Cavalcanti, by whom sold to P. & D. Colnaghi and Co. Ltd., London, 1962, from whom acquired*

Ref: *Ann. Rep.* 1965, pl. VI; *Paintings II,* pp. 40–1

The subject is from Matthew 4:18–20. This is a study for one of the wall frescoes of the chapel in the Villa Sacchetti (now Chigi) at Castel Fusano. Landscapes with small figures depict the life of Christ and form part of a large scheme of decoration commissioned from Pietro by Marcello Sacchetti, his most important early patron, in 1626; the work was complete in 1630. The study is very close in composition to the fresco, one of the rare views seaward by an Italian painter. A much modified version is at Chatsworth.

Pietro went from Cortona to Rome in 1615, remaining active there for most of the rest of his life. He was one of the most talented artists of the Baroque, engaged as an architect, painter, decorator and designer of tombs and sculpture. Although he had worked on fresco decoration earlier, the Villa Sacchetti commission was the first in which Pietro was in charge. The landscapes in the chapel, and the Fitzwilliam study show his development of Bolognese landscape style, particularly that of Domenichino. Pietro introduced a greater painterly freedom to evoke a more delicate play of light and shade and atmosphere. The rain-shower in the distance of the Fitzwilliam painting is typical of the fresh and immediate rendering of atmospheric effects in his landscape paintings of the 1620s. His interest in landscape paintings did not survive Sacchetti's death in 1629, and it may well have been the patron's interest in the genre (he was himself an amateur landscape painter) which stimulated Pietro.

CH

Cat. 97 No. 2043

VAN DYCK, Sir Anthony
Antwerp 1599–1641 London

Archbishop Laud. 1635

Oil on canvas
H: 120.5cm W: 96cm
C. H. Shannon bequest, 1937

Coll: *Mrs W. F. Wrangham (née Frances
Grimston), 1840-1929, Neaswick Hall,
Driffield, Yorkshire; her sale, Christie's 30
January 1920, lot 267, bought by C. Ricketts
and C. H. Shannon*

Ref: *Darracott, no. 122; Paintings I, pp. 37–8*

William Laud (1573–1645) was
appointed Archbishop of Canterbury
by Charles I in 1633. He was an
ecclesiastical reformer and a highly
successful Chancellor of Oxford University.
Impeached by Parliament in 1640, he was
beheaded in 1645.

In the year of Laud's appointment, Van
Dyck was in residence at Blackfriars as
"principall Paynter to their Majesties". He
was preoccupied with royal portraits, so it
was not until 1635, after a period in
Antwerp, that he was available to paint the
new Primate of All England. The formula
which he chose, of Laud resting his right
arm on the pedestal of a column, was
derived from a drawing which he had
made in Italy after a portrait by Titian. He
had already employed the formula to great
success in the full-length portrait of Cesare

Scaglia (collection of Viscount Camrose,
London), painted in Antwerp in 1634. Laud
is shown three-quarter, rather than full-
length, a choice which probably suited the
purse and stature of the Archbishop, "a
little, low red-faced man" (Symonds
D'Ewes, *Journal,* II, p. 100).

The portrait was justly celebrated and
much reproduced and imitated: over forty
versions were painted in the seventeenth
century. The cleaning of the Fitzwilliam
picture in 1981 revealed an unalloyed
masterpiece by Van Dyck, very probably
the prime version painted for Laud (the
status of this and other versions has been
fully discussed by Michael Jaffé, 'Van Dyck
Studies I: The portrait of Archbishop
Laud', *Burl. Mag.* CXXIV, October 1982,
pp. 600–6). Particularly beautiful is the
expressive life of the hands, which concerts
with the piercing gaze to produce an air of
impatient authority. The fluency and subtle
luminosity of the draperies convey no less
convincingly the unsurpassed sensitivity of
Van Dyck's handling of paint.

The provenance between 1640 and 1920
of the Fitzwilliam picture remains obscure,
but it may have been removed from
Lambeth Palace, perhaps for safe-keeping
by a supporter of Laud. An old label stuck
to the back, inscribed *L 783 Graham Picture*
might suggest a connection with the
Grahams of Esk, who were raised to the
baronetcy by Charles II for services during
the Civil Wars. After the Restoration, a
substitute, post-Restoration, version was
installed at Lambeth Palace; the
substitution has continued to mislead
writers into accepting the picture at

Lambeth as the original. Another version,
in the Hermitage, Leningrad (no. 1698), has
also been considered as the original and is
certainly from Van Dyck's studio. Its
earliest known owner was Sir Henry Vane,
whose agent sold it to Philip, 4th Baron
Wharton, in 1656 in a group of Van Dyck's
called "Original coppyes". It may be the
same hand as the version dated 1635 which
Laud sent to the President and Fellows of
his own college at Oxford, St. John's. A
studio version, by a different hand, is at
Reading School; it was in the possession of
James, 3rd Marquess of Hamilton, by 1643.
All three of these studio versions alter and
spoil the Archbishop's hands, which are so
sensitively and naturally deployed in the
original. The only version faithfully to
convey the hands of the Fitzwilliam
painting is at Welbeck Abbey and is of
markedly superior quality to the other
studio replicas; nothing is known of its
early provenance.

From the studio versions it is evident
that Van Dyck employed as many as three
assistants at Blackfriars to produce replicas.
Unlike Rubens he was not in the habit of
touching and retouching the efforts of
assistants to bring their work nearer to his
own level. Nor did he make sure that
justice was done to the particular qualities
of the original. Prints after the portrait
derive from studio versions, which, after
Laud's death, were better known than the
original. Only a bust-length engraving by
Wenzel Hollar of 1640 (reissued 1641) seems
to have used the Fitzwilliam picture as a
model.

CH

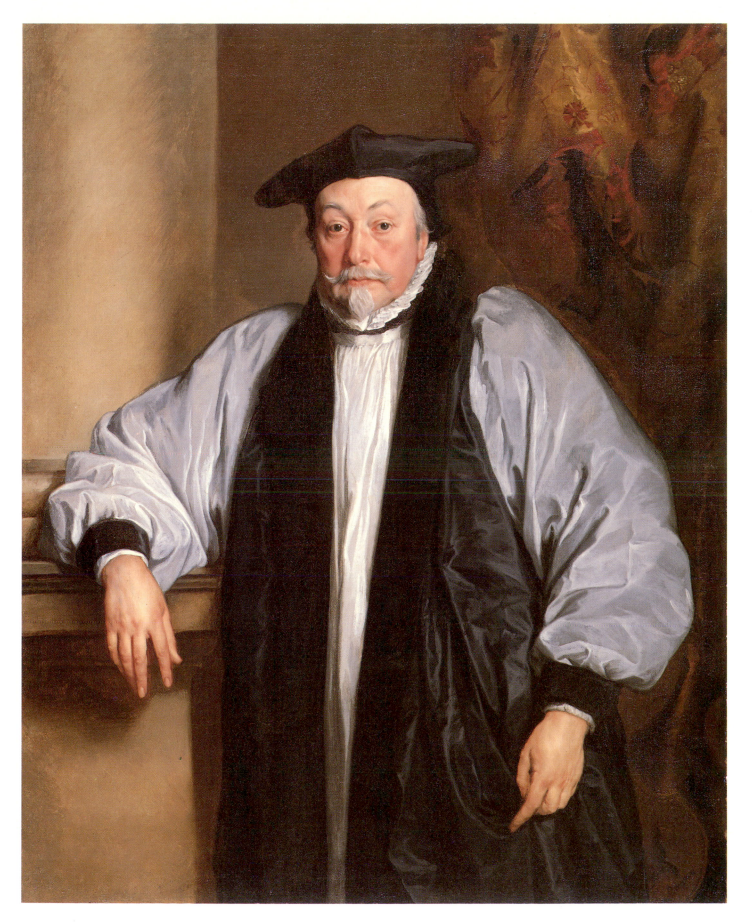

Cat. 96 PD. 59-1974

BOSSCHAERT, Ambrosius II
?Arnemuiden 1609–1645 Utrecht

Vase of flowers with a monkey. About
1635

Oil on canvas
Signed: *A. Bosschaert*
H: 141.5cm W: 103cm
Bequeathed by Henry Rogers Broughton,
2nd Lord Fairhaven

Ambrosius II worked in Utrecht. He was
the eldest brother in a family of
flower-painters which included his father,
Ambrosius I (1573–1621), his brothers
Johannes (1610/11 – about 1640) and
Abraham (about 1613–43) and his uncle
Balthasar van der Ast (1593/4–1657). His
earliest flower-pieces resemble those of his
father in their neat bouquets and
monogrammed signatures. The style and
form of signature of this painting place it
among his more complex and animated
compositions of the mid-1630s and later.
He usually painted on a small scale. This
exceptionally large canvas recalls the
showpiece painted by his father in 1620
(Nationalmuseum, Stockholm, no. 373) in
its ambitious scale and in the form of the
vase.

Like most flower-painters of the time,
Ambrosius II painted from separate
drawings of flowers which were assembled
into a bouquet on the canvas. This allowed
the combination of flowers which bloomed
at different times of the year, and it
accounts for the replication in other works
of some of the flowers in this painting, e.g.
the uppermost of the two striped tulips on
the left occurs in an exactly similar form at
the top of the flower-piece formerly in the
Chabot-Steenberg collection (L.F. Bol,
Bosschaert Dynasty, Leigh-on-Sea, 1960, no.
8), which has the same form of signature;
the stem of lilies of the valley at the bottom
and the rose nearest to it also appear in a
painting dated 1633 formerly in the P.
Landry collection (Bol. *op. cit.,* no. 11),
which has an earlier form of signature.

The popularity of flower painting in
seventeenth-century Holland reflects the
interest in horticulture and botanical
illustration. The tulip, which had been
introduced from Turkey about 1560, incited
a craze which reached its height in the
1630s. Tulip bulbs, particularly of the
striped variety, changed hands for
astronomical sums before the market
crashed in 1637. Flowers were also painted
for the symbolic meanings which they had
earlier carried in religious paintings.
However, it is wrong to expect every
bouquet to hold a message beyond a vague
reminder of the beauty and transience of
life. The grapes, pomegranate and butterfly
painted here may refer to the immortality
of the soul through the Resurrection, or
they may just be included as established
parts of the repertoire of flower-painting.
The monkey is a more unusual feature: it
may be just a representative of the natural
world, or it may represent man's folly in
valuing earthly things (in a painting in the
Frans Hals Museum, Haarlem, Jan Breughel
II satirised tulipomaniacs by depicting
them as monkeys at a tulip-sale).

CH

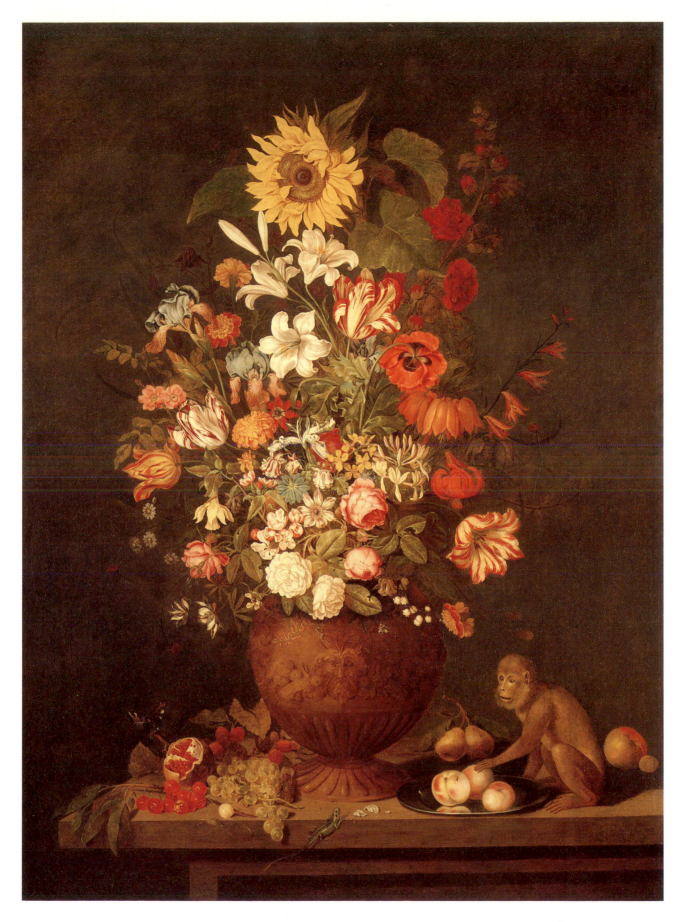

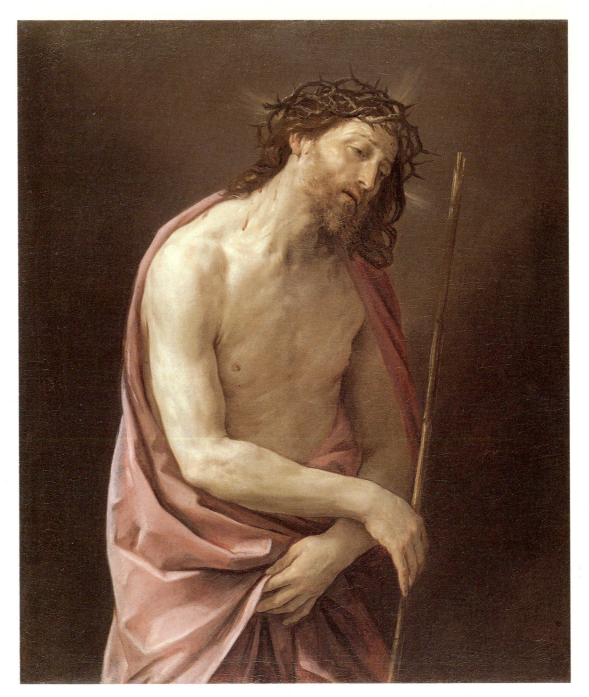

Cat. 98 No. 2546

RENI, Guido
Calvenzano 1575–1642 Bologna

Man of sorrows. About 1639

Oil on canvas
H: 111.7cm W: 94.2cm
Given by Mrs. Sigismund Goetze, 1943

Coll: *Prince Lucien Bonaparte by 1808;*
Bonaparte sale, New Gallery, 60 Pall Mall
London, 1815, bought by Sir Thomas Baring;
bought by his second son, Thomas Baring

(1848), who bequeathed it to his nephew,
Thomas George Baring, 1st Earl of Northbrook
(1873); Northbrook sale, Christie's 12
December 1919, lot 127, bought by Goetze

Ref: *Paintings II*, pp. 156–7; *Winter*, no. 58

One of Guido's late masterpieces,
comparable in treatment with
Christ crowned with thorns (Musée du
Louvre, no. 528) and *The Crucifixion*
(Galleria Estense, Modena, no. 282). It is a
supreme example of the sublety of his
colouring, and conveys the intense emotion
of human suffering with great economy of

means. There is a copy in the Musée des
Beaux-Arts, Nantes (no. 1903).

Guido was a pupil of the Carracci in
Bologna, which remained his home except
for three sojourns in Rome (1600–4, 1607–
11, and 1612–14). He enjoyed early success
in Rome, receiving major commissions for
frescoes and altarpieces, which revealed an
assured and flexible classicising style. He
was the dominant force in Bolognese
painting from the 1620s and the last decade
of his life was the most productive (D.
Stephen Pepper, *Guido Reni*, Oxford, 1984,
passim).

CH

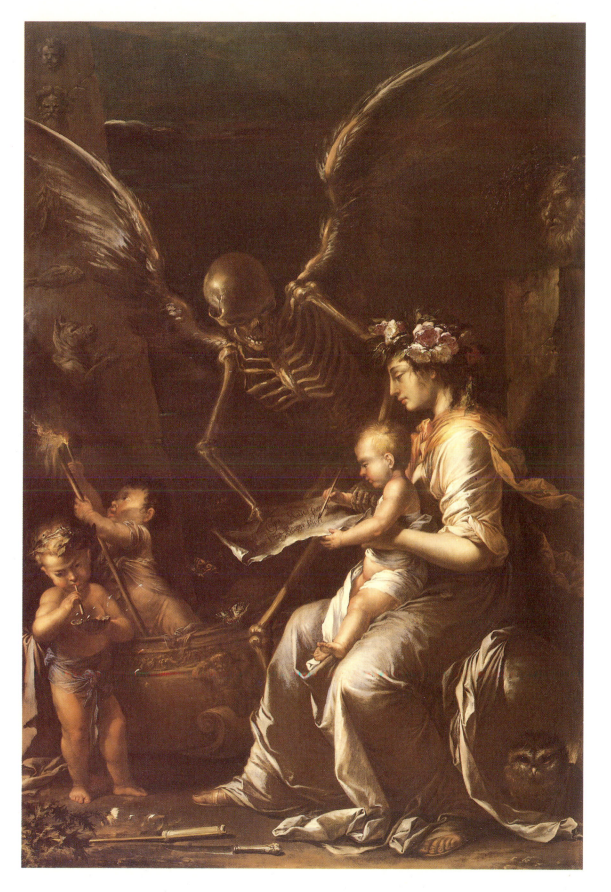

Cat. 99 **L'Umana fragilità**

Cat. 99 PD. 53-1958

ROSA, Salvator
Naples 1615–1673 Rome

L'Umana fragilità. About 1656

Oil on canvas
Signed with monogram on the knife-blade
H: 197.4cm W: 131.5cm
Bought from the L. D. Cunliffe Fund

Coll: *Cardinal Flavio Chigi (about 1630–1690); by descent; John, 2nd Lord Northwick (1770-1859); his sale, Thirlestane House, Cheltenham, Philips 26 July 1859, lot 1120, bought Agnew; sold to R. C. Fergusson, 1859; by descent to Lt. Col. Wallace Cunninghame; his sale, Christie's 7 March 1958, lot 28, bought by Knoedler*

Ref: *Ann. Rep.* 1958, pl. I; *Paintings II*, pp. 139–43

Although the symbolism appears complex, all the elements allude to a simple theme: human frailty and the transitoriness of life. The inscription which the baby writes on the paper, his hand guided by the Skeleton of Death, sets out the pessimistic message of the picture: "Conceptio Culpa, Nasci Pena, Labor Vita, Necesse Mori" (Conception is Sinful; Birth a Punishment; Life, Hard Labour; Death Inevitable). The words come from a poem by the twelfth-century writer Adam of St. Victor; all but the opening phrase were alluded to in a letter to the artist from his friend G. B. Ricciardi, for which Rosa thanked him in a letter of July 1652 (GB Cefareo, *Poesie e lettere edite e inedite di Salvator Rosa*, Naples, 1892, p. 143, letter XC). This association and the stylistic and iconographic similarities to Rosa's painting of *Democritus* (Statens Museum for Kunst, Copenhagen, no. 597) have led some to date the picture 1651–2; but, given the equally strong stylistic relationship with *La Fortuna* of 1658 (Malibu, J. Paul Getty Museum), the painting may be later, and most recent references date the picture about 1656. The later dating is supported by the fact that Flavio Chigi, probably the picture's first owner, only returned to Rome in 1656; he was made a cardinal in the following year.

Three drawings are connected (Dwight C. Miller, 'A preparatory study for Salvator Rosa's L'Umana fragilità', *Burl. Mag.*, April 1977, vol. CXIX, p. 272, figs. 63-5). One is probably a record of the composition rather than a preparatory study (private collection, Warwickshire). The drawing at Leipzig (Museum der Bildenden Künste) is an early scheme for the composition: the woman

faces to the right, the child does not sit on her lap and there are fewer symbolic references than in the final picture. The Leipzig drawing develops a compositional idea derived from Dürer's engraving *Melancolia I*, which Rosa had previously developed in his painting *La filosofia* (Enzenberg collection, Caldaro, Bolzano). A third drawing (Weisgall collection, formerly on loan to the E. B. Crocker Gallery, Sacramento) brings the composition closer to the final painting. The direction of the composition is reversed (bringing it closer also to *Melancolia I*) and the child is placed on the woman's lap – strongly suggesting that she is its mother. At this stage, and in the final painting, the artist included more and more recondite symbols. The gloomy, smouldering atmosphere of the painting binds together the allegorical elements, the chief of which can be interpreted as follows: the woman's crown of roses represents love and its evanescence; Death's wings, his speed; the glass sphere on which the woman sits, the fragility of worldly fortune and achievement; the sculptured head behind her, Terminus, god of Death (cf. cat. 48); the owl, an ill-omen of death; the knife, death and separation; the soap bubbles round the *putti* to the left, the spent rocket and the butterflies refer to the brevity of life; the easily scattered seeds of the thistle emphasise its frailty and the *putto* in the cradle sets fire to some tow which will soon die down (tow was ignited at the coronation of a Pope to the accompaniment of the words "Pater sancte sic transit gloria mundi"); the obelisk behind the *putti* is a funerary emblem and has five reliefs, which refer to the ages of man (the head of a baby and that of an old man establish the theme; the fish represents hatred and death; the falcon, human vitality; the hippopotamus, the violence and discord in which man ends his days). Many of these elements were common in allegorical pictures of human vanity; others were explained in books of symbols which artists used as a source, such as Piero Valeriano's *Hieroglyphia*, 1st ed. Basle, 1556, and Michael Jaffé has suggested the skeleton may derive from the engraving of *Deux hommes écorchés accompagnés de leurs squelettes* by Domenico del Barbiere after Rosso Fiorentino (*Bartsch* 8).

Rosa went to Rome with ambitions as a history painter but enjoyed more success with his *banditti* and hermit saints, which were seen later, in eighteenth-century England, as the epitome of the 'sublime' in painting. It is therefore not surprising that *L'Umana fragilità* entered an English

collection. The intellectual elements are treated in Rosa's most 'sublime' manner: the tenebrous hues of his Neapolitan training, the pungent whiff of his interest in alchemy and witchcraft and the profound pessimism which it is hard not to interpret in terms of Rosa's own febrile temperament. In contemplating the bitter message of the pointlessness of conception and the brevity of life, it is worth bearing in mind that both the brother and the son of the artist died in 1656.

 CH

Cat. 100 No. 150

HALS, Frans
Probably Antwerp about 1580/83–1666 Haarlem

Portrait of an unknown man. About 1660–6

Oil on canvas
Connected monogram: *FH*
H: 79cm W: 65.4cm
Given by Joseph Prior, 1879

Coll: *Rev. R. E. Kerrich*

Ref: *Paintings I*, pp. 56–7; *Winter*, no. 67

All writers on Hals have dated this picture to the last six years of his life. The extraordinarily free and vigorous brushwork, made more apparent by cleaning, undertaken especially for this exhibition, shows his bravura at its most extreme and brilliant. During this cleaning Karen Groen demonstrated the survival of traces of selvage on both left and right edges of the canvas, showing that Hals was using a bale with a width of 70cm. Cleaning has also confirmed scientifically that Hals used only two pigments in this painting besides black and white: a red and a yellow. X-radiographs reveal a different head and shoulders, upper left.

Other late portraits of unidentifiable men are comparable, particularly those in the Museum of Fine Arts, Boston (no. 66.1054), and the Musée Jacquemart-André, Paris (no. 427). The bold handling of these works and the light tonality and restricted palette of the Paris portrait are close to the Fitzwilliam picture.

Cleaning in 1949 revealed the hat and the silver-grey background which had been overpainted with an opaque dark-brown, probably in the late eighteenth or early nineteenth century; traces of overpaint, particularly in the background and the hat, have only recently been removed. A coarsely painted, reduced copy, made after

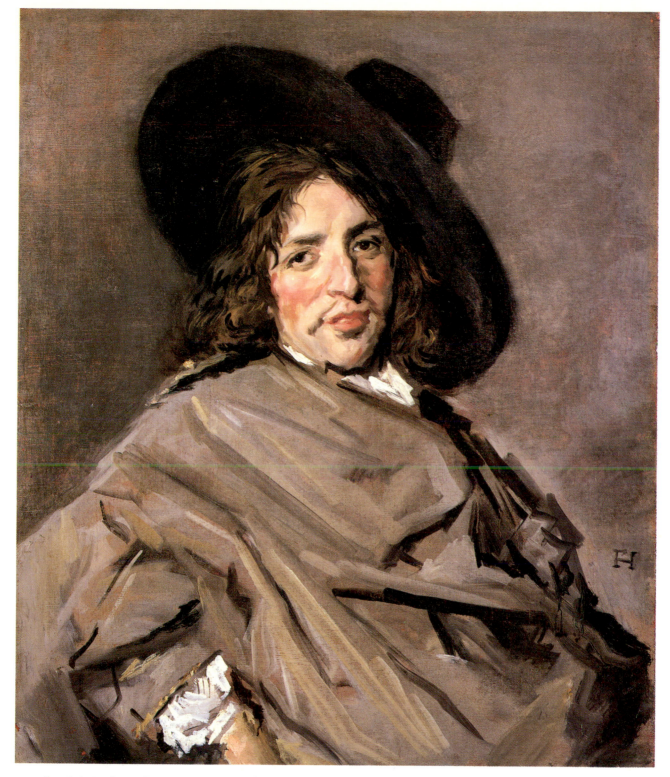

the hat was overpainted, is in the Hallwyl collection, Stockholm (no. B.146). The *Portrait of a seated man* in the Hermitage, Leningrad (inv. no. 772) was subjected to a similar overpainting to accord with similarly changed taste.

Seymour Slive (*Frans Hals*, 3 vols., London and New York, 1970–4, vol. II, p. 201) suggests that the portrait reflects a change of taste in men's clothing in mid-seventeenth century Holland. A number of contemporary Dutch paintings show grey cloaks, like this one, thrown across the chest and shoulders, for example Vermeer's *Young woman drinking with man* (Staatliche Museen, Berlin, no. 912c). Men are also shown wearing hats at an angle – though not usually at so rakish a slant as this. The disposition of the costume contributes to the characterisation of the sitter, which is typical of the unidealised treatment in late portraits by Hals.

CH

101

Cat. 101 PD. 13-1972

DOLCI, Carlo
Florence 1616–1686 Florence

Sir Thomas Baines 1622–1681. About
1665–70

Oil on canvas
H: 86.3cm W: 70.8cm
Given by the NACF

Coll: *Sir John Finch; by descent to the Earls of
Winchelsea and Nottingham, Burley-on-the-
Hill; Major Jones, Hamburg sale, Christie's 20
June 1947, lot 19; Sir Thomas Barlow; S.W.
Christie-Miller, from whose estate acquired*

Ref: *Ann. Rep.* 1972, pl. IX; *Lely to Hockney*,
no. 3

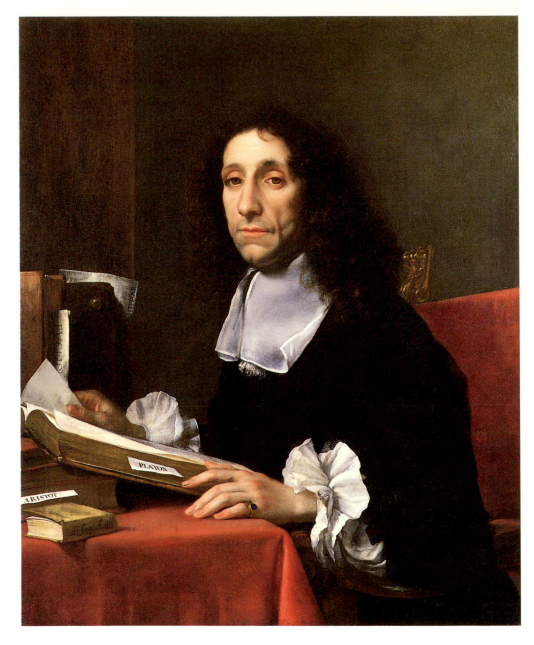

A companion portrait to the *Sir John
Finch*, acquired by the Fitzwilliam at
the same time, both in their original frames
(PD.12-1972). They were painted in
Florence between 1665 and 1670 during the
period of Finch's Residency as Minister to
the Grand Duke of Tuscany. The
contemporary art-historian Baldinucci
refers to Dolci's portraits of Finch and
''dottor Fava, suo confidentissimo
gentiluomo''. *Fava* is Italian for beans, i.e.
Baines! (F. Baldinucci, *Notizie dei Professori
del Disegno da Cimabue in qua*, VI, Florence,
1728, p. 503.)

Finch and Baines had been inseparable
companions since they met as students in
Cambridge. Baines was admitted to
Christ's College as a pensioner in 1638, and
Finch in 1645. Both became pupils of Henry
More a Cambridge Platonist, and travelled
to Padua together in 1651 to study
medicine. When they returned to England
in 1661 Baines was appointed Gresham
Professor of Music at London. They both
became Extraordinary Fellows of the Royal
College of Physicians and Nomination
Fellows of the Royal Society. Finch was
knighted in 1661, and Baines in 1672. In
1665 Baines accompanied Finch on his
diplomatic postings, first to Florence, and
in 1672 to Constantinople, where they were
known as 'the Ambassador and the
Chevalier'. Baines died in 1681 and his
body was brought back to England by
Finch to be interred in Christ's College
Chapel, where Finch himself was buried a
year later.

Their portraits have remained together.

That of Baines is the finer: an outstanding
example of Dolci's portraiture at the height
of his career as a fashionable painter in
Florence. In comparison with Dolci's earlier
portraits the pair shows more serious
interest in the physical and psychological
portrayal of the sitters. Baines is shown
with the meditative calm and attributes of a
scholar, whereas Finch holds a letter and
seems preoccupied with the cares of
diplomacy. Finch's patronage of Dolci

extended to several history paintings,
including the *Salome* and *Magdalene* which
he gave to Charles II and Queen Catherine
(Royal Collections, Hampton Court, 1428
and 1427). For Finch's patronage of Dolci,
see Charles McCorquodale, 'Some
paintings and drawings by Carlo Dolci in
British collections', *Kunst des Barock in der
Toskana*, Florence-Munich, 1976, pp. 313–20.

CH

Cat. 102 PD. 60-1974

MONNOYER, Jean Baptiste
Lille 1636 – 1699 London

An urn of flowers. 1698

Oil on canvas
Signed: *J. Baptiste Pinxit/1698*
H: 161.3cm W: 114.5cm
Bequeathed by Henry Rogers Broughton,
2nd Lord Fairhaven, 1973

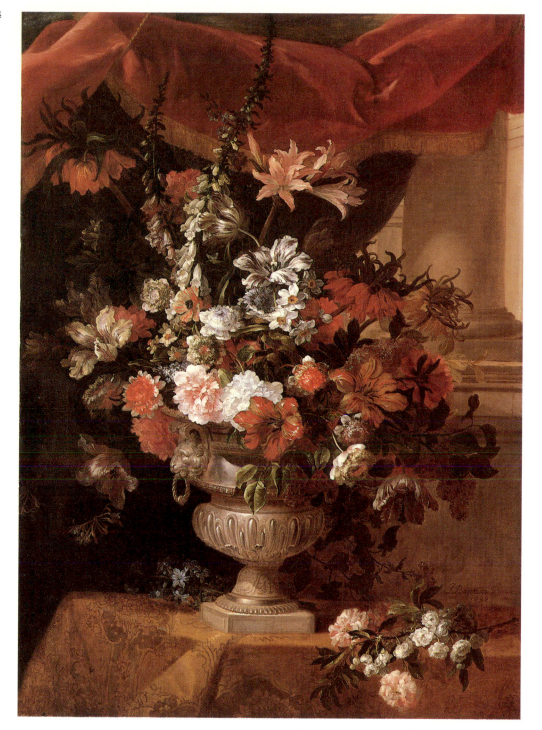

Monnoyer established his reputation in Paris. He became the principal flower painter to Louis XIV and was much patronised by the French aristocracy. Some sixty of his paintings decorate the palace at Versailles, and he also contributed to the decoration of the royal residences at Vincennes, Trianon, Meudon and Marly. His successful decorative style set a pattern for the adornment of great houses, and his fame spread to England. In 1678 the Duke of Montagu, English ambassador to Louis XIV, commissioned Monnoyer, together with Charles de Lafosse and Jacques Rousseau, to decorate his house in Bloomsbury – later to become the British Museum. Queen Mary and various noble patrons also commissioned works from Monnoyer, who remained in London from 1690 until his death in 1699.

This grand flower-piece must have been painted in London. It is typical of his assured, flamboyant style and inventive sense of composition. Much of his work suffers from the help of assistants (including his son Antoine, 1672–1747), but here there seems to have been little interference. The urn is an example of the grandiose silver work with heavy cast ornament produced in France under Louis XIV. Most large-scale silver was subsequently melted down and is known today principally through paintings, prints and tapestries (but see cat. 78).

Henry Broughton, 2nd Lord Fairhaven, was an avid collector of flower-pieces. By gift and bequest he provided the Fitzwilliam Museum with 119 paintings and over 900 drawings.

CH

Cat. 103 M. 65-1937

WILTON, Joseph
London 1722 – 1803 London

**William Pitt, 1st Earl of Chatham
(1708–1778). 1766**

Marble
H: 78cm W: 50cm D: 31cm
Socle: H: 15cm Diameter: 20.2cm
Given by the Friends of the Fitzwilliam

Coll: *Dukes of Newcastle at Clumber Park;
Earl of Lincoln's Clumber sale, Christie's 19
October 1937, lot 344, from which acquired*

Ref: *FOF.* 1937, p. 4, no. 3b

Wilton was sent by his father, a maker of architectural ornament in plaster and *papier mâché*, to train in Nivelles with Laurent Delvaux, a sculptor who had previously collaborated in England with Scheemakers before returning to Flanders in 1733. He studied in Paris with Jean-Baptiste Pigalle (cat. 104) from 1744, travelling to Rome about 1747, and to Florence about 1750. He returned to England in the company of the architect William Chambers, whose continuing friendship brought him noble and royal patrons (M. Whinney, *Sculpture in Britain 1530–1830*, London, 1964, pp. 137–9).

Cat. 103 was acquired, without identification, with another identically socled bust, the date and artist being assumed because of the inscription on the other. Ellis Waterhouse was the first to identify it as Pitt, on the basis of the bust acquired in 1947 by the Scottish National Portrait Gallery (no. 1493), inscribed and dated on the plinth to 1759. This may indicate the date of execution, or may commemorate the victories of that year at the end of the Seven Years' War.

1766, the year of the repeal of the Stamp Act, brought in response to colonial gratitude a plethora of Wilton Pitts: full-size marbles were erected in Cork, South Carolina and New York, Wilton being recommended by Pitt. If, as seems likely, the unidentified pair to cat. 103 is the 1st Duke of Newcastle, with whom Pitt both shared, and jostled for, power, the date of 1766 is most likely to be correct.

The Fogg Museum possesses a similar bust in terracotta, given by Benjamin Franklin in 1769, and Wedgwood's 1779 catalogue includes a basaltes bust after the Wilton.

A variant, dated 1780 and based on a death mask, is in the collection of the Duke of Rutland (J. Carslake, *Early Georgian Portraits*, London, 1977, p. 48). Another, signed and dated 1781, was in an English private collection in 1983.

Also carved in 1766 is the life-size marble of King George II in the Senate House of the University of Cambridge. In 1768 Wilton was one of three sculptors who were Foundation Members of the Royal Academy of Arts.

RAC

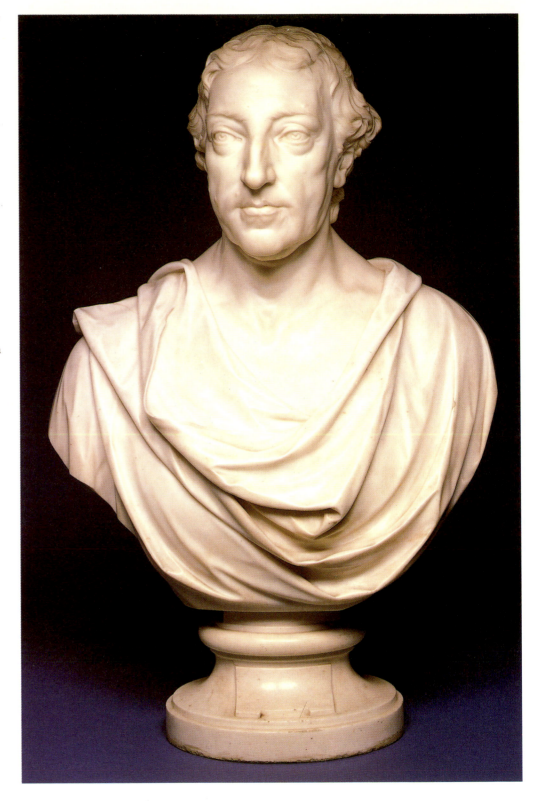

Cat. 104 M. 1-1979

PIGALLE, Jean-Baptiste
Paris 1714 – 1785 Paris

Pierre-Louis-Marie Maloët (1730–1810).
About 1775–85

Bronze, cast and chased, on marble socle
H: 61cm W: 55cm D: 30.4cm
Socle: H: 14.5cm Diameter: 16.5cm
Bought from the Gow Fund, with
contributions from the NACF and the
Regional Fund administered by the Victoria
and Albert Museum

Coll: *Baron Pichon (d. about 1898); M.
Lowengard; M. Gilles; Dr. Georges Tuffier (all
in Paris); sale, Ader, Picard and Tajan, Paris,
29 November 1973; with Artemis, London,
from whom bought*

Ref: *Ann. Rep.* 1979, pl. XXI

Probably best known for *Mercury
fastening his sandals*, the marble
commissioned by Louis XV in 1748 and
given to the King of Prussia in 1750, Pigalle
also executed a relatively small number of
portrait busts, including at least four
doctors or surgeons.

Despite the lack of traceable provenance
before the Pichon collection, the
identification is confirmed by comparison
with the engraving dated 1786 by St. Aubin
after C. N. Cochin (E. Bocher, *Augustin de
Saint Aubin*, Paris, 1879, no. 162). The
appearance supports the dating proposed
by Rocheblave, although he had never seen
the bust, to the last ten years of Pigalle's
life. (S. Rocheblave, *Jean-Baptiste Pigalle*,
Paris, 1919, p. 385).

The chasing and finishing of the cast is
meticulous in attention to textural detail,
particularly of flesh, fabric and hair.

Maloët was personal physician to Mmes.
Adelaide and Victoire, daughters of Louis
XV, accompanying them into exile in Rome
in 1791, suffering as an emigré distraint of
possessions. After the establishment of the
Empire he was appointed one of
Napoleon's doctors. He published a
pioneering report in 1783 on the use of
electricity in the treatment of nervous
disorders.

 RAC

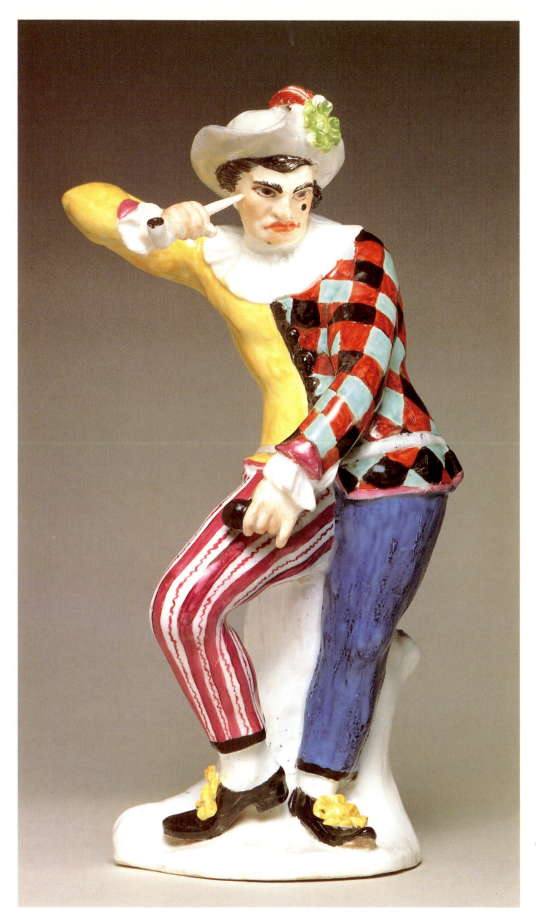

Cat. 105 C. 1-1951

The angry Harlequin. About 1740

Modeller: Johann Joachim Kaendler (1706–75)
Hard-paste porcelain painted in enamel-colours
H: 18.7cm
Bought from the Cowper Reed Fund

Ref: *Ann. Rep.* 1951, pl. III; *Treasures*, no. 78; *Winter*, no. 78

Johann Joachim Kaendler joined the staff of the Meissen porcelain factory in 1731 and was appointed chief modeller in 1733. Initially he produced many wonderfully lifelike models of animals and birds for the Japanese Palace in Dresden, but from about 1735 turned his attention to small-scale human figures. By the end of the 1730s he had developed these as an independent European genre, which had a functional role as table decoration.

Kaendler was an acute observer of character and as a result the postures and expressions of his human figures are extremely convincing. They mirror the gamut of mid-eighteenth-century society from beggars to kings, but not unnaturally the subjects chosen reflect chiefly the interests, activities and amusements of the Court at Dresden. Among the last, the exploits of Harlequin and his companions in the *Commedia dell'Arte* provided a fertile source of inspiration for the depiction of human emotions and predicaments. Kaendler portrayed several of the well-known characters, singly and in groups. Harlequin was usually modelled in a mischievous, playful or even pensive mood. Here, in contrast, he is shown glowering angrily. *The scowling* or *angry Harlequin* is not one of Kaendler's most amiable figures, but its strong pose and bold colouring make it one of his most forceful.

JEP

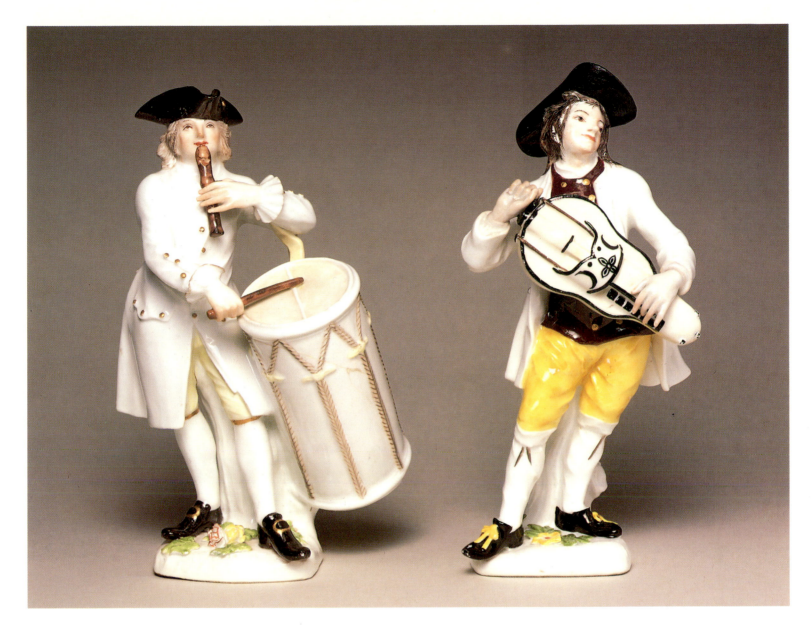

Cat. 106–7 C. 27-1954 & C.32-1954

Cat. 106 **Provençal drummer**
Cat. 107 **Hurdy-gurdy player**
About 1745

Modeller: Peter Reinicke (1715–68)
Hard-paste porcelain painted in enamel-
colours and gilt
Cat. 106: H: 20.2cm
Cat. 107: H: 19cm
Given by the 2nd Lord and Lady Fisher of
Kilverstone through the NACF

Ref: *Ann. Rep.* 1954, pl. III; *Poole, I* p. 51, H8

These figures belong to a set of
Cries of Paris, which were modelled at
Meissen by Peter Reinicke or by Reinicke
and Kaendler between 1745 and 1747. They
were derived from engravings by the
Comte de Caylus (1692–1765) after
drawings by Edmé Bouchardon (1689–
1762). These prints, entitled *Études prises
dans le bas Peuple ou les Cris de Paris,* were
issued in sets of twelve, two in 1737, and
one in 1738, 1742 and 1746. The complete
series, accompanied by the drawings, was
bound and given by Bouchardon to his
friend Jean-Pierre Mariette, the celebrated
Parisian printseller and connoisseur
(British Museum Print Room, Imp. 197.8c).

Between 1736 and 1746 Meissen acquired
many French prints as source material for
its modellers and painters. It is not clear
when the *Cris de Paris* arrived, but a dozen
of the prints remain in the factory's
archives. The *Hurdy-gurdy player* and the
Drummer were derived from the eighth and
ninth prints in the fourth set published in
1742: *Le Vieilleux* and the *Provençal*
respectively. Curiously, while some figures,
such as the *Map seller, Baker's boy* and
Tinker were modelled to match the prints,
others, including the *Hurdy-gurdy player*
and *Provençal drummer,* were transposed
and correspond with the original drawings.

During the mid-eighteenth century the
upper classes showed considerable interest
in the more picturesque aspects of low life
and these figures, so evocative of the lively
bustle of Parisian streets, were an
immediate success. They were followed
about 1750 by a series of *Cries of London*
derived from engravings by Pierre Tempest
after Marcellus Laroon, and in the mid-
1750s by further *Cries of Paris* after designs
commissioned from Christophe Huet
(d. 1759) and dated 1753.

JEP

107

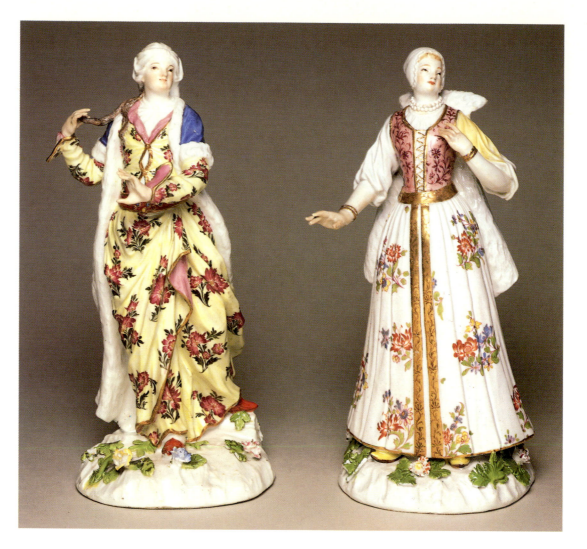

Cat. 108–9 C. 41-1950 & C. 47-1954

Cat. 108 Sultana Asseki
Cat. 109 Hungarian lady
About 1750

Modellers: Johann Joachim Kaendler (1706–75)
Peter Reinicke (1715–68)

Hard-paste porcelain painted in enamel-colours and gilt
Mark: crossed swords underglaze in blue
Cat. 108: H: 22.2cm
Cat. 109: H: 21.7cm
Given by the 2nd Lord and Lady Fisher of Kilverstone through the NACF

Ref: *Poole II,* p. 45, G1b (cat. 109)

During the eighteenth century Europeans were fascinated by the exotic costumes and customs of the Ottoman Empire, and their interest was stimulated by the publication of illustrated books on costume and other topics. Among the best-known of these was the Comte de

Ferriol and Le Hay's *Recueil de cent estampes représentant différentes nations du Levant,* Paris, 1714. This was reprinted in 1715 and a smaller German edition in two volumes with the plates reversed was published by Christoph Weigel at Nuremburg in 1719 and 1721, with the title *Wahreste und neueste Abbildung des Türchischen Hofes.*

The plates in the *Recueil* were engraved from drawings made in 1707 and 1708 by Jean-Baptiste Vanmour (1671-1737), who was a member of the Comte de Ferriol's entourage during the ten years from 1699 which he spent as Louis XVI's ambassador to the Sublime Porte. They depicted the Sultan, his Court, and the various people of the Ottoman Empire who frequented Istanbul.

A selection of plates from the *Recueil* or the German edition served as designs for a series of Meissen figures popularly known as *The Levantines,* which were modelled by Kaendler and Reinicke in 1749-50. The *Sultana Asseki* (the title given to the Sultan's second wife who had borne a son)

corresponds to the transposed pl. 3 in the Nuremburg edition, but has a more elongated figure and stylised pose. The *Hungarian lady,* who matches pl. 77 in the Paris edition, has a more static pose, in keeping with her costume. Both figures lean back slightly from the waist, in a manner characteristic of many mid-eighteenth-century Meissen figures. The Fitzwilliam collection also includes the *Hungarian gentleman,* the *Bulgarian* and *Bulgarian maiden,* the *Persian* and *Persian lady,* the *Crimean Tartar,* and the *Albanian soldier.*

This series of figures was one of the most influential produced by Meissen. Several models from it were imitated by other German factories, such as Ansbach, Fulda, Höchst and Kloster-Weilsdorf. The illustrations in the *Recueil* or Meissen models also inspired sets or individual models at Doccia in Italy, the Imperial Porcelain Factory in St. Petersburg, Copenhagen in Denmark, and Liverpool and Longton Hall in England.

JEP

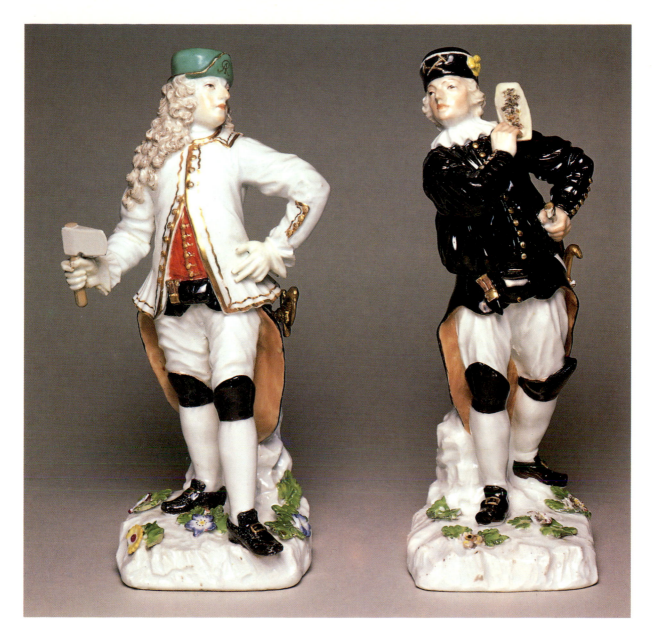

Cat. 110–11 C. 34-1954 & C. 39-1954

Cat. 110 **Mine Commandant**
Cat. 111 **Mine Inspector**
About 1750

Modeller: Johann Joachim Kaendler (1706–75)
Hard-paste porcelain painted in enamel-colours and gilt
Mark: crossed swords underglaze in blue
Cat. 110: H: 21.4cm
Cat. 111: H: 21.3cm
Given by the 2nd Lord and Lady Fisher of Kilverstone through the NACF

The ceremonial costumes of the various ranks of Saxon miners were recorded in a set of drawings by H. C. Fehling, which were engraved by Christoph Weigel and published at Nuremburg in 1721 with the lengthy title *Abbildung und Beschreibung derer sämtlichen Bergwerks Beamten und Bedienten nach ihrem gewöhnlichen Rang und Ordnung in behörigen Berg-Habit* (Illustration and description of the costumes of all the mine officers and employees according to their customary rank and class). They commemorated the participation of the Saxon miners in the festivities which took place in Dresden in 1719 to celebrate the marriage of Prince Frederick Augustus to the Princess Maria Josepha von Habsburg.

Mining was one of the most important industries in Saxony and a major source of revenue. Painted mining scenes occur on Meissen tablewares, and Augustus III, who took a keen interest in mining, commissioned pieces of this type. About 1750 Kaendler and Reinicke modelled a set of figures inspired by Weigel's prints. The exact date is not known because the factory records of the modellers' work are missing between 1748 and 1764. Most of the miners are in bold but static poses on roughly square mound bases, but some rare examples stand or kneel on rocks, the later attacking the mine face with hammers and chisels. All have accessories, such as tools, musical instruments and batons, which indicate their rank and occupation. The bearing of the *Mine Commandant* is very self-assured and he has often been said to represent Augustus the Strong; *the Mine Inspector* holds a tray of ore.

JEP

109

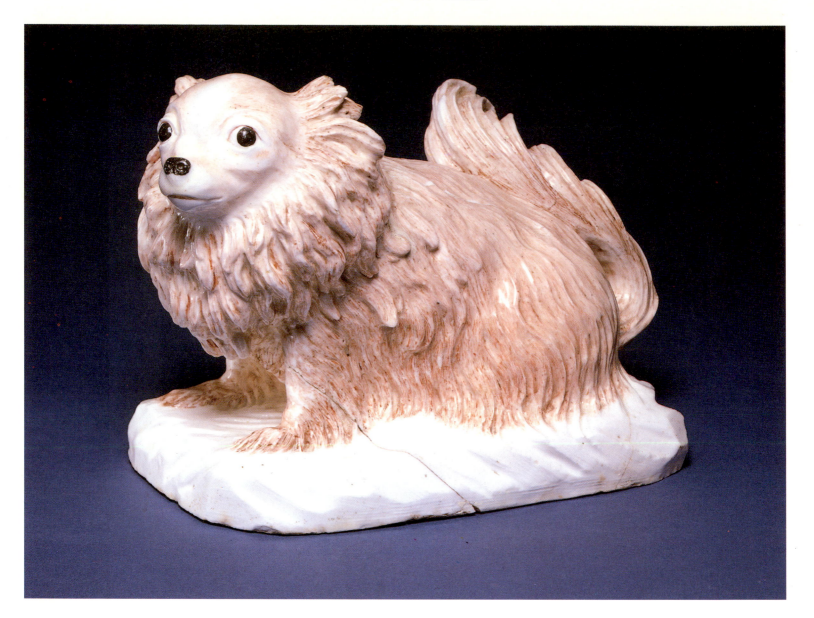

Cat. 112 C. 5-1961

Dog. About 1751–3

Soft-paste porcelain painted in enamel-colours
Mark: script *B* incised underneath
H: 17.9cm W: 25cm D: 13.4cm
Bequeathed by Louis C. G. Clarke, 1960

Ref: *Ann. Rep.* 1961, pl. VI

Porcelain dogs were probably being made at Vincennes by about 1750, as by October 1752, when a general inventory was taken, 263 were in stock. Unfortunately it is not possible to identify the Fitzwilliam model in this inventory. It names only two breeds: *Dogues* (mastiffs) in three sizes, of which there were 83; and *Chiens Barbet* (water spaniels), of which there were 4. Of the rest, 168 were described simply as *Petits chiens*, 3 as *Chiens* and 5 as *Chiens de Mad. de Belfond*, presumably referring to the owner of a dog of that type, rather than a breed. The price of the dogs ranged from 20 sols to 10 livres according to their size and whether or not they were painted.

The Fitzwilliam dog is large for a figure, and if it was in stock at Vincennes in 1752, might have been the one painted example of the *Chiens de Mad. de Belfond*, at 10 livres, or one of the *Chiens*, at 6 livres. However, it may well have been made after the inventory was taken. No moulds have survived for this model, nor does the factory's register of sales in the 1750s mention any dogs in sufficient detail to enable any of them to be matched with it.

The incised *B* on the underside of the Fitzwilliam dog indicates that it was made during one of the two periods when J. J. Bachelier was head of the *atelier de sculpture*, the first of which ran from 1751 to 1757. This mark had not been noted when the dog was shown at the exhibition *Porcelaines de Vincennes, Les Origines de Sèvres*, held at the Grand Palais, Paris, 1977–8 (cat. 465). The dog's solid construction, speckled glaze and firing cracks suggest that it was made during the first two years of that period, rather than later, when glazed figures were phased out of production in favour of biscuit.

The Fitzwilliam dog is the only coloured example of this model. Of the few undecorated examples recorded, one was acquired by the National Museum of Victoria, Australia in 1983; another was sold at Christie's on 28 March 1983, lot 23, but differs from the others in having a straight-edged base with roughly canted corners.

JEP

Cat. 113 C. 80-1950

The indiscreet Harlequin. About 1753–55

Soft-paste porcelain painted overglaze in enamel-colours and gilt
H: 19.5cm W: 15.1cm
Given by Mrs. W. D. Dickson

Ref: *Ann. Rep.* 1950, pl. III; *Poole I*, p. 50, H1

From about 1750 Meissen figures were to be seen in London; and during the next few years porcelain table decorations became a feature of desserts at fashionable entertainments. The earliest Bow figure known to have been based on a Meissen model is dated 1750 and depicts a negress standing beside a covered basket, presumably intended to hold some kind of sweetmeat. After that there was a delay of about two years before a spate of copying and adaptation of Meissen models began. The copies were mainly of single figures or pairs. Groups were attempted infrequently, partly because fewer seem to have been imported and partly because they posed greater technical problems for inexperienced English modellers.

The indiscreet Harlequin was modelled by J. J. Kaendler about 1740. Like many of his *Commedia dell'Arte* and court-life groups, it displays a sly sense of humour, rarely found in English models. Columbine, seated on Beltrame's knee, is so engrossed by her lover that she is oblivious of Harlequin, who lecherously lifts her skirt to peer beneath it. This group, press-moulded in soft-paste and decorated in a somewhat gauche manner at the Bow factory in London, lacks the wit and vitality of the original, but has a rustic charm which is characteristically English.

JEP

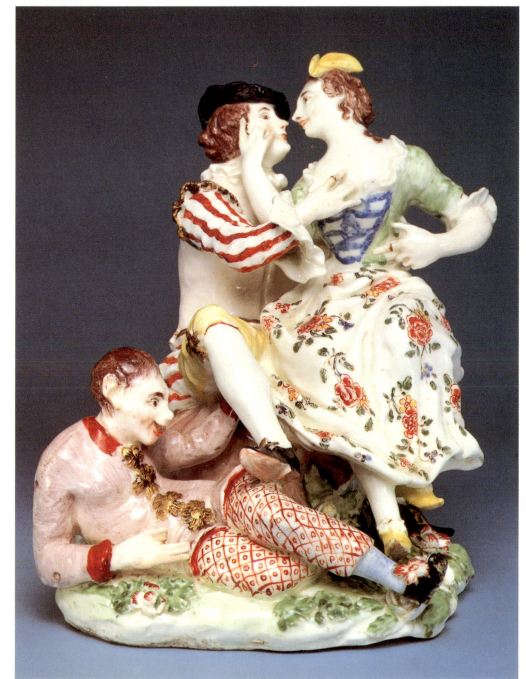

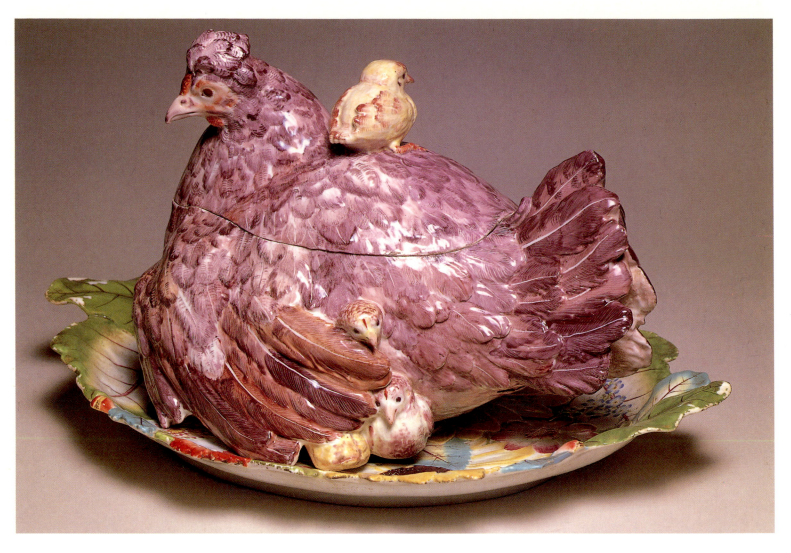

Cat. 114 C. 3-1958

Hen and chickens tureen. About
1755–6

Soft-paste porcelain painted in enamel-
colours
Mark: a red anchor
Hen: H: 25.3cm L: 34cm W: 24cm
Dish: H: 7.1cm L: 48.7cm W: 37.6cm
Bequeathed in memory of Robert Gelston,
Limerick, by his brother Dick Gelston, 1957

Ref: *Treasures*, no. 85

During the red-anchor period, 1752–8,
the Chelsea factory produced many
wonderfully naturalistic tureens in the
shapes of fruit, vegetables, animals and
fish. The fashion for these fanciful, but
nevertheless functional, tablewares had

begun on the Continent, where they were
made in porcelain at Meissen and at
German and French faience factories,
notably Joseph Hannong's in Strasbourg.
Some Chelsea tureens were undoubtedly
influenced by Continental examples, but
the *Hen and chickens* was thoroughly
English in conception. It was derived from
a print of about 1658 by Francis Barlow
(1626–1702), best known for his illustrations
to Aesop's *Fables*. The irregularly shaped
dish which accompanies the tureen is
moulded with sunflowers, several smaller
flowers and leaves. This may have been
inspired by Meissen sunflower dishes, but
does not replicate them.

Apart from their red-anchor mark, *Hen
and chickens* tureens can be dated from
their appearance in the catalogues of the
annual Chelsea sales. Eleven were sold in
1755 and four in 1756. The fullest

description was given for lot 50 on the first
day of the 1755 sale: "A most beautiful
tureen in the shape of a HEN AND
CHICKENS, BIG AS THE LIFE in a curious
dish adorn'd with sunflowers." Its
importance was indicated by the capital
letters, also used to draw attention to other
lots of special merit, such as boar's head
and rabbit tureens, vases, *épergnes* and
figures. The sales also included a larger
number of chicken tureens accompanied by
smaller sunflower dishes for desserts.

Large Chelsea tureens, such as the *Hen
and chickens*, are now rare and it seems
probable that for technical and economic
reasons very small numbers were
produced. The Fitzwilliam also has a *Carp
on a dish*, a *Rabbit* and a pair of *Fighting
cocks*.

JEP

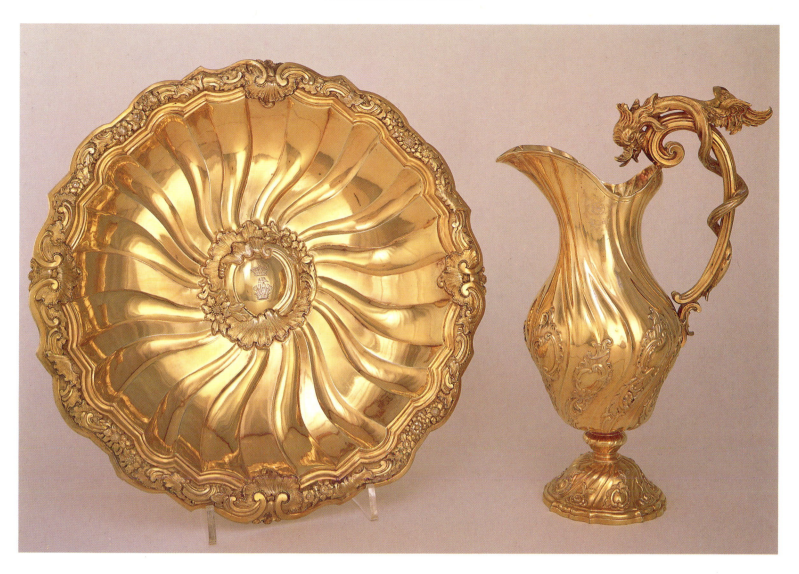

Cat. 115 M. 10 & 11-1982

Ewer and basin. About 1758–68

Silver-gilt with embossed, chased and engraved ornament, the handle of the ewer cast and chased
Signed: maker's mark on basin: *RC* monogram
Ewer: H: 30.9cm W: 11.1cm
Basin: H: 4.8cm W: 34.8cm
Allocated by the Minister for the Arts after acceptance by H. M. Treasury in lieu of capital taxes from the estate of James, the 6th Marquess of Ormonde

Coll: *Ormonde collection*

Ref: *Ann. Rep.* 1982, pl. X

Mid-eighteenth-century Portuguese goldsmiths, like those elsewhere in Western Europe, were strongly influenced by the exuberant rococo style of Parisian silver. They were also influenced by Augsburg, the other great European centre for goldsmiths' work, which had developed its own version of the rococo. Although fashion demanded the acquisition of foreign silver by the royal house and members of the aristocracy, Portuguese goldsmiths' work at its best was of a very high standard and worthy of their patronage.

Ewers and basins were sometimes made *en suite* with toilet services, but more commonly as a separate set, for use at meals or for the toilet. In France, there was a predilection for shaped oval basins, but in Portugal, circular basins were preferred, although oval and shell-shaped were also made. Ewers were generally helmet-shaped or like the example exhibited, piriform with an upward curving lip, domed foot and a handle rising above the rim, in this case playfully ornamented with a fanciful cross between dolphin, flying-fish and dragon. The overall effect of these pieces is more reminiscent of Augsburg ewers and basins than of French, but individual features were drawn from an international rococo repertoire of scrolls, shells, asymmetrical cartouches, flowers and foliage. Spiral fluting, giving a strong sense of upward movement on hollow-ware, and a swirling effect on dishes and basins, was another common feature of rococo silver frequently employed in Portugal.

Both pieces are engraved with the Ormonde crest surmounted by a Marquess's coronet, indicating that they belonged to Walter Butler, 18th Earl of Ormonde (1770-1820), who was raised to the rank of Marquess in 1816. During the early nineteenth century the Earl amassed an immense collection of plate, mainly by leading English goldsmiths, such as Paul Storr. This remained in the Ormonde family until the death of the sixth Marquess, after which it was allocated to various museums in England and Northern Ireland in lieu of capital taxes.

JEP

113

Cat. 116 M/F. 11-1938

LANGLOIS, Pierre, the Elder
Died London 1767

Commode with drawers. Probably about 1766–7

Pine carcase veneered with rosewood and various exotic woods; ormolu mounts and legs
Inscribed: *Daniel Langlois* in red chalk on the carcase under the top drawer
H: 90cm W: 127.5cm D: 60.5cm
L. D. Cunliffe bequest, 1937

Coll: *Captain M. Weyland of Woodeaton, Oxfordshire; sold Christie's 2 December 1904, lot 28, bought by testator*

Although 'Daniel Langlois' is scrawled on this commode, it was almost certainly made by Pierre Langlois the Elder, whose workshop was at 39 Tottenham Court Road, London. A pair of commodes of similar size and design, but with scagliola tops, was commissioned from Langlois by the Marquess of Tavistock (1739–67), son of the 4th Duke of Bedford. After the deaths of the Marquess and Pierre Langlois in 1767, a bill of £140.00 for "two commode tables of inlaid wood" was paid to the latter's widow. When the Marchioness died in 1768, the commodes were inherited by the Duke of Bedford, and are clearly described in the inventories taken on his death in 1771, one at Woburn Abbey, the other at Bedford House, London (Geoffrey Beard and Helena Hayward 'Interior Design and Furnishings at Woburn Abbey', *Apollo*, vol. CXXVII, June 1988, pp. 393–400, p. 397 and fig. 9).

A third commode of this design, with a floral marquetry top, was ordered for Blenheim by the 4th Duke of Marlborough (1739–1817), who was married to the Marquess of Tavistock's sister. No documentary evidence has been found to link this commode with Pierre Langlois the Elder, but it must surely have been made by him.

The rectangular straight-sided form of these commodes, their neo-classical ornament of Greek key pattern, ram's heads and festoons of husks, and their short

spirally fluted legs, are very different from most of the furniture attributed to Langlois (Peter Thornton and William Rieder, 'Pierre Langlois, Ebéniste', Parts 1–5, *Conn.*, CLXXVIII, December 1971; CLXXVIX February–May 1972). This suggests that the design was supplied by someone else, possibly Sir William Chambers, who worked for both families, and was paid £10.10.00 for unspecified services for the Duke of Bedford in 1767.

Pierre Langlois was famed for his floral marquetry, a prominent feature of the commodes attributed to him. The marquetry landscape on the top of the Fitzwilliam commode is in a totally different style. Helena Hayward (unpublished draft catalogue entry) relates it to that of the Neuwied workshop of Abraham Roentgen, who visited London in 1766. His journeyman, Johann Michael Rummer (1747–1812), was also in London about 1765. It is possible that the panel was executed by him.

The superb ormolu mounts on the commodes were probably supplied by Dominique Jean, who had married Pierre Langlois' daughter in 1764. Daniel Langlois, who is believed to have been the son of Pierre, was not apprenticed to Jean until 1771 and was therefore too young to have been responsible for them. Possibly he wrote his name on this piece while watching its construction in his father's workshop. It is not clear where Jean operated during the 1760s and 70s, but by 1782 he had moved into the Langlois workshop. Between the death of Pierre and 1774, it was run by his widow and from then until 1781 by Pierre Langlois the Younger. It is conceivable that the Fitzwilliam commode was made during that period, but unlikely in view of the date of the Woburn commodes.

JEP

Cat. 117 No. 3752

COSWAY, Richard
Okeford, Devon 1742 – 1821 London

George IV as Prince Regent, 1762–1830. About 1790

Watercolour on ivory
Oval: H: 77mm W: 65mm
F. Leverton Harris bequest, 1926

Coll: *Godfrey Duracher; his sale, 1898; testator*

Ref: *Bayne-Powell*, p. 41, col. pl. V

Cosway began by painting large portraits in oils but soon established a successful practice as a miniature painter. After studying briefly at the Royal Academy schools he was made an Academician in 1771, and around 1786 was appointed Principal Painter to the Prince of Wales. He nurtured his lucrative connections with the *beau-monde* of London through elegant soirées held in the sumptuous surroundings of his home at Schomberg House, Pall Mall, at which the Prince and his companion Mrs. Fitzherbert were regular guests.

This portrait is consistent with the tighter handling of Cosway's style around 1790. It shows the Prince Regent wearing the Ribbon and Star of the Order of the Garter, and the light-blue uniform coat and

badge of the 10th Light Dragoons, of which, as Sir Oliver Millar has pointed out (Museum files), the Prince was the devoted Colonel.

The Fitzwilliam Museum owns twelve further examples of Cosway's work as a miniaturist from the late 1780s to about 1795. Another miniature of *George IV as Prince Regent* by Henry Pierce Bone (1779–1855), after the portrait by Sir Thomas Lawrence at Windsor Castle, is also in the Fitzwilliam (M. 4-1962, *Bayne-Powell*, p.12).

JAM

Cat. 118 No. 3922

SMART, John
Norfolk 1743 – 1811 London

Charles, 1st Marquis Cornwallis, 1738–1805. 1792

Watercolour on ivory
Signed: with initials, and dated, in black, lower left: J.S./1792/I
Oval: H: 59mm W: 45mm
Given by Mrs. W. D. Dickson, 1945

Ref: *Bayne-Powell*, p. 202, repr.

Charles, 2nd Earl and 1st Marquis Cornwallis, enjoyed a distinguished military career in postings in Europe, America and India.

He studied at Eton and the military

academy in Turin, and later took a prominent part in the Seven Years War. Although of Whig sympathies, he agreed to join the fight against the American insurgents in 1776 and went on to win some of the campaign's most decisive victories at Philadelphia and Brandywine in 1777 and at Virginia in 1780. Lack of supplies forced him to capitulate at Yorktown in 1781, and he subsequently resigned his commission in protest at the Government's mismanagement of the affair. In 1785, "much against his will and with grief of heart", he accepted the post of Governor-General and Commander-in-Chief in India. His reform of the civil service and military forces in Madras, and his defeat of Sultan Tippoo Sahib near Seringapatam in 1791 earned him much acclaim at home, and in 1792, the year of this portrait, he was created Marquis in recognition of his services.

Smart spent ten years in India, from 1785 to the winter of 1795. He established himself in Madras, where he enjoyed the patronage of both the British community and the Indian aristocracy; a miniature of an Indian prince, possibly the grandson of Muhamed Ali, Nawab of Arcot, is also in the Fitzwilliam (PD. 16-1948).

Like Cosway's *George V* (cat. 117), this miniature is painted on ivory, a support which became popular in England from the beginning of the eighteenth century.

JAM

Cat. 119 No. 2265

WATTEAU, Antoine
Valenciennes 1684 – 1721 Nogent-sur-Marne

A man playing a flute. About 1706 – about 1716

'Aux trois crayons' on buff paper, pasted down; repairs to upper right and lower right corners
H: 171mm W: 173mm
C. H. Shannon bequest, 1937

Coll: *Ricketts and Shannon*

Ref: Paris, Lille and Strasbourg, *Cent Dessins*, no. 96; *European Drawings*, no. 119

Watteau characteristically made use of this figure in more than one of his paintings. With the addition of a hat it appears in his *Concert champêtre*, dated variously about 1707 – about 1716 (Angers, Musée des Beaux-Arts), and, bare-headed, in another treatment of the same subject known from the etching by Benoit Audran (E. Dauer and A. Vuaflart, *Jean de Jullienne et les Graveurs de Watteau au XVIIIe Siècle*, Paris, 1957, III, pp. 35-36, no. 72; see also anonymous etching no. 72a). A flautist in the same pose, but with the head only slightly indicated, appears as the left-hand figure on a sheet of studies in the British Museum (BM 1868–8–8–274).

Musical references are to be found in over one third of Watteau's *oeuvre*, often in the form of observations of particular musical instruments and their players, which reflect his deep understanding of the music of his time (Florence Getreau, 'Watteau and music' *Watteau 1684–1721*, exh. cat., Washington, Paris and Berlin 1984-5, pp. 533–52). In this drawing both the position of the hands on the transverse flute (an instrument which was extensively developed at the beginning of the eighteenth century, and which was especially popular in France) and the gentle inclination of the body to the right, recall a passage in Jacques Hottenterre's *Principes de la Flûte* (1707):

"Si l'on est debout, il faut être bien campé sur ses Jambes, le Pied gauche avancé, le Corps posé sur la Hanche droite; le tout sans aucune contrainte . . . A l'égard de la position des Mains . . . on apprendra qu'il faut mettre la main gauche en haut, Tenir la flûte entre la Pouce et le premier doigt. Plier le Poignet en dessous; Arranger les Doigts, en sorte que le premier et le deuxième soient un peu arrondis, et le troisième plus alongé. Pour ce qui regarde la main droite il faut tenir les doigts presque droits . . . Le petit doigt pose sur la Flûte entre le sixième trou et la moulure de la pâte" (If standing, the weight should be evenly distributed on both feet; the left foot forward, the weight of the body on the right hip; the posture as a whole should not be forced. As regards the position of the hands . . . one will learn that the left hand should be placed above, and the flute held between the thumb and forefinger. Fold the fingers below; arrange them so that the first and second are slightly bent and the third stretched out. The fingers of the right hand should be kept almost straight . . . the little finger placed on the flute between the sixth hole and the moulding of the joint.)

No provenance is known before this drawing was bought by Ricketts and Shannon. Despite the animated gestures of the flautist, it is clear that Ricketts' love of Watteau was inspired by the *tristesse musicale* which dominated nineteenth-century understanding of his work. It was perhaps in this drawing that Ricketts, himself of French descent, most acutely discerned the "vague and languid harmony" of Watteau's *fêtes galantes* (*Pages on Art*, London, 1913, p. 34).

JAM

Cat. 120

PD. 30-1959

TIEPOLO, Giambattista
Venice 1696 – 1770 Madrid

The gates of a villa. About 1759

Pen and dark-brown ink with dark-brown wash on paper
H: 140mm W: 252mm
G. J. F. Knowles bequest

Ref: *Ann. Rep.* 1959, pl. I

In the late summer of 1759 Tiepolo travelled to Udine with his eldest son Giandomenico (1727–1804) to paint an altarpiece and frescoes for the Oratorio della Purità, an institution of a school of Christian doctrine for children. This was one of many commissions which took him away from Venice in his later years to Treviso, Udine, Verona and Vicenza.

While based at Udine, from August to mid-September, he made a group of pen and wash drawings of the villas and farms in the surrounding countryside. The summary description, and bold contrasts of light and shadow in this drawing are characteristic of this series, which was intended purely as a record of visual experience, wonderfully evocative of ''the smell of dry straw and tile and earth, like the perennial scent of the Italian countryside in summer'' (Michael Levey, *Tiepolo*, London, 1986, p. 245). Other studies are in the Fitzwilliam, the British Museum, and the Fogg Art Museum (*Disegni del Tiepolo*, exh. cat., Udine, Loggia del Lionello, 1965, nos. 103–13).

George Knox has related the rustic building, lower right, to a drawing formerly in the collection of Sir Edmund Davy (*Un quaderno di vedute di Giambattista e Domenico Tiepolo*, Venice, n.d., no 46).

JAM

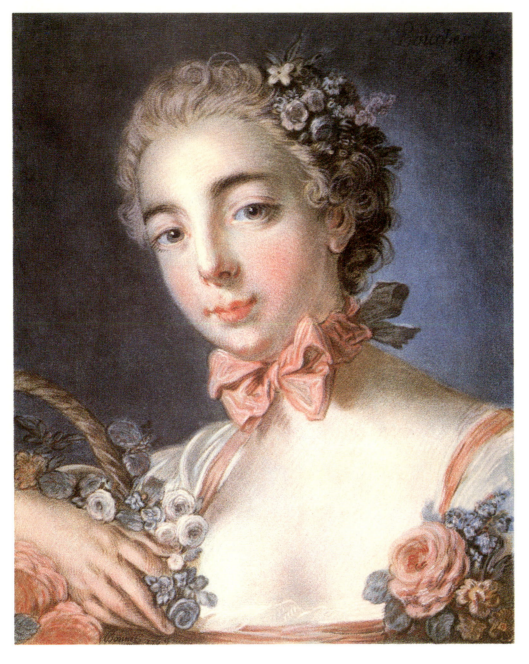

Cat. 121 — P. 59-1959

BONNET, Louis-Marin
Paris 1736 – 1793 Saint-Mandre

Tête de Flore (Head of Flora). 1769

After a pastel by François Boucher (1703-70)
Pastel-manner etching and engraving
printed in colours from eight plates, on
paper
Signed in plate: *f. Boucher 1757; Bonnet
1769*
H: 409mm W: 325mm
Given by the Friends of the Fitzwilliam

Coll: *Comte de Béhague (L. 2004); Julius
Model; Eldridge R. Johnson*

Ref: *FOF* 1959, cover

A magnificent example of the first state of the print (Jacques Hérold, *Louis-Marin Bonnet (1736–1793), Catalogue de l'oeuvre gravé*, Paris, 1935, no. 192i). *Tête de Flore*, Bonnet's masterpiece, is one of the supreme achievements of colour printing in eighteenth-century France. On the basis of its success Bonnet was awarded a pension by the King. Bonnet perfected his techniques of colour printing after his return to Paris from Russia in 1767 in a series of *têtes à plusieurs crayons* after Boucher, printed from as many as six plates. In 1769 with *Tête de Flore* he went two better and used eight plates for the early impressions; in later impressions he reduced the number of plates (and colours), presumably because some of the plates had worn.

To align his eight plates Bonnet introduced registration pins, a system that was to become standard for French colour prints. Another innovation was that three of the plates were inked with more than one colour, *à la poupée* (applied with a pad). The plates were printed in a carefully designed order, always finishing with the specially constituted white ink for which Bonnet was famous and which contributed so much to the imitation of delicate touches of chalk. Most impressions of *Tête de Flore* have been trimmed like this one to exclude any margin; this removes any trace of the registration pins and enhances the illusion that it is a drawing. The print was undoubtedly trimmed for framing when originally issued, as it was advertised at a price of 6 *livres* unframed, or framed at 10 or 15 *livres*, depending on the moulding.

Boucher's pastel of 1757 portrayed his 17-year-old daughter Marie-Emile (for suggested identifications of the drawing see *Regency to Empire, French Printmaking 1715–1814*, exh. cat., Baltimore Museum of Art, 1985, p. 197).

CH

118

Cat. 122a & 122b PD. 11 & 12-1964

HOGARTH, William
London 1697 – 1764 London

122a Before Cat. **122b After**

About 1730–31

Oil on canvas
Cat. 122a H: 36.5cm W: 44.8cm
Cat. 122b H: 37cm W: 44.6cm
Bequeathed by A. J. Hugh Smith through
the NACF

Coll: *London Art Market, 1832; H. R. Willett
of Shooter's Hill, London (1842); Frederick (?)
Locker-Lampson; 13th Duke of Hamilton (by
1907); bought by A. J. Hugh Smith, 1919*

Ref: *Ann. Rep.* 1964, pl. X a, b; *Paintings III,*
pp. 114–15

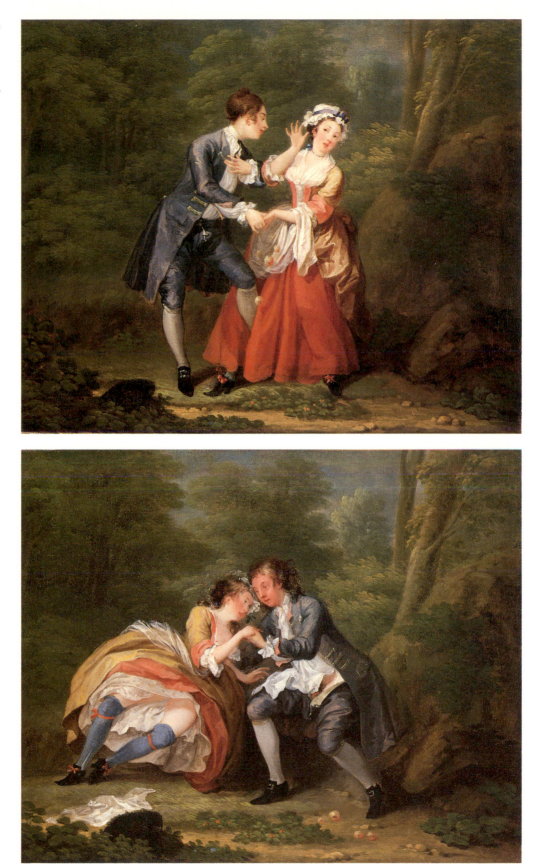

Hogarth painted two pairs of small
pictures on this theme. This pair is
probably that recorded with the titles
Before and *After* in a list of unfinished
paintings "bespoke for the present year",
drawn up by Hogarth on 1 January 1731.
The listed pair was ordered on 7 December
1730 by "Mr. Thompson" – probably the
John Thompson who was on the Commons
Committee for the Relief of the Industrious
Poor. He may never have collected his
paintings before he fled the country in
October 1731 with embezzled profits and
the Charitable Corporation's account
books.

 The other pair (Getty Museum, Malibu,
nos. 78PA 204 and 205), showing the same
couple indoors, seems a little later in style.
It was said to have been painted "at the
particular request of a certain vicious
nobleman", and so is less likely to be the
pair painted for Mr. Thompson.
The outdoor pair has an affinity with
French paintings, particularly Jean François
de Troy's small *fêtes galantes* of the 1720s,
which Hogarth would have seen in the
collection of Dr. Mead but could also have
known through engravings. The theme,
poses and colouring (especially the foliage)
all echo de Troy. By contrast, the indoor
pair lacks all traces of French gracefulness.
It narrates by allusive detail rather than by
the explicit observation of the figures
which is so remarkable in the outdoor pair.
This contrast is still more evident in
Hogarth's prints made after the indoor pair
in 1736.

 CH

119

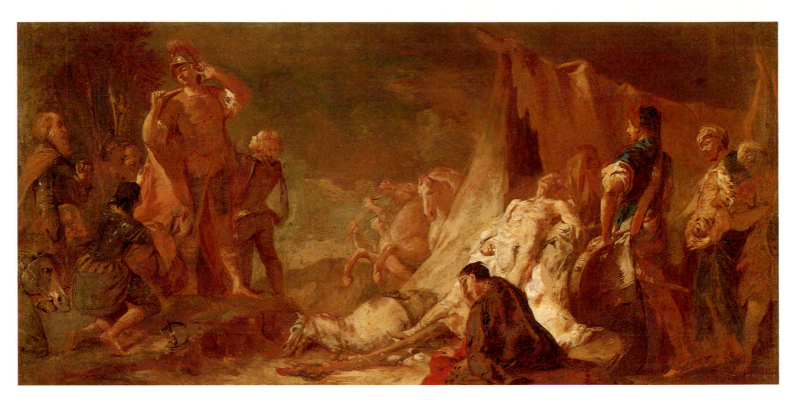

Cat. 123 No. 1117

PIAZZETTA, Giovanni Battista
Venice 1683 – 1754 Venice

The death of Darius. About 1745

Oil on canvas
H: 38cm W: 77.5 cm
Given by F. Leverton Harris, 1923

Ref: *Paintings II*, pp. 132–3

This is a preparatory sketch for the large painting (Museo Correr, no. 2181) commissioned from Piazzetta by the Pisani for Palazzo Pisano–Moretto a San Polo, Venice, as a pendant to *The family of Darius before Alexander* by Veronese (National Gallery, London 3294). George Knox (letter to the Museum, 27 September 1981) pointed out that Piazzetta was paid for the finished picture on 30 August 1745 and 30 August 1747. So this sketch probably dates from about 1745. A drawing preparatory to our sketch was formerly in the Janos Scholz collection, New York.

The subject, from Plutarch's *Life of Alexander,* is the episode in which Alexander, confronted by the naked corpse of Darius, unfastens his cloak to cover the body. The two subjects treated by Piazzetta and by Veronese recur in a pair of oil sketches in the Museé Ingres, Montauban. These have been attributed to Piazzetta, but the compositions greatly differ from the Palazzo Pisano paintings.

The virtuoso handling, the paint thinly applied with bravura to make use of the red–brown ground, is typical of the eighteenth century in Venice. Less typical is the expressive use of light, whereby Alexander seems almost to recoil from the brilliance of Darius' body. The finished picture is among the greatest of Piazzetta's late works.

CH

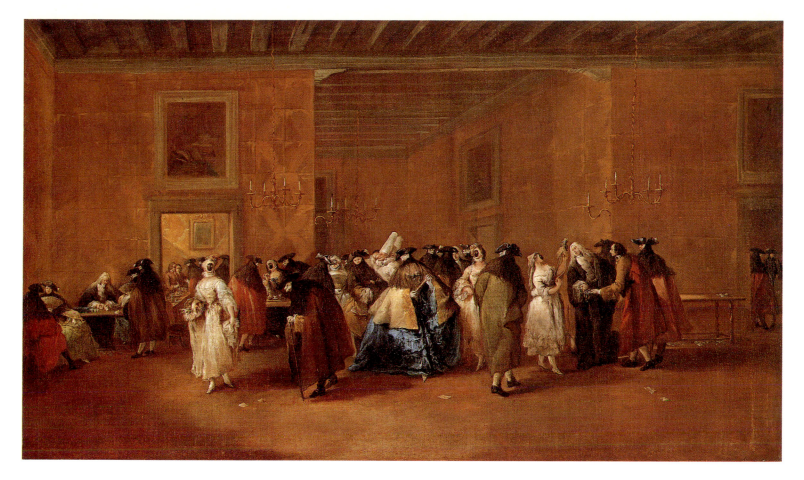

Cat. 124 PD. 1-1980

GUARDI Gianantonio
Venice 1698 – 1760 Venice

**The Sala Grande of the Ridotto,
Palazzo Dandolo, San Moisè.** About
1755–1760

Oil on canvas
H: 48cm W: 84cm
Bought from the Gow Fund with
contributions from the NACF and the
Regional Fund administered by the Victoria
and Albert Museum

Coll: *?Piot sale, Paris, 21–4 March 1890, lot
564; ?Agnew's; Evan Charteris; with P. & D.
Colnaghi, London; Lord Rothermere; Judith
Wilson; the Faculty of English, University of*
*Cambridge, with a life interest to Dame Edith
Evans, relinquished in 1969*

Ref: *Ann. Rep.* 1980, pl. XII

The fashion for depicting Ridotto
interiors seems to have been set by
Francesco Guardi, the younger brother of
Gianantonio. Francesco's famous painting
of about 1750 (Ca'Rezzonico, Venice)
inspired both Pietro Longhi's painting
(Segromigno Monte), which was engraved
by Alessandro Longhi in about 1760, and at
least four versions by the Guardi brothers,
including this one (A. Morassi, *Guardi*, I.
n.d., pp. 351–2, nos. 233–6). A drawing
inscribed *Ant. Guardi* (Art Institute,
Chicago) seems to be a record by
Gianantonio of the Ca'Rezzonico painting.

 Francesco is the better known of the

Guardi brothers: his Venetian *vedute* stand
beside Canaletto's in esteem, although they
are more fluently and atmospherically
handled. The sequence of the versions after
Francesco's Ca'Rezzonico painting is
difficult to establish but they are probably
all by Gianantonio. The attribution to
Gianantonio of the Fitzwilliam picture was
made by Michael Jaffé. It is characteristic of
the artist's splintery handling and among
his best paintings. The addition of *pulcinelli*
in Gianantonio's version to the single
pulcinello in the Ca'Rezzonico painting
seems to reflect the Tiepolo *Ballo in
maschera* (Musée du Louvre) of about 1755
which was engraved by Jakob Leonardi in
1765 with a dedication to Count Algarotti.
Gianantonio's variants should therefore be
dated to the last years of his life.

CH

Cat. 125 PD. 4-1950

BATONI, Pompeo
Lucca 1708 – 1787 Rome

Charles, 7th Earl of Northampton. 1758

Oil on canvas
Signed: *Pompeo Girolamo / Batoni Pin^e a
Roma / 1758*
H: 235.3cm W: 149.3cm
Bought from the S. G. Perceval Fund

Coll: *7th Earl of Northampton; by descent to
Capt. the Hon. J. C. C. Cavendish; sale
Sotheby's 22 June 1944, lot 51, bought by F.
Harbord; with Thomas Agnew & Sons Ltd,
from whom bought*

Ref: *Paintings II*, pp. 13-14

Charles Compton (1737–63) succeeded
his uncle George as 7th Earl of
Northampton on 6 December 1758 while in
Italy. He was recorded as being in Florence
and Rome in 1758 by Lady Mary Wortley
Montagu (letter to the Countess of Bute, 31
December 1758). "The young Earl of
Northampton is now at Florence, and was
here the last year. He is lively and good
natur'd, with (what is call'd) a pretty
Figure." He returned to England by 13
September 1759 and married Lady Anne
Noel, daughter of the 4th Earl of Bedford.
He was subsequently appointed
Ambassador Extraordinary and
Plenipotentiary to Venice (1761–3) and
became a close friend of the young George
III. He died in Italy of consumption, aged
26, on 18 October 1763.

Batoni was active principally in Rome,
where he was much patronised as a portrait
painter by foreign visitors. The
Northampton shows him at the height of his
powers: the composition is intricately
designed yet graceful, and the references to
the 21-year-old Earl's taste and learning are
effortlessly incorporated. Batoni worked
also as a history painter: indeed
Northampton commissioned *Hector's
Farewell to Andromache* (location unknown)
in the same year as his portrait. Premature
death deprived England of one of the most
enterprising patrons of the arts of his
generation, as Antony Clarke observes
(*Pompeo Batoni*, London, 1985, p. 45).

CH

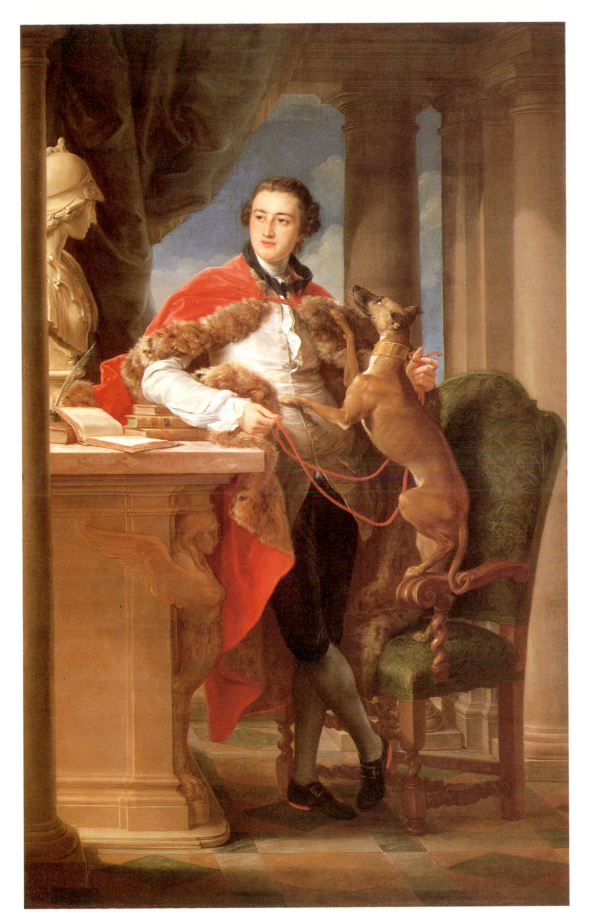

Cat. 126 No. 1

WRIGHT, Joseph
Derby 1734 – 1797 Derby

The Hon. Richard Fitzwilliam. 1764

Oil on canvas
H: 74.5cm W: 61.7cm
Given by Rev. Robert Fitzwilliam Hallifax,
1819

Coll: *Samuel Hallifax (1733-90); his son, Rev.
Robert Fitzwilliam Hallifax*

Ref: *Lely to Hockney,* no. 9; *Paintings III,*
pp. 292–3; *Treasures,* pp. 2, 4

Painted in 1764 for Samuel Hallifax,
Fellow and Tutor of Trinity Hall,
Cambridge, and private tutor to the young
man who was to stand godfather to his son.
Richard Fitzwilliam (1745–1816) was
admitted to Trinity Hall in 1761. He must
have sat to Wright before he received his
M.A. in 1764, as he is here depicted in the
gown of an undergraduate Fellow-
Commoner, of the kind worn by noblemen
on special occasions. Richard succeeded his
father as 7th Viscount Fitzwilliam of
Merrion in 1776. He bequeathed his
library, his art collections, and a sum of
money to the University of Cambridge in
1816 to found the Fitzwilliam Museum. The
only other known portrait of him is the
type deriving from a painting of 1809 by
Henry Hudson (1769–1847). That shows the
sitter aged 64 (version in the Fitzwilliam
Museum, no. 2).

Wright was a pupil of the portrait painter
Thomas Hudson (1701–79) in London in the
1750s. In the early 1760s his own style
developed rapidly. Cat. 126 shows
something of Hudson's taste for decorative
fabrics, but the more natural pose and
treatment of light around the face seem to
follow the example of Allen Ramsay (1713–
84), whose practice in London was
flourishing at the time.

In 1777 Wright settled in his native town
and became known as 'Wright of Derby'.

CH

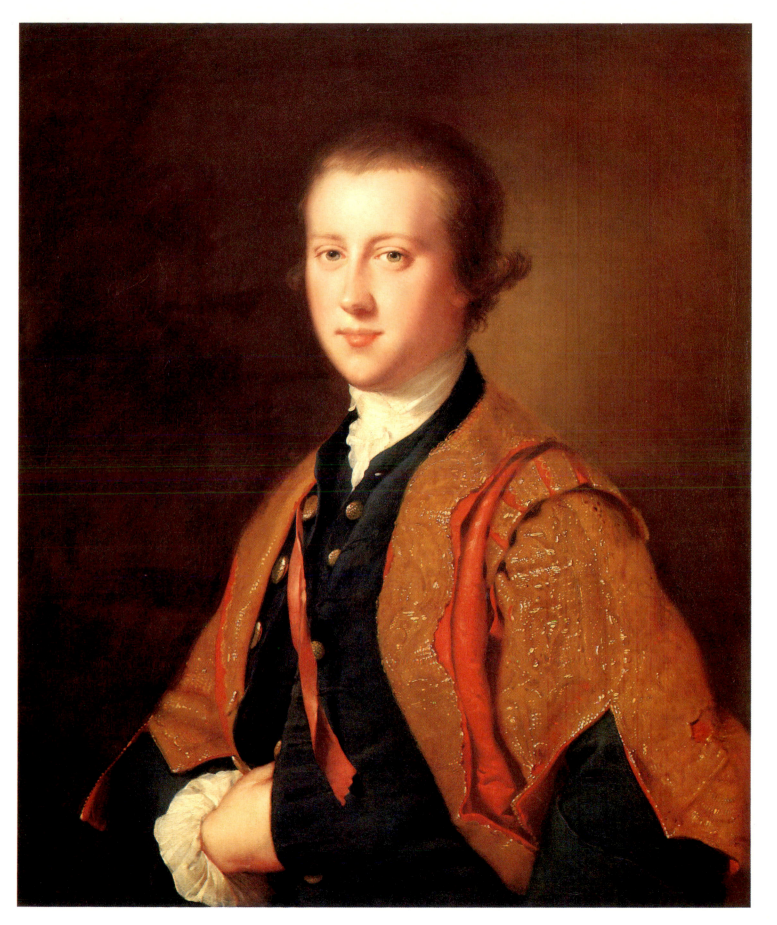

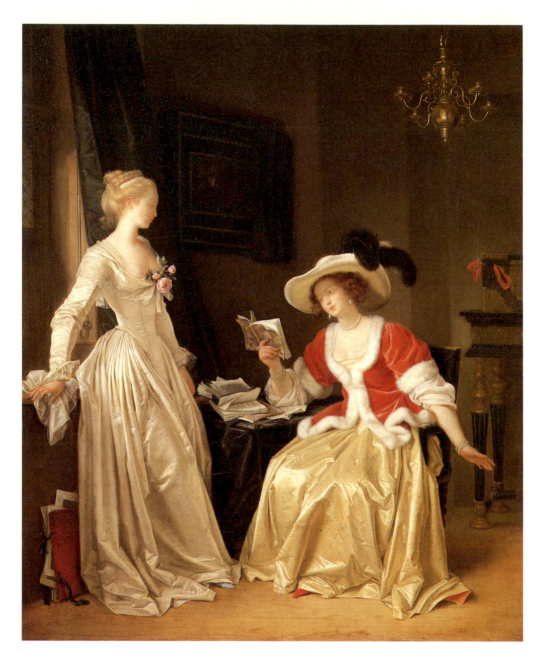

Cat. 127

M. 8

GÉRARD, Marguerite
Grasse 1761 – 1837 Paris
FRAGONARD, Jean-Honoré
Grasse 1732 – 1806 Paris

The reader. About 1786

Oil on canvas
H: 63.7cm W: 52cm
C. B. Marlay bequest, 1912

Ref: *Paintings I*, p. 177; *Winter*, no. 94

Marguerite Gérard came to Paris
from Grasse in 1775, to live with her
sister Marie-Anne, who was married to
Jean-Honoré Fragonard. Marguerite

became a pupil of her illustrious brother-
in-law and from 1778 helped to make prints
after his paintings. There is also evidence
that the two artists collaborated on a
number of paintings, notably *Le Premier
Pas de l'enfance*, which was engraved with a
date of 1786, and its pendant *L'Enfant chéri*
(both Fogg Art Museum) engraved in 1792.

The reader was painted largely by Gérard,
but the head and shoulders of the standing
woman can confidently be attributed to
Fragonard. The painting is closely
comparable to a number of domestic
interior scenes of similar format including
Jeune Femme debout pinçant de la guitare
(Staatliche Kunsthalle, Karlsruhe), which
was sold in 1795 as the work of both Gérard
and Fragonard, and *L'Enfant endormi*

(London art market 1962, location
unknown). As with all of these works, *The
reader* shows Gérard's debt to seventeenth-
century Dutch genre painting. It is painted
with a precise attention to the appearance
of fabrics, especially the ravishing silks. In
the Fitzwilliam catalogue the figure of the
standing woman was attributed to
Fragonard and her costume was compared
with that in *Le Baiser à la dérobée*
(Hermitage, Leningrad, inv. no. Г3 1300),
but it is now thought that Gérard was
responsible for the costume in both the
Leningrad and Fitzwilliam pictures (Pierre
Rosenberg, *Fragonard*, Paris, 1987,
pp. 574–5).

CH

126

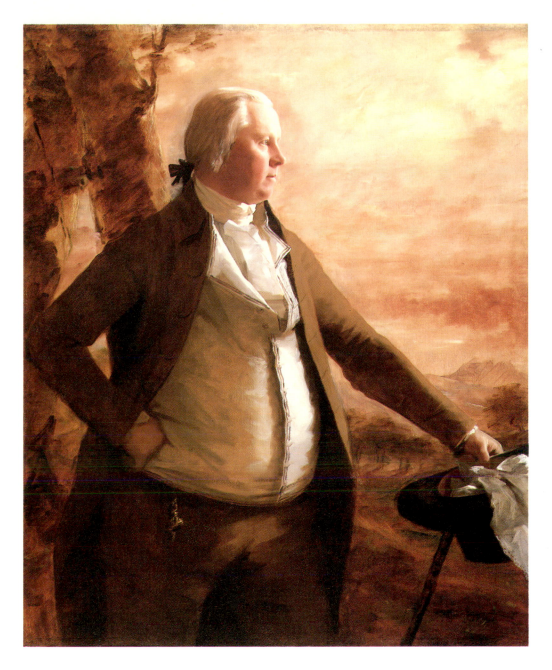

Cat. 128 No. 220

RAEBURN, Sir Henry
Stockbridge 1756 – 1823 Edinburgh

William Glendonwyn. About 1795

Oil on canvas
H: 125cm W: 100cm
Bought with the University Purchase Fund,
1892
Coll: *H. O. Collins; his sale (anon.), Christie's
22 February 1890, lot 78, bought Lesser; with
William Holder, London, from whom bought*

Ref: *Paintings III*, p. 197; *Treasures*, no. 89;
Winter, no. 96

William Glendonwyn of Glendonwyn and Sarton was married in 1781, when he is recorded as of the College Kirk parish. His name, an archaic form of Glendinning, is derived from a property in Westerkirk, Dumfriesshire. Raeburn painted a companion portrait of Glendonwyn's wife and their eldest daughter Mary, which was sold together with this picture in 1890. The companion is untraced, although there is a remote chance that it was the *Portrait of Mrs Glengoven and her daughter* in Sotheby's 14 July 1976, lot 114.

The style suggests a date in the 1790s, which is supported by the costume. The setting of the subject against a landscape derives from Reynolds' portraiture, but Raeburn developed his own system of subtle side and back lighting within a restricted palette to relate figure to landscape. The source of light and the way it partially models the figure in broad brushstrokes is a feature of other portraits, such as *Sir John and Lady Clerk of Penicuik* (the Beit collection, Russborough, County Wicklow) of 1792. It was Raeburn's method to paint on the canvas without preliminary underdrawing. He was the leading portrait painter in Edinburgh in the late eighteenth and early nineteenth centuries. In 1822 he was knighted and appointed His Majesty's Limner for Scotland.

CH

Cat. 129 PD. 16-1984

FABRE, François-Xavier
Montpellier 1766 – 1837 Montpellier

Allen Smith seated above the Arno, contemplating Florence. 1797

Oil on canvas
Signed: *F. X. Fabri / Florentiae 1797*
H: 69.3cm W: 89.2cm
Given by the Friends of the Fitzwilliam in celebration of their 75th anniversary, with the aid of a special gift from the Directors of Hazlitt, Gooden and Fox and contributions from the NACF and the Cunliffe, Perceval and University Purchase Funds.

Coll: *Henry Sinclair of Dalkey Lodge, Dublin; his sale (anon.) Christie's 1 December 1916, lot 101, bought Agnew's for Charles B. O. Clarke; by descent to the late J. P. S. Clarke and Mrs. K. A. J. L. Clarke, from whose Executors acquired*

Ref: *Ann. Rep.* 1984, pl. XIII

The traditional identification of the sitter as Mr. Smith was dropped after 1916 and only reaffirmed by Philippe Bordes in 1981 (letter to the Fitzwilliam). This is probably one of two portraits commissioned by Smith from Fabre which are mentioned in a letter from the Comtesse d'Albany in the Holland Papers, postmarked 12 July 1797 (British Library MS.51.637, ff.69–70). One of the portraits is described as "un grand comme nature au milieu des ruines de l'ancienne Rome" and it is uncertain whether this was completed. A small oil-sketch in the Musée Fabre (inv. 837-1-156) shows Smith seated under a tree to the left with a Corinthian capital to the right. This may have been for the Fitzwilliam picture before the view of Florence was intended. The sketch was formerly attributed to Tischbein on the basis of its close relationship with his famous *Goethe in the Roman Campagna* painted in 1786 (Städel, Frankfurt, Inv. 1157). Fabre in fact owned a drawing by Tischbein which is related to the Goethe portrait (Musée Fabre, Inv. 837-1-991) and his known portraits of Smith use the Tischbein as a model. A letter from Fabre to Lord Holland (British Library, MS.51.637, f.90) dated 24 August 1799 gives credit for the composition of his portrait to Smith: "quant à la composition du tableau de M.

Smith, vous devinez parfaitement juste; l'honneur de la composition est tout à lui". Whether this refers to the Fitzwilliam portrait or the proposed portrait in the ruins of Rome is uncertain, but it may have been Smith who suggested a portrait in the manner of Tischbein's *Goethe,* and it may have been Smith who asked for the *modello* to be adapted to include a view of Florence. Another change between the sketch and the Fitzwilliam picture is the modification of the sitter's pose away from that of Tischbein's *Goethe,* who looks casually at the viewer. In the Fitzwilliam picture Smith is modelled in profile against dark foliage with the formal grace of a portrait cameo. The 'Egyptian hieroglyph' decorating the column on which Smith is seated is meaningless.

Little is known of Smith, but his patronage of Fabre (he commissioned three history paintings at the same time as the portraits) indicates that he was a tourist of means. Fabre was a pupil of Jacques-Louis David from 1783 and won the Premier Grand Prix de Rome in 1787. He stayed in Rome from 1788 until 1793, when he departed for Florence, remaining there until 1824.

CH

Cat. 130 M. 1-1866

CHAUDET, Antoine-Denis
Paris 1763 – 1810 Paris

Napoléon I. 1808

Bronze, cast and chased
Signed: *Denon, directeur / Chaudet, fecit /
Gonon; Canleurs, ciseleur. 1808.*
H: 56cm W: 30.5cm D: 26cm
Given by J. E. Fordham Esq.

Coll: *Dominique Vivant, baron Denon; 3rd
Earl of Orford; his sale, Christie's 26 June
1856, lot 143, bought by donor*

This superbly finished and unadorned
bust in herm form has its origin in
Chaudet's conventionally truncated and
draped bust of Napoleon as first Consul in
1799, which in turn provided in 1805 the
prototype for the full-length marble
Napoléon législateur. The original marble for
cat. 130 seems to have been conceived in
association with this.

The exact date is uncertain, but a
damaged replica in the Musée de Tours is
inscribed *Chaudet An XI,* i.e. between 23
September 1802 and 23 September 1803.

The image, with its Augustan
associations, was preferred by Napoleon to
the more famous Olympian conception
by Canova of the Emperor as Mars. A
plaster was sent to Carrara where it served
as model for over 1,200 versions produced
by 1809 (S. G. Hubert, *La Sculpture dans
l'Italie Napoléonienne,* Paris, 1964, pp. 343–
8). It was also rendered full size in *biscuit de
Sèvres* between 1805-8, and in various
reductions throughout the century.

Napoleon reserved the production of
plasters and bronzes to Paris: the bronzes
were apparently of higher quality than the
marbles, and reserved for especially
important presents.

The only other bronze now known is one
with many casting faults, acquired for the
Musée du Louvre, unprovenanced, in 1896.

Cat. 130 proceeds from the personal
collection of baron Vivant Denon,
Napoleon's first Director General of
Museums. It is no. 715 in L.J.-J. Dubois,
*Description des objets d'arts qui composent le
cabinet de feu M. le baron V. Denon,* Paris
1826, pp. 155–6, which cites the Chaudet
authorship, the caster, Gonon (chiefly
remembered now for his lost-wax single-
pour castings for Barye in the 1830s), and
the chaser, Canleurs.

In Lord Orford's sale cat. 130 was
incomprehensibly attributed to Canova, a
mistake which persisted until it was recata-
logued by A. F. Radcliffe in the late 1970s.
RAC

Cat. 131 M. 1-1861

CHANTREY, Sir Francis Leggat
Norton 1781– 1841 London

John Horne Tooke (1736–1812). 1818/19
after a model of 1811

Marble
Signed: *F. Chantrey Sc.*
H: 67cm W: 46cm D: 26cm
Socle: H: 11.3cm Diameter: 22.2cm
Given by Lady Chantrey

Coll: *the artist; his widow, by whom given*

Ref: *Chapman*, pl. opp. p. 6, & p. 6

The son of a farmer and carpenter, Chantrey was apprenticed in Sheffield to a carver and art dealer from 1797 to 1802, when he set up independently as a portraitist, moving to London later that year. He was introduced to Tooke by a fellow sculptor Thomas Banks, and exhibited a bust of him, in plaster, at the Royal Academy in 1811. This was such a success that Nollekens moved one of his own pieces to give it greater prominence. Chantrey received £12,000 worth of orders, and won the competition for an equestrian figure of King George III for the City of London.

His career as a portraitist was now assured. When he died he left £150,000 to his wife in her lifetime, the residue forming the Chantrey bequest to the Royal Academy for the purchase of British works of art for the nation.

The plaster, or a copy, was included in the 1842 gift by Lady Chantrey to the Ashmolean Museum of the models left in her late husband's studio.

Neither Chantrey nor Tooke could afford a marble in 1811; but one, ordered in 1818 by G. W. Taylor M.P., was completed in 1819. It was never paid for and remained with the Chantreys until it was given to the Fitzwilliam as "one of my husband's best works" (J. W. Goodison, *Cambridge Portraits*, Cambridge, 1955, p. 87, Cat. 123).

Born John Horne, the son of a poulterer (taking the additional surname from his friend and mentor William Tooke in 1782), the sitter had the most extraordinary career. After losing an eye in a knife fight with a fellow Etonian, Tooke read law at Cambridge, before taking holy orders, and receiving a curacy in Brentford. A radical reformer in politics, he was a friend of John Wilkes until falling out with him over moneys raised to support Wilkes and other dissenters. He established the rival Constitutional Society. Following the Lexington skirmish, of 19 April 1775, Tooke was instrumental in publishing a resolution of the Society on 7 June, calling for a subscription to be raised for "our beloved American fellow subjects . . . who had preferred death to slavery". For that he was fined £200 and jailed in the King's Bench prison for a year in 1778. His intermittent travels to France brought him into contact with such as Voltaire and Sterne.

Together with Thomas Banks and other friends he was arrested in 1794 for high treason for expressing support, in 1790, for the French Revolution, but was found not guilty.

The bust was modelled during Tooke's last illness.

RAC

Cat. 132 M. 2-1959

RODIN, François Auguste René
Paris 1840 – 1917 Meudon

Frère et soeur. 1890

Bronze, patinated green
Signed: *A. Rodin*
H: 39cm W: 22cm D: 20cm
G. F. Knowles bequest

Coll: *the artist, by whom given to the testator*

Ref: *Ann. Rep.* 1959, pl. IV

This charming and serene group of a young girl with a child was conceived by Rodin in 1890. It relates in theme to a neo-rococo *Mother and child* of his early years in Brussels, and in conception to a high relief of the same subject of similar date (J. Cladel, *Auguste Rodin, L'Oeuvre et L'Homme*, Brussels, 1908, pl. facing p. 24).

In view of the number of posthumous casts of Rodin bronzes abounding on the art market, it is of interest to record not only that cat. 132 was produced in Rodin's lifetime, but also, by citing an autograph note from the testator, to offer a small insight into Rodin's mercurial temperament:

''We all knew Rodin well. As a boy I was allowed to 'play with clay' in his studio and adored it tho' I never had the 'divine fire'. Many of the bronzes came to me from Father. The 'Frère et Soeur' I acquired as follows. I was in R's studio when the first cast was delivered &, expressing my admiration, asked if I could buy it. R. called me every sort of name – 'As soon as a man does something he is reasonably pleased with, some B.F. comes along and wants to take it away', so I calmed him down, gave him lunch & didn't refer to it again. A month or so later a packing case arrived in London. It was the 'Frère et Soeur', cast & a note from R. saying 'I was quite wrong. When a man does something which arouses the enthusiasm of the man who sees it, then that is the man who should possess it'. It was a gift to me.''

RAC

Cat. 133 M. 16-1972

Decanter. 1865

Designer: William Burges (1827–81)
Makers: Josiah Mendelson, George Angell

Dark-green glass mounted in silver with
applied and engraved ornament, set with
malachite, semi-precious stone, *cloisonné*
enamels, coral cameos, intaglios, classical
coins, ivory and rock crystal
Marks: London hallmarks for 1865 and
maker's marks of Josiah Mendelson and
George Angell
H: 27.3cm W: 19cm
Bought from the Perceval Fund and the
Regional Fund administered by the Victoria
and Albert Museum

Coll: *William Burges; C. and L. Handley-Read*

Ref: *Ann. Rep.* 1972, pl. V; *Robinson and
Wildman*, p. 13, no. 20

William Burges was one of the
outstanding English architects of
the High Victorian Gothic Revival. His
knowledge and love of medieval art,
interest in fine craftsmanship, and
imaginative designs for metalwork, stained
glass and furniture made him also an
important precursor of the Arts and Craft
movement.

Burges had already conceived the idea
for this decanter by 1858, when a similar
vessel was shown with several pieces of
metalwork in a watercolour serving as the
frontispiece of his *Orfèvrerie Domestique*
(RIBA Drawings collection). On the 10th,
11th and 12th sheets of this, there are
further drawings for the decanter, the last
of which is dated 1864. It was made in 1865,
as were two variants: one made for Burges
himself, now in the Cecil Higgins Art
Gallery, Bedford (*Victorian and Edwardian
Decorative Art, The Handley-Read Collection*,
exh. cat., Royal Academy, 1972, B 87, cat.
134 being B 88, pp. 32–3); the other, made
for James Nicholson, and now in the
Victoria and Albert Museum (Patricia
Wardle, *Victorian Silver and Silver-Plate*,
London, 1963, pl. 49).

The design of the decanter demonstrates
Burges's flair for combining diverse
materials and eclectic components to create
vessels which were both visually successful
and highly idiosyncratic. The lion's head
on the handle was based on the pommel of
an eighth–seventh-century BC Assyrian
dagger-hilt; the rock-crystal lion finial is
Chinese, eighteenth century; and the silver
mounts are set with Greek, Roman and
Byzantine coins, Roman and Sassanian
intaglios and seventeenth-century coral

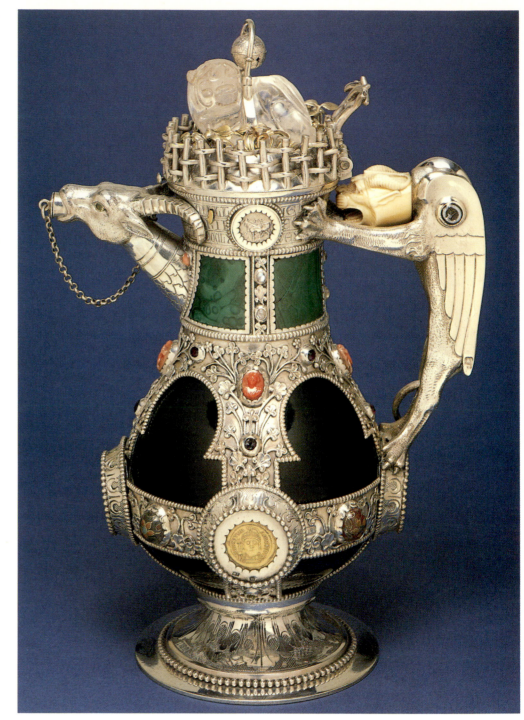

cameos. The concept is reminiscent of early
medieval crucifixes studded with re-used
Roman cameos, intaglios and uncut
gemstones. The foliage applied to the body
is also medieval in inspiration, and
engraved on the foot, like animals in the
borders of an illuminated manuscript, are a
hedgehog, a frog, a mouse and a wren with
worm in its beak, humorously
accompanied by the 'signature' *I WREN*, for
Jenny Wren.

The partly obscured inscription on the

neck, *WILLIELMUS BURGES ME FIERI
FECIT ANNO DI MDCCCLXV EX HONS
ECCL[ESI]AE CONSTANTINOPOLITANAE*,
indicates that Burges paid for the decanter
from the fees which he had received for his
prize-winning design of 1856 and later
modifications to it for the Crimea Memorial
Church in Constantinople. This, like
several of his architectural projects, was
never built because its estimated cost
proved too high.

JEP

Cat. 134 M. 16-1980

BULLOCK, George
1778 or 1782/3 – 1818 London

Cabinet. 1817

Larchwood and ebony with brass inlay and ormolu mounts, the interior fitted with two sets of six drawers sliding on side runners
H: 86.8cm W: 120cm D: 46.6cm
Bought from the Gow Fund with a contribution from the NACF and the Regional Fund administered by the Victoria and Albert Museum

Coll: *the 4th Duke of Atholl; perhaps his widow as Mrs. Bagshawe, near Stafford; Mrs. C. Adams, probably of Bristol or Weston-super-Mare; with Temple Williams Ltd., from whom bought*

Ref: *Ann. Rep.* 1980, pl. XXIV; *Treasures*, no. 96

George Bullock was one of the most enterprising and original English furniture-makers of the early nineteenth century. Yet after his death in 1818, he sank into obscurity until rediscovered in the 1950s. Initially a wax-modeller and sculptor, Bullock went into business as a furnisher and marble-cutter in Liverpool in 1804, where he remained until moving to London in 1812. Since 1806 he had been the proprietor of the Mona Marble quarries on Anglesey and had several important commissions to his credit, such as furnishings for Cholmondeley Castle, Cheshire. The superb quality of Bullock's work, which was strongly influenced by the fashionable French Empire style, ensured his success in the capital. In addition, he possessed an easy manner which enabled him to establish cordial relations with aristocratic and other patrons. A summary of his career and major commissions was included in *The Dictionary of English Furniture Makers* (eds. Christopher Gilbert and Geoffrey Beard, Furniture History Society, London, 1986, pp. 126–8); a more detailed study was published in connection with exhibitions held in parallel at the Studeley Art Gallery, Liverpool and at H. Blairman & Sons Ltd., London, in 1988 (Clive Wainwright et al., George Bullock Cabinet Maker, London, 1988).

This cabinet is one of three commissioned from Bullock by the 4th Duke of Atholl (1755–1830), probably for Dunkeld. The other two, of similar form and style but larger and with different detail in the ornament, are now at Blair in Perthshire, the seat of the present Duke (Wainwright, et al., op. cit., pp. 68–71, no. 9). An account for the cabinet, dated 12 July 1817, was included with that for the others, made out on 12 February 1819, over nine months after Bullock's death. All three incorporate larchwood and Glen Tilt marble from the Atholl estates. (Incidentally, the introduction of the larch into Scotland is attributed to Sir William Lockhart of Lee (cat. 78).) It is not certain when or how the single cabinet left Scotland, but it may have occurred when the 4th Duke's second wife (d. 1842) remarried in her widowhood a Mr. Bagshawe who lived near Stafford (information from the present Duke to Michael Jaffé).

Designs for the Fitzwilliam cabinet, and the pair at Blair, including the patterns for the boulle work on the doors, are among 'The Wilkinson Tracings' at Birmingham City Art Gallery (Wainwright et al., op. cit., p. 70, fig. 26; p. 107, fig. 47). These tracings were made in 1820 from designs by Bullock, by a Thomas Wilkinson, whose identity is uncertain.

A more sumptuous pair of cabinets of similar form, but largely of ebony and rosewood with Mona Marble tops inlaid with late-seventeenth-century scagliola panels, was also made in 1817 for the 1st Marquess of Abercorn (Wainwright et al., *op. cit*, pp. 85–7, no. 23). A less ornate cabinet of similar design was formerly in the possession of Queen Mary at Marlborough House (Christie's 1–2 October 1959, lot 45, and Sotheby's 28 February 1969, lot 144).

These cabinets illustrate prominent traits of Bullock's style, notably his predilection for dramatic contrasts. Their severely rectangular forms have a strong sense of projection and recession; and smooth surfaces of dark and light woods are counterbalanced by the textured effect of coloured marble and the opulent but unostentatious glow of ormolu mounts and boulle work. Shaped plinths with a central semicircular drop decorated with a palmette recur on other Bullock cabinets and bookcases (cf. Frances Collard, *Regency Furniture*, Woodbridge, 1985, pl. 18).

JEP

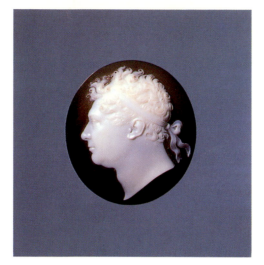

Cat. 135 CM. 9-1980

PISTRUCCI, Benedetto
Rome 1784 – 1855 Englefield Green,
Windsor

The Prince Regent. About 1816

Brown and white onyx cameo
Signed: *PISTRUCCI*
H: 38.8mm W: 35mm
Given by the Friends of the Fitzwilliam in
honour of Lady Butler of Saffron Walden
with contributions from the NACF, the
Regional Fund administered by the Victoria
and Albert Museum, and from Mr. Malcolm
Carr.

Coll: *Christie's 26 June 1980, lot 153*

Ref: *Ann. Rep.* 1980, pl. XX; *Treasures*, no. 98

Pistrucci was a gem engraver and
designer of coins and medals who was

active in London from 1815 until his death.
He was employed principally at the Royal
Mint from 1816 to 1849, being appointed
Chief medallist in 1828. He designed
coinage for both George III and George IV,
his design of St. George and the Dragon
being still in use for gold coins. His official
medals included the coronation medals for
George IV and for Queen Victoria. Pistrucci
prepared his designs as wax models and as
cameos. This superb cameo was carved as
the model for the royal portrait for a medal
proposed to commemorate the purchase by
the Government in 1816 of the Elgin
Marbles. The medal was never issued; but
the designs have survived in this cameo,
and in wax models for the complete
designs (obverse and reverse) which are
preserved in the Museo della Zecca, Rome.

JGP

PATTERN VICTORIAN COIN

Cat. 136 Henderson 1878

WILLIAM WYON, designer/engraver
1795 – 1851
United Kingdom: Victoria (1837–1901):
London, Tower Hill mint. 1839

Obverse: **VICTORIA D: G:
BRITANNIARUM REGINA F: D:**. Head of
Victoria left, wearing head-band:
truncation inscribed **W. WYON. R.A.**
Reverse: **DIRIGE DEUS = GRESSUS
MEOS : MDCCCXXXIX**; **W WYON R.A.**;
Victoria (Una) front left, directs, with
sceptre, lion walking left.
Edge: (rosette) **DECUS ET TUTAMEN**
(rosette) **ANNO REGNI TERTIO.**

Metal and denomination: pattern gold (AV)
5-pounds (proof)

Weight: 38.95g Diameter: 38mm
Axis: 360°

Standard literature
*Seaby's Standard Catalogue of British Coins:
Coins of England and the United Kingdom,*
eds. S. Mitchell, B. Reeds, London, 1987,
no. 3851.

J. R. Henderson bequest, 1933

Ref: *Treasures*, no. 99

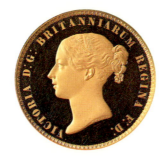

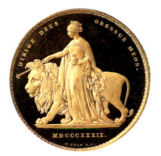

William Wyon was the most
distinguished member of a
celebrated dynasty of medallists. His
connection with the Royal Mint began in
1815, when he came to London to assist his
uncle, Thomas Wyon Snr., in the engraving
of new Great Seals. Appointed to the post
of Second-engraver the following year, he
was disappointed not to be promoted
Chief-engraver, when his young cousin,
Thomas Jnr., died in 1817 after only two
years in post. The salary was given instead

to Benedetto Pistrucci (cat. 135), although,
as an alien, he was barred by statute from
taking the title. Owing to the Italian's
unwillingness to undertake work on the
coinage, Wyon became in practice Chief-
engraver well before his formal
appointment was finally gazetted in 1828.
Rivalry between the two artists continued
through the accession of Queen Victoria in
1837, bolstered by a newspaper controversy
that played as much on the question of
nationality as on artistic merit. Both men
were commissioned to make portrait dies
of the new queen. Wyon, it is said, refused
to take his sittings at the same time as
Pistrucci. In the event, the latter's portrait
was poorly received, while that produced
by the Englishman after only one sitting
was employed not only for the British
imperial currency, but also for the postage
stamps (the obverse of the pattern coin
shown here is a reworking of the currency
effigy). Wyon had the satisfaction, too, of
being the first medallist to be elected to the
Royal Academy (1838), an honour
advertised on both sides of this piece.

The pattern five-pound piece was never
issued in currency form. The remarkable
reverse type, for which the Fitzwilliam
Museum possesses the artist's original wax
model (CM. 279-1968; illustrated in Jones at
no. 16), represents the Queen as Una, the
fair princess and personification of Truth in
Book I of Edmund Spenser's allegorical epic
The Faerie Queene (1596). During an
enforced separation from her champion,
the Red Crosse Knight (St. George, patron
saint of England), Una is befriended and
protected by a noble lion, whose fierceness
turns to devotion at the sight of her beauty
and purity. Here the lion is identified by
Wyon with Great Britain, his steps guided
by Victoria. Divine direction is invoked by
the legend 'Guide thou, O Lord, my steps',
a phrase adapted from Psalm 119:133. The
obverse contains the standard titles of the
contemporary currency issues; Victoria is
styled 'By the Grace of God, Queen of the
Britains [i.e. of Great Britain and her
Dependencies], Defender of the Faith'. The
edge of the coin reproduces a legend ('An
ornament and a safeguard') suggested by
the celebrated seventeenth-century
antiquarian and royalist John Evelyn, who
had seen it on the book-plate of Cardinal
Richelieu's New Testament. It was
employed on all early milled silver coins of
England (from 1662) and was recently
reintroduced on the United Kingdom
coinage to decorate the edge of certain
issues of one-pound pieces. (For W. Wyon,
see L. Forrer, *Biographical Dictionary of
Medallists* VI, London, 1916, pp. 650–87; for
his time at the Royal Mint, see Sir John
Craig, *The Mint: A History of the London
Mint from AD 287 to 1948*, Cambridge, 1953,
especially pp. 294–8; for this piece and the
preparatory wax of the reverse, see M. P.
Jones, 'L'oeuvre des Wyon: un reflet de
l'ère pré-Victorienne et Victorienne', *La
Monnaie, Miroir des Rois,* Paris, 1978
(exhibition: Hôtel de la Monnaie, Paris),
pp. 493–500, the wax at no. 16, the coin at
no. 17.)

TRV

Cat. 137–8

BLAKE, William
London 1787 – 1827 London

Cat. 137 No. 1769

The house of Death. About 1795

Colour print, finished in pen, chalk and watercolour, heightened with white
H: 480mm W: 603mm
Inscribed on verso by William Linnell: *This drawing by Wm. Blake does not belong to the series of Mr. J. Linnell Snr., but was bought by me of a dealer in London. William Linnell*
T. H. Riches bequest, 1936

Coll: *Mrs. Blake; Frederick Tatham, sold Sotheby's 29 April 1862, lot 188 (as 'A vision of the Lazar House'), bought H. Palser; unknown; William Linnell by 1876; his son-in-law; the testator*

Ref: *Bindman, no. 17, pp. 17–18, pl. 18*

Blake's large colour plates were conceived in 1795, although, as the watermark in the paper has shown, several of them were not executed before 1805. They are among his most impressive achievements as a print-maker.
The house of Death, also known as *The Lazar House,* illustrates a passage from Milton's *Paradise Lost,* xi, 477–93:

Immediately a place
Before his eyes appear'd, sad, noisome, dark,
A lazar-house it seem'd, wherein were laid
Numbers of all diseased, all maladies
of ghastly spasm, or racking torture, qualms
of heart-sick agony, all feverous kinds,
convulsions, epilepsies, fierce catarrhs,
Intestine stone and ulcer, colic pangs,
Demoniac frenzy, moping melancholy,
And moon-struck madness, pining atrophy
marasmus, and wide-wasting pestilence,
Dropsies, and asthmas, and joint-cracking rheums
Dire was the tossing, deep the groans; Despair
Tended the sick, busiest from couch to couch;
And over them triumphant Death his dart
Shook, but delay'd to strike, though oft invoked
With vows, as their chief good, and final hope.

Blake's technique to produce these plates was a form of relief engraving, first described by his young follower Frederick Tatham, and quoted by Rossetti in a supplementary chapter to Alexander Gilchrist's *Life of Blake,* London, 1862, vol. I, p. 375:

"Blake when he wanted to make his prints in oil, took a common thick millboard, and drew in some strong ink or colour his design upon it strong and thick. He then painted upon that in such thick oil colours and in such a state of fusion that they would blur well. He painted roughly and quickly, so that no colour would have time to dry. He then took a print of that on paper, and this impression he coloured up in watercolours, repainting his outline on the millboard when he wanted to take another print."

Closer examination suggests that Blake did not repaint his millboard plate between impressions, as Tatham remembers, but that pen and watercolour were used to touch up later pulls from the plate which were weaker in intensity. Blake appears to have made up to three pulls of each of the twelve designs of various subjects from the Old Testament, Shakespeare, Milton and the Life of Christ, which has suggested to Martin Butlin (*The Paintings and Drawings of William Blake,* London, 1981, vol. I, no. 322, p. 174, pl. 399) that he intended to produce three complete sets.
In his catalogue of the Fitzwilliam Museum collection, Bindman (*op. cit.,* p.18) interpreted *The house of Death* as standing for the world subject to the renewed domination of Urizen, whose features Death recalls. Butlin, however, has argued that the plate represents the Creator presiding over the inevitable decay of his material creation.

JAM

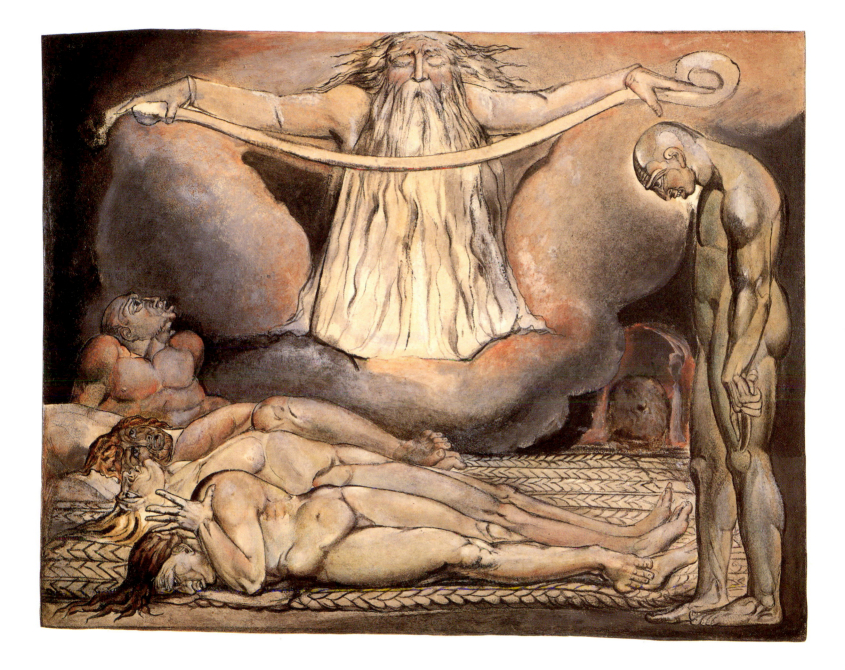

Cat. 138

No. 765

Death on a pale horse. About 1800

Pen and ink, grey wash and watercolour on paper
Signed in monogram, lower right: *W. B. inv*
H: 394mm W: 310mm
Given by the Friends of the Fitzwilliam, 1914

Coll: *Thomas Butts; Thomas Butts Jnr.; sold Foster's 29 June 1853, lot 91, bought by Colnaghi; Alfred Aspland by 1876; sold Sotheby's 27 January 1885, lot 63; bought by Colnaghi; Crawford J. Pocock, offered Christie's 12-14 May 1891, lot 585, bought by Mrs. Crawford Pocock; sold Sotheby's 8 July 1895, lot 127, bought by Keppel; ?Frederick Hollyer, sold anonymously Sotheby's 24 June 1903, lot 42, bought by Quaritch for W. A. White; repurchased by Quaritch 1914, from whom acquired*

Ref: *Bindman,* no. 23, p. 24, pl. 11; *FOF* 1914, p.3

Between about 1800 and 1809 Blake painted over eighty watercolour illustrations to the Bible for his major patron Thomas Butts (1757–1845). The series varies considerably in style, and follows no pre-established programme; Butts evidently paid Blake one guinea for the drawings as they were delivered, with the intention of filling up an extra illustrated Bible. Dates for individual watercolours are tentative, although Bindman's date of about 1800 for *Death on a pale horse,* which shares the highly expressive use of chiaroscuro characteristic of those painted at the beginning of the series, has gained general acceptance.

The subject is taken from Revelation 6:8: "And I looked, and behold a pale horse: and his name that sat on him was Death, and Hell followed with him." Martin Butlin has established that the biblical reference was inscribed just below the lower right-hand corner of the original series, with the title given above and below (*op. cit.* cat. 137, vol. I, no. 517, p. 368, pl. 578). In many cases, as here, these have now disappeared due to remounting or trimming.

The Book of Revelation was a popular source for British artists at the end of the eighteenth century, and was of particular relevance to Blake's attempts to link its prophecy of the end of the world and the triumph of the Spirit with contemporary political events. As Bindman has shown (*William Blake His Art and His Times,* exh. cat., 1982, p. 138), its imagery recurred throughout Blake's career, from the veiled references to it in early watercolours of the 1780s to later prophecies such as *Vale of the four Zoas.*

The Fitzwilliam owns a further four watercolours from the Butts series (Butlin, *op. cit.,* nos. 436, 495, 503 and 505), as well as a later reworking of *The parable of the wise and foolish virgins,* painted for John Linnell about 1822 on the basis of a composition painted for Butts in 1805. Two of the series of tempera illustrations to the Bible which Blake also painted for Thomas Butts from 1799, *The judgement of Solomon* (PD. 28-1949) and *The Circumcision* (PD. 153-1985) are also in the Fitzwilliam. The latter was part of a large bequest of paintings, watercolours, drawings, prints and illuminated books bequeathed in 1985 by the Blake scholar and collector Sir Geoffrey Keynes.

JAM

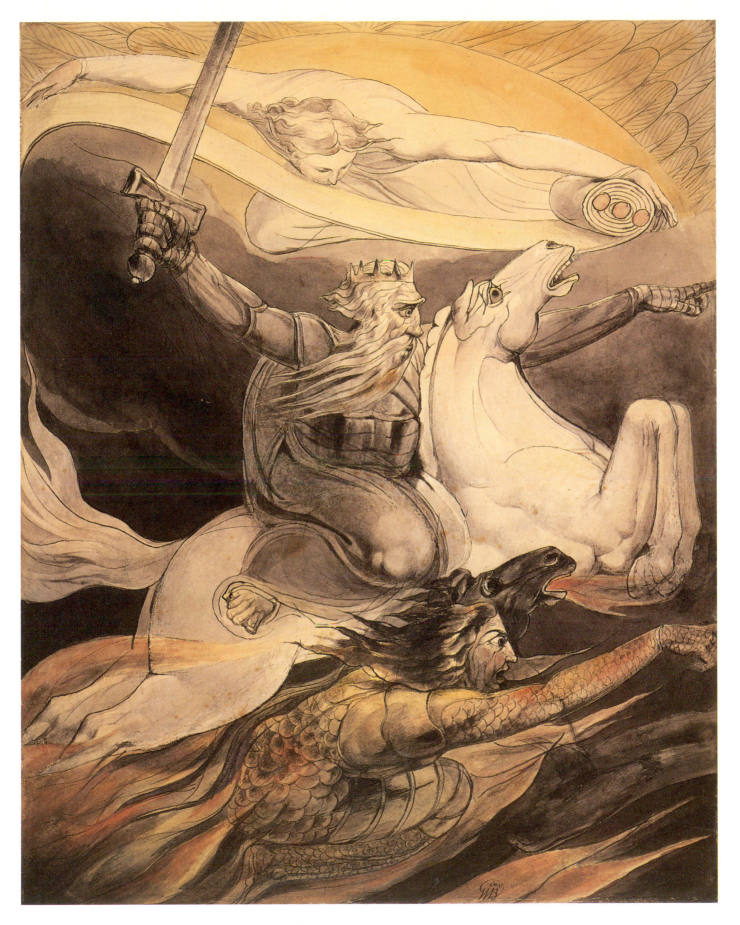

Cat. 139–40

TURNER, Joseph Mallord William
London 1775 – 1851 London

Cat. 139 No. 1585

Fortified pass, Val d'Aosta. 1802

Black chalk, watercolour and bodycolour on
grey tinted paper, with scratching out;
watermarked *J. WHATMAN 1801*
H: 322mm W: 479mm
Given by the Friends of the Fitzwilliam,
1931

Coll: *John Ruskin; Arthur Severn, sold
Sotheby's 10 May 1931, lot 109*

Ref: *Cormack I*, no. 10, pp. 34–5; *Robinson*,
no. 40, pp. 33–4; *FOF* 1931, p. 4, no. 6b

Turner made the first of six visits to
Switzerland in the summer of 1802.
As on his tours of England, Scotland and
Wales during the previous decade, he filled
a number of small leather-bound
sketchbooks with pencil sketches of the
landscape as he passed through it; but in
addition to these, he produced a series of
larger drawings, such as this from the *St.*

Gothard and Mont Blanc sketchbook of 1802
(T.B.LXXV), which record his reactions to
the imposing Alpine scenery. Most of the
leaves (watermarked *J. WHATMAN 1801*)
are now mounted separately in the Clore
Gallery, London, and include views of the
Val d'Aosta made during the same tour
(e.g. T.B. LXXV-23, T.B. LXXV-35). Like
many in the series it is executed in sombre
greys, greens and browns with black chalk
on prepared grey paper, which, together
with the use of a high horizon line and
vigorous scratching out, conveys the mass
and grandeur of the rock formations. As
Andrew Wilton has suggested, Turner's
conscious restriction of his palette, first
evident in the 'Scottish pencils' of 1801,
may have been influenced by his
contemporary experimentation with a
toned background in his oil painting
('Turner's Swiss Watercolours', *Turner in
Switzerland*, ed. Walter Amstutz, Zürich,
1976, p. 23).

This drawing was never intended for
public exhibition. However, it served as
the basis for two more elaborate versions of
the theme: the first for his patron Walter
Fawkes, identified by Wilton as *Mont Blanc
from Fort Roch in Val d'Aosta* (about 1810)
(A. J. Finberg, *Turner's Watercolours at*

Farnley Hall, London, 1912, p. 22, no. 24),
which was itself developed into the large
watercolour of *The Battle of Fort Roch, Val
d'Aosta, Piedmont, 1796,* exhibited at the
Royal Academy in 1815 (no. 192) and
accompanied by a quotation from 'Fallacies
of Hope'.

Thanks to the generosity of John Ruskin,
Turner's faithful supporter and former
owner of this drawing, the Fitzwilliam
Museum owns one of the best
representative collections of Turner's
watercolours outside London. In 1861 he
presented to the University of Cambridge,
for the Fitzwilliam, 25 watercolours,
including examples of the late Venetian and
Swiss watercolours, intended in his own
words, "to illustrate Turner's modes of
work at various periods of his life". "They
are all small", he continued, "and the
market value will not at present be more
than 1400 pounds; but I think they may be
useful for reference and occasional example
to the younger students who take interest
in the study of English art and in the
practice of drawing". Due to the terms of
the gift, these drawings may not be
exhibited outside the Fitzwilliam.

JAM

Cat. 140 PD. 50-1958

The woodwalk, Farnley Park. 1818

Watercolour and bodycolour, heightened
with white on grey paper
H: 294mm W: 400mm
Bought from the Fairhaven Fund

Coll: *Walter Fawkes, Farnley Hall; by descent
to Rev. Ayscough Fawkes; his sale, Christie's
28 June 1890, lot 43 (as ''In Wharfdale with a
rustic bridge''), bought Woolner; with Thos.
Agnew & Sons 1903*

Ref: *Ann. Rep.* 1958, pl. III

Farnley Hall, near Otley in Yorkshire,
was the home of Walter Fawkes,
Turner's friend and major patron from
about 1808 to his death in 1825. This is one
of a series of views of the house and
surrounding grounds painted while Turner
stayed with the Fawkes family in
November 1818. The present title – *The
woodwalk* – was acquired only in 1903 at
Agnew's sale, but in the catalogue of the
exhibition *Turner in Yorkshire* (York 1980,
no. 62, p. 44), David Hill identified the
scene with no. 9 in the 1850 MS catalogue
of the Farnley Turners by Hawksworth
Fawkes, *Glen leading to Loch Tiny* in the
grounds of Farnley Park. Another view of
this glen, *Lake plantation, Farnley Hall,*
looking down in the opposite direction
from the present picture, towards Lake
Tiny, is in a private collection (Wilton, *op.
cit.* cat. 139, no. 605).

Turner appears to have worked up the
present drawing from a pencil sketch in the
'Hastings' sketchbook (T.B. CXXXIX-2). As
Duncan Robinson has pointed out (*op. cit.*
cat. 139, p. 36), the autumnal colouring is
consistent with the presumed date of
November 1818.

JAM

Cat. 141 No. 2067

GOYA Y LUCIENTES, Francisco de
Fuendetodos 1746 – 1828 Bordeaux

"Segura union natural". About 1824

Black chalk on grey-white paper
H: 193mm W: 151mm
Signed (?) verso: *Goya*
Inscribed, lower centre: *Segura union
natural*, over earlier titles not easily
decipherable (one may read: *Hombre la
mitad mujer la otre . . .*)
Numbered, top right: *15*
C. H. Shannon bequest, 1937

Coll: *J. Peoli (L. 2020); his sale New York,
8 May 1894; Ricketts and Shannon*

In 1824, 78 years old and in failing
health, Goya moved from Madrid to
Bordeaux, where he spent his last four
years. This is a sheet from Album 'G', one
of the two so-called 'Bordeaux' albums
which were used between 1824 and 1827,
but broken up in the 1840s.

Both albums have the same format and
paper, and in both Goya has used for the
first time a combination of black chalk and
lithographic crayon, perhaps with a view to
producing a series of lithographs or
etchings. The subject matter in each album
is similar, though Pierre Gassier (*The
Drawings of Goya. The Complete Albums*,
London, 1973, p. 516) has convincingly
proposed a slightly earlier date of 1824 to
about 1826 for album 'G' because of

references to the 1826 Bordeaux fair in
drawings in Album 'H'.

Marital harmony – or, more often,
disharmony – preoccupied Goya
throughout his career. Here, as Gassier
suggests, he seems to imply that the bond
of matrimony is made indissoluble only by
being joined in the narrowest sense. The
image may have been influenced by the
depiction of "concorde (union) conjugale",
showing a couple sharing a heart in *Le Petit
Trésor des artistes*, II, Paris, An VIII, p. 45
(letter from Eleanor Sayre in the
Fitzwilliam's files, 1967).

Alterations in the inscriptions and in the
figures demonstrate the pains which Goya
took to achieve a perfect balance between
word and image.

JAM

Cat. 142 PD. 80-1950

COTMAN, J. S.
Norwich 1782 – 1842 London

Postwick Grove, Norfolk. Early 1830s

Watercolour
H: 178mm W: 272mm
Given by T. W. Bacon

Cotman's idiosyncratic style and bold use of colour evolved from his knowledge of Thomas Girtin (1775–1802) and John Varley (1778–1842). It reached maturity in the watercolours executed on his visits to Yorkshire about 1803–5, which are some of the freshest and most poetic of English watercolours.

In 1806 Cotman became one of the leading members of a thriving provincial school in Norwich. At this time he took up oil painting, a medium in which he found little commercial success. His income came largely from teaching ("sorry drudgery") and from providing soft-ground etchings to illustrate such volumes as *The Antiquities of Norfolk*, London (1811–18), and *The Architectural Antiquities of Normandy*, London (1822).

Cotman's earliest drawing of Postwick Grove, in black and white chalks, was made about 1814 (B.M. 1902–5–14–115). It was used as the basis for a soft-ground etching in his *Liber Studiorum*, published in 1838. The present drawing may be dated by style to the early 1830s, when he abandoned oils and began to experiment with opaque watercolour. The exact composition of his medium is unknown, but it is thought that transparent watercolour was thickened with an agent derived from rotting flour paste, which gives the intensity of colour and rhythmic brushwork in this watercolour.

A version of the subject, showing only the trees and bank, but painted with all the freedom of the Fitzwilliam drawing, is in the British Museum (1902–5–14–29).

JAM

Cat. 143–4

DE WINT, Peter
Stone, Staffordshire 1784 – 1849
London

Cat. 143 PD. 137-1950

**Sketch of a tree and the hull of a boat
at mooring.** About 1835–40

Watercolour on paper
H: 252mm W: 215mm
Given by T. W. Bacon

Coll: *with Messrs. Palser, London, 1910, from
whom bought by donor*

Ref: *Scrase*, cat. 29

De Wint's informal studies are
among the most unaffected of English
watercolours. This loosely painted sketch
manifests his ability to define place and
mood with the minimum of detail. Boat,
river-bank, tree and water are described by
a few overlapping blots of colour; each
given its fullest expression by contrast with
the white paper ground, which in this
context is used as a positive force in the
composition.

Although contemporaries such as Ruskin
condemned his *bravura* as slapdash, De
Wint enjoyed considerable success as a
watercolourist. One of his most ardent
admirers was the poet John Clare, who in
1829 wrote to ask him for "a bit of your
genius to hang up in a frame in my
Cottage. What I meane is one of those
scraps which you consider nothing after
having used them that lye littering about
your study for nothing would appear so
valuable to me as one of those rough
sketches taken in the fields that breathes
with the living freshness of open air."
 JAM

Cat. 144 PD. 121-1950

On the Dart. 1848

Watercolour with gum arabic over traces of pencil on paper
Inscribed, verso, in pencil, in the artist's hand: *Holme [sic] Chase on the River Dart / Devonshire / 9th Sept. 1848*
H: 331mm W: 507mm
T. W. Bacon bequest

Ref: *Scrase*, cat. 123

In autumn 1848 De Wint made his last painting excursion to Devon in south-west England. The following year, only weeks before his death, he exhibited at the Old Water Colour Society *On the Dart* (*Scrase*, cat. 124), also in the Fitzwilliam (PD.5-1977), for which this is a study.

Comparison with the finished version demonstrates how the spontaneity of the sketch has been tempered to produce for exhibition a more conventionally picturesque view. As well as giving greater definition to topographical detail, De Wint has more carefully articulated the perspective by adding a water-mill and a winding path to undefined areas of the foreground, groups of cattle and an angler to the river-bank in the middle-distance, and by extending the composition over the distant hills on the right.

De Wint was renowned for his ability to capture broad effects of light and shade and subtle atmospheric conditions. Much of his success depended on his use of rough paper to absorb the transparent colour washes, and on his dragging a brush scarcely wet over the surface, as here in some parts of the distant hills, to allow the white paper to sparkle through as highlights.

An inscription on the verso identifies the scene as Holne Chase, near Ashburton on the south-east edge of Dartmoor; the distinctive arches of the fifteenth-century Old Holne Bridge are visible in the middle-distance of the finished watercolour.

JAM

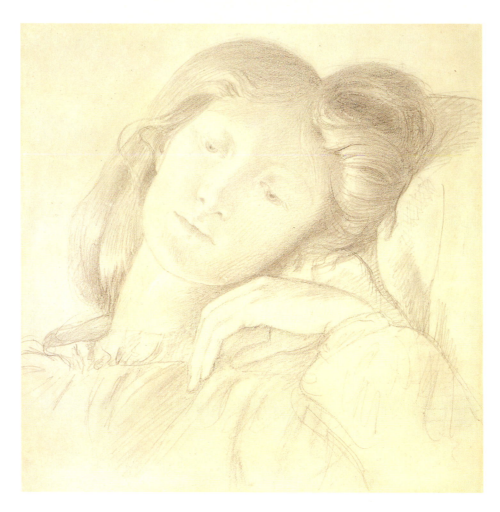

Cat. 145 No. 684

ROSSETTI, Dante Gabriel
London 1828 – 1882 Birchington-on-
Sea

Elizabeth Siddal. About 1854

Pencil on paper
H: 258mm W: 251mm
Given by C. Fairfax Murray, 1909

Coll: *given by William Michael Rossetti to*
Fairfax Murray when the latter bought
Elizabeth Siddal's Clerk Saunders *(also in the*
Fitzwilliam Museum, no. 680)

Elizabeth Siddal (1834–62) was
introduced in 1850 to the Pre-
Raphaelites by Walter Deverell, who had
met her in a milliner's shop in Leicester

Square. Between 1850 and 1852 she sat to
William Holman Hunt and to Millais (for
his *Ophelia*, 1852, Tate Gallery, no. 1506).
After that date she modelled exclusively for
Rossetti.

Rossetti developed something of a
monomania for Lizzie Siddal (his
'Guggums' from the time of their
engagement in 1854). That October Ford
Madox Brown recalled him drawing,
"wonderful and lovely 'Guggums', one
after the other, each one a fresh charm,
each one stamped with immortality"; less
than six months later he was shown, a
"drawerful [sic] of 'Guggums'; God knows
how many, but not bad work I should say,
for the six years he has known her" (*Diary*;
quoted W. M. Rossetti, *Ruskin, Rossetti and*
Pre-Raphaelitism, London, 1899, pp. 19 and
40).

The Fitzwilliam Museum owns eight

further drawings by Rossetti of Elizabeth
Siddal, mostly informal studies from the
life (V. Surtees, *The Paintings and Drawings*
of Dante Gabriel Rossetti, London, 1973, nos.
465, 466, 502, 503, 504 and 548), although
one, depicting her in the role of Delia
(Surtees, *op. cit.*, no. 62E), is a preparation
for Rossetti's *The return of Delia to Tibullus*
(1853, private collection, Surtees, *op. cit.*,
no. 62).

Rossetti and Siddal married in 1860.
According to a note by William Rossetti,
the artist's brother, this drawing was made
either immediately before or immediately
after their marriage. Siddal's health was
always delicate; tragically, following two
years of failing health attributed to a
variety of causes from curvature of the
spine to a nervous disorder, she died from
an overdose of laudanum in 1862.

JAM

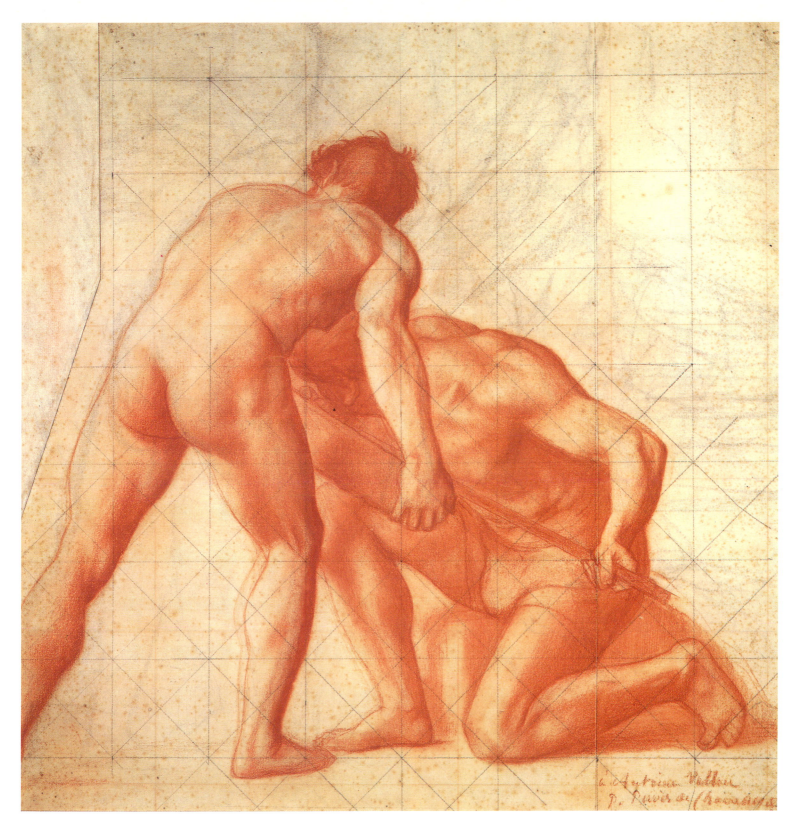

Cat. 146 **A study for "Le Travail"**

Cat. 146 No. 2135

PUVIS DE CHAVANNES, Pierre Cecile
Lyons 1824 – 1898 Paris

A study for "Le Travail". About 1862–3

Pencil, black and red chalk on paper; the left-hand side of sheet repaired and filled in. Squaring in pencil
Signed and inscribed lower right, in red chalk: *à Antoine Vollon / P. Puvis de Chavannes*
H: 624mm W: 610mm
C. H. Shannon bequest, 1937

Coll: *Antoine Vollon; probably his sale, Paris, 22 June 1901; bought by Durand Ruel; sold to E. J. van Wisselingh, 17 May 1901; bought by Charles Ricketts, 7 August 1901*

Ref: *Darracott, pl. 23*

Following the success of his painting *Concordia* (*La Paix*) at the Salon in 1861, where it was bought by the State for the newly built Musée Picardie, Amiens, Puvis gave to the same museum its companion piece *Bellum* (*La Guerre*). He painted two further compositions on complementary themes, *Le Repos* and *Le Travail*, both exhibited at the Salon of 1863, to add to the decorative cycle at Amiens. This study, squared up and dedicated to Puvis' friend the painter Antoine Vollon, is for the two workmen in the left background of *Le Travail*.

The aim of Puvis in each of the canvases (still *in situ*) was to convey an abstract idea (Peace, War, Rest and Work), without alluding to a particular time or event. Figures are draped or partly draped; and all four paintings are executed *à la cire*, that is, using on canvas a mixture of oil and wax, which dulls the colours in imitation of the fresco cycles of the Renaissance masters.

Ricketts was thrilled by his acquisition: "Great red-letter day. One of Puvis de Chavannes' nine stupendous sanguines for the Amiens decorations was bought by me at E. J. van Wisselingh's for the huge sum of one hundred and thirty four pounds. I burst into perspiration at the sight of it, so great was my lust of possession." (*Journal*, 7 August 1901, quoted in T. Sturge Moore and C. Lewis, *Self-portrait, taken from letters and journals by Charles Ricketts R.A.*, London, 1939, p.65). Three days later he ensured that Shannon saw the drawing in the most favourable circumstances: "Shannon returned from Lincolnshire. I made him drunk, having placed the Puvis on a table during the grub for him to see when he went into the next room. He blundered in, burbled over his coffee, not turning round towards that side of the room where stood the drawing between two candles. When he turned round, he suddenly became quite sober and serious for an instant, and almost white with astonishment and pleasure." (Sturge Moore and Lewis, *op. cit.*, p. 66.)

A black conté crayon drawing closely related to the figure on the left is in the Musée des Beaux-Arts, Marseilles (no. 180); a squared-up study in black chalk for the central group of smiths, dedicated to the painter Walter Thornley, is in the Musée Bonnat, Bayonne.

A reduced version of the painting at Amiens, painted in 1867, is in the National Gallery of Art, Washington (Widener collection, no. 651).

JAM

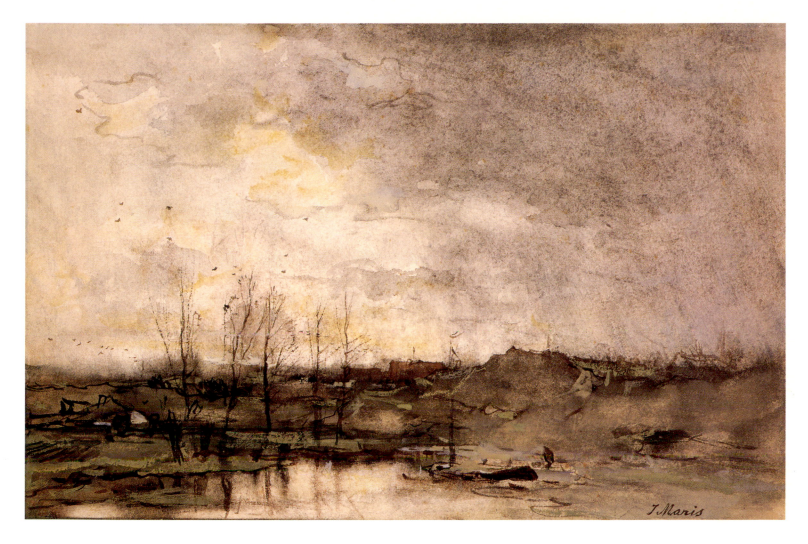

Cat. 147 No. 848

MARIS, Jacob
The Hague 1837 – 1899 Carlsbad

A rainy day. About 1880

Bodycolour on paper
Signed, lower right: *J. Maris*
Inscribed, verso, in pencil: *G.C.9200*; in
ink: *Paysages Dunes*
H: 251mm W: 384mm
T. H. Riches bequest, 1917

Coll: *Sir John Day; sale, Christie's 13 May
1909, lot 21, bought by testator*

Maris was a leading member of a group of realist painters known as The Hague School, which flourished in Holland in the 1870s. He drew most of his subjects from the towns and countryside around The Hague; but paradoxically it was about 1870, towards the end of a five-year stay in Paris, largely spent painting pretty Italian models for the dealer Goupil, that he turned to seascapes.

A rainy day owes much of its charm to its simplicity. Two fluidly painted areas of grey, undisturbed by extraneous pictorial drama, define the relations between sky and sea which fascinated Maris. The painters of The Hague School were particularly criticised for their dingy grey palette; however in this case Maris introduces a fresh, airy quality by allowing specks of the rough white paper to sparkle through the thin layer of paint.

The Hague School was avidly collected in both Great Britain and the United States at the end of the nineteenth century. This watercolour belonged to Sir John Charles Frederic Sigismund Day (1826–1908), a well-to-do London lawyer who assembled an extensive collection of Barbizon works, as well as Hague School works by Mesdag, Mauve, Israëls and the brothers Maris. His collection, which included a considerable number of etchings and engravings, was sold the year after his death.

JAM

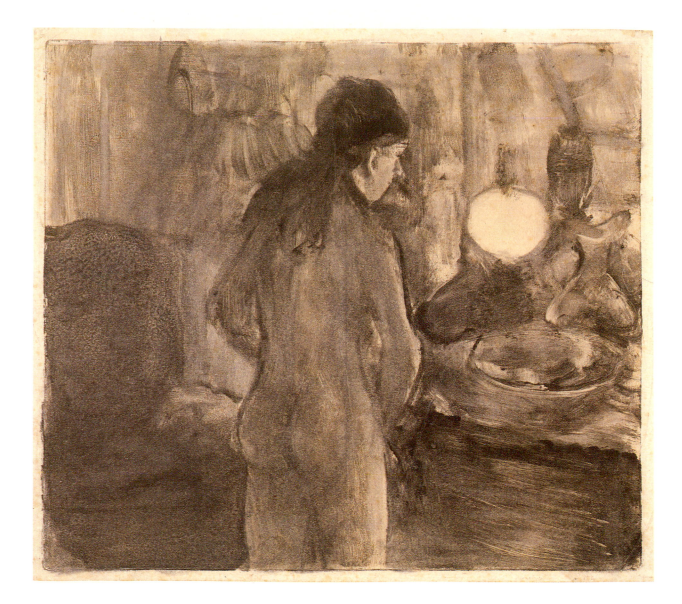

Cat. 148 P. 10-1978 H: 273mm W: 309mm

DEGAS, Hilaire-German-Edgar
Paris 1834 – 1917 Paris

Femme à sa toilette: la cuvette (Woman at her toilet: the washbasin). About 1880–3

Monotype printed in black ink on china paper
Inscribed faintly in pencil in lower margin:
31 monotype 1ᵉ [epr?] []
Gow bequest through the NACF

Coll: *Vente Degas (Estampes), 22-3 November 1918, no. 245; Maurice Exteens; Paul Brame; Lefevre Gallery, bought from them by A. S. F. Gow in 1960*

Ref: *Gow, no. 33*

One of a group of monotypes of female nudes at their toilet, executed by Degas in the 'dark field' manner in the early 1880s. He began by coating a plate with a thin layer of ink; the design was created by thinning or wiping away the ink; an impression of the design was then printed on paper. When a second impression was taken from the plate it was considerably weaker and was usually strengthened with pastel. This impression is not touched and, as the inscription may indicate, was certainly the first impression. No second impression is known; although a counterproof, printed from this impression, was included in the same lot in the Degas sale (lot 245, ''La Toilette (la cuvette) Monotype et contre-épreuve'').

CH

Cat. 149 No. 2118

MENZEL, Adolf van
Breslau 1815 – 1905 Berlin

A study of a lady's head and hand.
About 1890

Pencil on paper
Signed with initials, lower right: *AM*
H: 135mm W: 210mm
C. H. Shannon bequest, 1937

Coll: *Ricketts and Shannon, lent to the Fitzwilliam Museum, 1933–7*

Much of Menzel's early career was devoted to book illustration and to painting historical scenes from the life of Emperor Frederick II. In the last decades of his life, however, he drew increasingly from the quotidian. The vast number of his close studies of human figures and heads evince his relentless pursuit of descriptive accuracy. The *mise en page* of a woman's head and alternative right hands – one holding spectacles, the other a strand of wool – exemplifies this quest for objectivity. Each element is studied independently of the other and of its physical environment, as if presented for scientific analysis. However, Menzel's masterly handling of his medium – in this case a soft carpenter's pencil – raises clinical observation to the level of the poetic, by his sensitive rendering of delicate details such as the woman's earring and by the rich tonal effects which he uses to describe light and texture.

Charles Ricketts, a former owner, was one of many to point to the marked affinities between the work of Menzel and Degas; their love of realism was, he wrote, "not only temperamental, it was an intellectual bent" (*Pages on Art*, London, 1913, p. 141). In fact Degas owned several of Menzel's drawings, while Menzel thought Degas "ein tüchtiger Mensch". (William Rothenstein, *Men and Memories*, London, 1932, vol. II, p. 15).

JAM

Cat. 150 PD. 14-1961 Ref: *Ann. Rep.* 1961, pl. XX

BOCCIONI, Umberto
Reggio di Calabria 1882 – 1916 Sorte

Study for "Vuoti e piani astratti di una testa". 1912

Pencil on laid paper
Signed, lower right in pencil: *Boccioni*
H: 330mm W: 243mm
Bought from the Walter Butterworth Fund

Coll: *F. T. Marinetti; E. Estorick; with Grosvenor Gallery, 1961, from whom bought*

A study for the destroyed plaster of 1912, shown at the first one-man exhibition of Boccioni's futurist sculpture at the Galerie la Boëtie in Paris in 1913. M. Calvesi and E. Coen (*Boccioni*, 1983, no. 776, repr.) associate five other drawings with the project, which was one of the most acclaimed by critics of the day.

The traditional suggestion that the woman's head portrays the artist's mother cannot be substantiated. The sitter may be the artist's sister, but the harshness of the features and downturned mouth are not characteristic of Boccioni's other drawings of her.

In accordance with his revolutionary *Technical Manifesto of Futurist Sculpture* published in 1912, and doubtless influenced by his meetings with Archipenko, Duchamp-Villon and Brancusi later in the same year, Boccioni consciously broke away from naturalistic representation in his sculpture. The sculpture of the future would, he claimed, abandon the restrictive boundaries of physical reality: "We break open the figure and enclose it in its environment" (quoted Herschel B. Chipp, *Theories of Modern Art. A Source book by Artists and Critics*, New York, 1969, p. 302).

JAM

152

Cat. 151 PD. 37-1949

MODIGLIANI, Amedeo
Livorno 1884 – 1920 Paris

Revue actress in a large hat. About
1918–19

Pencil on paper
Signed, lower right: *Modigliani*
H: 434mm W: 269mm
Given by Louis C. G. Clarke

Modigliani made numerous drawings and paintings of women in large hats. Stylistically this drawing, on a page torn from a sketchbook, compares well with three studies made about 1918-19 for a painting of his wife, Jeanne Hebuterne, in a large hat (*L'opera completa di Modigliani,* ed. Piccioni and Ceroni, 1976, no. 180; Christie's 1 December 1972, lot 219; Sale dell' Angelicum, Milan 1961, lot 116, and with Hanover Gallery, London, 1979).

About this time Modigliani's work was first shown to a hostile British public. Sir Osbert Sitwell remembered buying individual drawings for 1/- to 2/6d, and the sale of a whole collection of his work for £700 to £1000 (*Left Hand, Right Hand. An Autobiography of Osbert Sitwell,* 1984 edn. p. 354). He claimed for himself and his brother Sacheverell credit for having introduced Modigliani's work to England in an exhibition held at Heal's Mansard Gallery in 1919 (in fact Bomberg had shown his paintings in a mixed exhibition five years earlier), and recorded the particular outrage caused by Modigliani's stylised elongated necks: "I believe that it would have been possible . . . to extract a mathematical formula, the heat of the anger seeming to be based on the number of times the neck of the given Modigliani could be multiplied to make the neck of the person protesting. Certainly, the thicker the neck, the greater the transports of its owner, and the thicker still would it become, swelling with fury" (*op. cit.,* p. 353).

JAM

Cat. 152 PD. 2-1983

BONINGTON, Richard Parkes
Arnold 1802 – 1828 London

**Boccadasse, Genoa, with Monte Fasce
in the background.** 1826

Oil on millboard
H: 24.5cm W: 32.5cm
Bought from the Fairhaven Fund with
contributions from the Regional Fund
administered by the Victoria and Albert
Museum, and the NACF

Coll: *Samuel Rogers; bequeathed by him in
1855 to his nephew William Sharpe; by
descent to Professor E. S. Pearson, who
presented it in 1962 to Cranbourne Chase
School; with Thomas Agnew & Sons, from
whom bought*

Ref: *Acquisitions*, p. 134, no. 19; *Ann. Rep.
1983*, pl. XVII

Probably bought by Rogers at
Bonington's sale, lot 159, as *Part of
Genoa and the Bay*. The subsequent title,
Lake Garda, was perhaps given by Rogers as
he had visited the lake in 1814 and
described it in glowing terms in his diary.
The precise identification was made orally
in 1984 by Signora Katarina Bloch, dei
marchesi Cattaneo Adorno.

Bonington painted several views near
Genoa in the early summer of 1826 during
his only visit to Italy. Accompanied by
Charles Rivet, who kept a diary of the
journey, Bonington left Paris on 4 April and
crossed the Alps via Sion and Brig on the
way to Milan. They skirted Lake Garda
between 14 and 18 April and proceeded by
Verona to Venice. The return started on 19
May. They passed through Padua, Ferrara,
Bologna, Florence (one week), Sarzana,
Lerici, and La Spezia, which they reached
on 7 June. From there they went to Genoa

and Alexandria, reaching Turin on 11 June,
and Paris on 20 June.

Bonington was depressed on the outward
journey and only regained his spirits in
Venice. The change in mood is also evident
in the sketches – those made in Venice and
on the return journey show him at his most
vivacious and brilliant. The present sketch
is an outstanding example of Bonington's
talent, the paint being handled with great
freshness and consummate ease. It is
comparable with another sketch in the
Bonington sale, lot 160, *View of the environs
of Genoa*, which was bought by Sir Thomas
Lawrence and is now in the National
Gallery of Scotland (no. 1017 as *Landscape
with mountains*).

Bonington moved to France as a child
with his family and trained in Calais and
Paris, where he remained. He was a friend
of Delacroix, who much admired his work.

CH

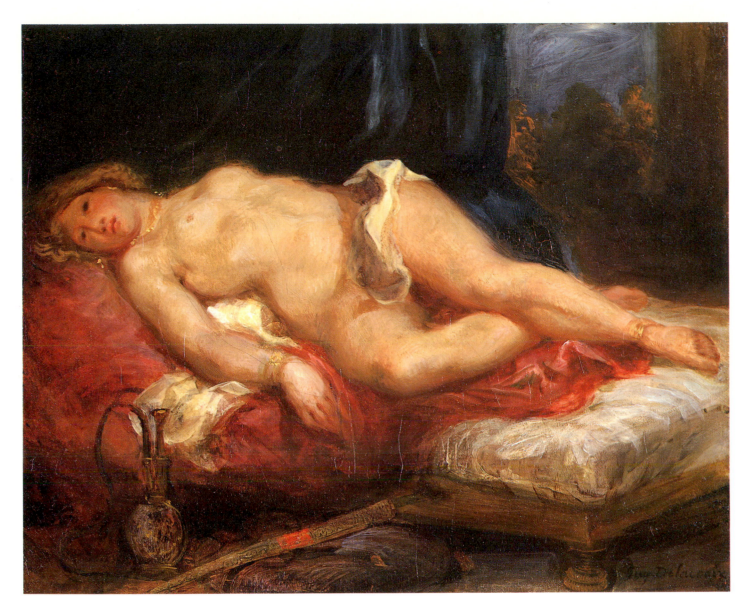

Cat. 153 PD. 3-1957

DELACROIX, Eugène
Charenton-Saint-Mauricel 1798 – 1863
Paris

Odalisque. About 1825–8

Oil on canvas
Signed: *Eug. Delacroix*
H: 36.5cm W: 45.3cm
Bequeathed by Percy Moore Turner
(d. 1950) with a life interest to his wife

Coll: *Amable Paule Couton; his sale 19 April,
1830, bought ?Delacroix; Delacroix sale
February 1864, lot 69, bought M. Barroilhet;
his posthumous sale 15 March 1872, lot 118;
Dassonvalle sale 3 March 1879, lot 51; P. A.
Cheramy (1891); his sale 5 May 1908, lot 172,
bought T. Montaignace; estate of P. A.
Cheramy sale 15 April 1913, lot 21, bought*

*Cassirer, Berlin; A. Rothermundt, Dresden
(1922); M. Silberberg, Breslau sale, Paris 9
June 1932, lot 20; Percy Moore Turner by 1937*

Ref: *Ann. Rep.* 1957, pl. III; *Paintings I,*
pp. 165-6

The breadth of form and freedom of
handling have sometimes led writers
to identify this study with a *Femme au lit*
which Delacroix noted that he began in
1850. The greater likelihood that this was
the *Odalisque sur un lit de repos* in the 1830
Couton sale suggests a dating in the 1820s.
This is supported by the presence of a nude
in this exact pose on a sheet of pen and ink
studies datable to about 1825-7 (Lee
Johnson, *The Paintings of Eugène Delacroix,*
1981, p. 10).

The pervasive mood of sensual abandon
is consistent with the picture having been

painted about the same time as *The death of
Sardanapalus* (Musée du Louvre, no. 667),
which was finished in 1828.

These paintings share an Oriental theme,
established in *Odalisque* by the foreground
accessories. Harem *odalisques* were a
favourite theme of French Orientalist
paintings, notably Ingres' *Recumbent
odalisque* of 1814 (Musée du Louvre, no.
1101) and the more overtly erotic *Odalisque
with slave* of 1839 (Fogg Art Museum). In
contrast to the restrained, classical
approach of Ingres, Delacroix's energetic
brushwork heightens the eroticism in what
is one of the most highly charged of his
more intimate paintings. *Pentimenti* reveal
that he changed the perspective of the
divan at bottom right, and that he may at
first have painted the left arm of the
woman across her torso.

CH

155

Cat. 154 PD. 49-1956

ROUSSEAU, Pierre-Étienne-Théodore
Paris 1812 – 1861 Barbizon

Paysage panoramique. About 1834

Oil on canvas
Inscribed: *ticharminil/flavigny/Moneville/
Merlin(?)*
H: 25.5cm W: 54.7cm
Bought from the Anne Pertz and C. B.
Marlay Funds

Coll: *Anon. sale, Parke-Bernet Galleries, New
York, 11 May 1953, lot 63, bought for the
Hazlitt Gallery, London; from whom bought*

Ref: *Ann. Rep.* 1956, pl. III; *Paintings I,*
pp. 193–4

An early work, probably of 1834, when
Rousseau made a journey from Paris
to the Jura. The place-names inscribed
along the lower edge are difficult to read,
but *flavigny* is probably the village of
Flavigny-sur-Ozerain, between Dijon and
Tonnerre. The panoramic viewpoint
allowed the artist to record the topography
of a large area of the landscape through
which he was travelling. The delicate
brushwork is lucidly suggestive of both the
detail and atmosphere of the landscape. A

number of small sketches of the early 1830s
employ a panoramic viewpoint (Nicholas
Green, *Theodore Rousseau*, Norwich, 1982,
nos. 16–19), but no other includes a feature
in the foreground such as the building in
the Fitzwilliam study.

Rousseau was the foremost painter of the
Barbizon School, although only in later life
did he achieve recognition. The realism of
his exhibition pieces of the 1830s and early
1840s led them to be rejected by Salon
juries. He first painted in the Forest of
Fontainebleau in 1826 and stayed there
regularly from 1833. Finally he settled in
nearby Barbizon.

CH

Cat. 155 M.Add.3

MADOX BROWN, Ford
Calais 1821 – 1893 London

The last of England. 1860

Oil on canvas
Signed: *F. MADOX BROWN 1860*
H: 46cm W: 42cm (oval image)
 47.7cm 43.8cm (canvas)
Bought from the Marlay Fund, 1917

Coll: *Bought from the painter by Col. W. J. Gillum (d. 1910); Mary Slater (by 1909), from whom bought*

Ref: *Paintings III*, pp. 41–2

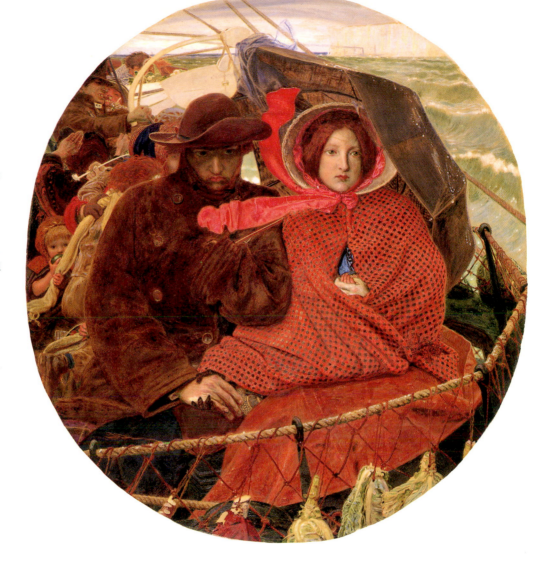

An autograph repetition, about half-size, painted for Gillum in 1860 of the panel of 1852–5 (Birmingham Museum and Art Gallery, no. 24'91). There are slight variations in colouring from the original, and the check of the shawl is larger. A finished cartoon of 1852 is also in Birmingham (no. 791'06).

Madox Brown painted the original at a time when he was intensely miserable and himself was considering emigrating to India. The spark for the subject was the emigration to Australia of his friend Thomas Woolner, the Pre-Raphaelite sculptor. Madox Brown may have accompanied Dante Gabriel Rossetti and William Holman Hunt when they went to see Woolner's departure. He used himself, his wife Emma and their children as models. His own description of the work written in 1865 states clearly his aims and the scrupulous methods which he shared with the Pre-Raphaelites:
''The picture is in the strictest sense historical. It treats of the great emigration movement which attained its culminating point in 1852 . . . I have, . . . to present the parting scene in its fullest tragic development, singled out a couple from the middle classes, high enough, through education and refinement, to appreciate all they are now giving up, and yet depressed enough in means, to have to put up with the discomforts and humiliations incident to a vessel 'all one class'. The husband broods bitterly over blighted hopes and severance from all he has been striving for. The young wife's grief is a less cankerous sort, probably confined to the sorrow of parting with a few friends of early years.

The circle of her love moves with her . . . To insure the peculiar look of *light all round,* which objects have on a dull day at sea, it was painted for the most part in the open air on dull days, and when the flesh was being painted, on cold days. Absolutely without regard to the art of any period or country, I have tried to render this scene as it would appear. The minuteness of detail which would be visible under such conditions of broad day-light, I have thought necessary to imitate, as bringing the pathos of the subject more home to the beholder'' (quoted in Ford Madox Hueffer, *Ford Madox Brown*, London, 1896, p. 100).

The original was immediately sold.

Madox Brown painted a further replica, smaller and in watercolour, in 1864–6 (Tate Gallery, no. 3064). In 1862 he was considering having an engraving made, using the Fitzwilliam version and a copy of a photograph of the original which he had coloured for T. E. Plint. It was finally engraved by Herbert Bourne for the *Art Journal* of 1870, pp. 236–7.

Madox Brown was of an earlier generation than the original members of the Pre-Raphaelite Brotherhood and had some early contact with the German Nazarene artists in Rome. Of all those in the Pre-Raphaelite circle, his work was the most socially motivated.

CH

Cat.156 PD. 108-1975

ELMORE, Alfred
Clonakilty 1815 – 1881 London

On the brink. 1865

Oil on canvas mounted on wood
Signed: *A. Elmore, 1865*
H: 113.7cm W: 82.7cm
Given by the Friends of the Fitzwilliam in
memory of Dr. A. N. L. Munby, with a
contribution from the Regional Fund
administered by the Victoria and Albert
Museum

Coll: *E. J. Coleman (by 1867); Randall Davies
(1866-1946); his executors sale, Sotheby's 11
February 1947, lot 168, bought A. N. L.
Munby; acquired from Dr. Munby's executors*

Ref: *Ann. Rep.* 1975, pl. IV; *Paintings III*,
pp. 70–1; *Treasures*, pp. 96–7

Elmore made his reputation as a
history painter. *On the brink* was his
first picture with a modern subject. When
it was exhibited at the Royal Academy in
1865, critics agreed on the interpretation of
the narrative. The critic for the *Illustrated
London News* wrote:
"A haggard-looking, fashionably-dressed
young woman sits in the cooling
moonlight; the expression of her face
relapsing towards despair, and the empty
purse hanging from her relaxed hand, tell
us she has lost her last florin. Whispering
at her ear in the shadow . . . is a young man
offering her the wherewithal to return to
the table, but at a price of ruinous slavery
of obligation, . . . which the woman's
conscience will not as yet permit her to
accept, though the result of the struggle is
still dubious; she is 'on the brink'."

The torn gaming-card at her feet and the
flowers at her side – passion-flowers for
passion and susceptibility, a lily for purity
– help tell the story. The gambling room, lit
with a hellish glow, was variously
identified by critics as that at Baden or at
Hesse-Nassau. An inscription, *Homburg*, on
the reverse suggests the famous Kurhaus
Hesse-Nassau, a Homburg site where rich
and fashionable tourists flocked to the
gaming rooms.

On the brink is one expression of a
general concern for the dangers of
gambling, especially for ladies. Alfred
Steinmetz (*The Gaming Table*, London, 1870)
wrote: "It could happen that a lady lost
more than she could venture to confess to
her husband or father. Her creditor was
probably a fine gentleman, or she became
indebted to some rich admirer for the
means of discharging her liabilities. In
either event, the result may be guessed"
(quoted by Lynda Nead, 'Seduction,
prostitution, suicide: *On the brink* by Alfred
Elmore', *Art History*, September 1982,
pp. 310–22).

The treatment of a moral dilemma is
typical of Victorian painting. A forerunner,
noted by Steinmetz (*loc. cit.*), was
Hogarth's *The lady's last stake*, 1758–9
(Albright-Knox Art Gallery, Buffalo). *The
gaming table*, an oil sketch by Elmore on a
closely conected theme, was with the
Alexander Gallery, London, in 1976.

 CH

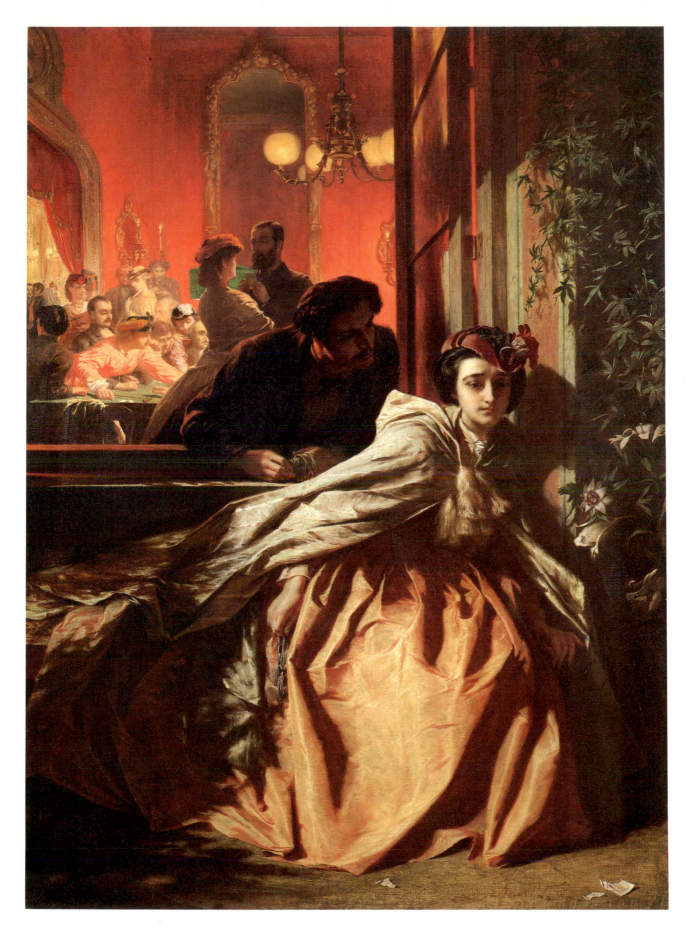

Cat. 157–8

FANTIN-LATOUR, Henri
Grenoble 1836 – 1903 Bure

Cat. 157 No. 1016

White cup and saucer. 1864

Oil on canvas
Signed: *Fantin 6-*
H: 18cm W: 27.4cm
Given by Sir Herbert Thompson, Bt., 1920

Coll: *Mrs. Edwin Edwards; bequeathed by her in 1907 to the donor*

Ref: *Paintings I*, p. 169; *Treasures*, p. 95

The date is recorded by Madame Fantin-Latour. Fantin was introduced to Edwin Edwards, lawyer and artist, in 1861. Later that year he stayed with Edwards and his wife Elizabeth at Sunbury, near London, on the first of several visits. His first English biographer, Frank Gibson (*The Art of Fantin-Latour*, London, 1924), recalls "He spent a month of quiet enjoyment, painting still life and flower studies superior to anything he had done hitherto." From July to October 1864 Fantin again stayed at Sunbury, and perhaps it was then that this picture was painted and acquired by Mrs. Edwards. The Edwardses, who acted as agents for the artist in England and promoted his still-lifes with special success, were the subjects of one of Fantin's best portraits (Tate Gallery, no. 1952).

Fantin is chiefly known for his numerous flower-pieces and his fantasies on music. Yet simple-seeming, small-scale still-lifes represent him at his best (see also cat. 158). They are in a tradition of still-life painting in France which in the 1860s was practised by Fantin's friends Edouard Manet and François Bonvin. Bonvin's still-lifes, inspired by the work of Chardin, are closely comparable to Fantin's.

CH

Cat. 158 No. 1017

White candlestick. 1870

Oil on canvas
Signed: *Fantin. 70*
H: 15.2cm W: 23.3cm
Given by Sir Herbert Thompson, Bt, 1920

Coll: *Mrs. Edwin Edwards; bequeathed by her in 1907 to donor*

Ref: *Paintings I*, p. 169

See cat. 157. The still-life, *Alms bowl and book* (Musée Municipal, Boulogne), also dated 1870, is very close in size and manner to this picture. During 1870 Fantin moved to rue Bonaparte, sheltering there and at the Hôtel des États-Unis with his father during the Siege of Paris (15 September–20 March 1871). In March 1871, before the fighting of the Commune broke out, Edwin Edwards visited Paris and bought all that Fantin had painted during the Siege; it was probably on this occasion that he acquired the *White Candlestick*.

CH

Cat. 159 PD. 30-1953

DIAZ DE LA PEÑA, Narcisse Virgile
Bordeaux 1807 – 1876 Menton

Stormy landscape. About 1870

Oil on canvas
H: 95cm W: 127.7 cm
Given by F. Matthiesen

Coll: *Jacques Duborg, Paris*

Ref: *Landscapes*, no. 19; *Paintings I*, p. 167

Despite the sale stamp, lower right, this is not identifiable with any picture in the Diaz sale, Paris, 22–7 January 1877.

Like Renoir, Diaz trained as a porcelain painter. His early canvases depict typical romantic figure-subjects, but after meeting Rousseau in the Forest of Fontainebleau in 1837 he developed his interest in landscape. By the time he stopped exhibiting at the Salon in 1859 he was well-known for his landscapes of Fontainebleau. This extraordinary evocation of a threatening storm is unsurpassed for its powerful drama in the work of any Barbizon painter. The boldness of the impasto and the scale suggest that it is a late work.

CH

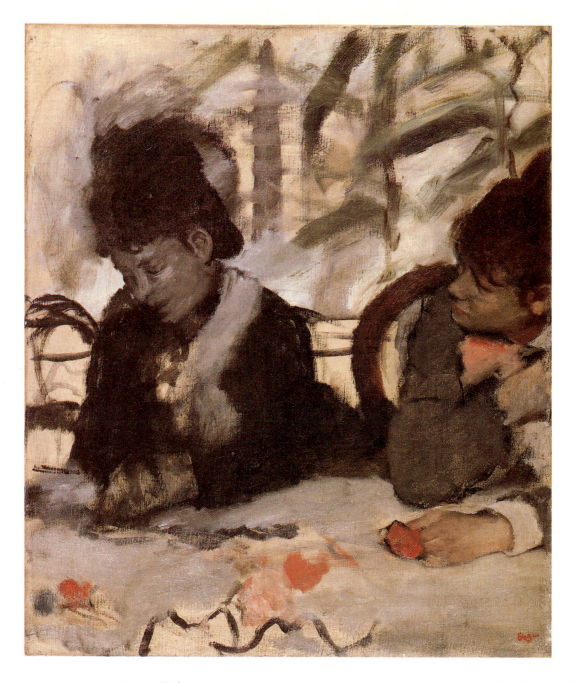

Cat. 160 No. 2387

DEGAS, Hilaire-Germain-Edgar
Paris 1834 – 1917 Paris

Au café. About 1876–7

Oil on canvas
Signed: *Degas*
H: 64cm W: 53.3cm
F. Hindley Smith bequest, 1939

Coll: *vente Degas I, Galerie Georges Petit,*
Paris, 6–8 May 1918, lot 71; P. Moore Turner;
O. F. Brown (1922); testator by 1925

Ref: *Paintings I*, pp. 161–2; *Treasures,* no.
105; *Winter*, no. 104

The title is that accepted at the Degas
sale. Nevertheless it has been suggested
that the women are sewing artificial
flowers on to clothes and that the painting
should be related to Degas' series of
paintings of milliners of the 1880s.
However, both style and technique, the
street clothes and the mood, as well as the
absence of sewing movements, support the
tradition that this is a café scene of about
1876–7. It is similar in colour range and
subject matter to *L'Absinthe* (Musée du

Louvre, inv. R.F. 1984) of about 1876. There
are no related drawings and the figures are
not used elsewhere.

The cutting of the figure by the right-
hand edge is typical of Degas' use of bold
compositional ploys to give an immediacy
to his depiction of modern life. Similar
cropping, perhaps influenced by snapshot
photography and pictures in newspapers,
was also used by Renoir (cat. 161).
Although Degas was exhibiting with the
Impressionists at this time, his café scenes
inhabit the drab world of Zola's novels
rather than the vibrant world of translucent
colours familiar from Impressionism.

CH

Cat. 161 PD. 44-1986

RENOIR, Pierre Auguste
Limoges 1841 – 1919 Cagnes

La Place Clichy. About 1880

Oil on canvas
Signed: *A. Renoir*
H: 64cm W: 53.5cm
Bought in 1986 from the Abbott, Cunliffe,
Robin Hambro Works of Art, Leverton
Harris, Marlay, Perceval and University
Purchase Funds and the Bartlett bequest,
with the aid of very generous grants from
the NHMF, the NACF, the Wolfson
Foundation through the NACF, the
Regional Fund administered by the Victoria
and Albert Museum, the Esmée Fairburn
Charitable trust, the Pilgrim Trust, the
Seven Pillars of Wisdom Trust, the
American Friends of Cambridge
University, the Friends of the Fitzwilliam,
and the following Cambridge Colleges:
Trinity, King's, Gonville & Caius, St John's,
Emmanuel, Peterhouse, Sidney Sussex,
Clare, Corpus Christi and Churchill,
together with contributions from numerous
firms and individuals

Coll: *Adolphe Tavernier sale, Paris, Galerie
Georges Petit, 6 March 1900, lot 64, bought
Marquise Arzonati-Visconti; Alexandre, Prince
de Wagram (1907–9); Reid and Lefèvre,
London; from whom bought by Samuel
Courtauld; given by him to his daughter
Sidney (Mrs. R. A. Butler); by whom
bequeathed to her daughter Sarah (Mrs.
Price), from whom bought*

Ref: *Ann. Rep.* 1986, pl. I

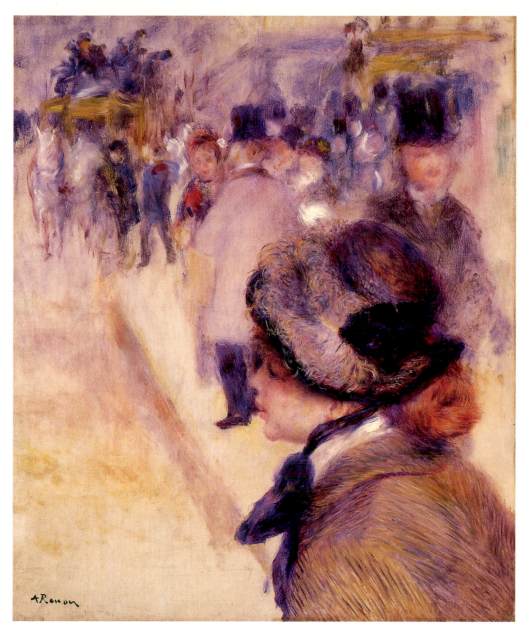

Although catalogued as *La Place Clichy*
as early as the Tavernier sale of 1900,
the topography is not certain and it may be
the Place Pigalle. The complete composition
was carefully prepared in a small sketch
(collection of the late Sir Anthony and Lady
Hornby), and there is a schematic sketch
for the back view of the top-hatted man in
the middle distance and the woman next to
him (formerly with Wildenstein, New
York). A finished study of the young
woman in the hat (Bührle collection,
Zürich, no. 168) probably post-dates the
picture.

 La Place Clichy represents Renoir's most
sophisticated development of
Impressionism. The painting of the girl can
be compared with *Le Déjeuner des canotiers*

of 1880-1 (The Phillips collection,
Washington) and the secondary figures
recall those in *Le Bal au Moulin de la Galette*
(Musée du Louvre, no. 2739) of 1876.
Subsequently he felt that he had taken
Impressionism as far as it could go, and by
1883 had reached an impasse. He had
already ceased to exhibit with the
Impressionists after his first acceptance at
the Salon in 1878.

 The depiction of the focussed figure in
the foreground against a blurred
background seems indebted to snapshot
photography. This interest in how a lens

sees recalls *La Loge* of 1874 (Courtauld
Institute Galleries, London, no. H. H. 210),
in which the sharp and blurred focus of the
painting reproduces the experience of the
man looking through opera-glasses.
Snapshots may also have suggested the
bold cropping of the subject of *La Place
Clichy*, with the young woman almost
accidentally appearing in the bottom
corner; this evokes wonderfully the
immediacy of urban life. The composition
is likely to have been influenced also by
Japanese Ukiyoe prints then widely
admired by Western artists.

 CH